ALSO BY JOHN RICHARDSON

Manet

Georges Braque

Braque

A Life of Picasso: The Prodigy, 1881–1906

A Life of Picasso: The Cubist Rebel, 1907–1916

A Life of Picasso: The Triumphant Years, 1917–1932

The Sorcerer's Apprentice: Picasso, Provence, and Douglas Cooper

Sacred Monsters, Sacred Masters: Beaton, Capote, Dalí, Picasso, Freud, Warhol, and More

A LIFE OF PICASSO

The Minotaur Years
1933–1943

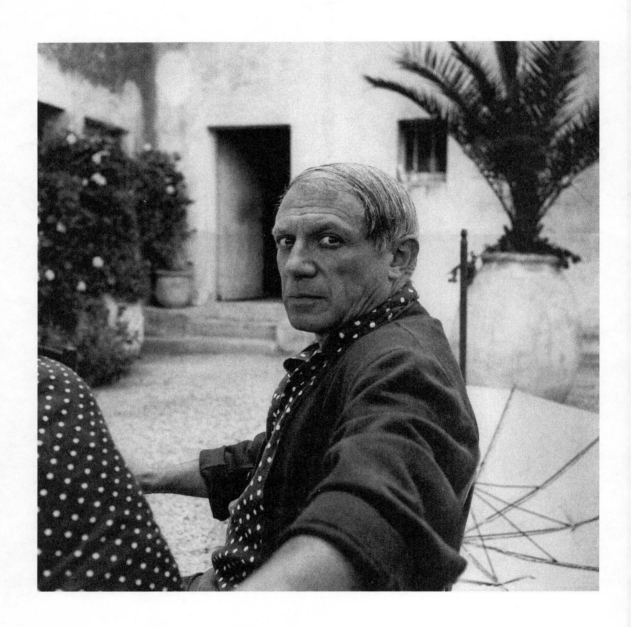

A LIFE OF
PICASSO

The Minotaur Years
1933–1943

John Richardson

with the collaboration of Ross Finocchio and Delphine Huisinga

Alfred A. Knopf · New York · 2021

Frontispiece: Lee Miller. Picasso at Hôtel Vaste Horizon, Mougins, 1937.
Lee Miller Archives, England

For Sonny Mehta

CONTENTS

A LIFE OF PICASSO

The Minotaur Years
1933–1943

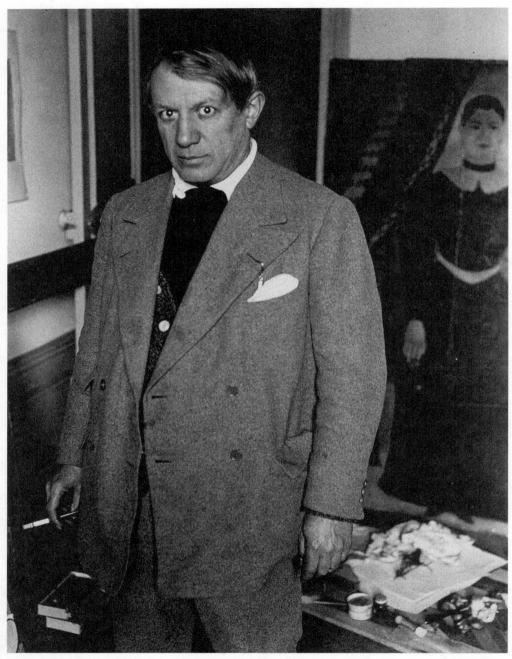

Brassaï. Picasso in front of the portrait *Yadwigha* by Henri Rousseau in his studio at rue la Boétie, Paris, December 1932. Musée National Picasso, Paris.

1

The Home Front

Of all the problems besetting Picasso in late 1932, foremost was the misery of married life with his Russian wife, Olga. As recounted in volume III, the former ballerina, who had prided herself, to Picasso's ever-increasing dismay, on being an impeccably ladylike consort and hostess, had become a termagant at home. The reasons were numerous, some dating back to the time of their wedding, in 1918. In April of that year, an injury and operation on her left leg had forced Olga to abandon her dream of balletic stardom.[1] Never again would she dance in public. Nor would she ever again see her parents and siblings after her marriage to Picasso. The Soviet Revolution had torn Olga's tsarist family apart. The disappearance of her father in 1919 and the absence of her two brothers in the military put her mother and sister in dire circumstances, detailed in the troubling letters they sent to Olga in Paris. On December 24, 1919, Olga's sister, Nina, wrote that they were facing sickness, scarcity of food, risk of eviction, and the brutally cold Russian winter.[2] Their elderly mother, Lydia, who would die in 1927, was reduced to peddling her belongings to survive. Olga and Picasso regularly sent money and other necessities to ease their suffering, but this did little to alleviate Olga's guilt at knowing that her loved ones lived in poverty.[3]

In 1922, Olga had to undergo yet another surgery, this time to treat a serious illness, the nature of which has never been divulged.[4] Stabilizing her condition required years of painful procedures in hospital. Olga's delicate health further alienated her from the superstitious husband, who blamed her for her own misfortune. As the artist once told me, he believed "women's illnesses are women's fault." Picasso's extramarital affair(s) and his violence contributed to Olga's physical and mental debacle. Since 1929, Olga had known of Picasso's relationship with Marie-Thérèse Walter—the very young woman he had met outside the Galeries Lafayette in 1927—from whom she had intercepted a postcard.[5] She kept the address of her husband's mistress in her agenda but seems to have told no one. Nor did she act upon it.

Another element in Picasso's loathing of Olga: the heavy Russian cloud of refugee resentment, grief, and nostalgia that permeated her entourage. Olga's rooms in their

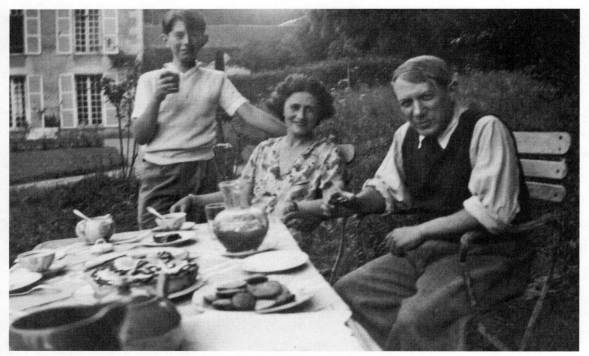

Paulo, Olga, and Picasso, Boisgeloup, c. 1933. Archives Olga Ruiz-Picasso.

apartment on the rue la Boétie resounded with Russian rather than French chatter. So much of this had rubbed off on him, Picasso told me, that a barber had even asked him, "Monsieur est russe?" And indeed, thirty years later he could still mimic Russian to perfection. This most superstitious of men had even adopted many Russian rituals. For instance, before embarking on a journey he insisted that those with him sit in silence for several minutes.

References to Olga in Picasso's work often turn out to be mockeries of balletic artifice. In one of his cruelest images, he depicts her with her hands clasped above her head in a travesty of the fifth position. He sometimes portrays his mistress Marie-Thérèse looking very much at ease in the same position. Olga has also been identified with the monstrous, horselike women that appeared in his painting since the 1920s. The link becomes more explicit in his corrida images of the 1930s, which often depict a hysterical horse raging against the charging bull or minotaur that stands for Picasso.

Despite these indignities, the thought of leaving Picasso seems never to have crossed Olga's mind. Her husband, on the other hand, had probably begun thinking about divorce. Until recently it had been illegal in Spain. However, as Picasso must have known, the liberal government that came to power in 1931 was in the process

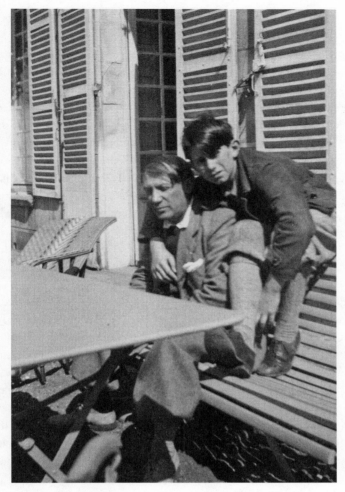

Picasso and Paulo, Boisgeloup, c. 1933. Archives Olga
Ruiz-Picasso.

of legalizing it. Indeed, a law was passed in 1932 allowing divorce for the first time in
Spain. Since divorces for foreigners married in France had to follow statutes of the
husband's native country, one can only imagine that Picasso's visit to Spain in sum-
mer 1933 was not only to see his family but also to check out how the new regime
might help him get free of Olga.

Complicating the couple's domestic problems was the news that Fernande Olivier,
Picasso's mistress from 1904 to 1911—years during which he and Georges Braque
masterminded the cubist revolution—was publishing a memoir about her affair with
the artist.[6] Fernande turned out to be a natural writer. Her account of bohemian
life in Montmartre is far more down-to-earth and convincing than Henri Murger's
celebrated, if novelettish, *Scènes de la vie de bohème* of 1851. She wrote it, Fernande

said, because she was broke. Also, she had never received the settlement that Picasso had promised when he left her. In the summer of 1930, Fernande had arranged to have her story serialized in the evening newspaper *Le Soir*.

Fernande's articles infuriated Picasso, who would try, not always successfully, to keep his multifaceted love life out of the press. This was the first time that intimate details of his hitherto very private life had appeared in a popular newspaper. He tried and failed to stop the publication; but Olga, more aware than ever of the sheer scale of Picasso's infidelities, reacted as ferociously as if Fernande still shared her husband's bed. It was probably Olga, rather than Picasso, who pressed his lawyers to take legal action. Six installments of Fernande's memoirs would appear before their efforts prevailed. Meanwhile, Paul Léautaud, editor of the literary journal *Mercure de France*, had been so impressed by the vividness of Fernande's story that he asked to publish it, and an agreement was reached to print three more excerpts in three consecutive issues of the *Mercure*.

In 1933, Picasso once again tried to stop publication when Stock printed Fernande's memoirs in book form, with a preface by Léautaud. Once again he failed. *Picasso et ses amis* came out to considerable success. Thirty years later, Picasso told me that, much as he resented the invasion of his privacy, Fernande's book described things the way they had been: "the only true picture of the Bateau Lavoir years," he said.

In April 1931, two years before the publication of her book in France, Fernande had reached out to her old friend Gertrude Stein to help find an American publisher for the memoir. This, wrote Fernande, would "rescue me from material difficulties that have left me at the end of my strength." Gertrude referred Fernande to her American agent, William Aspenwall Bradley, who agreed to represent her in finding a translator and a publisher. It would be a great inducement, he said, if a celebrated writer, such as Gertrude, could be persuaded to write a preface introducing Fernande to the American public. Gertrude declined. She could not, she said, write anything that did not correspond to her "ideal." Fernande was hurt. "Don't forget me, I beg of you," she implored Gertrude. "This book is the last card in my hand. If it doesn't succeed, I'll stop struggling for an existence, whose poetic meaning eludes me."[7]

Fernande heard nothing from Bradley or Gertrude for two years. The reason became abundantly clear when friends in America informed her that Gertrude was coming out with *her* memoirs. And instead of finding a publisher for *Nine Years with Picasso*, as Fernande wanted to call her book, Bradley had arranged for Harcourt, Brace to take Gertrude's *Autobiography of Alice B. Toklas*. This turned out to cover much of the same ground as Fernande's book and to have once had a very similar title (*My Twenty-Five Years with Gertrude Stein*). It was also written, albeit with more art, in the same vivid, snapshot style—a totally new departure for this usually arcane writer. Bradley had arranged for extracts from Gertrude's entertaining book

to appear in *The Atlantic Monthly*, and it was these extracts that friends brought to Fernande's attention. Fernande had always regarded Gertrude as a mentor, someone to whom she could turn when things went wrong. Now, rightly or wrongly, she felt deceived as well as betrayed. Fernande accused Stein of plagiarism and went so far as to threaten a lawsuit, which she never carried out.[8]

In November 1932, shortly before publication of *The Autobiography of Alice B. Toklas*, Stein invited Picasso and Olga to her celebrated studio—whose walls boasted some of his finest cubist works, not least the great portrait of Gertrude—to hear her read from the manuscript. Olga was appalled by the bits about Picasso's sacrosanct private life, not least the story of his breakup with Fernande: "She and Pablo have decided to separate forever. . . . You know Pablo says if you love a woman you give her money. Well now it is when you want to leave a woman you have to wait until you have enough money to give her. Vollard has just bought out his atelier and so he can afford to separate from her by giving her half."[9] Humiliated by passages like this, Olga walked out of the room in the middle of Gertrude's reading. Gertrude recalled the incident in the book she published five years later, *Everybody's Autobiography*: "I was

reading [Picasso] was listening and his eyes were wide open and suddenly his wife Olga got up and she said she would not listen she would go away she said. What's the matter, we said, I do not know that woman she said and left. Pablo said go on reading, I said no you must go after your wife, he said oh I said oh, and he left . . ."[10] After this evening, Picasso would not speak to Gertrude for the next two years.

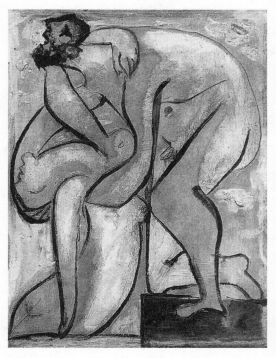

Picasso. *Le Sauvetage* (*The Rescue*), November 20, 1932. Oil on canvas, 35.5 x 27.5 cm. Private collection.

Marie-Thérèse fell seriously ill toward the end of 1932. While swimming or, more likely, kayaking in the Marne, she contracted a spirochetal disease from the rats in the river.[11] She was hospitalized with a high fever for several weeks, and most of her hair fell out. This was the second time that Marie-Thérèse had nearly died in the water. Françoise Gilot told me of an earlier incident that seemingly occurred in summer 1928, when Picasso and Olga were staying at Dinard on Brittany's Emerald Coast. Marie-Thérèse had been hidden away in a nearby *colonie de vacances*. What perverse, surreal pleasure Picasso must have derived from having

 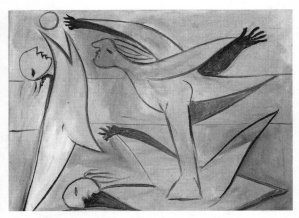

LEFT Picasso. *Women at the Seashore,* November 25, 1932. India ink on paper, 24.8 x 34.8 cm. Collection Gail and Tony Ganz, Los Angeles. RIGHT Picasso. *Female Bathers with Ball,* December 4, 1932. Oil on canvas, 81 x 100 cm. Musée National Picasso, Paris.

his teenage mistress concealed from his wife in a summer camp for children. In the course of their fun and games, Marie-Thérèse, who was an excellent swimmer, rescued one of the other girls in the camp from drowning. In doing so, she was nearly drowned herself.

Marie-Thérèse's aquatic accidents of 1928 and 1932 would haunt Picasso's art for years. In the *Sauvetage* of November 20, 1932, he envisioned Marie-Thérèse's lifesaver as a naked hulk of man—presumably self-referential—who appears to be embracing rather than resuscitating the girl's backward-bending body.[12] Drawings done five days later depict her underwater, entangled in weeds, while her sisters prance around.[13] On December 4, Picasso painted a grisaille beach scene on the *Sauvetage* theme in which two athletic girls play ball while another is seemingly trampled. The lack of color lends a deadly meaning to the image.

As we shall see, the distress triggered by Marie-Thérèse's accidents prompted Picasso's turn to votive magic: ex-votos—vows to gods, be they Mithraic or Christian—in the face of sickness, accident, or death. A sequence of votive works, paintings as well as sculptures, would dominate Picasso's imagery for the next four months and reappear sporadically over the next four years.[14]

Picasso's principal ex-voto work takes the form of a masterpiece. In the spring and summer of 1933, he would devote himself to making what is widely perceived as one of his finest sculptures, *Woman with a Lamp,* traditionally called *Woman with Vase.* This would materialize in the secrecy of his Boisgeloup studio. Why did Picasso choose this sculpture for his grave at Vauvenargues, his château on the slopes of Mont Sainte-Victoire (Cézanne's favorite subject)? Hitherto, no one has identified

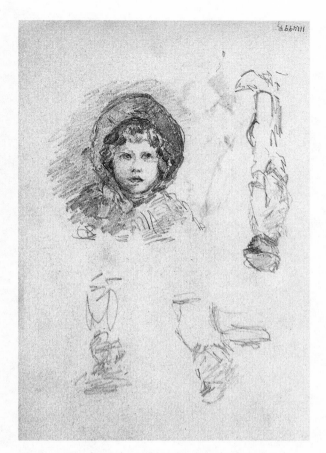

Picasso. Conchita, the artist's sister, and other sketches; page of a sketchbook. A Coruña, 1894–1895. Pencil on paper, 19.5 x 13.5 cm. Museu Picasso, Barcelona.

the figure holding a lamp, though various guesses have been made, including a misguided one in volume III. Here, I propose a new identification of the girl who presides over the artist's grave. It is no less than his long-dead sister, Conchita.

The turbulence of Picasso's life and work in the early 1930s harks back to his adolescence. In 1891, the Picasso family had moved from their Mediterranean hometown of Málaga to the Atlantic seaport of La Coruña. The artist's father had been appointed principal of this city's art school. During Christmas 1894, Pablo's seven-year-old sister, Conchita, for whom he had developed an obsessive adoration, was struck down with diphtheria. Paris was the only source for serum. Weeks would pass before it arrived. In the throes of adolescent piety imposed by his once priestly family, thirteen-year-old Pablo had vowed to God that he would never paint again if his sister's life was spared. He did paint again. The serum failed to arrive in time, and Conchita died on January 10, 1895.

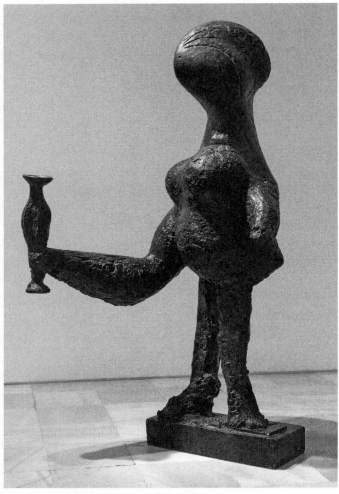

Picasso. *Woman with Vase,* summer 1933. Bronze, lost-wax
casting and patinated, 220 x 122 x 110 cm. Edition: 1/2.
Museo Nacional Centro de Arte Reina Sofía, Madrid.

Besides commemorating Marie-Thérèse's mishap, *Woman with a Lamp* honors
his little sister Conchita, whose death would haunt him for life. True, the figure over
his grave does not represent a seven-year-old; he preferred to immortalize her as a
grown woman. The beloved child's early death would cast an inescapable shadow
over virtually all of Picasso's relationships with women, especially that with Marie-
Thérèse. According to Jacqueline Roque, half a century later, the secret of the broken

vow had never been divulged to anyone else but the women in his life.[15] Fernande Olivier was lucky: she was abandoned, seemingly unscathed by Picasso's psychic demands. His wife Olga spent the last thirty years of her life in self-destructive devotion. By virtue of being a substitute for Conchita, Marie-Thérèse survived her affair with the artist, but she took her own life four years after his death. Her successor, Dora Maar, would suffer a mental collapse, from which Dr. Jacques Lacan rescued her by transforming her from a surrealist rebel into a devout Catholic conservative. Françoise Gilot (whose reign lasted from 1943 to 1952) survived, fought back, and thrived after leaving the artist. Jacqueline Roque, however, Picasso's second wife, would sacrifice herself on the altar of his art. Thanks largely to her, the last decade of his life was enormously productive. Thirteen years after his death, Jacqueline, too, would commit suicide.[16]

Brassaï. Picasso and Tériade in front of the sculpture studio, Boisgeloup, c. winter 1932–33. Musée National Picasso, Paris.

2

Brassaï at Boisgeloup

On December 21, 1932, the young Hungarian-born photographer Gyula Halász—called Brassaï, after Brasşov, his Transylvanian birthplace—spent the day at Picasso's Paris apartment. Brassaï had studied painting and sculpture in Budapest and Berlin, but in 1929, having worked in Paris for five years as a journalist, he took up a new career in photography, "the medium specific to our time," as he would later state, "capable of capturing the beauty of the Parisian night (that beauty with which I had fallen passionately in love during my Bohemian adventures . . .")[1]

Brassaï poured this passion into his first photographic book project, *Paris by Night*, which pictured the city's bars, dance halls, and brothels with a cool and detached eye. The book's immediate success thrilled Brassaï, who wrote to his parents, "I'm bound to get plenty of new offers. . . . Many people have bought it. A lot of bookstores sold all their copies the very first day."[2] The Swiss publisher Albert Skira and the Greek art critic Efstratios Eleftheriades, called Tériade, had both been so impressed by *Paris by Night* that they commissioned Brassaï to document Picasso's recent sculptures for the inaugural issue of *Minotaure*, the luxurious art magazine they were planning to launch in spring 1933.

The thirty-three-year-old Brassaï was anxious about meeting the legendary fifty-year-old Picasso, but he was put at ease by the artist's friendly welcome into his studio. The photographer, who took copious notes that would become the basis of his later memoirs, described the scene: "I set the word 'studio' in quotation marks because in the rue la Boétie apartment a suite of four or five rooms had been transformed into a combination junk shop and old-curiosity shop rather than into an atelier. The rooms, each with a fireplace surmounted by a mirror, were totally empty of furniture and were filled with piles of pictures, reams of paper, stacks of books, packages, wrapped models for sculptures, all lying helter-skelter on the floor, everything covered with a thick coating of dust." The chaos of Picasso's work space was in sharp contrast to the elegance and order of the rooms on the floor below, where Olga "reigned as the perfect *maîtresse de maison*." She was determined, Brassaï remembered, "to preserve an elegant and chic atmosphere" against the incursions of Picasso's "eternal disorder."[3]

Brassaï. Olga, Picasso, and Tériade reflected in the mirror at Boisgeloup, 1932. Musée National Picasso, Paris.

The following day Picasso arranged for Brassaï and Tériade to drive down to Boisgeloup, the Norman château near the town of Gisors that he had purchased in June 1930 and where he had set up his sculpture studio. They were joined by Olga and eleven-year-old Paulo. They drove to the château in Picasso's Hispano-Suiza. Although ever more secretive about his private life, Picasso relished the attention his car attracted. Wherever it stopped, admirers gathered to inspect the coachwork without and within—not least the mirrored interior, with its crystal vases of flowers—as well as the impeccable white-gloved chauffeur.

Brassaï. Plaster sculptures by Picasso in the Boisgeloup studio, December 1932. Musée National Picasso, Paris.

Picasso never, ever drove. He was adamant: "An artist should never put his hands at risk." He held André Derain's love of Bugattis against him, and later upbraided Braque, who had bought a house in Normandy and liked to drive there in his Rolls-Royce with stacks of canvases on the roof. Hadn't Picasso, I once asked him, as the inventor of welded sculpture, been obliged to put his hands at risk by using a welding machine? Of course not, he said; that was the job of Julio González, the Spanish artist whose innovative use of iron as a medium made him one of modernism's greatest sculptors.[4]

On entering Picasso's property, the car passed a deserted chapel covered in ivy

Brassaï. Façade of the Château de Boisgeloup lit by a car's headlights, 1932. Musée National Picasso, Paris.

before stopping in front of the château. Once inside, Brassaï observed "vast dilapidated rooms, all totally empty save for some of Picasso's huge canvases of the 'giants' period. A tiny apartment under the mansard roof had been furnished for the painter and his family."[5] By the time they opened the sculpture studio, a former stable, the light was fading. Nonetheless, Brassaï was dazzled by the brilliant whiteness of Picasso's plaster busts of Marie-Thérèse. Like most in Picasso's circle, Brassaï knew nothing of Marie-Thérèse's existence, let alone that the works he had come to photograph were inspired by her image. One wonders, however, if Olga, well aware of Picasso's affair, suspected as much. If so, how heartbreaking to see her domain populated by tributes to her husband's young mistress.

"You've got your work cut out for you, Brassaï," Picasso said, "and it gets dark very quickly here." The studio had never been electrified. Night was falling so, *faute de mieux*, Picasso took down the hanging hurricane lamp that he used when working at night. Placed on the floor and shaded from the photographer by a watering can, the lamp provided a source of light. Typical of Picasso to improvise a lighting system, and typical of Brassaï to use the improvisation to heighten the chiaroscuro. Brassaï had brought along twenty-four *clichés-verres*—glass photographic plates—permitting forty-eight exposures. The imaginative use of the kerosene lamp resulted in a series of memorable art photographs. "For a sculpture to achieve its full round

shape," Picasso said, "its lit parts have to be brighter than the background and its dark parts darker. It's so simple."[6] Before leaving the château around midnight, Brassaï used his last *cliché-verre* to capture a dramatic image of the building's façade illuminated by the headlights of the Hispano-Suiza. [7]

As Brassaï and Tériade took their leave after their triumphant but exhausting trip, Picasso suggested they meet again the following evening. "Where could it be . . . the Moulin Rouge? The Bal Tabarin? Why don't we go to the Cirque Medrano? I love it, and I haven't been for ages. And it would certainly amuse Paulo."[8] And so, the following evening, Brassaï, Tériade, Olga, and Paulo reassembled at the Cirque Medrano, where Picasso had taken a box. He hooted with laughter at the clowns, while Paulo scarcely smiled. Nor did Olga: she looked taciturn and distant—and no wonder. As yet there had been no talk of divorce, but Olga's "moodiness and bad temper," in Brassaï's words, had made everything more fraught.[9]

At intermission they toured the circus's stables, and Picasso reminisced about his early days at the Bateau Lavoir and visits to the old Cirque Medrano, where he had made friends with the clowns, who taught him tricks. He rambled on about the fourteen-year-old girl who used to sell flowers, as well as herself, outside the circus. This girl had inspired one of his finest Rose Period paintings, snapped up by Gertrude and Leo Stein.

Besides the usual circus acts, the Medrano had recently added an exciting new spectacle, *Le Cirque sous l'eau*—The Underwater Circus. Described by circus historian Dominque Jando as a "water pantomime," it involved "an army of clowns, beau-

tiful naiades in an aquatic ballet, and a battalion of sixteen showgirls. The pool equipment had been rented from the famous lion trainer Alfred Schneider's circus in Germany. . . . The legendary equestrienne Therese Renz (who was seventy-three and had not been seen in Paris since 1900!), the superlative Russian juggler Massimiliano Truzzi, and the Australian tightrope walker Con Colleano were among the 1932–33 season's highlights."[10] Six weeks later, Picasso organized a return visit to *Le Cirque sous l'eau* to celebrate Paulo's twelfth birthday, February 4.[11] It would be much happier than the previous outing. This second visit inspired several

Picasso. *The Circus,* February 5, 1933. Oil on canvas, 33 x 41 cm. Private collection.

paintings of wired trapezists splashing like flying fish in and out of the spotlights in an element that is both aqueous and aerial.[12]

The day spent with Brassaï at Boisgeloup would resonate in Picasso's work for months to come. Seeing his busts of Marie-Thérèse through the photographer's lens imprinted her sculptural likeness on the artist's mind and revived the impulse that had generated these works in the spring and summer of 1931. Josep Palau i Fabre puts it well: "The sculptural adventure with Marie-Thérèse had been a moment of euphoria, of plenitude, and he wanted to perpetuate it."[13] Picasso's obsession with his mistress's body found expression in a group of paintings, drawings, and etchings of sculptural subjects executed between January and May 1933. Brassaï wrote, "Sculpture was lurking like a virtuality deep within his paintings themselves, betraying nostalgia for art in the round."[14]

Consider the large still life of January 29, *Plaster Head and Fruit Dish*,[15] in which the artist opposes a strongly modeled bust of Marie-Thérèse on the left with a flat-

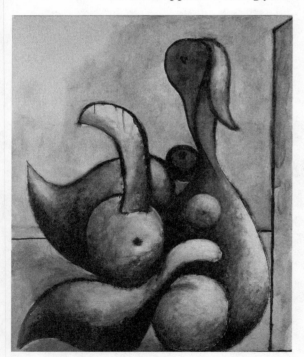

Picasso. *Seated Nude,* February 20, 1933. Oil on canvas, 130 x 97.3 cm. Kunstsammlung Nordhein-Westfalen, Düsseldorf.

tened compotier on the right—the symbolic motif used to stand for her in many subsequent paintings. Three weeks later, he again presents two- and three-dimensional visions of Marie-Thérèse in a pencil drawing of an artist's studio.[16] With its wide-open windows onto the sea and sky, the setting harks back to the still lifes Picasso made in his hotel room at Saint-Raphaël in summer 1919. On the left, he has set an easel with a painting of his sleeping mistress. On the right she appears as a bulbous, balloon-like sculpture on a pedestal.

This nude figure also provided the subject of a monochromatic painting done a day or two prior, in which the flippered form of Marie-Thérèse sits on a simplified seashore.[17] The vertical element on the far right recalls the beach cabanas where she and the artist would meet in the first summers of their affair.

In the last week of February Picasso's experimentation with sculptural imagery turned toward found objects. In the space of a week he did the *Anatomies*: ten impeccably rendered

pencil drawings of pinheaded female figures in groups of three.[18] The bodies are composed of basic household elements: cups and saucers, cog wheels, planks, a coat hanger, cushions, picture frames, hoops, potatoes, a ball and chain, a funnel, and, exceptionally, a chalice. Despite their surreal contrivance, the figures are so three-dimensionally detailed that they cast consistent shadows on the ground.

We must also take Picasso's prints of sculptural subjects into consideration. In six weeks between late March and early May Picasso executed some forty etchings on the theme of the artist and his model. Later dubbed the *Sculptor's Studio* series, this group would form a crucial part of the so-called *Vollard Suite* of one hundred copper plates acquired from Picasso in 1937 by his first Parisian dealer, Ambroise Vollard, and printed by Roger Lacourière for the first time two years later. Unlike Picasso's two previous print series, made for deluxe editions of Ovid's *Metamorphoses* and Balzac's *Le Chef-d'oeuvre inconnu* (*The Unknown Masterpiece*), both published in 1931, this body of work has no literary inspiration. Instead, it was born of Picasso's renewed fascination with his

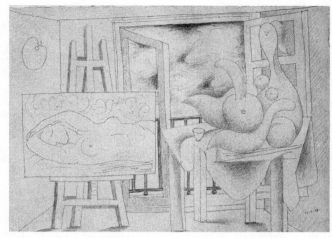

Picasso. *The Studio,* February 22, 1933. Pencil on paper, 26.2 x 34.3 cm. Musée National Picasso, Paris.

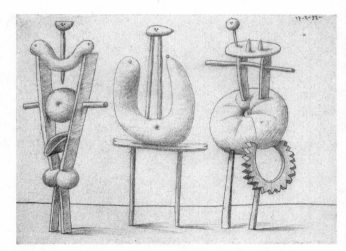

Picasso. *An Anatomy: Three Women,* February 27, 1933. Graphite, 20 x 27 cm. Musée National Picasso, Paris.

own sculptures of Marie-Thérèse as well as his long-standing interest in the art of the classical world. A decade or so earlier, he had ventured into classicism after the revelation of the monumental Farnese sculptures which had bowled him over on his visit to the Museo Archeologico Nazionale in Naples in 1917.[19] Picasso, a native of southern Spain, was very aware of his classical Mediterranean heritage; hence his fascination with the subject matter and styles of antiquity; hence, too, his perverse impatience with it. As he said, "Les beautés du Parthénon, les Vénus, les Nymphes, les Narcisses, sont autant de mensonges" ("The beauties of the Parthenon, the Venuses, the Nymphs, the Narcissuses, are so many lies").[20]

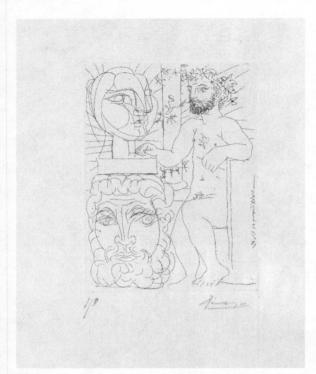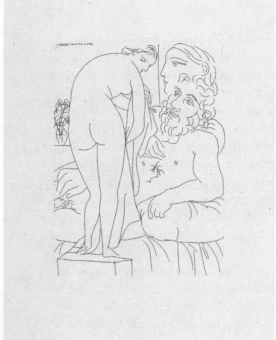

LEFT Picasso. *Sculptor and His Self-Portrait Serving as a Pedestal for the Head of Marie-Thérèse, Vollard Suite,* March 26, 1933. Etching on parchment, 44.5 x 36 cm. Staatsgalerie Stuttgart. RIGHT Picasso. *Sculptor in Repose with Marie-Thérèse and Her Representation as the Chaste Venus, Vollard Suite,* March 27, 1933; printed 1939. Etching, plate: 26.8 x 19.4 cm; sheet: 44 x 33.7 cm. The Museum of Modern Art, New York, Abby Aldrich Rockefeller Fund.

And so in these prints he chose to portray himself as a shaggy-haired and bearded sculptor of Greek antiquity, taking his ease in an Aegean studio "on a hilly island in the Mediterranean, like Crete," as he would tell his future mistress Françoise Gilot.[21] Marie-Thérèse is in attendance as both mistress and model. In many of the prints in the series, huge self-portrait heads charge the studio with Praxitelean energy, while the sculptor works away on variants of the phallic-nosed heads of Marie-Thérèse that Picasso had done two years earlier.[22] In the context of antiquity, they look idyllically at home.

He made no secret of his familiarity with the Louvre's Roman copy of Praxiteles's *Aphrodite of Cnidos*—one of the first female nudes in history (c. 400 BC). What better role for Marie-Thérèse than Aphrodite, goddess of love? The *Sculptor's Studio* prints are more tender and wistful than erotic, as if Picasso's bearded stand-in had arrived at a peaceful setting where he and Marie-Thérèse could live out their destinies in neoclassical bliss. Hence the air of wishful thinking.

In summer 1933, Picasso's ruminations on sculpture, triggered by his photographic

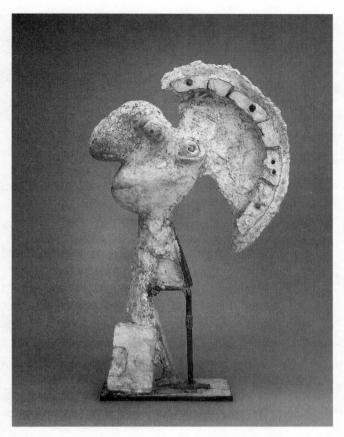

Picasso. *Head of a Warrior.* Boisgeloup, 1933. Plaster, metal, and wood, 120.7 x 24.9 x 68.8 cm. The Museum of Modern Art, New York. Gift of Jacqueline Picasso.

outing with Brassaï in December, would culminate in real, three-dimensional figures on a monumental scale. Back in his Boisgeloup studio, the artist would complete the first version of his *Woman with a Lamp*, discussed in the previous chapter, as well as *Head of a Warrior*, both in white plaster. Note particularly the ferocity of the latter figure's eyes, which were fabricated from two tennis balls—a testicular pun. This disconcerting masterpiece—ironical, comical, and sublimely ugly—derives partly from the hieratic noses he had devised for his busts of Marie-Thérèse in 1931. But this new monster stands for Picasso himself. The huge penile nose hints of self-portraiture. Its protuberant eyes, according to Gijs van Hensbergen, seem to refer to Saint Lucy, the patron saint of the blind (her emblem: two eyes on a dish), whom Picasso held in superstitious reverence.

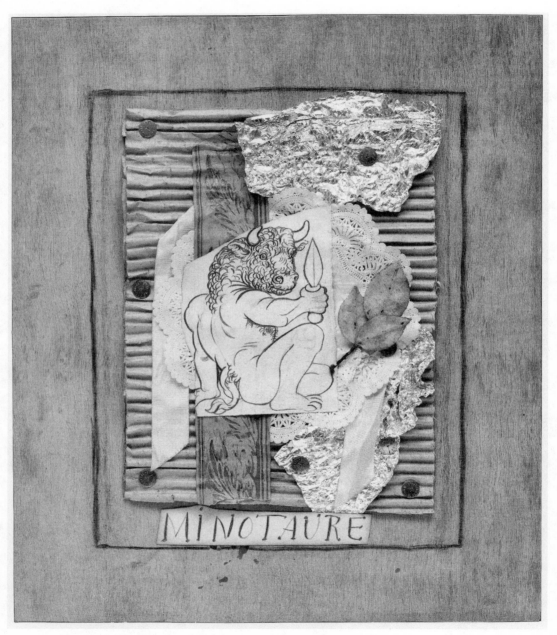

Picasso. Maquette for the cover of the journal *Minotaure,* 1933. Assemblage of corrugated card-board, metal foil, ribbons, printed paper, paper doily, artificial plant, tacks, and pencil-on-paper, mounted on wood with charcoal additions, 48.5 x 41 cm. Museum of Modern Art, New York. Gift of Mr. and Mrs. Alexandre P. Rosenberg.

3

Minotaure

Picasso's contributions to the inaugural issue of *Minotaure* brought him closer to surrealist writers and artists, who had sought from the start to coopt him into their ranks. Indeed, the movement's very name had been adapted from a term Picasso claimed to have coined to denote, in his words, "a resemblance deeper and more real than the real, that is what constitutes the sur-real."[1] Guillaume Apollinaire was the first to publish the term *sur-réalisme,* in the program for the 1917 ballet *Parade*—produced by Diaghilev's Ballets Russes with sets by Picasso—but by the time poet and writer André Breton wrote the first *Surrealist Manifesto* in 1924, the unhyphenated word's significance had expanded beyond the sphere of art and aesthetics. Breton defined surrealism as "psychic automatism in its pure state," and expounded its relation to Freud's theories on the workings of the subconscious mind. Nine years later, Picasso still complained of how Breton and his followers had misconstrued his meaning: "The surrealists never understood what I intended when I invented this word, which Apollinaire later used in print—something more real than reality."[2]

Conflicting concepts of surrealism did not prevent Breton from striving to ingratiate himself into Picasso's life and lure him into the movement. Breton's blandishments, in the form of public statements, private letters, and published essays, began even before the official founding of surrealism. On July 6, 1923, both men attended the Soirée du Coeur à Barbe (Evening of the Bearded Heart), a program of Dada performances organized by Tristan Tzara at the Théâtre Michel, where the poet Pierre de Massot dared to disparage Picasso by declaring him "dead on the field of battle." Upon hearing this, Breton leaped onto the stage and demanded that Massot leave the theater. When the latter refused, Breton set upon him so violently that he broke Massot's arm and had to be removed by police.[3] Picasso could hardly have forgotten this dramatic demonstration of support when, two months later, Breton begged him to do an author portrait for his soon-to-be-published collection of poems *Clair de terre.* "I would do anything for you if you would permit a portrait of myself by you to

Man Ray. Photograph of Paul Éluard and André Breton, 1930. Musée National d'Art Moderne, Centre Georges Pompidou, Paris.

preface [my] book," wrote Breton, "a long-standing dream that I have never had the audacity to propose to you."[4]

Breton's wish was granted in the form of a brilliant drypoint likeness in three-quarter profile that would become the frontispiece to *Clair de terre*. The time spent with Picasso while sitting for the portrait gave Breton the opportunity to realize another long-standing dream: persuading the artist to sell his cubist masterpiece *Les Demoiselles d'Avignon* to Jacques Doucet, the collector for whom Breton acted as librarian and art advisor. By the end of 1924, the deal was done and the painting in Doucet's apartment, further solidifying the bond between the poet and the painter.[5]

Breton's overtures also succeeded in ensuring Picasso's involvement in surrealist journals and exhibitions. The first issue of *La Révolution surréaliste* (December 1924), edited by Breton, featured a photograph of Picasso's recent sheet-metal *Guitar* as well as a portrait of the artist by Man Ray. Picasso also allowed Breton to reproduce many of his paintings, including *Les Demoiselles*, which was properly published for the first time in the July 1925 issue of *La Révolution surréaliste*. Breton wrote a landmark essay, "Painting and Surrealism," for the same issue, illustrated solely with Picassos, tying the movement's future to the artist he venerated. "If surrealism must chart itself a moral line of conduct," he declared, "it needs only find where Picasso has gone and where he will pass again."[6] Although Picasso would never be seduced into joining the surrealist movement, preferring instead to remain on the periphery, he was undoubtedly flattered by the adulation of Breton and his young followers.[7] He also had no compunction about selectively incorporating some of their techniques—eerie lighting, blasphemous references, sexual fetishism—into his own work throughout the 1930s. While he put no stock in their obsession with dreams and automatism, "what Picasso drew from Surrealist ideas," notes Pierre Daix, "was the liberty they gave to painting to express its own impulses, its capacity to transmute reality; its poetic."[8] Picasso's participation, in turn, lent legitimacy to the movement's nascent publications and exhibitions.

Breton was not the only surrealist seeking an alliance with the artist. In 1929, he had caused a schism by excommunicating from the movement a group of dissidents

that included Georges Bataille, a numismatist at the Bibliothèque Nationale and the author of the sexually transgressive novel *Histoire de l'oeil* (*Story of the Eye*). Over ninety years after its publication, the Sadeian perversity of Bataille's novel, in which a female protagonist pleasures herself with the detached eyeball of a dead priest, still shocks.[9] Active hitherto only on the fringes of the movement, Bataille became a leading renegade in April 1929 when he founded the journal *Documents*, recruiting as contributors most of the other dissidents alienated by Breton. While Breton relished his role as "the Pope of Surrealism," Bataille described himself as the movement's "old enemy from within," and considered *Documents* a "war machine against idealism," particularly the idealization of art, poetry, and the unconscious that distinguished *La Révolution surréaliste* as well as Breton's next journal, *Le Surréalisme au service de la révolution*.

Georges Bataille, c. 1935. Getty Images.

Underlying the editorial policy of *Documents* was Bataille's concept of "base materialism," which destabilized cultural conventions, high and low, for an unflinching look at violence, crime, religious cults, and sexual taboos. These were some of the subjects covered by *Documents* in erudite essays on archaeology, ethnography, fine art, and popular culture. Base materialism also informed the journal's treatment of Picasso's work. In the second issue, Michel Leiris, the artist's friend and Bataille's close collaborator, wrote that Picasso's painting was too *terre à terre* (down to earth): "never emanating from the foggy world of dreams, nor does it lend itself to symbolic exploitation—in other words, it is in no sense surrealist."[10]

Competition for Picasso's participation enflamed the antagonism between the Breton and Bataille factions of the movement, and spilled over onto the pages of their respective reviews. Not to be outdone by *La Révolution surréaliste*, Bataille reproduced more of Picasso's work in *Documents* than that of any other artist, and dedicated a special issue to him in April 1930. The editor's contribution to this *Hommage à Picasso* was a short philo-

Man Ray. Photograph of Michel Leiris, c. 1930. Musée National d'Art Moderne, Centre Georges Pompidou, Paris.

sophical text titled "Soleil pourri" ("Rotten Sun"), in which Bataille sought to align Picasso with the founding principles of *Documents* by finding in his work "the search for that which ruptures the highest elevation," and "the elaboration and decomposition of forms." In that vein, Leiris contributed a poetic tribute to the artist filled with the kind of visceral imagery that would, as we'll see, distinguish Picasso's own writing five years later:

> Everyday implements
> excrete stars
> and the stars do the same right back
> They clear their bowels of gutted fruits
> and bodies consumed on the off chance
> out of the cynical-eyed window
> whose damp woodwork spies[11]

Seemingly subdued and withdrawn, Leiris was a man of immense intellect and courage. He had met Picasso in spring 1924 through Daniel-Henry Kahnweiler, the artist's pre–World War I dealer and the publisher of Leiris's first book, *Simulacre*. The following year Leiris married Kahnweiler's stepdaughter, Louise Godon (called Zette), who would take over Kahnweiler's gallery in 1941. Though stable enough, the Leirises' union was complicated by the severe neuroses and sexual hang-ups rooted in the childhood traumas laid bare in Leiris's 1934 autobiography, *L'Âge d'homme*. Once an active contributor to *La Révolution surréaliste*, he had been purged along with Bataille from Breton's circle of surrealists in March 1929. Several months later, in a bout of depression and alcoholism, Leiris appeared on Bataille's doorstep at five in the morning asking for a shaving razor with which to castrate himself. Bataille put him off with the excuse that he only used an electric, and advised his troubled friend to see a psychoanalyst.[12]

It was also while working with Bataille in the editorial office of *Documents* that Leiris made the acquaintance of Marcel Griaule, one of the founding fathers of anthropology in France. Despite Leiris's total lack of experience in the field, Griaule invited him to join a state-sponsored expedition across equatorial Africa to gather cultural artifacts for the Trocadéro Ethnographic Museum.[13] Embarking in May 1931, Leiris became the secretary-archivist for the Mission Dakar-Djibouti, responsible for maintaining the logbooks and making inventories of objects acquired and photographs taken by Griaule's team. While also keeping a voluminous personal diary of the journey—published in 1934 as *L'Afrique Fantôme*—Leiris found time to correspond with Zette, Picasso, and Olga. The encounters with exotic animals and native tribesmen recounted in his letters captivated the imagination of young Paulo,

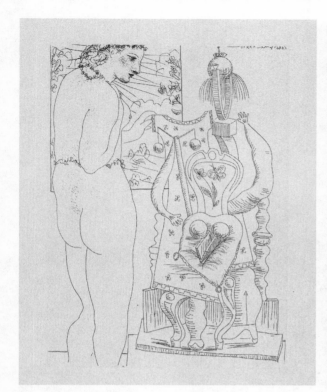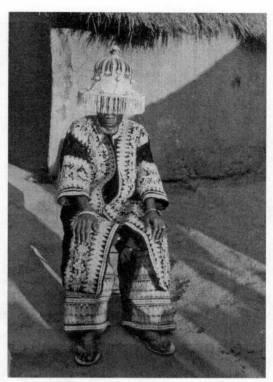

LEFT Picasso. *Model and Surrealist Sculpture, Vollard Suite,* plate 74, May 4, 1933. Etching on Montval laid paper, 26.8 x 19.3 cm. Kunstmuseum Pablo Picasso Münster. This image of Marie-Thérèse confronting a surrealistic mirror image of herself seems to be based on one of the photographs taken during the Dakar-Djibouti expedition. RIGHT Manigri chieftain in ceremonial clothing, December 1931. This photo was published in the second issue of *Minotaure*. Fonds Marcel-Griaule, Bibliothèque Éric-de-Dampierre, LESC/CNRS, Université Paris Nanterre.

who liked to pretend that he was part of the expedition.[14] Picasso, too, was amused by news of Leiris's African adventures, sending him a postcard from Boisegeloup on which he drew an ostrich, a rhino, and a giraffe walking the streets of the French village.[15] On February 20, 1933, when Leiris and his colleagues returned to Paris after two years abroad, Picasso was among the crowd waiting at the train station to welcome him home.[16]

Meanwhile, neither of Paris's leading surrealist journals had generated enough sales to sustain publication. Around the time Leiris left for Africa, *Documents* had closed down after its chief sponsor, dealer Georges Wildenstein, rescinded his support. Base materialism was probably not what Wildenstein—publisher of the *Gazette des Beaux-Arts*, one of the oldest French art journals—had in mind when he agreed to finance Bataille's venture. Breton's Marxist review, *Le Surréalisme au service de la révolution* (successor to *La Révolution surréaliste*), lasted longer but failed to live up

Brassaï. Albert Skira in his *Minotaure* office, 25 rue la Boétie, Paris, 1932. Private collection.

to its portentous title. Mainly self-funded by its contributors, its prospects fell when Breton was expelled from the Communist Party for inveighing against the USSR's ever-more-draconian directives. So much for his *service de la révolution*. So much, too, for the party's backing of his journal. Breton's coeditors, Louis Aragon and Paul Éluard, did their best to keep *Le Surréalisme au service de la révolution* going, but in May 1933 it, too, folded. In its last issue, Breton ran a full-page advertisement for the next periodical he would edit, *Minotaure*, newly founded by Albert Skira and Tériade.

These young impresarios were well-known to Picasso. Skira had commissioned the artist's 1930–31 prints for Ovid's *Metamorphoses*.[17] Two years later, while planning *Minotaure*, Skira moved part of his business from Geneva to an office next door

to Picasso's rue la Boétie apartment. Thus he could be even closer to the artist than his principal competitor in the field of artist-illustrated books, Ambroise Vollard. As for Tériade, he had been the modern-art critic for *Cahiers d'Art*, the journal whose publisher, Christian Zervos, was also compiling Picasso's catalogue raisonné.[18]

The failure of earlier surrealist journals created an opportunity for Skira and Tériade to dazzle the art world with a lavishly illustrated magazine in which they hoped to combine the best elements and contributors from *Documents* and *Le Surréalisme au service de la révolution.* This, of course, would require a truce between the movement's two most controversial and antagonistic figures, Breton and Bataille, as well as their partisans. Éluard doubted that the opposing camps could work together, writing to the artist Valentine Hugo, "I don't know about the magazine Schira [sic] has asked Breton to run for him. It seems to me impossible for us to collaborate with such disgusting elements as Bataille who . . . says that man lives with his own death. Mystical vomit."[19] Tériade managed to reconcile the rivals for a short time, but the question of who would direct the journal seems to have reignited their mutual hostility. While the dissident surrealists hoped to exclude Breton and his followers, the latter were scheming to push out Bataille. "I tried to bring them together," Tériade recalled, "but it was no use."[20] Picasso helped settle the matter when he insisted that Breton write the feature article about him for *Minotaure*'s first issue. In the end, perhaps in deference to the artist, Skira gave Breton the reins and would eventually make him editor. In April, Éluard gloated to his ex-wife, Gala (soon to marry Salvador Dalí), "Great news: M. Bataille has been kicked off Skira's review. Which strengthens our contribution. . . . Our politicking was good."[21]

Though Bataille's contribution would be limited to the magazine's conceptualization, his influence helped determine its ideological character as well as its title.[22] The painter André Masson described how *Minotaure* got its name during a meeting held at the poet Roger Vitrac's apartment in February 1933. "Some of the dissident Surrealists had gathered . . . the title of the new magazine being founded by Tériade and Skira came under discussion. What would it be? The dissidents proposed *L'Age d'Or*, from the film by Luis Buñuel and Dalí. Georges Bataille and I preferred *Minotaure*, a little-known personage who was in keeping with the disquieting character of our time. The Minotaur is not in the main line of Greek mythology but an obscure personage whom Theseus put to death. Theseus stood for intelligence and rationalism, while the Minotaur answered to something more incomprehensible, more dramatic."[23]

By adopting the Minotaur as an emblem, the surrealists gave new life to a fearsome deity, a hybrid offspring of a bull and the wife of King Minos of Crete. According to legend, Athenian youths had to be sacrificed to this monster, whom Minos kept confined in a labyrinth. In the early years of the twentieth century, the eminent Brit-

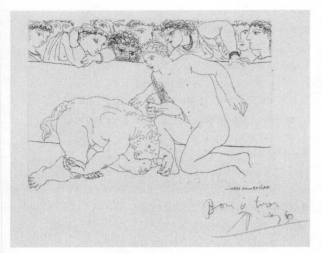

Picasso. *In the Arena: Young Man Killing the Minotaur,*
Vollard Suite, plate 89, May 29, 1933. Etching,
19.4 x 26.8 cm. Musée National Picasso, Paris.

ish archaeologist Sir Arthur Evans had set out to uncover the origins of the Minotaur myth at Crete's Bronze Age palace of Knossos. By the 1930s, Evans was in the midst of publishing his multivolume archaeological study of Knossos, which would have a lasting impact on the study of ancient Greece.[24]

Now that the surrealists had a name for their magazine, the editors had to come up with an eye-catching cover. They first chose Masson. However, as Masson told Bataille's biographer Michel Surya, "Picasso, having got wind of it, seized upon the idea. It was really a matter of papacy. Breton was indeed the 'Pope' and the financiers were his fanatical supporters."[25] Picasso got the job, and he immediately started work. On May 25, 1933, he revealed to Brassaï his collage for the cover.[26] Picasso had thumbtacked onto a wooden panel a piece of corrugated cardboard with a drawing of a Minotaur stuck onto it. This self-referential image was festooned with evocative bits of crumpled silver paper, some floral trimming, a lace doily, and some plastic foliage, which he told Brassaï he had pinched from one of Olga's hats.[27] Picasso was very insistent that the thumbtacks be much in evidence.[28] The collage would make for a costly cover, but the daring publishers were determined to impress. Tériade recalled: "Skira and I wanted it to be a deluxe magazine illustrated with color reproductions. This Picasso cover was horribly expensive and threw our budget out of balance, but it was necessary for the launching of *Minotaure*."[29]

In devising this image, Picasso became obsessed with the Minotaur. Over the next few days, he did engravings portraying a classicized version of himself as a wounded Minotaur in the bullring. In one of these, the Minotaur receives the coup de grâce from a naked youth.[30] Might this be Theseus? Like the Minotaur, he is another of the artist's alter egos. The description of the work Picasso gave to Françoise Gilot skirts this point; he told her: "Every Sunday, a young Attic Greek came over from the mainland and when he killed a minotaur he made all the women happy . . ." In the following day's version, the Minotaur is alone; a group of women look down on the mortally wounded beast. Among them, Marie-Thérèse reaches out to touch him in the arena.[31] In the last of the series, the Minotaur returns to life and crouches over the sleeping Marie-Thérèse.[32] "He's studying her," Picasso told Gilot, "trying to read her thoughts, trying to decide whether she loves him *because* he's a monster. It's hard

to say whether he wants to wake her or kill her."[33] Might Picasso have felt this way about Marie-Thérèse? Such thoughts often surface in references to his women.

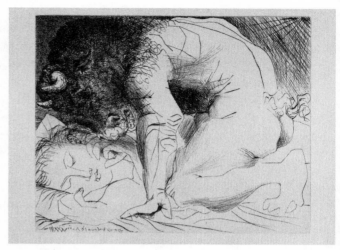

Picasso. *Minotaur Caressing the Hand of a Sleeping Girl with His Face, Vollard Suite,* plate 93, 2nd and last state, 1933. Drypoint on Montval laid paper, 29.9 × 36.5 cm. Kunstmuseum Pablo Picasso Münster.

*M*inotaure nos. 1 and 2 came out together on June 1, 1933. Picasso dominated no. 1. The frontispiece illustrated four of his Minotaur etchings[34] in which the monster holds a dagger that recalls the Minoan labrys (a double-edged axe) excavated by Arthur Evans on Crete. This made way for André Breton's fulsome essay "Picasso dans son élément," illustrated by Brassaï's photographs of the Paris and Boisgeloup studios. This article offered a revelatory view inside the artist's inner sanctums. Brimming with the lofty metaphors that Breton loved (and Bataille detested), it also provided worshipful praise of Picasso's career, described as "the uninterrupted attempt to confront what exists with what might exist; to bring out of the never-seen whatever can push the already-seen to be perceived less carelessly." Referring to one of Brassaï's images of the rue la Boétie apartment, Breton imputed deep significance onto the clutter of Picasso's surroundings: "Let a pile of abandoned cigarette packs on a mantelpiece, with its irregular and meaningless whirl of red and white stickers, arbitrarily form a pair (a pair such as to plunge the spirit of arrangement and bourgeois luxury into eternal despair) with a plaster figure surrounded by some absurd multicolored vase, and suddenly the whole mystery of human and animal construction is at stake."

Besides Brassaï's sculptural photographs, Breton included Picasso's intensely moving *Crucifixion* drawings (September 1932). These had been inspired by a recent visit to the Grünewald altarpiece at Colmar, which he saw on the way back from his retrospective in Zurich.[35] Picasso also allowed Skira to publish his *Anatomies*, pencil drawings conceived as sculptures—gigantic ones, given their placement on the page. These friezes of grotesque bathers on a seemingly sunlit beach can be seen as a surrealist commentary on the Golgotha darkness and skeletal whiteness of the no less surrealist Grünewald-inspired *Crucifixions*. The grotesquerie of their component parts constituted an adherence to surrealist principles, which Picasso, as we've seen,

had previously been at pains to avoid. Hence Breton's hosannas. Apart from Picasso, Masson was the only artist to receive major coverage in *Minotaure* no. 1. Five pages were devoted to his electrifying drawings of massacres—arguably his *chef d'oeuvre*. This gifted artist would never again shine quite as brightly as he did under surrealist auspices.

Breton's surrealist associates, writers as well as painters, were well represented in *Minotaure*'s pages. The magazine's most surprising contribution to literature was a "play" in five acts by the Marquis de Sade, with a dramatis personae and a plot, but no dialogue. Otherwise, the most unexpected inclusion to *Minotaure* was a page from the score of the as yet unpublished "sung ballet" *The Seven Deadly Sins* with a libretto by Bertolt Brecht and music by Kurt Weill. Although none of the sensational paintings by the surrealists' new superstar Salvador Dalí figured in the first issue, Dalí contributed a text entitled "Interprétation paranoïaque-critique de l'image obsédante L'Angélus de Millet," the prologue to a psychoanalytical study he was writing about Jean-François Millet's nineteenth-century icon. Though the excerpt in *Minotaure* mentions the eponymous painting only once, in a photo caption, it's enough to get the thrust of Dalí's interpretation: "How could *The Angelus*, an image of sublime symbolic hypocrisy and popular obsession, have been able to mask such flagrant and unconscious 'erotic fury'?"[36] In April, Éluard had warned Dalí not to submit something too outrageous for publication in the magazine: "It is necessary for Skira that your text should be in no way pornographic. Work it out, it's urgent. Send it to Breton."[37]

On his first visit to Paris in 1926, Dalí—already something of a prodigy, though as a writer rather than a painter—had intrigued Picasso, who kept a close eye on his development and his self-promotional cult of paranoid perversity. The two artists could even converse in Catalan, and enjoyed joking about the *Caganer*, the "shitter" from Catalan folklore who returns the earth's produce back to its source. Politics would come between them, when Dalí became a wacky fascist, as would Dalí's obsession with money, which inspired Breton's anagrammatic nickname for him: Avida Dollars.

Art dealers, traditional as well as avant-garde, helped finance *Minotaure* with advertisements. One of the more stylish of them was Pierre Colle, who announced in the magazine the June 1 opening of an exhibition at his gallery entitled *Le Surrealisme en 1933* with Breton and Éluard as curators. The surrealist predilection for *objets trouvés* was the focus of their show. Picasso had been one of the originators of this genre, and three of the all-important examples he had recently fashioned are listed in the catalogue. The *objets-trouvés* show turned out to be a major event in surrealist history, partly because it included Dalí's quintessential *Retrospective Bust of a Woman*, a mannequin bust with a baguette on its head. Rumor has it that Picasso

attended the show with his Saint Bernard dog, which attacked Dalí's statue and took a bite out of the baguette, to Picasso's delight.

Colle and *Minotaure*'s other early advertisers were cashing in on the ever-growing market for modern art, not least surrealism, which lent itself to sensational photographic promotion. The magazine's sumptuous quality and excellent reproductions were intended to serve the interests of dealers as well as artists, and titillate a sophisticated and affluent public who found surrealism much more fun and far more sexy than cubism. *Minotaure*'s success would signal the movement's steady commercialization, the softening of its revolutionary violence, and the crossover of its activity "from the street to the salon."[38] Over the next several years, surrealist art would even make its way into marketing campaigns for fashion and beauty products. Designer Elsa Schiaparelli's enormously popular perfume, Shocking, launched in 1937, was one of countless products to derive inspiration from surrealism, revealing how rapidly a movement that was rooted in radical Marxist and Freudian principles could degenerate, so far as its founders were concerned, into an eye-catching, mind-blowing gimmick of immense use to advertisers, fashion photographers, and moviemakers. Breton would be horrified by this development; Dalí delighted.

4

Summer at Cannes and Barcelona

As he had done most summers since the 1920s, Picasso spent summer 1933 on the Côte d'Azur with his wife and son. He kept his mistress, Marie-Thérèse, well away in Biarritz, most likely at the villa of his old Chilean friend Eugenia Errázuriz. Back in Cannes at the height of the season, Picasso took to prowling the beach. The Côte d'Azur had been his retreat ever since he and the Murphys had invented its summer season ten years earlier, and he derived ironical satisfaction from watching the crowds of visitors enjoying the touristic revolution he felt he had wrought.[1] Much of the time, the Picassos kept to themselves in the Hôtel Le Majestic. And there he was able to work—on paper, though not on canvas.

Shortly after his arrival, Picasso did a gouache, *Silenus Dancing,* in which he classicizes the holidaymakers who were swarming into Cannes during the weeks leading up to Bastille Day, July 14.[2] A bacchanalian gaggle of naked revelers frolics and gropes its way along the beach. In the finest of these Cannes images, *The Sculptor and His Statue* (July 20, 1933), he recapitulates a theme from the *Sculptor's Studio* series.[3] This time he reveled in using brilliant color. The statue looks almost as if it were etched, a device that enabled Picasso to differentiate between the *matière* of the statue and the living flesh of the sculptor.

His longing for Marie-Thérèse is evident in a watercolor done on July 30. In two dramatic halves, it contrasts a sunlit, self-referential head from the *Sculptor's Studio* series with a shadowy portrait of Marie-Thérèse stuck on a wall above an ornate vase of flowers.[4] It's as readable as a diary entry. This gorgeous image would find its way into the collection of one of *Minotaure* magazine's sponsors: Edward James, a major British patron of the surrealist movement and a benefactor of Salvador Dalí.

Meanwhile, Picasso treated other subjects which, while still classical and melancholy in feeling, are unmistakably surrealist. The drawings, watercolors, and gouaches dating from this summer at Cannes are what Picasso had in mind when he claimed 1933 as the only time his work could be described as surrealist, given their surrealist *cadavre exquis* technique. They usually represent disquieting figures made up of a heterogeneous array of objects—dilapidated furniture, household utensils, frag-

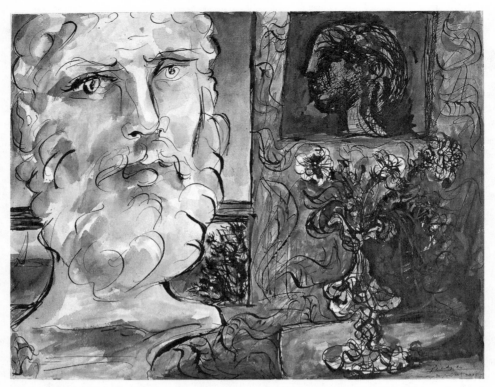

Picasso. *Still Life with Classical Head and Bouquet of Flowers,* July 30, 1933. Watercolor and pen and ink on paper, 40 x 50.5 cm. Private collection.

ments of sculpture, and studio debris. On July 28, Picasso did a drawing of two such figures, one composed of a chair on which balance a door, cushion, a tree trunk, and the arm of a statue holding a stone bust, while the other includes such diverse objects as a shutter, amphora, mirror, and old glove.[5] The following day Picasso executed a watercolor, likewise of two figures contemplating one another, one a naturalistically drawn nude (only the black shape or shadow behind her is ambiguous), the other a strange two-headed creature consisting of bits of statuary balanced on half a table, which in turn balances on a ball.[6] In contrast to almost all of Picasso's previous work, this subject is deliberately enigmatic and obscure, and therein lies the picture's power to disquiet—an image thrown up by the artist's subconscious. Unlike Dalí and other surrealists, Picasso does not try to induce a *frisson* self-consciously or artificially, but to express his own dilemma via pictorial symbols with a private significance.

Other drawings from July and August tell different kinds of stories, from *chagrin d'amour* to macabre fairy tales. All that remains of the sculptor's attic studio are the huge marble heads littering the beach. Tottering columns form an archway in which Marie-Thérèse makes an apparition.[7] She is all too evidently unavailable to him. Eventually, Picasso sees himself as a sea monster rescuing her from the waves,

Picasso. *Two Figures on a Beach,* 1933. Ink on paper, 40 x 50.8 cm. Purchase. The Museum of Modern Art, New York.

whereupon he rapes her and seemingly kills her.[8] Was he perhaps re-enacting her *noyade*? Black comedy, self-pity, and conceivably self-doubt merge in these surreal beach scenes. In one of them, the artist sees himself imprisoned behind a basement grating by a menacing female made of bits and pieces (his wife?).[9] It was time to leave Cannes.

On August 18, Picasso, who had not visited Spain since 1926, left Cannes for Barcelona. As they had done on their last visit to the city, the family settled into the Barcelona Ritz for a week.[10] Bullfights were a priority.

Besides attending *corridas,* Picasso had some messy family business to confront, involving his mother, his sister Lola, and Lola's brain-doctor husband, Juan Bautista Vilató Gomez. They had allowed crooked dealers to make off with hundreds of drawings and other precious early works that Picasso had left in their care. Their dereliction had landed him in what would turn out to be an eight-year legal battle—known to the press as *l'affaire Picasso.*[11]

Back in May 1930, a Catalan art crook, Miguel Calvet, and a so-called Picasso

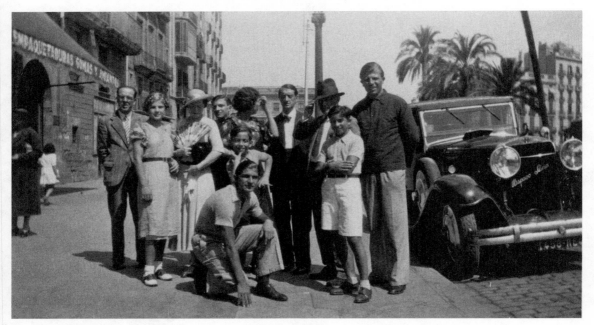

Left to right: Juan Bautista Vilató Gómez, María Dolores (Lolita) Vilató Ruiz, Olga Picasso, Pablo Vilató Ruiz, Lola Ruiz-Picasso, Jaime Vilató Ruiz (in front of Lola), José Vilató Ruiz (aka J.Fin, kneeling in the foreground), Angel Fernández de Soto, Picasso, Javier Vilató Ruiz, and Juan Vilató Ruiz. Barcelona, 1933. Archives Olga Ruiz-Picasso.

enthusiast, Joan Merli, had called on Doña María in Barcelona, saying they knew Picasso well and were writing a study of his early work. Would she lend them some of her treasures? No one was ever allowed to see them, Doña María said, let alone borrow them. Undeterred, Calvet proceeded to sweet-talk her into showing him a dusty old basket filled with early drawings and a few oil studies that had been stored in the attic. Calvet conned her into handing over the basket, that contained hundreds of items, for his spurious book. After pressing her into accepting 150 pesetas, he got her to sign a piece of paper, which she did not realize was a bill of sale. Worse, the gullible brother-in-law helped the thieves carry off the loot.

It would take Picasso some time to realize why so many Paris dealers had been asking him to sign very early works. The scales fell from his eyes when a Paris gallery owner, Madame Zak, asked him to come and look at her show of early drawings. Immediately, Picasso realized what they were. After promising to come back and sign them, Picasso took legal steps to have the drawings seized.

To his understandable rage, the French courts decided in 1932 that since the gallery owner had purchased them in good faith, she was entitled to them. Picasso's

lawyers fought back. So did the canny Madame Zak, who had taken on an aggressive, soon-to-be-famous young lawyer, Maître Maurice Garçon. Picasso was appalled that the public went along with Garçon's trumped-up accusations that Calvet and company had acted out of charity because Picasso did not give his mother enough money to live on. This was not entirely untrue: the artist did keep family members on a short monetary leash. Yet another hearing had been scheduled for October 1933 in Paris; and since his brother-in-law and family felt obliged to attend, there was all the more reason for Picasso to visit them in Barcelona beforehand.

At this fraught moment Picasso also may have wanted to consult Spanish lawyers on another matter: his desire for a divorce from Olga. Spain's liberal government had legalized divorce on March 2, 1932; but with the precarious new regime threatened by opposition on the right, it would have behooved Picasso to inquire about a Spanish divorce as soon as possible, and to behave cautiously when it came to his mistress. Stories that he had smuggled Marie-Thérèse into Spain and kept her hidden are unfounded. On the contrary, he missed her so much that he devised a collage from his bullfight ticket stubs and mailed it to her.[12] He made a point of taking Paulo to the *corridas* to enhance the boy's *afición*, much as his own father had done with him. Paulo would prove to be a lifelong aficionado.

On August 22, Picasso paid a call on one of his oldest and most supportive friends, the Catalan sculptor Manolo (Manuel Hugué), at his house (now a museum) some thirty miles north of Barcelona at Caldes de Montbui. Ten years older than Picasso, Manolo had been the only person who dared to mock or contradict him during their days, three decades earlier, at Els Quatre Gats café, a favorite gathering place of Barcelona's modernists. "Little Pablo," as Manolo called him back then, was wowed by his companion's outrageous clowning and was sometimes the victim of his pranks, as when Manolo introduced the youthful-looking Picasso as his daughter. Having evaded military service as a young man, Manolo had been unable to return to Spain. He settled in Montmartre, where his ambition was to become a modernist sculptor. In her memoirs Fernande Olivier described Manolo as "the quintessential Spaniard, small with the blackest possible eyes set in a black face beneath the blackest of black hair. He was ironic, gay, sensitive, lazy, and very excitable." A Spanish royal decree in 1927 granting amnesty for deserters had enabled him to return to his native country. Manolo's charm and humor never left him. His dying words to his wife, Totote, in 1945 were in character: "Je m'en vais . . . tu viens?" ("I'm off . . . are you coming?").[13]

Totote played no less of a role in Picasso's cosmology. He likened her to Celestina, the villainous heroine of Fernande de Rojas's 1499 masterpiece, *La Celestina*, the inspiration of Picasso's last great series of prints, *Suite 347*.[14] He claimed that Totote had pimped for him, and indeed, eighteen years later, when he was between mistresses, she tried inveigling him into marrying her daughter. He declined.

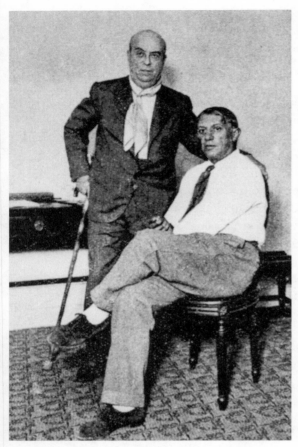

Manolo standing next to Picasso at the Hotel Ritz,
Barcelona, 1933. Biblioteca de Catalunya, Barcelona.

At Caldes de Montbui, Manolo had brought together the surviving members of the Els Quatre Gats group. The Soto brothers, the Junyer-Vidal brothers, and other old friends were so thrilled to see Picasso that they begged him to return the following year. Inevitably there was also a vestigial resentment on the part of Catalan artists who had resisted the lure of Paris and failed at home. They had every reason to feel that their "little Goya" had abandoned them. Still, they knew the door of Picasso's studio was always open, should they visit Paris; and many, as we'll see, would find shelter there from the violence in their home country. One such was the sculptor Apel·les Fenosa, whose career Picasso had helped to launch. In August 1933, Fenosa welcomed Picasso into his Barcelona studio at 6 Carrer del Vidre and even arranged to sell him a sculpture (which he apparently never delivered).[15] When the two artists met again, five and a half years later, in Paris, Fenosa was a refugee of Spain's civil war.

Picasso's trip to Barcelona had originally been planned to be brief, but Olga and Paulo had gotten sick along the way.[16] As a result, they stayed on for three or four more days. To Picasso's dismay, he had to face up to the press. Despite his distaste for interviews, he received a Catalan journalist from *La Publicitat,* Jaume Passarell, who had been hounding him. On arriving at the Ritz, Passarell had been made to wait in Picasso's suite, where he found Paulo wrestling on the floor with his cousins, Lola's two boys. Also in the room were Picasso's buddies Manolo and Angel Fernández de Soto. They had been instructed to warn journalists that Picasso was not prepared to say anything interesting about his work. When he finally appeared, the artist lived up to their words, limiting himself to banalities and announcing to Passarell: "You can write whatever you like about my art. It doesn't matter."[17]

· · ·

The ennui that marred Picasso's interview in Barcelona followed him back to Paris, where he was confronted with a set of intractable frustrations. If he had indeed hoped to dissolve his marriage in the Spanish courts, it would have vexed him to learn that recent changes in divorce law were ineffective in his case. Fernande Olivier's memoirs, *Picasso et ses amis*, with their intimate details of the artist's private life, only deepened his conjugal problems. Despite Picasso's legal efforts to block publication, the book had gone to press. No less infuriating was the ongoing *affaire Picasso*, which proved another source of bad publicity as Madame Zak's brilliant lawyer, Maître Garçon, had accused one of the world's richest artists of letting his old mother starve back home in Barcelona. Picasso had only himself to blame. Instead of courting journalists, he had antagonized them.

Worse, he had managed to antagonize a potential ally, the great Spanish liberal, diplomat, intellectual, and pacifist, Salvador de Madariaga, by failing to meet with him in Paris, where he was ambassador. Hitherto, Spain had made little attempt to honor its greatest living artist; but in fall 1933, Ricardo de Orueta, a Malagueño art historian newly appointed director general of fine arts, began exploring the possibility of a state-sponsored Picasso retrospective in Spain. His inquiries to Madariaga at the Paris embassy were met with a blunt reply: "I consider Picasso's behavior to be truly rude . . . and I tell you, without any reservation, that I find it deplorable that you do anything official for him until he justifies his conduct in this respect."[18] Perturbed by Madariaga's comment, Orueta took no further action. However, more progressive elements in the government persisted and came up with a proposal. Unfortunately, so depleted were the new government's coffers that there were no funds for shipping or insurance. Loans from foreign sources would be impossible. All they could promise was a contingent of the Guardia Civil to escort the paintings from the frontier to the capital.[19]

Picasso's only consolation in fall 1933: he was reunited with Marie-Thérèse. He hid her away at Boisgeloup and made up for lost time by doing two small corrida paintings inspired by his recent trip to Spain. The first of these (September 6) depicts the death throes of an infuriated bull.[20] A nearly nude Marie-Thérèse appears as a wounded *matadora*, a woman bullfighter, falling from the back of a gored horse—a confusing but explicit scene executed in pastel tones on a miniature panel. [21]

Marie-Thérèse's image in the arena may well have had its origins in a recent phenomenon. A sensational sixteen-year-old *torera* named Juana Cruz de la Casa (known as Juanita Cruz) had made spectacular appearances mounted on a horse in the arenas of Madrid and Barcelona in 1933. We have no evidence of whether Picasso saw her fight, but he would certainly have known about this extraordinary new star. In due course, Franco would ban women from bullfighting, forcing Juanita, who was

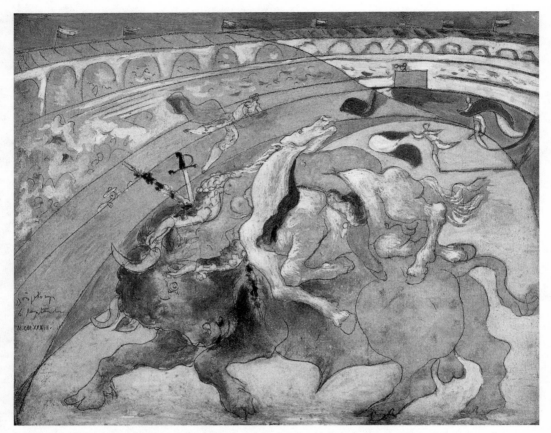

Picasso. *Bullfight: Death of the Female Toreador.* Boisgeloup, September 6, 1933. Oil on wood, 21.7 x 27 cm. Musée National Picasso, Paris.

passionately anti-Franco, to leave the country. She spent much of her exile in South America and Mexico, where she continued her triumphant career.[22]

On September 19 Picasso painted a second corrida, with a male matador whose face bears the profile of Marie-Thérèse.[23] More prominent in this brighter, slightly larger version are flags of the Second Spanish Republic on the roof of the arena. This rare reference to the government adds a political dimension to the symbolism of bullfighting, and seems to signal the artist's awareness of factional conflict in his home country. Elements of the corrida would take on potent political symbolism in Picasso's work during the Spanish Civil War, most notably in *Guernica*.[24] The composition of these paintings, however, has a very different inspiration.

One of the sources for the entangled bodies in Picasso's 1933 corridas appears to be Horace Vernet's famous painting *Mazeppa and the Wolves* in Avignon's Musée

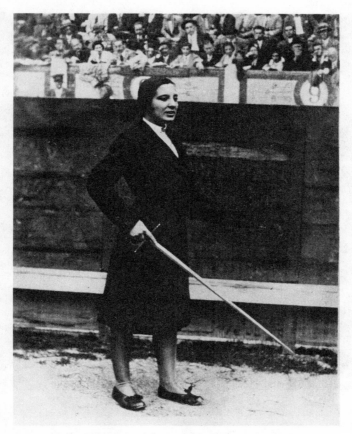

Juanita de la Cruz, the celebrated female toreador. Spain, January 1933. Bibliothèque nationale de France.

Calvet, a supremely kitschy work that Picasso was fond of. The subject is a much-mythologized real-life Ukrainian hero who (according to Byron's fanciful poem) as a page to the king of Poland seduces a countess and is consequently strapped naked to the back of a wild horse and packed off back to the Cossacks in the Ukraine, whose people would come to idolize him. The figure of Mazeppa was worshipped by the Romantic movement, not just by Byron but by Pushkin, Liszt, Tchaikovsky, and many others. Vernet's image became a nineteenth-century icon; more recently it has emerged as a gay symbol—an ambivalence that would have amused Picasso.[25]

In both the September 19 painting and the pen-and-ink bullfight drawing done five days later, a disemboweled horse in its death agony serves as the principal focus of the composition, thanks to the monstrously erectile stretch of its neck. As always, no trace of the protective *peto*—a mattress-like covering that authorities had recently

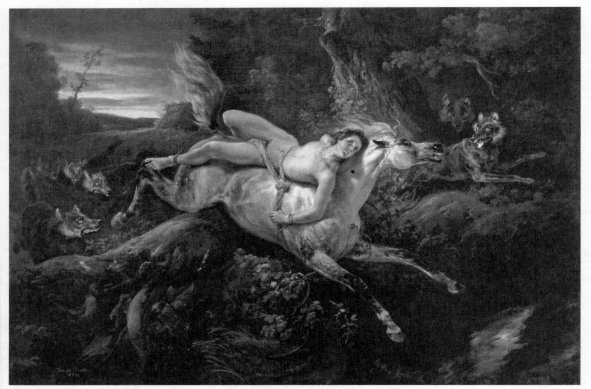

Horace Vernet. *Mazeppa and the Wolves.* First version, Avignon, 1826. Oil on canvas, 100 x 130 cm. Fondation Calvet, Avignon.

introduced to prevent the horse's guts from being ripped apart by the enraged bull. Such sentimental compassion scandalized Picasso. Twenty years later, he was still fulminating at a *corrida* in Nîmes. I was sitting next to him. He turned to me and said, "Those horses are the women in my life."[26] Jacqueline Roque, who overheard this, winced.

For the rest of the year, Picasso did no further paintings. Heavy-hearted remarks made to Kahnweiler in December suggest that the artist's legal and marital woes had devolved into a depression. Picasso told his friend and former dealer that "an evil god is responsible for everything he [Picasso] hates. He wishes he could be poor again with no more chauffeur or English nannies."[27] Probably from this period is a group of little but dazzling reliefs of Marie-Thérèse in profile, manipulated, thanks to the swoop of her coif, into a baroque ear. None of these pieces is dated, so it is difficult to see how they stand in relation to his other sculptures.

W hile Picasso was spending the summer at Cannes and Barcelona, his omnifarious publisher Christian Zervos had gone off with many of his fellow modernists on a trip to his native Greece organized by the fourth Congrès Internationaux d'Architecture Moderne (CIAM). On July 29, 1933, the expedition embarked at Marseille on the SS *Patris II*, bound for Athens and carrying over one hundred members of the CIAM.[28]

The voyage engendered a sense of excitement and anticipation captured in the short film that the Hungarian artist László Moholy-Nagy recorded during the cruise. Celebrated modernist stars wrote their impressions of Greece, including Fernand Léger, Amédée Ozenfant, Maurice Raynal (author of a *Histoire de la peinture moderne*), and Le Corbusier, one of the organizers, on whom the trip had an overwhelming effect. "Here in Ancient Greece," he proclaimed, "we have found it intact on its isles, amidst ruins, we tasted its essence and we experienced its intrinsic drama . . . We will, we can, rediscover the Greece that possessed the heroes and created the gods."[29] Excursions to archaeological sites on mainland Greece and the islands revealed prehistoric ruins as well as the famous monuments of the classical period.

When the ship steamed back toward Marseille on August 14, Zervos stayed behind for two months to collect material for upcoming issues of *Cahiers d'Art* devoted to the art of ancient Greece, as well as for a groundbreaking monograph on the same subject. The Neolithic origins of his country's sculptural heritage had never as yet received anything like the amount of worldwide accord given to Phidias and Praxiteles and other heroes of the great classical tradition. Zervos wanted to popularize primeval art from as far back as the third millennium BC. The excellent photographs that he gathered from museums and sites all over Greece would be published in a 1934 book entitled *L'Art en Grèce*.[30]

Zervos hoped that *L'Art en Grèce* would attract modernists away from the obsession with African primitivism that Picasso and Braque had initiated some twenty-five years earlier. The second issue of *Minotaure* (June 1933), devoted to the Dakar-Djibouti expedition that Picasso's friend Michel Leiris had recently taken, attested to the enduring lure of African art and culture for French intellectuals of the early 1930s. The patriotic Zervos wanted *L'Art en Grèce* to make up for this promotion of Africa at the expense of Greece. He marketed the volume as "an essential handbook for the understanding of modern art," and in an emotional introductory essay he rebuked art historians for overlooking early Hellenic sculpture. Like Leiris, Zervos understood that photography provided a powerful mode of transmission, and relied on it to make his case. British critic Herbert Read highlighted this fact in his favorable

Picasso. *The Feast* from Aristophanes's *Lysistrata,* 1934.
Etching. Illustrated book with six etchings and thirty-four line
block reproductions after drawings. The Museum of Modern
Art, New York, The Louis E. Stern Collection.

review of *L'Art en Grèce* for *Burlington Magazine*: "In the study of classical art, the
photograph has replaced the plaster cast, and from the point of view of any aesthetic
evaluation, the change is all to the good. Except that it cannot give us the actual mass
of objects, the photograph is in every way superior, reacting, under careful supervi-
sion, exactly as the human eye would do, to those effects of light and texture on
which the sensory experience of a work of art chiefly depends."[31]

L'Art en Grèce would have an ever-growing success in avant-garde circles (at least
four editions would be published over the next fifteen years). It came at a propitious
time for Picasso. His American friend Gilbert Seldes had commissioned him to do a
set of engravings for his new translation of Aristophanes's supremely satirical com-
edy *Lysistrata* of 411 BC, to be published by New York's Limited Editions Club.[32]
Picasso claimed to have known the play by heart. Maybe Apollinaire had brought it
to his attention. Alfred Barr observed that Picasso's *Lysistrata* prints are truer to their

Picasso. *Young Greek Warrior* from Aristophanes's *Lysistrata,*
December 30, 1933. Etching. Musée National Picasso, Paris.

textual source than any of his previous book illustrations, including those he made
for Skira's 1931 edition of Ovid's *Metamorphoses.*[33]

The towering helmets seen in sketchy drawings and etchings for *Lysistrata*[34]—
eaglelike in their panache and menace—were irresistibly phallic and to that extent
suited to the play's plot: the women of Athens and Sparta go on strike, no sex until
their soldier husbands cease going to war. Aubrey Beardsley had scandalized the
European art world with his *Lysistrata* drawings of desperate soldiers with humon-
gous erections in the Wildean *Yellow Book* of 1894. Picasso was aware of Beardsley's
drawings, but took a different tack. The play accorded with his lifelong pacifism. He
enjoyed mocking militarism. Three years later, he would direct his mockery, and his
rage, against the Spanish general Francisco Franco.

Paulo, Olga, and Picasso, San Sebastián, 1934. Archives Olga Ruiz-Picasso.

5

Last Trip to Spain

The ever-increasing chaos of Picasso's private life explains the dearth of major work at the end of 1933. Marital and legal problems were largely to blame, but he was also becoming increasingly worried about political threats: daily, deadly friction between the Right and the Left that would eventually rip Spain apart. In the violently contested parliamentary election of November 1933, Spain's right-wing parties triumphed over the leftist Republicans. Labor strikes and church burnings broke out throughout the country in response but were quickly put down by the military.[1] The same 1932 divorce statute that Picasso may have hoped to exploit had become a propaganda tool that played on the fears and piety of Spanish women, who, having won suffrage only two years prior, were voting for the first time. Leaflets warned them of what would happen if they supported the Left: "Communism will come, which will tear the children out of your arms; the church of your town, symbol of OUR HOLY RELIGION, will be pulled down and leveled; the husband that you love WILL FLEE FROM YOUR SIDE, authorized by the DIVORCE LAW."[2] Scaremongering proved effective. After the election, politicians on both sides credited female voters for the Right's resounding victory.

Serving the interests of wealthy landowners and pro-Catholic conservatives, the reactionary new regime would rescind measures that the liberal government had pushed through, much to the detriment of Spain's working class and rural poor. In his seminal study of Spanish politics leading up to the civil war, Gerald Brenan noted that "the conditions in the country districts, which had been bad enough in 1933, were rapidly deteriorating. The fall of wages, the dismissals of workmen, the relaxation of the laws safeguarding tenants, permitted and encouraged by the Government in the hopes of reviving trade and stimulating capital, had brought an enormous increase in misery."[3]

Picasso's personal misery and loathing, sharpened by the trouble in Spain, permeate his pastel and charcoal drawing of November 19, 1933.[4] A sculpture made of what looks to be curvilinear bones hovers over the sea, from which a rabid reddish tongue—Olga's, as we know from other images—protrudes like an erection from

a niche of stubby teeth. Strands of straggly hair also give away the figure's identity. The disembodied eyeballs may well have a different source: the horrendous murders committed by the Papin sisters, Christine and Léa, which had obsessed France for most of this year.[5]

The surrealists took this crime to heart; so did Picasso. Obedient domestic servants, the girls suddenly went berserk in February 1933 and avenged themselves on the two women of the bourgeois household they worked for. Besides bludgeoning the heads of Léonie Lancelin and her daughter Geneviève to a pulp, they gouged out their eyes. It was reported that Christine Papin, the family's cook, had slashed Madame Lancelin's thighs and buttocks in the same way she would score a rabbit for roasting.

Picasso. *Figure at the Seaside,* November 19, 1933. Paris. Charcoal, ink, pastel on paper, 51 x 34.2 cm. Musée National Picasso, Paris.

After the crime, the two girls washed the murder tools, changed their clothes, and locked themselves in their room. That the police found them huddled together in bed fueled suspicions, never verified, of incest, as did Christine's later statement that she believed herself to have been Léa's husband in a previous life. While separated from her sister before their September trial, Christine suffered violent fits in which she tried to tear out her own eyes. She was put in a straitjacket to protect her from herself.

The surrealists exploited the Sadeian implications of the story while Marxists viewed the sisters as victims of social inequality. The case provided a perfect subject for the psychiatrist Jacques Lacan, who wrote a provocative analysis in the December issue of *Minotaure.* Not only did Lacan share the surrealists' fascination with unconscious impulses; he specialized in paranoid psychoses and had recently translated into French Freud's paper on the neurotic mechanisms of jealousy, paranoia, and homosexuality. These, argued Lacan, were the root causes of the Papins' *"orgie sanglante."* His *Minotaure* article challenged the court's treatment of Christine and Léa as sane adults, and asked, "What

significance cannot be found in the exclusive affection of the two sisters, the mystery of their life, the eccentricities of their cohabitation, and their fearful reconciliation in the same bed after the crime?"[6]

Lacan expounded his analysis in conversation with Picasso, who followed trial reports in *Paris-Soir*, but the artist remained unconvinced of the girls' insanity. He told Kahnweiler that the Papins had done what everyone wanted to do but lacked the courage. If the sisters were deranged, as Lacan thought, Picasso asked, "What

Picasso. *Nude in Front of Open Window,* February 7, 1934. Pen and ink, 26.2 x 32.7 cm. Musée National Picasso, Paris.

becomes of tragedy then? *Et les grands sentiments? La haine? . . .* Today's psychiatrists are the enemies of tragedy, and of saintliness. . . . And saying that the Papin sisters are mad means getting rid of that admirable thing called sin."[7] The artist's sympathy also extended to Violette Nozière, the Parisian teenager who poisoned both her parents with barbiturates in August 1934. She confessed to killing her father because he had been raping her for years—a claim wholly accepted by the surrealists, who saw in her case the underside of conventional family life. Picasso gave Breton the idea of publishing a small collection of surrealist art and poetry dedicated to Violette. The book was printed that December in Brussels, but French authorities forbade its distribution.[8]

The bizarre disfiguration of the female body that had marked the Papin murders became the subject for a sequence of erotic drawings from February 1934 in which Picasso deforms the figure of Marie-Thérèse into a kinky cluster of boxed vaginas, beehive breasts, and turdlike fingers.[9] The setting appears to be the apartment at 44 rue la Boétie where he had installed Marie-Thérèse. She lies on a bed in front of a window with shutters and railings and glimpses of sky. In March, Picasso brought his mistress and her sister Geneviève to Boisgeloup. The togetherness of the two girls inspired several tender paintings of them, seated close together at a table, arms around one another's shoulders, reading a book or a newspaper.[10] Compared to the surreal sadism of Picasso's recent imagery, these Boisgeloup paintings seem sentimental, but the intensity of Picasso's handling hints at erotic possibilities. Signs of springtime appear in the version of April 10.[11] The sisters sit before a window open to a blue sky. Their nuzzling faces take the forms of a heart and a half-moon.

The paintings and prints of Marie-Thérèse from May and June are permeated by

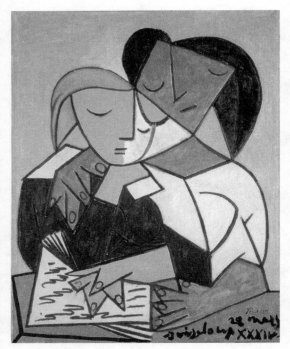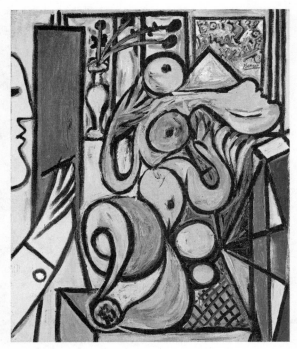

LEFT Picasso. *Two Girls Reading.* March 28, 1934. Oil on canvas, 110.17 x 89.38 x 7.62 cm. University of Michigan Museum of Arts. Gift of The Cory Walker Foundation. RIGHT Picasso. *The Painter.* 1934. Oil on canvas, 98.4 x 80.3 cm. Wadsworth Atheneum Museum of Art. The Ella Gallup Sumner and Mary Caitlin Sumner Collection Fund.

Picasso's sexual love for his mistress. On May 13, he depicts her naked on a chair, her curvilinear arms stroking her breasts.[12] She opens her body to the artist as he paints her. Nine days later she appears as a spiky pink nude against the dark-green foliage of a garden.[13] In June, Picasso came up with a masterpiece of himself as a preposterous joke painter working on a canvas of green vines and white flowers while confronted with a Marie-Thérèse-like model posing luxuriously with her hair trailing on the floor.[14] In a print of August 4, she is caught in the Minotaur's passionate embrace.[15] On the same day he painted another rapturous nude, twisted in such a way that her breasts and buttocks are unified, while a dot and an asterisk indicate the vagina and the anus.[16] Comparing this work to Picasso's earlier odalisque-like images of Marie-Thérèse, Robert Rosenblum detected in its loose brushwork and irregular contours "a restlessness that leaves one imperfection after another, as if the ecstatic ideal of serenity and pleasure attained in 1932 could no longer be sustained."[17] In the summer's last paean to Marie-Thérèse, Picasso depicts himself as Bacchus lifting a glass of wine to his recumbent lover.[18]

How different in style and tone these sensual idylls are from his fiendish July 7 portrayal of Olga as a bloodthirsty Charlotte Corday stabbing Marie-Thérèse in the guise of Marat.[19] Not for the first time, Picasso took the murder of the French

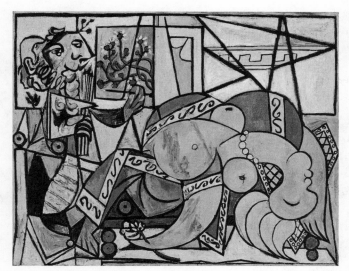

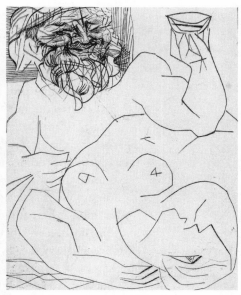

LEFT Picasso. *The Studio,* 1934. Oil on canvas, 128 x 159.4 cm. Eskenazi Museum of Art, Indiana University. Gift of Dr. and Mrs. Henry R. Hope. RIGHT Picasso. *Bacchus and Marie-Thérèse (as Ariadne?).* Boisgeloup, August 7, 1934. Drypoint etching, 29.7 x 23.7 cm. Musée Picasso, Paris.

revolutionary as a cipher for his own fears and preoccupations. But was it private torment or political violence that triggered this image of grotesque rage? Beyond its references to the artist's domestic life, the drawing reflects the shock and hor-

ror caused by a spate of assassinations in Nazi Germany the week prior. On June 30, Hitler consolidated power by ordering the extrajudicial killing of dozens, if not hundreds, of suspected political opponents in what became known as the Night of the Long Knives. News of the massacre made the Führer's brutality plain to the world. France, Picasso's adopted country, now found itself bordered on two sides by fascist states and pressured by right-wing movements from within. Only five months earlier, on February 6, thousands of French fascists had gathered for an antigovernment protest on the Place de la Concorde, not far from the artist's rue la Boétie studio. When demonstrators clashed with police, a riot

Picasso. *The Murder* (alternative title: *The Death of Marat*). Boisgeloup, July 7, 1934. Pencil, 39.8 x 50.4 cm. Musée National Picasso, Paris.

ensued that left over a dozen people dead and many more injured. Édouard Daladier, France's prime minister, resigned his post the next day.

Picasso's ongoing anxiety with such events also found expression in a group of bullfight paintings and drawings from July. The first of these agonizing tauromachic images is self-referential: a bull with a sword protruding from its shoulders roars out at us in its death throes.[20] In another work, the bull becomes the killer and Marie-Thérèse the victim.[21] The virtuosity of the drawing masks the horror of the subject. Goya inevitably comes to mind. The plates in his *Tauromaquia* inspired the first of these bullfight paintings. Despite all the obvious parallels, the deadly intensity and accuracy of Goya's burin is in total contrast to Picasso's votive vision with its Mithraic undertones. Whereas Picasso identifies as closely as he can with the bull, and wallows in the agony of its death (there are no survivors in his votive corridas), Goya keeps his distance and agonizes over his human subjects. Picasso had evidently envisioned the corridas he planned to attend on his trip to Spain later that summer. There he would indulge his passion for bullfights and meet the insidiously charming fascist leader José Antonio Primo de Rivera.

In October 1933, José Antonio, the charismatic son of Spain's former prime minister Miguel Primo de Rivera, had founded the Falange. In origin this movement was an idealistic version of Mussolini's New Order, which had captivated Filippo Tommaso Marinetti and his Italian futurists. For all his right-wing dogmatism, José Antonio, known as "El Jefe," invoked the power of poetry and courted writers and intellectuals. To promote his endeavor, he took on the dynamic Ernesto Giménez Caballero, owner-editor of the prestigious *Gaceta Literaria*, which had employed Luis Buñuel as a film critic and published Federico García Lorca and even a work by Picasso. Formerly one of the most progressive intellectuals in Spain, Giménez Caballero had experienced a radical epiphany and reinvented himself as a fascist ideologue who would forsake avant-garde involvement to write proselytizing Catholic tracts, including *La nueva catolicidad* (1933) and *Roma madre* (1939), as well as Franco's speeches. He had tried and failed to entice Lorca into his net, and in August 1934 he would try winning over Picasso to the fascist side, despite having condemned the artist in print only three years earlier.

As discussed in volume III, Giménez Caballero had attacked the eminent philosopher Gregorio Marañón in 1931 for calling on Picasso to consider returning to Spain, or at least to consent to be buried there when his brilliant career ended.[22] Marañón's heartfelt petition was signed by many celebrated Spanish dignitaries, including the Duke of Alba and the writers Eugenio d'Ors, Ramón Gómez de la Serna, and José Ortega y Gasset. Giménez Caballero assailed the petition in a front-page editorial

in *La Gaceta*, claiming Picasso had achieved fame "thanks only to the bourgeois class, the capitalists and their army of critics and merchants, the agents of the stock exchange of paintings." Three years later, Giménez Caballero would change his tune when he and José Antonio set about luring Picasso.

He first encountered the artist in August 1934 lunching with Olga and Paulo at San Sebastián's Club Náutico, a stylish Corbusierish pavilion attached to the pier above La Concha beach, designed by José Manuel Aizpurúa, a young architect and political protégé of José Antonio. "I have been here for several days," Picasso reportedly said to Giménez Caballero, "more than I thought. I came for twenty-four hours, but I have stayed much longer so that I can get back to the heart of Spain." He had been amused to discover that "nuns take their girls to the bullfights. Since the Republic, they have free passes as if it were a feast day and they were going to be blessed." Picasso had also been struck by all the "lost children on the beach and by the voice from a loudspeaker telling them what to do." "Perhaps Picasso was no more than a lost child on a Spanish beach," Giménez Caballero fantasized—as if he were the official with the loudspeaker.[23]

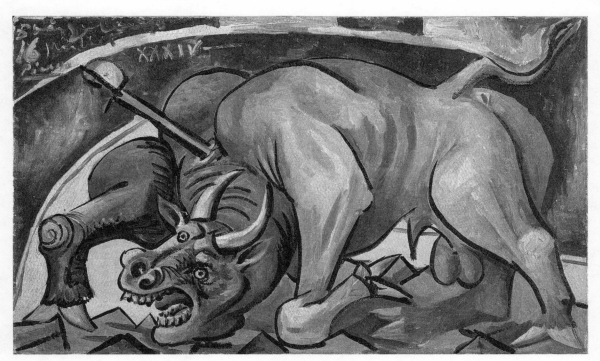

Picasso. *Dying Bull,* 1934. Oil on canvas, 33.3 x 80.6 cm. The Metropolitan Museum of Art, New York, Jacques and Natasha Gelman Collection, 1998.

José Antonio Primo de Rivera, Spain, 1935. Roger Viollet / Getty Images.

Giménez Caballero saw Picasso again the following day with a group of Falangists that included José Antonio. Most of the questions put to him were surprisingly dim: "Which book do you prefer of all those written about you?" His answer: "One in Japanese that I couldn't read." Or "Do you believe that art should be abstract?" "No, simple and direct, like a bridge connecting two different points." On being asked why he preferred living in Paris rather than Spain: "One carries one's passport on one's face."[24]

Picasso's habit of combing his graying forelock over his forehead reminded Giménez Caballero of a picador. The gold watch chain on his lapel, the handkerchief in his breast pocket, and "the waistcoated belly exploding from his jacket" were more reminiscent of "a priest in a casino."[25] There was some truth to this. A press photograph of Picasso with the Basque painter Jesús Olasagasti, probably taken on the veranda of the Club Náutico, reveals that, thanks largely to marital worry, the artist who usually watched his weight had evidently been gorging himself.

José Antonio was more suave than his henchmen. He asked the artist: "What would you say if in the distant future an encyclopedia defined you as a great Andalusian poet better known in his lifetime as a painter?" Picasso would recall this incident in the 1950s when his Argentine friend Roberto Otero asked the very same question that El Jefe had put to him at "the banquet in my honor at the San Sebastián Yacht Club. Strange, isn't it?"[26] Strange indeed, in that Picasso *did* abandon painting for poetry a year later.

The Falangists' attempts at indoctrination confirmed Picasso in his loathing for fascism, yet he was apparently flattered by José Antonio's proposal to honor him with a retrospective in Madrid. When Picasso complained about the Republican government's failure to come up with enough money to insure such a show the year prior, José Antonio promised a detachment of the Guardia Civil as an escort, "but only after we have insured your work." To further the prospect, Picasso told José Antonio that "the only Spanish politician who had spoken well of me as a national glory

Picasso and Jesús Olasagasti at Real Club Náutico San Sebastián, 1934. Collection Don Rafael Munoa and the Munoa family, San Sebastián.

was your father."[27] Besides hoping for an exhibition in the land of his birth, Picasso wanted to show his wife and son how highly regarded he was in his own country. It was perhaps for this reason that he accepted an invitation to attend the inaugural dinner of a "cultural and gastronomic club" called GU on August 29 at San Sebastián's Café Madrid, another modernist building designed by Aizpurúa.[28] He had not, however, realized that GU was the propagandist arm of the Falange.

Thirty years later, the excuse Picasso gave for accepting the compromising invitation at San Sebastián was political naïveté. He told Otero that José Antonio had been *"muy simpatico"* but maintained that he had been "set up":

> Just listen to what [Giménez Caballero] said about my eyes . . . that I had the same expression as Mussolini. Of course, that was a compliment of sorts, coming from him. However, for me it was anything but. I knew the people wining and dining me that night were very dangerous and as I remember I boarded the train for France that same evening. And that was my last day in Spain.[29]

This was not true. Far from returning by train to Paris, Picasso had stayed on to be feted by these "very dangerous" people. Juan Belmonte, Spain's greatest bullfighter, had come out of retirement, and though he had been repeatedly gored, he was due

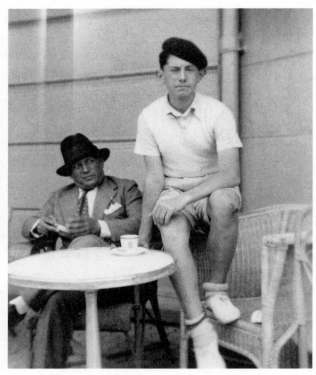

Picasso and Paulo, Saint-Jean de Luz, 1934. Archives Olga
Ruiz-Picasso.

to appear in the San Sebastián bullring on Sunday, September 2. Picasso is unlikely
to have missed that. When he left, it was not to return to Paris but to continue his
tauromachic tour in Barcelona, where he was joined at one memorable corrida by
fellow aficionados Michel Leiris and André Masson.[30]

After disdainfully dismissing a Catalan journalist in Barcelona the previous year,
the artist needed to rekindle his popularity. When *La Publicitat* the leading local
newspaper, proposed an interview in the summer of 1934 at the yet unopened
Museum of Catalan Art in the monumental Palau Nacional, he set aside the entire
afternoon of September 4. Picasso chose to speak in a mixture of Spanish and French
as well as Catalan. Unfortunately, his interviewer, Carles Capdevila, who wrote a
lengthy account of the tour, failed to ask the right questions. The article does not
comment on the Plandiura Collection, including twenty-two early Picassos, which
had recently been acquired by the museum. A portrait of Picasso by Ramon Casas is
the only work specifically mentioned.[31]

However, Capdevila does record the artist's reaction to the newly installed Roman-

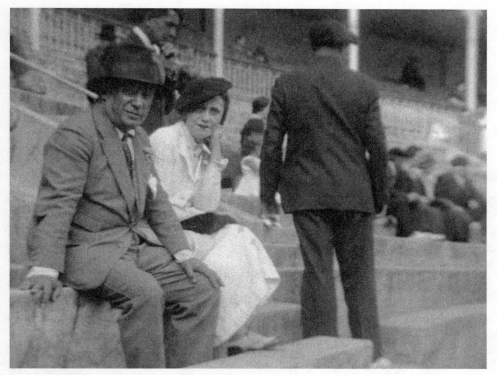

Olga and Picasso waiting for a bullfight, San Sebastián arena, 1934. Archives Olga Ruiz-Picasso.

esque section of the museum, which displayed the hitherto little-known sculpture and frescoes of medieval Catalonia. These, Picasso said, would be "essential for those who want to understand the origins of Western art, an invaluable lesson for the moderns"—an opinion he shared with Christian Zervos. Two years later, in the midst of the Spanish Civil War, artist and publisher would work to protect Spain's medieval monuments from destruction and collaborate on an exhibition of Catalan art in Paris.

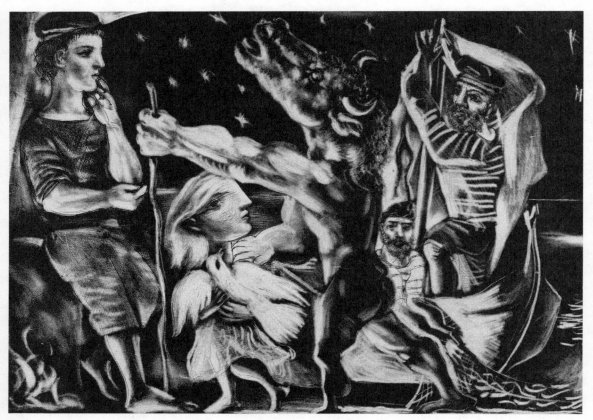

Picasso. *Blind Minotaur Guided by a Young Girl at Night, Vollard Suite,* plate 97, 4th and last state, January 1, 1935. Aquatint, drypoint, and engraving on Montval laid paper, 27.7 x 34.8 cm. Kunstmuseum Pablo Picasso Münster.

6

Minotauromachie

On returning to Paris in September 1934, Picasso exulted in being free of his wife after weeks of travel and reuniting with Marie-Thérèse, but he was more than ever depressed by the rapidly deteriorating situation in Spain. On September 22, he embarked on a new theme, the blind Minotaur, which would develop into one of his most moving and spectacular prints.[1] Starting with copper-plate engraving, he graduated to a very different technique—aquatint heavily worked with a scraper and mezzotint—that he would never use again. The deep blacks and brilliant highlights of the final version of *Blind Minotaur* were the result of Picasso's collaboration with master printer Roger Lacourière, whose knowledge of the intaglio process enabled the artist to achieve a greater range of tonal effects. As Picasso's friendship with Lacourière deepened, so would the virtuosity and sophistication of his prints.

Blind Minotaur commemorates Picasso's lifelong obsession with his eyesight. "The allegory of the blinded man," wrote Roland Penrose, "has pursued Picasso throughout his life like a shadow as though reproaching him for his unique gift of vision."[2] For a superstitious artist whose creativity derived in part from the *mirada fuerte* (strong gaze), prized by Andalusians as a source of sexual power, blindness represented a vital loss. The equation of vision, sexuality, and art making is the key that often unlocks the meaning of Picasso's work. Thus, when he turned his malign gaze on himself at a time of psychic stress in the fall of 1934, he ended up as a blind Minotaur. To ward off his fears during this time of trouble, he once again turned to a votive act, an expression of intense devotion, in this case to his sister Conchita. Sure enough, she is at the heart of the engraving, albeit endowed with the face of Marie-Thérèse. Conchita is running toward a young man on the left: the artist as he would have looked at the age of thirteen, the year of Conchita's death. She is seemingly in flight from the men on the boat, about to take her across the River Styx, on the right.

Picasso conceivably had another source of inspiration for this all-important print. As mentioned in volume I, during his Montmartre days, some thirty years earlier, he had been fascinated by a local art peddler called Léon ("Père") Angély, a retired legal clerk of limited means. He was known as a *dénicheur,* a spotter—ironically,

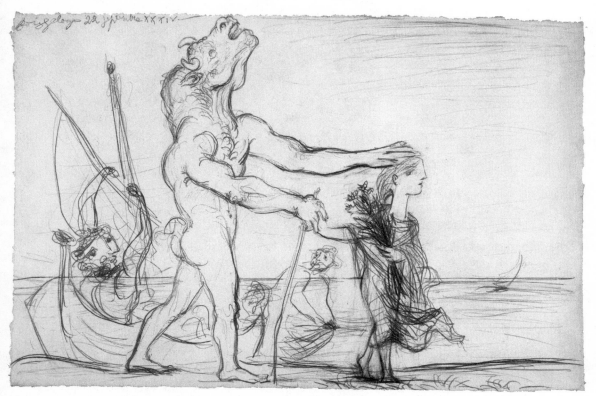

Picasso. *Blind Minotaur Being Led by a Little Girl,* September 22, 1934. Pencil on paper, 34.5 x 51.4 cm. Musée National Picasso, Paris.

since he was blind. Nevertheless, Angély spent his days going from one atelier to another, buying and selling works of art. Guiding his steps was a girl who described to him whatever he was "shown." Angély's inspired speculation fizzled out after World War I. He was obliged to sell off his Picassos, Modiglianis, Utrillos, and much else before he died in 1921. That Fernande Olivier mentions Angély's visits to the Bateau Lavoir—the building in Paris where Picasso had lived and worked between 1900 and 1904—in her memoir suggests they may have been a source of inspiration for Picasso's self-referential *Blind Minotaur.*[3]

Yet another source: Saint Lucy, the patron saint of the blind, whom many Spaniards held in superstitious awe. This early-fourth-century martyr, who was in fact Sicilian rather than Spanish, had her eyes gouged out during the Roman Empire's final wave of Christian persecution. By the thirteenth century Saint Lucy had become a cult figure throughout Europe. Hence, echoes of her legend in *Blind Minotaur* and *Minotauromachie.* One of Picasso's erudite poet friends might well have told him

about the role—small but significant—that Saint Lucy plays in Dante's *Divine Comedy*, when Dante begins to ascend the mountain of Purgatory, which emerges from a lake. On the lake's surface he sees a radiant boat floating on angels' wings carrying the souls of the redeemed. Dante soon falls asleep and upon waking is told by his guide, Virgil, that Saint Lucy has brought them to the gates of Purgatory.[4]

In October 1934, while still working on *Blind Minotaur*, the artist was horrified at the news of another violent uprising in his homeland, this time sparked by a revolt in the coalfields of Asturias. The miners, and their labor-union comrades in Madrid and Barcelona, were protesting the inclusion of a right-wing party (the Confederation of the Autonomous Right, or CEDA) into the Spanish government. Amidst the chaos, Catalonia briefly declared its independence, to disastrous effect. At the direction of General Francisco Franco, troops from North Africa used the utmost brutality to restore order: thirteen hundred strikers were killed and forty thousand arrested, some subjected to sadistic tortures to divulge the source of their weapons. The collapse and repression of Asturian revolt, wrote Gerald Brenan, "was an epic which terrified the bourgeoisie and fired all the working classes of Spain. One may regard it as the first battle of the Civil War."[5]

The insurrection would prompt many native artists and intellectuals to leave Spain, among them Salvador Dalí, who fled for Paris on October 6. As Dalí's memoirs record, he crossed into France with the help of an anarchist cab driver who carried the flag of the newly declared Republic of Catalonia, as well as the Spanish flag in case the new republic fell to government forces, which indeed it did only ten hours after its inauguration.[6] Dalí and Gala made it safely to the border, but were shocked to learn later that their driver had been shot and killed on his way back. Recalling the man's kindness and protection during their dangerous journey, Dalí wrote, "I shudder at the idea of the idiotic death unleashed by the wild men on all sides."[7]

On arrival in Paris, the Dalís connected with the ultra-chic American bohemian, and inventor of the modern bra, Caresse Crosby.[8] With Caresse's help, they soon had made plans for their first trip to America with a $500 loan from Picasso, essential for their living expenses. They booked a third-class compartment on the steamship *Champlain* and embarked on November 7 for New York. Dalí would make an immediate splash in Manhattan, thanks to a successful exhibition at Julien Levy's Midtown gallery, surrealist lectures at the Museum of Modern Art, and introductions to the city's wealthy socialites arranged by Caresse.

On March 23, 1935, Picasso embarked on what is unquestionably his most celebrated engraving, *Minotauromachie*.[9] Once again he visualizes himself as a Minotaur, but—in contrast to *Blind Minotaur,* so permeated with death as well

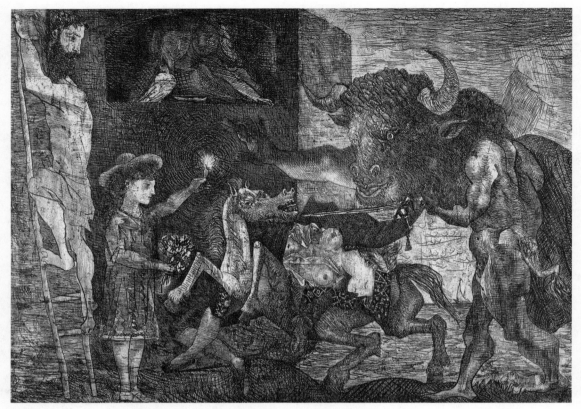

Picasso. *Minotauromachie,* 6th state. Paris, March 23, 1935. Etching and engraving, 49.7 x 68.8 cm. Musée National Picasso, Paris.

as blindness—*Minotauromachie* recasts Picasso's mythical alter ego as a figure of immense, albeit flawed, power.

Shortly after envisaging *Minotauromachie*, Picasso painted a large, somewhat banal landscape with figures, which bears no relation to anything he had ever done: *La Famille* (March 29, 1935).[10] He seemingly intended the style to reflect the dim genre paintings of his youth. This uniquely uncharacteristic work turns out once again to be an ex-voto. Picasso has turned his back on modernism in order to think his way back to his childhood, and his vow never to paint again if his sister's life were spared. In *La Famille* his mother clutches baby Conchita. Standing between her and the father are little Pablo and his sister Lola. The desolate landscape evokes the countryside back of La Coruña. It also evokes the painful winter of Conchita's death in 1895, the season of the broken vow.

Picasso. *La Famille* (*The Family*), March 29, 1935. Oil on canvas,
130 x 162 cm. Collection Marina Picasso.

La Famille signaled Picasso's temporary abandonment of painting. Now he could
go ahead with *Minotauromachie* at Lacourière's studio. The composition exists
in seven states with characters drawn from the artist's past, present, and personal
mythology. The setting is the Minotaur's legendary habitat on the island of Crete—
hence the sea and the inclusion of a distant sailboat. But given the central references
to bullfighting, we also seem to be in Spain.

As in so many previous bullfight images by the artist, Marie-Thérèse—who was
pregnant with Picasso's child in spring 1935—plays a central role in *Minotauro-
machie*, appearing as a wounded and near-to-death *matadora*. Once again, she is
bare-breasted and splayed across the back of her dying horse. Although seemingly
lifeless, her black-clad arm reaches up and manages to cling to a sword pointed at the
horse's head. The horse's entrails pour from its belly, in contrast to Marie-Thérèse,
who bares her chest and stomach to the Minotaur.[11]

Does Olga figure in this engraving? Not explicitly. The hideous horse in *Minotau-
romachie* might well be her. Olga had become the focus of Picasso's hatred. While
working on the print, the artist would initiate divorce proceedings against his wife.

At center left stands a young girl holding a light. She represents Conchita, and her

presence is central to the meaning of the composition. Conchita illuminates *Minotauromachie*. The Minotaur stretches out his right hand to grasp her light, but he fails to reach it. The flame represents the art Picasso had vowed to abandon if Conchita lived. In *Minotauromachie* he is unable to grab the emblem of his votive obsession. His broken vow would never be fully redeemed.

Besides Conchita's lamp, there is another source of light in the top-right corner of *Minotauromachie*: lines of light from the Mithraic sun rain down on the nape of the Minotaur's neck. In his misery Picasso seemingly invokes the Mithraic sun as well as the Mithraic bull. Mithraism—an ancient astrological cult that venerated both the sun and a cosmic bull-slaying deity—had immense appeal for Picasso. In the early years of the Roman Empire, Mithraism became the religion of the army. The cult excluded women, and its shrines were primitive—no pillared temples or marble statues. Nonetheless, Mithraism left behind many memorials in Rome, which Picasso may well have visited while working there with Diaghilev in 1917.

When he moved to Cannes in the 1950s, Picasso hung a Mithraic emblem on a studio wall. When I asked him about this sunburst ringed with spiky rays, he admitted that Mithraism fascinated him.[12] That bulls had to be sacrificed to Mithra resonated with this lifelong lover of the corrida. He was also aware that there were connections between Christianity and Mithraism, and that some Christian festivities were said to derive from Mithraic ones.

There is a reference to this link on the left side of the engraving. The Christlike figure climbing a ladder looks apprehensively across at the rays of Mithraic sunlight in the opposite corner. This figure has also been identified as Picasso's father, Don José, and indeed the artist once said: "Every time I draw a man, involuntarily I think of my father. For me, man is Don José, and that will be true all my life. He wore a beard. All the men I draw have more or less his features."[13] Don José came from a line of priests and hermits. Picasso was proud of having had a great-uncle who had lived as a celebrated hermit. Was he out to exorcise the piety of his ancestors? Might the Christlike figure threatened by Mithra's rays be a mocking allusion to the deity he had been brought up to revere and never entirely renounced?

Minotauromachie raises a number of questions, but characteristically, the answers Picasso gives are little more than riddles. Far from clarifying the work's meaning, the artist obfuscates. This engraving reflects the complexity and despair of his life at this time. A *cri de coeur*. One last question: What are Marie-Thérèse's two sisters doing at the window, upper left, with a pair of Picasso's father's pet pigeons? Like us, the girls are witnesses to this complex drama.

When Picasso finally ceased obsessively working on this engraving is unclear. According to an entry in the diary of Marga Barr, wife of Alfred Barr, director of the

Museum of Modern Art, Picasso was still at work on it on June 24, 1935. Marga had accompanied her husband to Paris while he was assembling loans for his *Cubism and Abstract Art* exhibition, which was due to open the following year in New York. Paul Rosenberg had told her that the artist had stopped painting. She also learned that Picasso's studios in Paris and the country had been sealed by court order as a result of the divorce suit that the artist had recently initiated.

It is true. Picasso is nervous. Only when he feels like it does he work on his Minau- toromachy etching. Picasso takes Alfred to his old apartment on rue la Boétie; all the drawers and cupboards are tied with string and legally proscribed with large, stamped clots of red sealing wax. Picasso shows this to Alfred with a certain pride, insisting again and again, "Look! Look what they've done to me!"[14]

Picasso. "On the back of the huge slice of burning melon . . . ," December 14, 1935. Pen drawing, colored pencil, Chinese ink, 25.5 x 17.1 cm. Musée National Picasso, Paris.

7

Painter into Poet

Picasso's ever-growing desperation, engendered by his wife, had come to a head in spring 1935. A series of bullfight images done at Boisgeloup in mid-April reveal the artist foundering in resentment. On April 15, he did a horrendously caricatural drawing of himself as a bull defensively holding his hoof up to a building and confronting Olga in the form of a hideously toothy horse.[1] It is a masterpiece of marital hatred. In a far more worked up and colorful drawing done two days later, Picasso sees himself as a naked, horned Minotaur weightlifter, triumphantly flexing his muscled arms over a horse in its death throes, its mouth open in a comically nasty snarl of rage and despair.[2]

It was around this time that he finally asked his lawyers to begin the divorce process. A Spanish document was not required; since they were married in France, they could get a French divorce. Years later, he discussed this episode with his Russian-born Polish friend Misia Sert, who had launched the Picassos into Parisian society after their marriage in 1918. Misia had been a witness to their wedding and subsequently became Paulo's godmother. This striking woman was celebrated for her looks in portraits by Renoir, Toulouse-Lautrec, Bonnard, and Vuillard and for her tyrannical social clout, which the artists had failed to catch. However, Misia was also distrusted for her treachery to her friends. Arbiters of *le tout Paris*, not least Jean Cocteau, dubbed her "Aunt Brutus."

The black humor emanating from Picasso's account of his attempt at divorce and Misia's involvement was recorded in a diary kept by her secretary Boulos Ristelhueber. Boulos recounts a dinner with Picasso in the bedroom of Misia's palatial rue de Rivoli apartment in December 1940. After dinner, Picasso sank back onto Misia's cushions and explained how he had gotten rid of Olga five years earlier.[3]

Olga, he said, had long, beautiful hair that she thought Picasso worshipped. One day, she began to talk of cutting it. Typically, she never stopped boring her husband to death, asking what he thought. Icily cold, he took a pair of scissors and chopped it all off. This part of Ristelhueber's story is confirmed by a series of portraits from March 1935, in all of which Olga's hair is dramatically short.[4] Her eyes have a desper-

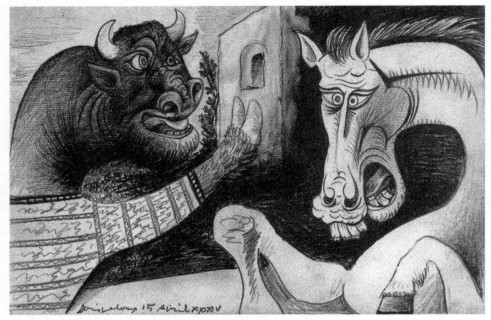

Picasso. *Minotaur and Horse.* Boisgeloup, April 15, 1935. Lead pencil on paper, 17.5 x 25.5 cm. Musée National Picasso, Paris.

ate look of abandonment. The ridiculous sausage-shaped beret on her head is a cruel addition, worn rather more gracefully by a beautiful, blond-haired Marie-Thérèse in a portrait done a day or two later.[5]

According to Ristelhueber's colorful account, Picasso took his wife and son to the Opéra-Comique to hear *Pagliacci.* Back home, he undressed Olga most affectionately before making love to her. The next morning, she was awakened by her maid: there was a gentleman waiting in the salon who wished to speak to her. "You go," Olga said to her husband, since she wasn't dressed. "Certainly not," he replied, "it's you he wants to see." Ten minutes later, Olga returned from the salon, looking very pale, clutching a document the visitor had given her: a summons to appear in court in order to respond to a divorce suit that her husband was bringing against her. Picasso wandered off, singing *Pagliacci* at the top of his voice.

When it came time for the divorce hearing, Picasso's lawyer—Maître Henri Robert, who had defended the artist twenty-four years earlier in the *affaire des statuettes* case—did not spare Olga. He told the court that she "spent her life throwing vases at her husband's head and never missed an opportunity to embarrass him in public."[6] According to Boulos, Misia was the only one of Olga's fashionable Parisian friends prepared to defend her in court. As Misia confessed to Picasso four years

later, when the judge asked her, "What in your opinion has driven her husband to ask for a divorce?," she had been about to reply, "Your Honor, simply because she's the most *emmerdante*, the most boring, woman I've ever known." Just in time, Misia recalled that she was there to testify *for* Olga, not *against* her. On being told this, Picasso rounded on Misia: "What a pity you didn't tell the truth! You don't deserve to be forgiven. You gave false testimony!"

On June 29, 1935, the court found sufficient grounds to issue a nonreconciliation order, legally authorizing Picasso to file for divorce in France. Four days later, he did so. This would necessitate an inventory of marital property in Paris and Boisgeloup, an infuriating procedure for the artist. On July 5, the caretaker of Boisgeloup reported that court bailiffs had sealed the doors of the château: "I tried to prevent them from entering but had to resign myself after they gave me the reason and I believe it is my duty to warn Monsieur."[7]

The inventory process would drag on for months and, for a time, strain Picasso's relationship with his dealer Paul Rosenberg, whose participation he needed. On November 20, Rosenberg brought a notary to Boisgeloup and urged the artist to cooperate: "There is nothing, nothing else to do . . ." Still, it seems Picasso delayed the completion of the inventory until at least January of 1936, when Rosenberg warned him that "you put yourself and you put me in a delicate position. You understand very well that I had no more desire than you did to accomplish this work, and that I accepted out of pure friendship. My report is almost ready."[8]

The case did not result in divorce. Why? Divorce would have obliged Picasso to hand over half of everything, above all his work, to his wife—an unthinkable prospect. The artist's grandson Olivier Widmaier Picasso points out that "they had married without a contract and were thus subject to the terms of joint ownership of possessions (including works of art) and property acquired jointly."[9] However, it seems that throughout the legal proceedings, Olga never pressed her claim on her husband's artistic property. The failure to finalize a divorce was, in fact, due to Olga's staunch resistance. She had no wish to break her bond with Picasso and fought every motion brought by his lawyer (whose death in spring 1936 caused further delays). In May 1938—after three years of hearings, inquiries, and adjournments—Picasso would drop his divorce suit and pursue instead a judicial separation.

When the artist's friends and associates first heard of the breakup in mid-1935, they became concerned for his well-being. Kahnweiler informed Picasso that Gertrude Stein was completely dumbfounded by the news. Odd that this perspicacious author had not seen it coming. On August 8, she wrote to pledge her friendship to Picasso and invite him to stay with her for a few days: "By chance I have heard that everything is the way it is, and I couldn't believe it . . . So, Pablo, would you consider spending a few days with us? We are, after all, friends. Nothing can change that and we can have

Picasso. *Portrait of Paulo.* Paris, October 13, 1935. Ink on paper, 25.5 x 33 cm. Fundación Almine y Bernard Ruiz-Picasso para el Arte, Madrid.

a talk, and we will empty ourselves of everything after we have talked."[10] On the same day, Picasso's banker Max Pellequer wrote a sympathetic note, inquiring about the artist's summer plans: "I am anxious to hear if you have recovered from your worries, if you are still planning to leave Paris, and if you have decided what to do this summer. Please know that I share all your troubles, all your dismay, and I understand what is going on."[11]

For an unstable woman obsessively in love with her husband, Olga's appearances in the divorce court would leave her more unhinged than ever. Picasso's cruelty had exacerbated her mental problems and brought on such a disastrous collapse that she needed a doctor's help. Letters from Paulo to Picasso suggest how deeply traumatizing the breakup had been for both mother and son. On July 18 he reported: "Maman is better and Miss Ethel Pierce [the English nanny] has left. The doctor told Maman to take a rest."[12] Olga's departure from the rue la Boétie in summer 1935 was particularly difficult. She set about packing her bags and left for Boisgeloup with Paulo. The court had granted her custody while the case went forward. In November, mother and son would move into the Hôtel California, on rue de Berri near the Champs-Élysées, where she had dwelt during her Ballets Russes days. It had been Diaghilev's headquarters—all the more painful for that.

The principal victim of the breakup would turn out to be fourteen-year-old Paulo. He had gone to stay with Georges Braque, Picasso's closest painter friend, in Dieppe on the Normandy coast. He missed his father and wrote on August 19 asking when they could meet. Braque followed Paulo's letter with one of his own, encouraging Picasso to join them at Dieppe.[13] Picasso's October 13 pen-and-ink drawing of Paulo engrossed in a book is one of the most tender and touching portraits of his son.[14] It is also tinged with guilt. The artist expressed his paternal feeling in a sublime sketch that captured the boy's anger and puzzlement at the disarray of his family life.

While still working on *Minotauromachie* Picasso would start writing poetry, which would replace painting and printmaking as his primary obsession for most of the following year. Was this, at least in part, an act of necessity: his reaction

to the court's decision to seal his various stu-
dios? On April 18 he filled thirty-four hand-
written pages with his first poem. It begins:

> if I should go outside the wolves would come
> to eat out of my hand just my room would
> seem to be outside of me my other earnings
> would go off around the world smashed into
> smithereens but what is there to do today it's
> thursday everything is closed it's cold the sun
> is whipping anybody I could be . . .[15]

According to Jerome Rothenberg, one
of the translators of Picasso's poetry, "the
world smashed into smithereens" refers not
only to the artist's personal and domestic
life but to the "nightmare of history from
which he repeatedly tries to waken. It is the
time and place where poetry becomes—for
him as for us—the only language that makes
sense."[16] Shortly after Picasso began writing,
Paul Rosenberg confirmed to Marga Barr
that political events were much on the art-
ist's mind: "There are rumblings from Spain;
civil war is about to break out. Two or three
boys—nephews or cousins—afraid they will have to take sides in the war turn up in
Paris expecting his help, which he willingly gives."[17]

Picasso. "Nunca se ha visto lengua." Typed poem
with handwritten annotations. December 24, 1935.
Dactylograph copy, red ink, 35.8 x 26.4 cm. Musée
National Picasso, Paris.

Since early days in Barcelona, Picasso had associated with the Els Quatre Gats
group of poets and painters. These included the poet Carles Casagemas, whose life
ended romantically and tragically. He killed himself because his love for a Parisian
cocotte was unrequited. Shortly after moving to Paris in 1901, Picasso had the good
fortune to fall in with the as yet unrecognized but sublime young poet Max Jacob,
who would open Picasso's mind to classical European literature as well as nineteenth-
century French poets, above all Baudelaire and Rimbaud. Later, Guillaume Apol-
linaire, more experimental and critical, would do for poetry what Picasso was doing
for art. Apollinaire's *sur-réalisme* was much closer to Dadaism than to the surrealism
it would morph into under the dictatorship of Breton.

Picasso's poetry has often been said to be surrealist, but Michel Leiris considered

it "closer (on the whole) to Dadaist nihilism than to surrealism."[18] In fact, his concept of poetry was even more inventive. It was painting with words. As Picasso later told the French poet and journalist Louis Parrot: "When I began to write [poetry] I wanted to prepare myself a palette of words, as if I were dealing with colors. All these words were weighted, filtered and appraised."[19] Hence, the writing is intensely visual and tactile. It partakes of the dark thoughts, fancies, manic fantasies, and fetishes of his everyday life. Picasso wrote poems in French as well as Spanish. He dispensed with the rules of grammar as well as punctuation marks, which he saw as "loincloths concealing the pudenda of literature."[20] He told his friend and secretary Jaime Sabartés, "If I were to start correcting the mistakes you mention, in accordance with rules which have nothing to do with me, whatever is personal in my writings would be lost. . . . I would prefer to invent a grammar of my own than to bind myself to rules which do not belong to me."[21] His poems are both visual as well as verbal. Ideally, they should be experienced in the handwritten original. Print castrates them. Translation extinguishes them.

From the start, Picasso's poetry provoked enthusiastic reactions from leading literary figures in France. Jean Paulhan, director of the prestigious *Nouvelle Revue Française*, offered to publish it in his journal.[22] Instead, the artist reserved this right for Christian Zervos, who by September 1935 had begun planning a special issue of *Cahiers d'Art* dedicated to Picasso's writing. Zervos conveyed his excitement in a letter to Gertrud Grohmann, wife of the German art critic Will Grohmann: "I have immense pleasure in telling you that Picasso has given me a dozen poems which will appear in the next number. He has written more than a hundred of them. The other night he read the poems to Yvonne and myself from 9:30 in the evening until 3:00 in the morning. It was wonderful. We were so moved by the reading that we didn't realize that we had walked all the way from Picasso's to our home. I have given the poems to Breton who will devote an essay to them, citing every one."[23]

Over the years Picasso's supremacy had profited from Breton's adulation, although he had strenuously avoided his pervasive surrealist taint. The opportunity to write about Picasso's poetry for *Cahiers d'Art* provided Breton with another opportunity to curry favor with the artist, as revealed in an obsequious letter of September 29:

I've been postponing for days now to try to visit you. I think of it every day and say to myself that there must be an hour when Picasso would see me with pleasure; why is that so hard to believe? I'm also anxious—please forgive me for telling you this—that you might be by yourself so I could shake your hand and put into this gesture all the emotion that I've never stopped feeling for you. You know how much I admire you and how much I dreamed when I was younger to occupy a little space in your life. To be one of your friends one day, this is pretty much what my

hope consisted of during the war. I'm telling you this very instinctively, in a naïve way. You do know, don't you, that I'm deeply your friend?[24]

Some friends, especially the egomaniacal Gertrude Stein, responded unfavorably to Picasso's switch to writing. Stein was outraged. How dare he poach on her preserve? In *Everybody's Autobiography*, she recalls chiding the artist for venturing into literature. "You never read a book in your life that was not written by a friend and then not then," she stated when the two met at Paul Rosenberg's for a Braque show. "You never had any feeling about any words, words annoy you more than they do anything else so how can you write . . ." Picasso got truculent and reminded her "you yourself always said I was an extraordinary person." To which she replied, shaking him by the lapels, "You are extraordinary within your limits but your limits are extraordinarily there." Picasso tried to parry her criticism by citing Breton's approval of his poetry, but Stein cut through this defense: "Breton admires anything to which he can sign his name and you know as well as I do that a hundred years hence nobody will remember his name . . ."[25]

O n October 5, 1935, the twenty-six-year-old Marie-Thérèse gave birth to a daughter at the Belvedere Clinic in Paris. She would be christened María de la Concepción, after Picasso's beloved sister, who had died forty years earlier in La Coruña. At city hall, Picasso registered the birth as "father unknown." The law obliged him, as a married man, to withhold his paternity of an illegitimate child on official documents.[26] At her baptism, he would identify himself as her godfather. At first the girl was known as Conchita, and thus treated with the same adoration that he had lavished on her namesake. He evidently felt that he was resurrecting his sister. Why else would the artist who was anything but domesticated supposedly do the cooking, housekeeping, and nursery chores? Marie-Thérèse later claimed that Picasso would visit her apartment to watch the baby sleep, help change her diapers, and give her candy.[27] In time, the name María became "Maya" in the mouth of the little girl.

Now that Olga and Paulo had moved out of rue la Boétie, Picasso was more than ever dependent on friends and fellow artists for company. Many were busy spreading the gospel of surrealism and courting the publicity that it engendered. He

Picasso. *Maya at Three Months,* December 11, 1935. Pencil on paper with yellow wash, 25.5 x 17.5 cm. Private collection.

pined for the past. He needed a friend who had no agenda or commitments. Some-one Spanish, perhaps? And so he turned back to the halcyon days of Els Quatre Gats, and reached out to Jaime Sabartés, the most discreet and trustworthy of his juvenile Barcelona coterie.

Despite being more mature and focused than most of the Els Quatre Gats group, Sabartés had never found a niche in Barcelona. Bad eyesight had ruled out a career as a sculptor, and his poetry never soared. But he had done well as a journalist in Guatemala, where he married his landlord's daughter, Rosa Corzo Robles, and had a son, Jesús. Sabartés also taught at the Academy of Fine Arts in Guatemala City and organized a series of modern-art exhibitions featuring Picasso's work. When Jesús fell ill in 1927, Sabartés brought him to Barcelona for treatment. The following year, he separated from Rosa and eloped with his young lover, Mercedes Iglesias. The new couple visited Picasso in Paris, and he gave them money to start a new life in Monte-video, Uruguay. In July 1935, with his divorce proceedings under way, Picasso, alone at home, summoned Sabartés back to Paris to work as his secretary, writing, "I'm sure you can imagine what has happened and what's still in store for me."[28]

When Sabartés and Mercedes arrived in November, Picasso met them at the Gare d'Orsay and brought them back to the rue la Boétie. Since his split from Olga, he had taken over the rooms that had been the setting for the social occasions she loved and he loathed. The place had become a shambles. Olga seems to have taken little away with her except for a cabin trunk that dated back to her career as a ballerina who spent much of her time on tour. The trunk was filled with mementos from her past: costumes, tutus, photographs, and ballet programs.[29]

Sabartés's description in his memoir of Picasso's life in the rue la Boétie apartment after Olga's departure is obsessively detailed. However, he never treats the reader to intimate insights. So fanatically secretive was the secretary that he never mentions Picasso's relationships with Marie-Thérèse, Dora Maar, or any of the other women in his life. It was as if they never existed. All we get in this part of Sabartés's book are the minutiae of two fifty-five-year-old roommates sharing a ramshackle apart-ment filled with treasures and dross, piles of newspapers and neglected mail. "At this time," Sabartés wrote, "Picasso was endeavoring to recapture the simplicity of our life as young men, despite the manifold and profound changes in us and around us. . . . He neither painted nor sketched and never went up to his studio except when it was absolutely necessary, and even then he put it off from day to day, no matter how urgent."[30]

Within days of Sabartés's arrival, he, Breton, Éluard, and Zervos were put in charge of a small but carefully chosen Picasso exhibition in Barcelona initiated by ADLAN (Amigos de las Artes Nuevas). The admiration of this youthful group—founded in 1932 under the direction of Josep Lluís Sert, nephew of Misia's ex-husband the fash-

Poster for the 1936 Picasso exhibition in Spain
organized by ADLAN. Musée National Picasso, Paris.

ionable muralist José Maria Sert—had won Picasso over. He agreed to loan paint-
ings from his collection that had never been exhibited in Spain.[31] Sabartés noted,
"Since most of the organization work was done in Paris, for a while there was a great
hubbub in the rue la Boétie apartment: goings and comings, requests for informa-
tion, photographs, interviews, consultations—in short, an endless series of vexations
for Picasso."[32] These preparations resulted in the most varied and comprehensive
show—twenty-five major works from 1907 to 1935—yet seen in his native country.
It was widely covered in the Spanish press.[33]

The exhibition opened at ten o'clock at night on Monday, January 13, 1936, at
Barcelona's Sala Esteva. Éluard represented Picasso, who had chosen to stay in Paris,
and his involvement with the ADLAN show deepened his friendship with the artist.
They had both frequented the Saint-Germain-des-Prés cafés since the early 1920s.
Once Picasso had rid himself of his wife and settled back into Parisian Bohemia,
the Café de Flore and Deux Magots would become his second homes, and Éluard

Picasso. *Portrait of Paul Éluard,* January 8, 1936.
Pencil on paper, 24.8 x 16.2 cm. Musée d'art et
d'histoire Paul Éluard, Saint-Denis.

his poet laureate. Éluard was rather more congenial than the arrogantly dogmatic
Breton. The evening before he left for Barcelona, he sat for an Ingresque portrait
drawing by Picasso, inscribed "Ce soir le 8 Janvier, XXXVI."[34]

The evening of the Barcelona opening, a group that included Picasso, the Bretons,
the Zervoses, and the Dalís gathered in the sculptor Julio González's Paris studio to
hear the live radio broadcast from Barcelona of Éluard's speech in praise of Picasso,
entitled "Je parle de ce qui est bien": "Having conquered the world [Picasso] had
the courage to turn it against him, being certain, not of victory, but of encountering
a worthy opponent."[35] Recitals of Picasso's poetry followed suit, as did readings by
Dalí, Breton, Sabartés, Miró, and González, all of which had been prerecorded for
the occasion.

Zervos had timed the release of the special issue of *Cahiers d'Art* to coincide with the ADLAN exhibition. It opened with an iconic photograph of the artist by Man Ray. Dalí contributed a lyrical text inviting readers to "listen to the sweeter than honey music / Coming from . . . Picasso's imaginative machine gun."[36] The Catalan González wrote a poignant essay claiming Picasso for Catalonia. "He is 'ours,'" González asserted, ". . . and do we not detect in the background of some of his work . . . the tragedy of his own country and of Catalan art?"[37] Breton—often criticized as a pompous and magisterial *chef d'école*—came up with a passionate and revealing tribute to the painter's poetry: "The play of light and shadow has never been observed more tenderly or interpreted more subtly and lucidly; it keeps the poem within the bounds of the present moment, of the breath of eternity which that moment at its most fugitive contains within itself . . . We have the impression of being in the presence of an intimate journal, both of the feelings and of the senses, such as has never been kept before."[38]

The most striking contribution to this issue of *Cahiers d'Art* took the form of an extended meditation by Picasso on his innermost artistic concerns. Odd that this obsessive analysis of his approach to painting, entitled "Conversations with Picasso," should appear during his abandonment of art for poetry. The analogy he drew between the power of artists and of military generals anticipates his full dedication to the cause of freedom in Spain: "We might adopt for the artist the joke about there being nothing more dangerous than implements of war in the hands of generals. In the same way, there is nothing more dangerous than justice in the hands of judges, and a paintbrush in the hands of a painter. Just think of the danger to society!" Roughly one year after these words were published, Picasso would commit to using his brush as a weapon against fascism. At the start of the Second World War, Alfred Barr would see fit to reprint this seminal text in the catalogue to his 1939 Picasso retrospective at the Museum of Modern Art.[39]

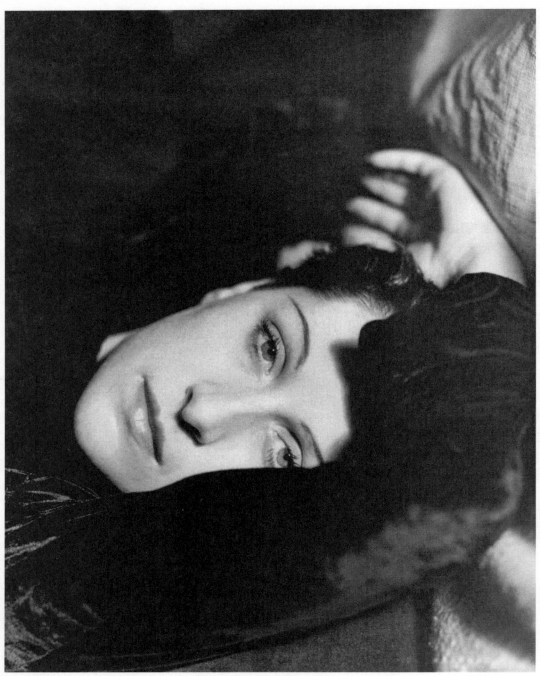

Man Ray. Photograph of Dora Maar, 1936. Musée National d'Art Moderne, Centre Georges Pompidou, Paris. Gift of Lucien Treillard.

8

Dora Maar

On January 7, a week before the opening of the ADLAN show, a private screening of Jean Renoir's film *Le Crime de Monsieur Lange* was held at Paris's Apollo Theatre where Éluard is said to have introduced Picasso to Dora Maar, a striking and sophisticated twenty-nine-year-old surrealist photographer. In fact, their paths had already crossed in surrealist circles, but they had not as yet embarked on an affair. The previous autumn, the film's screenwriter, Jacques Prévert, had invited Dora to photograph the set. Her work on projects like the Renoir film had grown out of a commitment to left-wing political activism that she shared with Prévert and Éluard.

All three were members of Octobre, an agitprop socialist theater troupe named after Russia's Soviet Revolution of October 1917. Since 1932, the troupe had been staging anticapitalist plays and performances; some even traveled to Moscow in June 1933, where they were honored at the international Olympiad of Revolutionary Theater.[1] In the year before Octobre disbanded (fall 1936), its headquarters was the home of actor Jean-Louis Barrault, in the attic of 7 rue des Grands-Augustins—the same space where Picasso would paint *Guernica* in May and June 1937. One of Octobre's last productions rehearsed in Barrault's attic was *Le Tableau des merveilles*. Dora photographed Barrault and the Octobre cast rehearsing their roles for Prévert's adaptation of Cervantes's 1615 satire.

In October 1933, through her participation in Masses, another circle of leftist intellectuals, Dora had met the surrealist author Georges Bataille. It has been said that perusing the vast collection of pornography stored in Bataille's basement stimulated her interest in sexual masochism. They began a five-month affair and would remain close friends for years afterward. On October 7, 1935, when Bataille and Breton formed a new union of revolutionaries to combat the spread of fascism in France, Dora signed their manifesto, becoming a founding member of Contre-Attaque.[2] Chanting the violent slogan "Revolutionary offensive or death," Contre-Attaque took to the streets for the first time on February 7, 1936, demonstrating in support of France's Socialist prime minister, Léon Blum. Old tensions between Bataille and Breton contributed to the group's dissolution six months later, but not before Bataille

Dora Maar. Two portraits of Picasso at Dora's Studio, 29 rue d'Astorg, 1936. Musée National d'Art Moderne, Centre Georges Pompidou, Paris.

convened two meetings in Barrault's attic, where members of Contre-Attaque could mingle with the actors of Octobre.[3] The themes chosen for the meetings reveal their extreme position on social questions. "Country and Family," the topic of their January 5, 1936, gathering, led Contre-Attaque to conclude that "respect for either made 'a human being a traitor to his fellowman.'"[4] When it met again on January 21—the 143rd anniversary of Louis XVI's beheading—Contre-Attaque celebrated the French Revolution's Reign of Terror and debated the widely held conspiracy theory that two hundred rich and powerful families (Rothschilds, Mallets, Wendels, and Schneiders among them) were controlling the French government and economy.[5] As Dora's most recent biographer, Louise Baring, states, "Though short-lived, Contre-Attaque proved the final noteworthy protest from the French intellectual far-left before the events of the Second World War."[6] It was in this radical Marxist milieu that Picasso met the woman who would become his primary mistress for the next eight years.

Henriette Théodora Markovitch was born in Paris in 1907 to a Croatian father and a French mother. The family moved to Buenos Aires for some years, where her father worked as an architect, and where Dora learned to speak Spanish. By 1926, they had returned to Paris. Dora studied painting and photography at the Union Centrale des Arts Décoratifs with her friend Jacqueline Lamba and eventually shortened her name to Dora Maar. Dora and Jacqueline also studied painting with the cubist André Lhote, an ardent admirer of Picasso, who during the German occupation would

defend the artist in print against conservative detractors. In Lhote's studio Dora met Henri Cartier-Bresson, who encouraged her to study photography, for which she took additional lessons at the École de Photographie de la Ville de Paris.

After art school, Jacqueline continued to paint but made ends meet as an underwater burlesque performer at the Aquarium du Colisée, while Dora took jobs in film and advertising. In the early 1930s she and a partner, Pierre Kéfer, set up their own photography studio in the backyard of Kéfer's parents' house in Neuilly. Dora then became the assistant to the fashion photographer Harry Meerson, who lent her a darkroom that she occasionally shared with Brassaï. In those days, both Dora and Brassaï got jobs photographing for *revues de charme,* or erotic magazines, such as *Beauté et Sex Appeal* and *Secrets de Paris.* In addition to her commercial work, Dora exhibited fine-art photography in Paris galleries. Over time she developed an eerie photographic style that blended surrealism and the baroque. One of her most extraordinary creations was the 1936 image of an embalmed armadillo fetus. She titled the work *Père Ubu,* after the notorious 1896 play *Ubu Roi* by Alfred Jarry,

whose grotesque title character resembled Dora's subject. The photograph became a surrealist icon, circulated on postcards and reproduced in surrealist journals.

Dora was immensely ambitious and took dramatic steps to catch the eye of Picasso, whom she had already envisaged as her god and guide but also her lord and master. To attract the artist, she set the scene for a public game. She assumed that he would not be averse to a kinky ploy. He later told Françoise Gilot that "one of the first times he saw Dora she was sitting at Les Deux Magots." She was wearing black gloves embroidered with pink flowers. She picked up a knife and began to stab at the gaps between her fingers. "From time to time she missed by a tiny fraction of an inch and before she stopped playing with the knife, her hand was covered with blood. [Picasso] was fascinated . . . He asked Dora to give him her gloves and kept them in a vitrine with other mementoes."[7]

Dora knew exactly what she was doing. Her *mise-en-scène* had been planned probably with the help of Jacqueline Lamba, who had played

Dora Maar. *Père Ubu,* 1936. The Metropolitan Museum of Art, New York. Gift of Ford Motor Company and John C. Weddell.

a similar game to lure André Breton into marriage two years earlier. Exploiting the surrealist fascination with chance encounters and hallucinations, Lamba had carefully orchestrated her first meeting with Breton at the entrance to his favorite café, the Cyrano, followed by a dreamlike promenade through the streets of Paris at midnight. The poet was immediately captivated, as he later revealed in his book *L'Amour fou*: "This woman was scandalously beautiful, from the first moments, a quite vague intuition has encouraged me to imagine tentatively that her fate could someday be entwined with mine."[8] Jacqueline's plan worked. Three months after her contrived rendezvous with Breton, the couple married.

The game Dora played to lure Picasso was no less calculated. Besides being a masochist by nature, she had been shown the ropes by Bataille, an erudite disciple of the Marquis de Sade. Indeed, Dora's self-advertising performance at the Deux Magots smacked of Bataille's notoriously sadomasochistic novel. There may have been a touch of surrealist exhibitionism to Dora's display, but also of black Catholic yearning. No wonder she would end up, ten years later, in the hands of the psychiatrist Jacques Lacan.

Nevertheless, Picasso took the bait and kept the gloves.[9] At first, the link between him and Dora appears to have been primarily photographic, as revealed in the series of portraits they took of one another at Dora's rue d'Astorg studio and at Boisgeloup

Picasso (attributed to). Portrait of Dora Maar. Boisgeloup, March 1936. Musée National Picasso, Paris. Donated by Succession Picasso, 1992.

in the first months of 1936. Picasso's photographs of Dora are enormously sympathetic compared with his later images of her as the Weeping Woman.

Dora's *m'as-tu-vu* bloodletting at the Deux Magots should also be seen in relation to Picasso's other women. Did she suspect that she had a rival for the artist's attention? In fact, Picasso was having an ardent affair with the French surrealist poet Alice Paalen (née Philippot), wife of the Austrian painter Wolfgang Paalen. Alice was a celebrated beauty, but childhood injuries had left her prone to physical pain and mental stress. Her poetic prowess had attracted her to the Parisian surrealists, through whom she had met her husband. Paalen's darkness would shadow their marriage. His Jewish father had converted to Protestantism and made a fortune inventing vacuum cleaners and other modern devices. The fortune had disappeared in the crash of 1929. His mother suffered from severe depression, and two of his brothers had attempted suicide.[10]

Alice had married Paalen in 1934 but set her eyes on Picasso. No paintings of her by him have been identified,

Man Ray. Photograph of Yvonne Zervos, Alice Rahon-Paalen, and
Picasso, 1930. Juliet Collection, Paris.

and no wonder. At first, their relationship was primarily poetic, as Picasso's elegiac
lines of February 10, dedicated to her, confirm:

> . . . the necklace of smiles deposited in the wound's nest by the tempest which with
> its wing prolongs her caressing martyrdom aurora borealis evening-dress of electric
> wires throws her in my glass to plunge in full swing sounding her heart to pick the
> branch of coral fastened to the mirror that holds its breath

The surrealistic *Le Crayon qui parle* (March 11, 1936) is Picasso's first artwork since
abandoning painting for poetry at the end of March 1935.[11] It dates from the climax
of the artist's affair with Alice. This mixed-media *jeu d'esprit* harks back to *Minotau-
romachie* in its inclusion of a ladder leaning against a wall and other self-referential
features, not least a decapitated classical head. Between the anthropomorphic tree
trunk on the left, which seemingly stands for Alice, and the Minotauromachian build-
ing on the right, hangs a cruciform contraption at the center. Below a pair of out-
stretched arms, a vestigial torso dangles with Dora Maar's bloodied glove suggesting
genitalia.

The title of this metamorphic composition derives from the long strip of news-
print collaged across the center of the composition which reads: "He is presenting
his latest creation, *The Talking Pencil*, in 18 charades that each will instruct as well as
amuse."[12] Picasso was apparently intent on merging the two roles of poet and painter.
Once again Mithraic rays of light illuminate the scene from above. Beside the tree
is a handwritten *dédicace* to the couples closest to him. *Soupe à l'oignon*: Christian

Zervos. *Chaux vive*: Yvonne Zervos. *Vif argenté*: Éluard. And *Nusche*: Éluard's wife. Picasso gave this encoded masterpiece to the Éluards.[13]

During the spring and summer of 1936, Alice sent Picasso a series of adoring letters. On March 20 she wrote, "I love you with love. I can't do anything about it. I'm so terribly unhappy because you're far. It is too painful to love you. I don't have the courage to learn to live without you. I thought my source of tears was dry. I don't want it to run again, weeping tears from the past and tears from the future . . . An hour ago you were in this room."[14]

To conceal their relationship from her husband, Alice had secret meetings with Picasso at a bar. In the evenings, when their paths crossed at parties or Saint-Germain-des-Prés cafés where Dora might be present, they took care not to reveal their affair.[15] Alice found ways to demonstrate her devotion discreetly. "I could not talk to you personally last night. I wanted to tell you that I had put some hair in the narrow end of your tie that goes underneath. That's what makes it a little big at that point. It's better if no one except you touches it. I hope this wick of hair will make you think of me, without you realizing it, for example when you sleep. And that it will strangle you when you forget about me."[16]

Later, Alice would recall Picasso's sadistic penchant for denying her the joy of orgasm for as long as possible during sex.[17] Thus he could love and torment her simultaneously. Their romance continued until Alice got pregnant. She sought out an abortionist who would perform the procedure secretly. "The only one I could ask for this favor," she wrote Picasso on July 28, "is this gynecologist—rather louche—who would do it for almost nothing, who could uphold the pretext of performing an operation on my lungs. But he would have to use some pretty outdated and barbaric methods and I don't think he's very skilled."[18] Thus ended her affair with Picasso, which she memorialized in a heartbreaking poem dedicated to the artist, entitled "Despair."

> The fireworks have gone off. Gray is the absolute color of the present tense.
> I saw that nightingales imitate dead leaves well before autumn. Despair
> is a school for deaf-mutes taking their Sunday walk.
>
> It would be better. I don't know what would be better. The thread breaks
> constantly; perhaps it's the same frustrating task as when a blind man
> tries to recall the memory of colors at his white window.
>
> Beautiful women with silver waists always fly above cities—Patience—
> the signs on those roads where every mistake is irreparable end in a
> horsehead-shaped club.

We must carry out all our secrets before it's too late. It's previously too late
if we've forgotten to leave the chair where despair will sit to join our
conversation. Despair will never be reduced to begging even if they burn
his arms.[19]

Alice's last letter to Picasso reveals her grief: "I won't annoy you any longer and
I think I owe you excuses for often being so exhausting. . . . I'm going to the hospi-
tal tomorrow for five or six days. Then as soon as I am well enough to travel I will
try to leave this awful city as fast as I can."[20] Alice would indeed quit Paris to travel
through India for several weeks with the poet Valentine Penrose, the soon-to-be-ex-
wife of Roland Penrose, in early 1937.[21] A romantic relationship reportedly developed
between the two women in the course of this trip, after which they would never see
each other again.[22] Her despair was compounded by the realization that Picasso simply
preferred Dora. "I had no chance," wrote Alice, "if you can spend so much time with
someone so different from me." She could hardly believe that Dora "could satisfy you
every day and tighten a bond that seems crazy with desperation. I felt disarmed and
defeated in advance. I know she has a certain easiness so dear to our friend Éluard."[23]

Had Picasso stayed with Alice, he is unlikely to have experienced as much *Sturm
und Drang* as he did from Dora's masochism. A drawing as factual as a diary entry,
made on August 1, depicts Dora inserting a key in Picasso's door, symbolically enter-
ing his life, suitably dressed in a coat and headscarf. Picasso awaits her in the guise of
a Greek god, a stick in his right hand and a dog clutched in his left.

Picasso. *Dora Maar and
Classical Figure*, August 1,
1936. Wash ink drawing,
34.5 x 51 cm. Courtesy
private collection.
Courtesy Axel Vervoordt
Company, Antwerp.

On August 3, the same day that Picasso received Alice's last letter, Dora also wrote, fearing that her own affair with the artist had become the subject of rumor: "First thing this morning, I ran into Madame de Noailles in the place Champerret. I need not say anything else, she has left me feeling desolate." Marie-Laure Vicomtesse de Noailles—daughter of the immensely rich banker Maurice Bischoffsheim—was a notorious gossip. In closing, Dora begged Picasso to visit the following day.[24] As he had done during his seduction of Alice, Picasso shared his poetry with Dora. "I am so moved from reading what you wrote to me I am compelled to reply immediately. I am shattered by this thing. What have I dared embark upon by entering into your life?"[25] Dora had won out over Alice. Years later, she too would be replaced.

In 1939, when war broke out, the Paalens would take refuge in Mexico, where they resuscitated their marriage and helped rescue surrealism, which the Nazis had dismantled in Europe. The movement found a new base in Mexico City. Alice would divorce Paalen in 1947, and twelve years later, after two more failed marriages, he killed himself. Alice too would remarry and divorce. She would also switch from poetry to painting, take the name Rahon, and exhibit her work internationally until her death in 1987. She was virtually forgotten until Mexico City's Museo de Arte Moderno gave her a retrospective in 2009.[26]

In addition to Alice Paalen, Picasso would be obliged to extricate himself from yet another relationship with yet another wounded woman: forty-nine-year-old Valentine Hugo, ex-wife of Victor Hugo's great-grandson, the painter Jean Hugo. Four years earlier, Valentine had left Hugo for André Breton, but their affair did not last. Breton would leave her to marry the fascinating Jacqueline Lamba. Poor Valentine proceeded to fall desperately in love with Picasso, as her letters to him reveal.[27] They had known each other since their Diaghilev days. He let her down lightly. They worked together on a lithograph based on a photograph of Valentine's 1921 pencil drawing of Picasso. The artist embellished the image with black chalk motifs and sharpened the eyes. An edition had been planned, but it never materialized.[28]

Meanwhile, his friend Éluard had proffered his wife, Nusch, to Picasso. Éluard had discovered this former Alsatian circus performer singing in the street in 1930 and married her in 1934. As was his way with his women, Éluard had made her available to Picasso, but the artist had turned him down: "Paul, you know, wanted me to sleep with her . . . but I didn't want to. I liked Nusch very much, but not that way. And Paul was furious. He said that my refusal proved that I was not really his friend." Picasso remembered keeping Nusch company at a café while Éluard went off to a hotel with a prostitute.[29] He told a different story to Françoise Gilot, admitting that he had slept with Nusch: "I only did it to make [Éluard] happy. I didn't want him to think I didn't

ABOVE Man Ray. Photograph of Nusch
Éluard, 1935. Private collection.
RIGHT Picasso. *Portrait of Nusch Éluard,*
autumn 1937. Oil on canvas, 92 x 65.2 cm.
Musée National Picasso, Paris.

like his wife."[30] The magical paintings of Nusch done over the next two years reveal
no trace of sexual desire but a fascination with her otherworldly looks and style.

While juggling multiple mistresses, Picasso was inundated with daily letters from
Olga—letters that he virtually never answered or acted upon. Picasso ignored her
appeals for help with their fifteen-year-old son. His work came first. His friends and
dealers also turned their backs on Olga, who became ever more anxious and despair-
ing. Her letters are heartrending: "I beg you, <u>what should I do</u>? I do not know how
Paulo spends his days. Do you realize we are talking about <u>your son</u>?"[31] As weeks
went by with no reply from Picasso, Olga intensified her pleas for help. "I'm tell-
ing you again, you have no idea what's going on with your son. . . . And you haven't
answered me. I can't believe that you have changed that much. Don't interpret this
letter badly, I beg you. It's not about me anymore but about our son. And it's not his
fault. The change is too big for him and you must realize how terribly, terribly sad he
is to be separated from you, and he is also nervous when he comes back from your
house. You have to speak to him seriously."[32] Olga's words did not seem to have had
the desired effect on Picasso. Things simply went from bad to worse. A year would
pass before Picasso arranged treatment for his son in a Swiss clinic.

Picasso. *Man in a Mask, a Woman with a Child in Her Arms.* Juan-les-Pins, April 23, 1936. Pen and ink, wash, 65.5 x 50.3 cm. Musée National Picasso, Paris.

9

Juan-les-Pins

On March 3, 1936, Paul Rosenberg opened a major show at his Paris gallery, *Picasso's Recent Works*. It consisted of twenty-nine paintings executed between 1931 and 1935, some of which had been shown at the Galeries Georges Petit retrospective in 1932. Sabartés wrote, "From the first day the crowds were huge."[1] At the opening he spotted Braque, Kahnweiler, and dealer Pierre Loeb admiring the work while "Rosenberg, exuberant, danced about from group to group shaking hands."[2] The young British collector Douglas Cooper repeatedly visited the show and told Picasso "one is happy for a whole week after seeing it."[3] Cooper had lent one still-life to the exhibition and purchased another from Rosenberg.[4] He would subsequently become a major historian of Picasso and cubism as well as a close friend of the artist.

In 1932, at the age of twenty-one, Cooper had come into a trust fund of £100,000. Today this would not generate the price of a Picasso drawing, but by the standards of the day Cooper was rich. Money meant that he could flout his father and devote himself to art history (at the Sorbonne and Marburg-in-Hessen) and—no less horrifying to his family—the pursuit of cubist works of art and good-looking young men. Most of the finest paintings that Cooper amassed between 1932 and 1939 came from a single source: a shadowy German called Gottlieb Friedrich Reber. Reber lived lavishly, if somewhat precariously, in a château outside Lausanne filled with by far the largest collection of cubist and postcubist art in private hands. Today Reber is forgotten, but in the 1920s and early 1930s he was one of the biggest players in the field of modern art.

Cooper and Reber entered each other's lives around 1932, at an opportune time for both of them. Heavy losses on the Paris Bourse in 1929 had transformed Reber, who had been the most adventurous art investor of the 1920s, into a panic-stricken unloader. Cooper would take full advantage of the fact that Reber was broke—so broke that he had to use many of his remaining paintings as collateral for loans. The greatest Picasso that Cooper ever acquired, the 1907 *Nudes in the Forest* (now one of the glories of the Musée National Picasso, Paris), had to be redeemed from the municipal pawnshop in Geneva for £10,000. Cooper never liked to admit that it was,

in fact, Reber's example he had followed when he limited his acquisitions to works by the four great cubists: Picasso, Braque, Léger, and Juan Gris. Though a close friend and fan of Léger's, Cooper would not become a close friend of Picasso's until 1950, when he and I settled into a broken-down château between Nîmes and Avignon.[5]

Picasso was not impressed by the critics' reactions—even the favorable ones—to his 1936 Rosenberg show. He grumbled to Sabartés that one critic who had deplored his recent paintings when shown them at Boisgeloup now praised them. "So you see! But what does it matter!" Picasso exclaimed. "Everybody is like that. I'm going away."[6] And go away he did.

On March 25, Sabartés took Picasso to the Gare de Lyon and put him on the night train to Antibes. Apart from his secretary, no one was to know about this excursion to a hideaway where he could finally resume painting on canvas.[7] Picasso enjoyed traveling "incognito." He felt he was "doing something wicked." He told Sabartés to address him as Pablo Ruiz, "like when we were youngsters."[8]

Picasso had legal reasons for concealing his identity. If he wanted Marie-Thérèse to live with him in the south, secrecy was essential. Given the state of his divorce suit, his lawyer, Maître Henri Robert, had ordered him, above all, not to cohabit with her.[9] Picasso even opened a checking account under his abbreviated name. "I'm sending you as requested a checkbook in the name of Pablo Ruiz," wrote his banker, Max Pellequer. "Rest assured that we perfectly understand your desire for peace and quiet."[10]

During the night on the train he wrote a surrealist dirge:

> Think evening <u>angelus</u> to see you <u>broken</u> in the mirror exploding from clog kick blow-pipe <u>to see you nailed</u> on the pond shivering detaching and rolling itself into a pill unhooks the hanged body of the naked one from the festoon of mouth untie your hand your hands

On arrival the following day, he composed yet another doleful poem:

> the slender sojourn of the secret price of pain simmers on the low fire of memory where the onion plays the star if the hand detaches itself from its lines having read and reread the past but at the crack of the riding-whip straight in the eyes

At Juan-les-Pins, a Mediterranean seaside place he already knew well, Picasso found a little villa with a garden.[11] As soon as he moved in, he had Marie-Thérèse and baby Maya join him. Before leaving Paris, he had warned her to shut off the gas, electricity, and water in her apartment and to bring the sheets. He looked forward to the arrival of his mistress and daughter, and added: "This 23rd day of May 1936,

I love you still more than yesterday and less than tomorrow. I will always love you as they say, I love you, I love you, I love you, I love you, I love you . . ."[12] His daily letters to Sabartés during the six weeks he spent with Marie-Thérèse are comical; but as the secretary noted, "anxieties continued to hound him. His ironical remarks and jokes in Catalan could not conceal his disquietude."[13]

Picasso would later tell people who wanted to write about him that "this was the worst period of my life." There were many reasons, but none more pressing than the fact that he now had to face the realities of his separation from Olga, and the prospect of ceding to her his cherished Boisgeloup, the magical place where he had generated so many masterpieces inspired by Marie-Thérèse, the nymph he had kept hidden there. The agony of his loss is all too evident in the touching allegory of himself as a Minotaur pulling a handcart piled with an escape ladder, a dying mare, a newborn colt, and a framed painting of a polychrome sun (April 6).[14]

Picasso with Maya at Villa Sainte-Geneviève, Juan-les-Pins, April 1936. Private collection.

Many of the numerous paintings and drawings Picasso did during his six weeks at Juan-les-Pins are tinged with anger or despair. However, the disgruntled artist had not painted for a year and was trying to find his way back to his mastery of previous years. The uneven quality of most of the paintings mirrors the difficulties he was having. He had brought to Juan-les-Pins a supply of brushes, paints, and canvases, a dozen or so standard-sized ones usually used for portraits. These would enable him to try variations of *têtes de femme*, a favorite motif, including a strikingly pointillistic portrait of Marie-Thérèse (April 22).[15] A recurrent feature of these Juan-les-Pins paintings is a comically ugly Victorian dressing table or sideboard in the seaside villa.[16] Twenty years later a similar monstrosity would appear in paintings he did at the Château de Vauvenargues.

On April 23 Picasso wrote Sabartés: "I am giving up painting, sculpture, engraving, and poetry to devote myself exclusively to singing."[17] Nonsense. He was writing a major poem virtually every day. He was also painting and drawing avidly to make up for his year-long absence from his studios. Picasso was determined to prove that he was still a dazzling draftsman, as exemplified in the superb reworking of the

LEFT Picasso. *Woman at the Sideboard*. Juan-les-Pins, April 9, 1936. Oil on canvas, 55 x 45 cm. Musée National Picasso, Paris. RIGHT Picasso. *Woman with a Watch*. Juan-les-Pins, April 30, 1936. Oil on canvas, 65 x 54.2 cm. Musée National Picasso, Paris.

Sauvetage theme, in which Marie-Thérèse and an identical look-alike appear to be rescuing each other from drowning (April 29).[18] Swollen nipples seen in the drawing reflect the fact that Marie-Thérèse was still breastfeeding Maya at Juan-les-Pins.

Picasso also did two brutally exorcistic paintings of a disheveled Olga sitting on the floor of a cell-like room, peering into a distorting mirror. In one of them, a bridal wreath slips off the end of her nose. There is a comb on the floor.[19] Six months later (October 6), Picasso wrote a note to himself with instructions on how to make this image of his wife more grotesque: "In the picture of April 30 canvas 15F woman looking in a mirror put on the floor a comb containing between its teeth some hairs and some lice on her hair too some lice and if possible on her hair some crabs (pleasant idea to add to the lot)."[20]

Weary of being shut up with Marie-Thérèse and the baby and hiding away from friends for a month and a half, Picasso returned to Paris. Sabartés writes: "By the middle of May, I realized that the little enthusiasm which he had taken along with him [to Juan-les-Pins] had reached its end. A laconic telegram announced his return on the fourteenth."[21]

The cozy monotony of family life at Juan-les-Pins did not diminish Picasso's desire for other women. As usual, he was at the mercy of his ever-roving eye. Marie-Thérèse would continue to play the role of the submissive mistress who looked after their

LEFT Picasso. *The Rescue,* April 29, 1936. Oil and charcoal on canvas, 65 x 54 cm. Private collection. RIGHT Marie-Thérèse nursing Maya at Villa Saint-Geneviève, Juan-les-Pins, April 1936. Private collection.

child, ready to resume their relationship whenever called upon to do so. Picasso remained exceedingly fond of her, but her replacement as *maîtresse-en-titre*, Dora Maar, was already a rising star in the surrealist firmament. Years later, Dora told me that after his separation from Olga, Picasso had become bored at the prospect of marriage to Marie-Thérèse. "Elle n'était pas faite pour ça," she said ("She wasn't made for it").[22] Picasso enjoyed playing the two adoring women off against each other, as his paintings of them bear out.

On returning from Juan-les-Pins and the boredom of quasi-married life with Marie-Thérèse, Picasso spent much time at Roger Lacourière's printmaking studio in Montmartre on a project that he had promised to do for Vollard five years earlier: a series of illustrations for one of the great scientific studies of the eighteenth century, Buffon's forty-four-volume *Histoire naturelle.* Buffon's encyclopedia of animal life offered a subject close to Picasso's heart. Instead of employing a mannerist or caricatural approach to each species, Picasso reverted to a conventionally naturalistic style, expressive and affectionate, as if they were his own pets. The only exception is the flea. Picasso depicts a beautiful girl removing the insect from her waist and magnificently back-to-front set of buttocks—a visual pun on the French words for "flea" (*puce*) and "virgin" (*pucelle*).[23] As Buffon had never mentioned a flea, this had to be included in a separate suite.[24]

Picasso. *The Monkey* and *The Virgin,* from the illustrated book *Eaux-fortes originales pour des textes de Buffon (Histoire naturelle)* by Georges-Louis Leclerc, Comte de Buffon, February 9, 1936, published in 1942. *The Monkey:* Aquatint and drypoint: 27.5 x 22 cm; sheet: 36 x 28.5 cm. The Museum of Modern Art, New York, The Louis E. Stern Collection. *The Virgin:* Sugar aquatint on paper, 36.2 x 27.9 cm. Victoria and Albert Museum, London.

Vollard, in Italy for the summer, was delighted to hear that Picasso had finally decided to complete the Buffon prints. The dealer sent a postcard from Rome of Romulus and Remus suckling a wolf and wrote, "Dear Mr. Picasso, the other side shows a magnificent animal that is not in our collection but deserves to be, except that in the last century someone added the two children, who do not strike me as entirely necessary. I've told those who love you here that you were reviving Buffon and they can't wait to see the book . . ."[25] Alas, the Buffon volume illustrated by Picasso would not be published until May 1942, three years after Vollard's death.

While working on Buffon, Picasso continued to write poetry. On May 20, he composed a surrealistic poem about the animals he was etching:

ah if the bird made of garlands woven from the hours asleep in the bronze spider's belly could make its star fritters up in the air of the sea of numbers at the angry blows of the billy goats dressed in feathers and sing on the rose telegraph wire of the eye of the egg's blue of the scarf hanging from the fiery nail planted exactly in the middle of the forehead between the horn of the toro's head what silence

Besides his Buffon prints, Picasso used Lacourière's studio to do illustrations for a new collection of poems by Éluard, *La Barre d'appui*.[26] Sabartés, who joined the artist on his daily trips to the print studio in Montmartre, described the process of etching four images on a single plate: "Picasso took a copper plate 215 mm x 315 mm, divided it into four equal parts by crossing two lines and filled in the first rectangle with a very intricate design. On another he sketched a portrait of Nusch, and got rid of the third space in a moment by drawing the head of a sleeping woman, with a landscape in the background. Since an empty rectangle remained, he daubed the palm of his hand with ink and applied it to the copper."[27] After doing eighteen impressions of this multi-image design, Lacourière cut the plate into four separate parts, which, except for the palm print, accompanied Éluard's poems in *La Barre d'appui*.

On June 3, Éluard spent the afternoon with Picasso at Lacourière's, where he was

Picasso's illustrations for Éluard's poem "Grand Air," June 4, 1936. Pen and ink on Kodatrace paper, 36.8 x 31.4 cm. Courtesy Galerie Kornfeld, Bern.

given a metal plate on which to inscribe his poem "Grand Air." The following day, Picasso framed Éluard's poem with large, marginal etchings. A faunlike Dora Maar, horns protruding from her forehead, makes her first appearance in Picasso's work.[28] With her mirror, she flashes rays of black light back at the blinded Mithraic sun in the opposite corner of the page. The imagery seems to relate to these lines in "Grand Air":

> Treasure guarded by immense beasts
> Guarding them from the sun under their wings
> For you
> Beasts that we knew without seeing them[29]

One week later at Lacourière's, Picasso began work on one of his most poignant prints: *Faun Revealing a Sleeping Woman*.[30] The composition derives from Rembrandt's intensely moving 1659 engraving of a naked Antiope at the mercy of

Picasso. *Faun Revealing a Sleeping Woman, Vollard Suite,* plate 27, 6th state. Paris, June 12, 1936. Aquatint, 31.7 x 41.7 cm. Musée National Picasso, Paris.

Jupiter. In Picasso's version, a horned satyr lifts the sheets to reveal the sleeping Marie-Thérèse. The image is both affectionate and a touch sad. The satyr is seemingly taking his leave. During their six-week stay at Juan-les-Pins, Picasso's *amour fou* for Marie-Thérèse had evaporated in the light of everyday life. By comparison with the artistic and articulate Dora, who could discuss—in Spanish, if need be—the finer points of avant-garde painting, poetry, politics, or photography, Marie-Thérèse now seemed immature and limited and, except in bed, ordinary. As Françoise Gilot has written, Marie-Thérèse had "replaced Olga as the one to escape from, in accordance with Pablo's form of logic."[31]

Meanwhile, Éluard and Breton were busy organizing loans for the first International Surrealist Exhibition, set to open in London in June. During the planning the two poets quarreled. Éluard grumbled to his ex-wife, Gala Dalí: "It's over, I will never participate in any activity with him again. I've had enough. Because of Breton, the whole thing all too often lacked a certain seriousness." Éluard's frustration with Breton had been simmering for years. It stemmed from their fundamental differences over the direction of the surrealist movement. As Éluard complained to Gala, "Surrealism shouldn't have become . . . a literary chapel where enthusiasm and god knows what pathetic activism had to answer to authority."[32] Competition for

Picasso's friendship probably contributed to their feud. In a March 16 letter, Breton confessed to feeling "jealous of the evenings [Picasso] spent with Paul Éluard."[33]

The groundbreaking London show had been conceived by two Britons who lived in France: Roland Penrose, a well-heeled young Quaker, and David Gascoyne, a nineteen-year-old Communist poet who had already published a survey of surrealism. With Éluard and Breton coordinating loans from French collectors, the exhibition would be one of the movement's most ambitious projects. Encompassing works of over sixty artists from fourteen countries, it opened on June 11 at the venerable New Burlington Galleries. Eleven works by Picasso had been chosen to identify the artist as a surrealist, one of which hung beside Dora's iconic 1936 photograph of an armadillo fetus, *Père Ubu*. Hitherto, Picasso had been ambivalent about the movement. His participation in the London exhibition may have been prompted by his fondness for English art and culture, inherited from his father and strengthened by his inclusion in Roger Fry's groundbreaking postimpressionist exhibitions in 1910–12.[34]

Penrose's London show included major works by Dalí, Giorgio de Chirico, Max Ernst, Paul Klee, René Magritte, Marcel Duchamp, Alberto Giacometti, Jean Arp, and Alexander Calder. Contributions also came from British surrealists, including Penrose himself, Paul Nash, Eileen Agar, and Henry Moore. Despite pressure from Penrose, Picasso did not bother to cross the Channel for the opening of the exhibition. He particularly regretted missing the spectacle of Dalí giving a lecture in an antique, malfunctioning deep-sea-diving suit. It had nearly asphyxiated him. Penrose described Dalí's performance as "an illustrated and extravagant account of his life and love for Gala. But owing to the suffocating heat in the gallery he had to be brought to the surface and the headpiece unscrewed before his discourse from the depths of the subconscious left him completely unconscious."[35]

Picasso had a good excuse for failing to attend the surrealist show in London. Back in Paris, he was focused on a major government commission. French elections in April and May 1936 had brought to power a new left-wing party: the Front Populaire, spearheaded by the country's first socialist prime minister, Léon Blum. Blum was fighting to make basic reforms that the Left had long been howling for—reforms that included paid vacations and a forty-hour work week. To bolster the new government's July 14 celebrations, the Maison de la Culture in Paris commissioned Picasso to do a curtain for a gala performance of *Le Quatorze Juillet*, a 1902 play about the fall of the Bastille in 1789, by the pro-Soviet Nobel laureate Romain Rolland.[36] By accepting the commission, the artist would put his work in the service of a political party for the first time.[37]

Picasso. *Le Quatorze Juillet,* June 13, 1936. Assemblage of 6 pieces of paper, graphite on imitation vellum, 68 x 67 cm. Musée National Picasso, Paris.

Twenty years earlier, Picasso had revolutionized theatrical décor with his sets for Diaghilev's ballets *Le Tricorne* and *Parade.* His sense of theater remained as sharp as ever. On June 13 he came up with a drawing for the theater curtain—an overtly Communist one. The Bastille is burning. Below, a mob of revolutionaries brandish their fists and raise their arms in a party salute. Some in the crowd hold the Soviet hammer and sickle. Picasso apparently realized that this first design was too blatantly partisan. He switched to an image that would have a less obvious connection to Rolland's play: *The Remains of the Minotaur in Harlequin Costume,* a gouache he had done on May 28,[38] the same day, incidentally, that forty thousand Renault automobile workers had gone on strike and taken over their factory.[39]

The image worked perfectly for *Le Quatorze Juillet.*[40] It depicts a dying Minotaur, cloaked in one of Picasso's Blue Period Harlequin costumes, carried by a malevolent half-human, half-bird figure, beaked like one of Max Ernst's macabre monsters from *Une Semaine de bonté,* the series of surrealist collages published two years earlier.[41] Picasso asked his friend Luis Fernández for help enlarging his gouache to the curtain's dimensions (27 x 43 feet), and invited his new mistress, Dora Maar, to document the process with her camera. Dora's photographs as well as her later statements to Douglas Cooper confirm that Picasso painted much of the enormous composition himself.[42] Besides being a brilliant photographer, Dora had a perceptive surrealist eye, which would become intensely Picassian.

Le Quatorze Juillet premiered at Paris's Alhambra theater. It featured an original score by composers Georges Auric, Darius Milhaud, and Arthur Honegger, and starred the celebrated actress Marie Bell. Newspapers reported that Picasso watched the opening performance from the balcony. His stage curtain for the play and his presence at the premiere were seen as sure signs of his allegiance to the Front Populaire.[43] A contemporary art exhibition had also been organized in the theater's foyer. Socialist painter Boris Taslitzky recalled the challenges of installing a show that included works by established stars—Matisse, Picasso, and Léger—as well as those

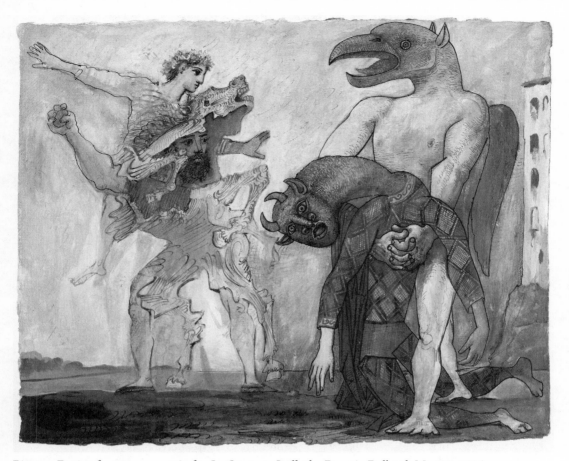

Picasso. Design for a stage curtain for *Le Quatorze Juillet* by Romain Rolland, May 28, 1936. Ink and gouache, 44.5 x 54.5 cm. Musée National Picasso, Paris.

of lesser-known painters and sculptors. "We were full of embarrassment: should we mix the senior artists with the young ones? We were hanging and changing our minds all the time when Matisse and Picasso arrived. Matisse was hesitant about what to do. Picasso assured us that he liked the 'mixed *charcuterie*' effect and said go ahead."[44]

In his journal, the seventy-year-old Romain Rolland interpreted Picasso's design and rejoiced that his play had new relevance to the situation in Europe:

The curtain by Picasso is a gigantic word puzzle: Fascism, bird of prey, supports the capitalist beast ready to collapse. Facing them is a bearded man breaking away from the remains of an animal and carrying on his shoulder a young genius covered with stars. . . . I am myself surprised by the power of the revolutionary propaganda of my work. It hides some explosive material. I understand why no government before

Dora Maar. Photograph of Picasso working on the stage curtain for the play *Le Quatorze Juillet* by Romain Rolland, 1936. Musée National d'Art Moderne, Centre Georges Pompidou, Paris.

this one has tried to play it. The press will claim that I have scattered allusions to present events; and this is true insofar as my writing applies to enemies of the *Front Populaire* as well as to events in Spain in the last month. However the entire text, without any changes, dates from more than thirty years ago.[45]

The first half of 1936 was a time of exultation for leftists in France as well as in Spain, where the Frente Popular won a narrow victory in the February 16 elections. Manuel Azaña became president of the Spanish Republic and immediately released from prison thousands of strikers arrested after the October 1934 Asturias insurrection. A parliamentary coalition of Socialists and Communists sought to reverse the conservative policies of the previous regime. Hope surged among Spain's working classes, but it would not last. No sooner did the new government take power than elements on the Right began plotting its overthrow.

10

War in Spain

The third performance of *Le Quatorze Juillet* took place on the same day that a military uprising exploded in Spain. From the Canary Islands, where he had been exiled by the new Republican government, Generalissimo Franco announced that his Fascist followers were launching a coup.

With the help of British agents masquerading as tourists, the fat little dictator-to-be was flown to Morocco, where he had rallied a formidable army. On July 19, 1936, Spanish prime minister José Giral sent a telegram to his French counterpart, Léon Blum: "SURPRISED BY DANGEROUS MILITARY COUP STOP BEG YOU TO HELP US IMMEDIATELY WITH ARMS AND AEROPLANES STOP FRATERNALLY YOURS GIRAL."[1] Under pressure from the French right-wing press and warnings from the British, Blum chose not to intervene. Picasso's adoptive country would provide no immediate help to his native country.

Support for the Fascist coup was immediately forthcoming from Hitler and Mussolini. German and Italian planes transported Franco's Moroccan troops to Seville, the first major city on mainland Spain to fall to the Nationalists. Colonel Juan Yagüe, who had helped Franco crush the Asturias uprising in 1934, was now in command of the Army of Africa. In working-class towns and villages captured at the start of the war, rebel soldiers murdered the men, raped the women, and pillaged anything portable, leaving behind what historian Paul Preston calls "a horrific trail of slaughter" as they moved north toward Madrid.[2]

On August 10, the walled medieval city of Badajoz, a few miles east of the Portuguese border, came under attack. Colonel Yagüe ordered a mass execution of civilians and prisoners in the city's bullring. French and American journalists covering the war dubbed Yagüe "the Butcher of Badajoz." The Butcher himself boasted to an American correspondent: "Of course we shot them. What do you expect? Was I supposed to take 4,000 reds with me as my column advanced, racing against time?"[3]

These atrocities provoked deadly reprisals in Republican-controlled territory. Left-wing militias and anarchists assassinated suspected Fascists by the thousands,

targeting the Catholic clergy for its support of the coup. Overwhelmed by the violence, Republican President Azaña confided to his brother, "The bloodshed disgusts me. I can't go on. It will drown us all."[4]

Besides the French newspapers which Picasso read avidly, and the Spanish ones sent to him by his mother in Barcelona, he received firsthand accounts of the horrors of war, committed by the Left as well as the Right, from friends who had fled to France.[5] As Sabartés wrote: "News about the disturbances in Spain reached us on July 18. Compatriots belonging to both sides began to pour into Paris, and our conversations centered on the events which were rocking our country."[6] To those around Picasso, his support of the Republican side was beyond doubt. In August, he joined Matisse and a group of signatories to a supportive telegram from the Maison de la Culture to the president of Catalonia, Lluís Companys: "SALUTE OUR HEROIC BROTHERS FIGHTING FOR LIBERTY IN SPAIN. FIRMLY EXPECT FINAL VICTORY OF SPANISH PEOPLE OVER CRIMINAL ATTEMPTS OF ADVENTURERS. LONG LIVE SPAIN, GUARDIAN OF CULTURE AND TRADITIONS WITH WHICH INDESTRUCTIBLE BOND UNITES US."[7]

A few days into the war (July 20), an anarchist mob vandalized Barcelona's Sagrada Família basilica and set fire to the crypt that contained the tomb of the great Catalan architect Antoni Gaudí. One month later, Dalí sent Picasso a frivolous postcard spreading a rumor that Gaudí's corpse had been disinterred and dragged through the streets. Dalí made a surrealist joke of the story: "He [Gaudí] did not look well (which is normal in his state). He was quite well conserved, embalmed, he had just been unburied. The anarchists always know where to find the good jar of jam."[8]

The day Dalí wrote this letter, his beloved friend the celebrated young poet Federico García Lorca, whom Picasso greatly admired but had never met, was arrested and condemned to death before a firing squad in his hometown, Granada. According to some accounts, the fusillade of bullets failed to kill the poet. He rose to his knees in agony, crying, "I'm still alive!" That night, one of the murderers did the rounds of the Granada cafés, boasting of how he had shot Lorca "up the ass" for being homosexual.[9] Alas, Picasso would never meet the greatest Spanish poet of the twentieth century. Did Lorca's death inspire the poem Picasso wrote a few weeks later, in September?

so moving the memory of the broken glass in his eye does not strike the hour on the bell that scents the blue so tired of loving the sighing garment that covers him the sun that may from one moment to the next explode in his hand reenter his claws and fall asleep in the shade that outlines the praying mantis nibbling on a communion wafer but if the curve that animates the song attached to the end of the hook coils up and bites the heart of the knife that charms and colors it and the bouquet

of starfish cries out in distress in the cup the flick of the tongue of his gaze wakes up the tragic ratatouille of the flies' ballet in the curtain of flames that reaches the windowsill

To escape the stifling heat of mid-August 1936 in Paris, Picasso decided to join Paul and Nusch Éluard at Mougins, a charming, as yet undeveloped seaside place near Cannes.[10] The town was not unknown to Picasso. He had spent time at Francis Picabia's Mougins villa in summer 1925.[11] This year, he took the train south on August 15 and stopped for a night's rest at Cannes's Hôtel Le Majestic, where he received a telegram from Dora reminding him of her Paris telephone number.[12] Parting from Picasso made her anxious, and she soon arranged to join him on the Côte d'Azur. The following day the artist moved to Mougins's modest Hôtel Vaste Horizon, less than five miles north of Cannes. The Éluards were staying with friends nearby.[13] They had brought Cécile, Paul's eighteen-year-old daughter by his ex-wife Gala Dalí. They had also invited Roland Penrose and his French wife, Valentine; Christian and Yvonne Zervos; and Man Ray. The poet René Char would visit them later, as would the dealer Paul Rosenberg.[14]

In the course of the summer Man Ray captured this polyglot family at play in a sixteen-minute color movie called *La Garoupe*, after the beach in Antibes they often visited.[15] Picasso had spent summers there in the mid-1920s with Olga, the Gerald Murphys, and dancers from the Ballets Russes. Man Ray's film provides us with a candid insight into the group's summer antics and bliss. It also included some comical sequences of them clowning for the camera. In the final clip, Picasso indulges in a bit of cross-dressing, donning a headscarf, smoking his cigarette *comme une femme,* and flicking the butt at the camera.

Meanwhile, at pains to conceal her affair with Picasso from her conventional parents, Dora went to stay nearby at Saint-Tropez with her friend Lise Deharme, a patron of surrealism and friend of Breton's.[16] Nevertheless, photographs reveal that she *did* visit him at Mougins.[17] Her intelligent and sympathetic company helped assuage the artist's anxiety over the situation in Spain, the safety of his mother and sister in Barcelona, and his ongoing divorce suit with Olga.[18] Picasso's intense fascination with Dora's face—a face that would soon become a major motif in his work—is first seen in the small portrait drawings done that summer. To a blue ink sketch, apparently made from memory, of Dora's strong profile, he added the affectionate inscription "*fait par coeur.*"[19] The charcoal, india ink, and crayon drawing from September 5 of Dora being ravished by Picasso in the guise of a Minotaur is one of his most viscerally erotic images of her.[20] In becoming his principal mistress, she became his photographer. Her camera would play a major role in their relationship. "She jeal-

Stills from Man Ray's movie,
La Garoupe, 1936

LEFT Nusch Éluard, Cécile Éluard (in beret) blocking Paul Éluard, Valentine Penrose, Picasso and, missing, Roland Penrose. All are visible at the bottom.

BELOW More stills from *La Garoupe,* with Picasso clowning.

ABOVE From left to right:
Valentine Penrose, Nusch Éluard,
Dora Maar, unknown woman,
Paul Éluard, Lise Deharme,
and Picasso, Mougins, 1936.
Photograph by Roland Penrose
Lee Miller Archives, England.

RIGHT At Mougins, 1936-37,
Dora Maar, Nusch Éluard, and
Jacqueline Lamba. Musée National
d'Art Moderne, Centre Georges
Pompidou, Paris.

Picasso. *Dora on the Beach,* 1936. Oil on canvas, 65 x 54 cm.
Private collection.

ously guarded that role," Brassaï recalled, "which she considered a prerogative, and
which, in fact, she assumed with diligence and talent."[21]

Penrose described Picasso's daily rituals that summer at Mougins:

Picasso usually went with Éluard and others to the beach, returning refreshed from
the sea to a late lunch which was always enlivened and prolonged by unfailing
wit and enthusiasm, engendered by the contact of poet and painter. During these
meals, which rarely passed without some anxious comments on the news from
Spain, Picasso's humor was a series of contrasts. Dressed in a striped sailor's vest
and shorts, at times he would enchant the whole table with boisterous clowning.
Holding a black toothbrush to his upper lip and raising his right arm he would give

Picasso. *Portrait of Dora Maar, "fait par coeur,"* September
11, 1936. Blue ink on paper, 27 x 21 cm. Archives Succession
Picasso.

them an imitation of Hitler's ranting . . . At other times, using whatever material
was at hand such as burnt matches, lipstick, mustard, wine or colour squeezed from
flowers and leaves, he would quietly draw portraits on the tablecloth taking quick
glances at the youthful smiling face of Nusch or at Éluard's daughter Cécile, with
eyes that seemed to devour what they saw.[22]

Only one member of Picasso's Mougins entourage failed to enjoy herself. Photo-
graphs reveal Penrose's wife, Valentine, in a state of grief. Valentine was desperately
trying to save her wreck of a marriage. In a letter sent to Penrose seven months later,
she conveyed her frustration with her husband's surrealist sexual liberty: "I want
to believe in life again and especially with the goal that every day contains some-

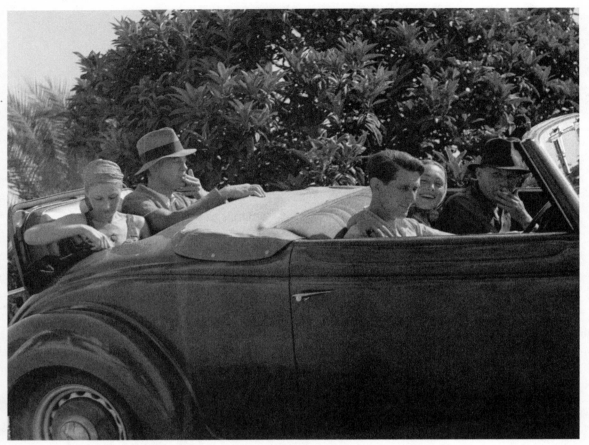

Back seat: Valentine Penrose, Paul Éluard; front seat: Roland Penrose, Nusch Éluard, and Picasso, 1936. Photograph by Man Ray. Musée National d'Art Moderne, Centre Georges Pompidou, Paris.

thing beautiful and not something 'easy' or 'experimental,' or 'curious.' It has been a heartbreaking trial to live like this and especially to see you like this last summer, because, for me, I had to force myself to do it for you."[23] They would soon separate, and Valentine would leave for India with Alice Paalen.

Picasso had left his Hispano-Suiza in Paris. Fortunately Penrose had taken his car to Mougins, and often drove the others to the beach. Late in August, with Picasso and Dora in the car, Penrose had an accident with an oncoming vehicle.[24] He and Dora were unhurt, but Picasso suffered severe contusions so painful that he thought his ribs were broken. On August 29 he wrote Sabartés: "Confidentially—a few days

ago on my way from Cannes by car with an Englishman, I had an accident which has left me all smashed up, and I can hardly move."[25] While recovering, Picasso resumed writing poetry, with Dora's help. She had been composing *vers libre* since childhood. On a sheet of Vaste Horizon letterhead, Dora took down in her hand a vivid example of their collaboration:

Hands gripping at dawn stolen from the cracks in the night full of salt and bird droppings when dregs of roses stain the torn draperies dragging feet beating wings mixing the furtive sighs of the awkward with the elaborate cries of the dumb the conman will come back to execute his daytime faces[26]

Penrose recalled how Picasso enjoyed visiting the villages on the coast and in the mountains back of Mougins. One day with Éluard and Nusch, they discovered the town of Vallauris, known for its ceramics since Roman antiquity. They wandered into the pottery workshops and were fascinated by the craftsmen's skill. Though ten years would pass before Picasso started working in ceramic, Penrose believed that the artist "understood at once that he had come across a new field to explore."[27]

By mid-September, most of the Mougins group had returned home; the Éluards to Paris, the Penroses to London. Rather than face the responsibilities that awaited him in Paris, Picasso decided to stay behind with Dora, who had left Saint-Tropez to join him at the Vaste Horizon. At last he could be alone with her. On September 12, Éluard, bereft of Picasso's company, wrote the artist: "My dear friend, Nusch is right, Paris is no fun at all. I am not myself here as I am in Mougins, as I am with all of you."[28]

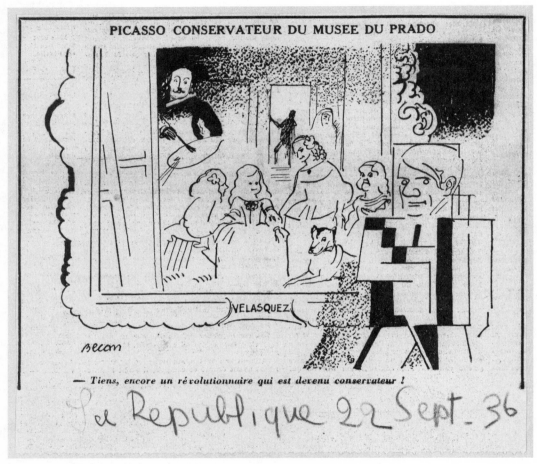

"Tiens, encore un révolutionnaire qui est devenu conservateur!" ("Here's another revolutionary who's become a museum curator!"). Cartoon depicting Picasso in cubist costume in front of *Las Meninas* as director of the Prado Museum. From *La République,* Picasso annotated press clipping, September 22, 1936. Print on newspaper, 15.5 x 17.3 cm. Donated by Succession Picasso, 1992. Musée National Picasso, Paris.

11

Prado Director

Shortly before leaving Mougins, Picasso received news that he had been nominated director of Spain's greatest museum, Madrid's Prado. Some of his closest friends—Zervos, Kahnweiler, and Éluard—were astonished by the announcement.[1] Éluard asked Gala Dalí, "Is it true? In that case, he'll have to return there. He's still at Mougins."[2] The decision to appoint Picasso had come from Josep Renau—the dynamic twenty-nine-year-old Valencian graphic designer turned political activist—who had recently been appointed Spain's director of fine arts.[3] Despite his youth, Renau had already founded the left-wing magazines *Proa* and *Nueva Cultura* as well as the Union of Proletarian Writers and Artists.[4] One of Renau's first acts as director general, later approved by President Azaña, was to offer the prestigious directorship of the Prado to Picasso. According to Renau, the artist accepted the honor unconditionally, saying he had never felt so Spanish nor so committed to a cause.[5] Renau wrote to thank Picasso for joining the "holy war against fascism . . . [and] deciding to live with this magnificent Spanish nation."[6] The appointment was honorary. Picasso was not expected to deal with the responsibilities involved, not least the mammoth chore of shifting the contents of the Prado to a place of safety.

In the past the directorship of the Prado had usually been awarded to the most renowned Spanish portraitists. In prerevolutionary days, offering the sinecure to Picasso would have been out of the question. True, but as a fervent Marxist Renau realized that the artist would be a major asset to his cause. He had no problem persuading Picasso, who had hitherto avoided political commitment, to join forces with Socialists and Communists on the Republican side. Eight years would pass before Picasso would actually join the Communist Party.

In late September, Picasso returned to Paris as director in absentia of the Prado. Marga Barr had arranged to interview him at the rue du Dragon offices of *Cahiers d'Art*. According to her journal: "[Picasso] arrives resplendent in bright tie, showy socks, and says . . . 'Moi aussi maintenant, je suis directeur de musée' " ("I too am now director of a museum"). They gossiped, and Picasso agreed to lend to the upcoming MoMA show *Fantastic Art, Dada, Surrealism*.[7] He told Marga, "Go to Kahnweiler's

Picasso. *Nude with Night Sky,* August 12–October 2, 1936.
Oil on canvas, 130.6 x 162.5 cm. Musée National d'Art
Moderne, Centre Georges Pompidou, Paris.

tomorrow, I will call you there at 11:00 and we'll make arrangements." Picasso stood Marga up. Kahnweiler was not surprised.[8]

Henceforth, civil war would be evermore on Picasso's mind. It inspired a large painting, *Nude with Night Sky,* begun in August before he left for Mougins and reworked after his return, as witness the related drawing of October 2.[9] A romantic subject all the more powerful for being repulsive: a pudgy Dora, angled as if pushed out at us, with stubby arms raised up to her phallic nose of a face, while her buttocky stomach melts into a row of toes. She reclines on a messy bed under a black night sky. A large moon, an evening star, and three lesser stars shine down, perhaps inspired by his nights with Dora at Mougins. Lydia Gasman, the little-known but most perceptive of Picasso's commentators, relates the image to the visions of Saint John in the Apocalypse, which Picasso revered, and notes, "He must have realized that his feelings about the Civil War and his new models demanded a new form of expression."[10]

One of these new forms, invented by Picasso and Dora in late September, combined photography and engraving. Dora's camera magic had come to obsess Picasso, and they began devising complex technical procedures in her photography studio at 29 rue d'Astorg. He soon came to prefer Dora's space to his own. Many years later, she told me that "he hated working in the Boétie studio after all the trouble he had had there with Olga and worked in my studio until I found him the studio on the rue des Grands-Augustins."[11]

The most striking example of Picasso and Dora's collaboration is the photoengraving *Nude in the Studio.* It started off as a photograph of a corner of Picasso's rue la Boétie apartment taken in 1934. The artist has scratched a transparent nude model into the photographic plate, set off by studio junk and canvases. Picasso added a burst of Mithraic light in the top-right corner. Mithraism would play a secret and recurrent role throughout his life. The Mithraic rays enabled the artist to create a figure of nothing but light. In doing so he came up with a whole new way of registering light. With Dora's help he made a number of variations on the original image.

This photoengraving appeared in a 1937 issue of *Cahiers d'Art* with the caption "Picasso, who is constantly seeking to enrich his art, recently conducted a new experiment that may yield remarkable results . . . preparing to merge an original

photograph with an original print, an exercise that is already leading him to an infinite number of combinations."[12] In the same issue Man Ray contributed a surrealist encomium to Picasso's photographic innovations:

Along comes a man who puts himself in place of the eye, with all the risks that act entails. Have you never seen a living camera?

... Since an eye was first hung in the sky and all the telescopes in the world were trained on it, countless wise men have come along to find out which telescope is the best.

A waste of effort!

The eye of Picasso sees better than it is seen.[13]

Picasso. *Nude in the Studio*, c. end of 1936 to beginning of 1937. Photoengraving, etching, and drypoint, 50.5 x 32.7 cm. Musée National Picasso, Paris.

By November, with Madrid besieged by Franco's Moroccan troops, saving the Prado collection had become a matter of desperate urgency for Spain as well as the rest of the civilized world. Every night, the Madrileños set up brilliant blue lights to indicate the sites of historic importance which should not be bombed. Nevertheless, the Germans dropped nine bombs on the Prado on November 16. Fortunately, the paintings had been stored in the basement; the sculptures had been left in place but protected by sandbags.

The extent to which Picasso, the new director, was involved in planning these precautions is unclear. He never left France despite repeated invitations to come to Spain.[14] His friend José Bergamín kept him closely informed of the work being done to safeguard the museum's treasures. Picasso's friendship with Bergamín—a Malagueño like himself, and the liberal son of a regional governor—dated back to 1927.[15] Bergamín had made a reputation as a poet and intellectual, but civil war had transformed him into a Communist, albeit a fervently Catholic one. Picasso, who usually steered clear of politics, would consult Bergamín about every issue, above all his responsibilities as director of the Prado. As president of the Alianza de Intelectuales Antifascistas, Bergamín organized the transport of the Prado paintings to safety in Valencia, where the Republican government had moved its headquarters. Volunteers helping him included the poet Rafael Alberti, who during the evacuation of

the museum had been obliged to dump Velázquez's masterpiece *Las Meninas* on the sidewalk of a crowded roundabout as he fled for cover from a bombing raid.[16] When Bergamín described these events to Picasso in Paris, the artist lamented: "So, I am the director of an empty museum!"[17]

While at Mougins in summer 1936, Picasso and his circle had been disturbed by news reports of the indiscriminate destruction of Spanish churches and monasteries by anarchist elements allied to the Republican cause. Christian Zervos decided to investigate the veracity of these reports for himself. Before leaving Mougins, he had organized a six-week expedition to Catalonia that would enable him to personally participate in the protection of Spanish art and architecture.

The mission began in Barcelona, where the Zervoses were joined by the painter Luis Fernández, Roland and Valentine Penrose, and David Gascoyne. The Penroses arrived with letters of introduction from England's Independent Labor Party, affirming their status as "trustworthy Socialists."[18] After inspecting Barcelona's major churches and museums, the group continued its work in Girona, Lleida, Vic, and other Catalan towns. At each location they documented what they found by taking extensive photographs and interviewing locals involved in saving works of art. At Vic, for example, they learned how a Republican soldier and former museum guide had protected the bishop's palace and its collection of medieval paintings: "He explained to the crowd that had gathered to set fire to it that by doing so they would be destroying treasures that now belonged to them and thus avoided catastrophe."

By the end of November, Zervos's team was back in Barcelona. At Picasso's behest, they paid a visit to his mother, Doña María, and his sister Lola, who lived together in an apartment "full of a marvelous small collection of early Picasso drawings and paintings," as Gascoyne recorded in his journal. "I could not speak much Spanish but [Doña María's] face and gestures were so expressive that I felt I could understand everything she was saying." She showed him a still life with a dead pigeon painted by Picasso at age twelve or fourteen, as evidence of her son's precocious talent: "See the fragile little claws stretching up in the air, so wonderfully pathetic and expressive!"[19] Near the end of the visit, she took her guests to a window at the back of her apartment overlooking a convent that had recently been firebombed. She told them, "It's only today that I have been able to open this after so many days when the smoke and stench . . . nearly asphyxiated us all."[20]

From Barcelona, Zervos assured Picasso of his family's safety: "We saw your mother three times. She is an astonishingly youthful woman. Naturally we talked about you. Your whole family is charming." The publisher also revealed another reason for his trip to Spain: "I have finished a magnificent book on fourteenth and fifteenth century Catalonian art. I am sure it will appeal to you very much."[21] Filled with

photographs gathered during Zervos's travels, the book, *Catalan Art from the Ninth to the Fifteenth Centuries* (1937), would also include a detailed report, coauthored with Penrose, about the threat to Spain's cultural monuments and the Republic's successful efforts to safeguard them, titled "Art and the Present Crisis in Catalonia." Zervos and Penrose also noted the Fascists' disrespect for the country's artistic patrimony: "Throughout Spain the progress of the war has shown that [Franco's] rebels have a bad record where mercy and respect for the enduring values of culture are concerned. Their deliberate bombing at Madrid of the Prado, the National Library and the Liria Palace seems to confirm the dying confession of Unamuno that [the Fascists] hated nothing as much as intelligence."[22]

War in Spain had triggered a war in the worldwide press. Atrocities by Republican extremists were denied by Europe's Communist papers, while Franco's use of Mussolini's planes was played down by conservative papers on both sides of the Atlantic. There was, however, one apolitical exception: the French journalist Louis Delaprée, heroic reporter for *Paris-Soir*, which Picasso read regularly. Delaprée was merciless in his denunciation of atrocities, no matter which faction was to blame. Alas, the ruthless honesty of his reports caused them to be eviscerated or turned down by timid editors. In his last dispatch from Madrid, Delaprée accused them of frivolity for devoting most of his paper's pages to the "*putain royale*": Wallis Simpson, who would ultimately cost Britain's monarch, King Edward VIII, his throne. This juicy scandal left little space in the paper for accounts of the massacre of Spanish children.

When *Paris-Soir* rejected Delaprée's vivid firsthand description of Madrid under the Fascist siege, "Madrid sous les bombes," he published it under a pseudonym in the weekly journal *Marianne* on November 25, 1936:

> The darkness shrouding Madrid is so thick that you could cut it with a knife. We cannot see the sky, but from the sky they can see us. Humming, rumbling, pounding . . . The rebel planes appear in an awesome crescendo. Pro-government fighter planes cannot pursue them in this darkness.
>
> Defenceless, we hear above our heads the deep musical vibration that is the herald of Death. . . . On the corner of Alcalá and Gran Vía, a hand clutches my leg. I free myself and light a match while I bend over the person who has grabbed this lifesaver. It's a young woman, her nose already pinched by approaching death. I don't know what her wounds are, but her robe is stained with blood. She whispers: "Look, look what they've done . . ."

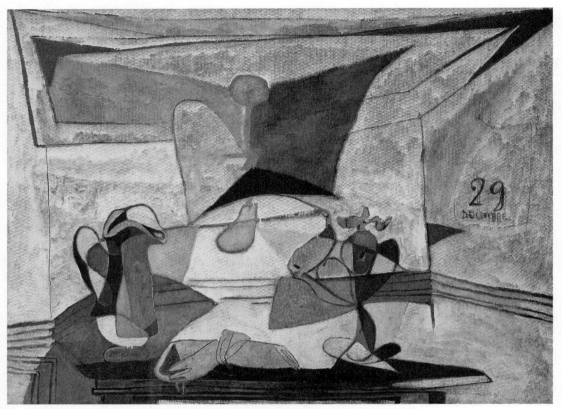

Picasso. *Still Life with a Lamp.* Le Tremblay-sur-Mauldre, December 29, 1936. Oil on canvas, 97 x 130 cm. Musée National Picasso, Paris.

Her last breath and death throes have opened up her robe. A terrible wound, looking as though it had been inflicted by a sadist's knife, has opened up her body from her left breast to the right hip.

An ambulance passes by slowly. We hail it. Is that a man getting down? The beam from an electric flashlight illuminates the corpse. "Dead," the man says drily, "they'll pick her up tomorrow. The wounded first." He sees [a] child's body, which is still in the road and might get crushed again. So he adroitly removes the broken glass, picks up the tiny corpse and places it on the woman's heart, next to the right breast, which is unharmed. A final flicker of the flashlight shows us the small infant's head on that maternal heart and everything sinks back into the night. . . .

We can only wait until the rain of killer meteorites has ended, wait until there have been enough dead and wounded to slake the thirst of General Franco's gods. . . .

Madrid burns for 15 hours, and then the fire tires. There is a lull for a day. But the following night, the 19th, at 2:30 in the morning, the killing is renewed. The fire starts again, we are back in hell.[23]

Summoned back to Paris from Madrid, Delaprée left on a French embassy plane, which was shot down while still over Spain, supposedly by Soviet agents, though the attack may have been a mistake on the part of Nationalist or Republican elements. The pilot managed to crash-land the plane. Delaprée's injuries were not serious, but his treatment was botched and he died five days later (December 11). His death devastated his loyal readers, not least Picasso and the surrealists. Louis Aragon organized a demonstration in Delaprée's memory and set about publishing his unexpurgated articles.

Picasso expressed his grief and rage at Delaprée's death in a memento mori: *Still Life with a Lamp* (December 29).[24] As he often did, he represents himself as a jug and his mistress as a compotier on a tabletop under a lamp. He has added a napkin resembling a severed arm in the foreground and a black shadow on the ceiling. Note the inclusion of a calendar on the wall dated December 29: the day Aragon had picked for his demonstration commemorating Delaprée. The announcement for the event proclaimed: "The voice of a dead man denounces the lies of the press." His admirers hoped that Delaprée's exposure of atrocities on both sides would awaken Europe to the anguish and destruction of civil war.

Picasso. *Figure of a Woman Inspired by the War in Spain,* January 19, 1937. Oil on canvas, 38.4 x 46 cm. Lewis Collection.

12

Dream and Lie of Franco (1937)

Picasso celebrated New Year's Day 1937 with an impromptu visit to his old friend the poet Max Jacob—a Jewish-born Catholic convert—at the Benedictine abbey of Saint-Benoît-sur-Loire, where Jacob had been living as a lay monk since 1921. After a two-hour drive south from Paris, Picasso arrived late in the day with Paulo, Dora, and their chauffeur, Marcel. This was probably Picasso's first and only trip to Saint-Benoît, and Jacob was surprised to see him. "January 1 is a day to spend with family. That's why I'm here," Picasso said, explaining his unexpected appearance. Jacob replied ironically: "I believe you've mistaken New Year's Day with the Day of the Dead." They dined together and talked until midnight. "We laughed and cried," Jacob wrote of the evening, but he was piqued by Picasso's jokes at his expense. "He did not stop making fun of me and I did not stop noticing it . . ." Nor was Jacob pleased by Picasso's parting invitation to bring him back to Paris. "He proposed that I should live with him forever. How kind! I realized I would have had to live among surrealists and Communists and I said, 'My faith, no!' Since then no news from him. It's for the best." Though they had been friends for over thirty years, Picasso and Jacob would never see each other again.[1]

In September 1936, the Spanish Republic had decided to bring international attention to its cause by participating in the upcoming Paris World's Fair: the Exposition Internationale des Arts et Techniques dans la Vie Moderne. As the fair was due to open the following May, Spanish officials had only eight months to organize their national pavilion. In December, they sent Josep Renau to Paris to meet Picasso. It was the first time he had ever left Spain. Renau's mission, as he recalled forty years later, was to summon Picasso, Dalí, Miró, and Julio González "to join the fight against fascism . . . either by offering work done specially for the Spanish pavilion or by showing previously executed pieces in it. . . . In the list of priorities for the guest artists that I brought from Spain, Picasso stood at the top."[2]

While searching for the artist's studio, Renau spotted Picasso playing cards with

Picasso. *The Dream and Lie of Franco,* January 8–9, June 7, 1937. Etching and aquatint with chine collé, plate: 31.7 x 42.2 cm. The Museum of Modern Art, New York, The Louis E. Stern Collection.

some workers at a café on rue la Boétie. Realizing he was overdressed for the occasion, the young Communist threw his necktie into the trash and took off his jacket before the approaching Picasso. The two men became instant friends. Renau installed himself in a makeshift Paris office, where he was soon visited by the next artist on his list for inclusion in the Spanish Pavilion. To Renau's rage, Dalí barged in, boosting himself at the expense of Picasso, whom he dismissed as a reactionary. So infuriated was Renau that he decided to keep Dalí out of the Spanish Pavilion at all costs. Dalí's appearance, a few weeks later, at the head of a fascistic anti-Republican demonstration revealed how wise Renau had been.[3] Picasso did not take Dalí seriously enough to be appalled. Dalí was Catalan, and Catalans could do no wrong.

Much as he abhorred Dalí's pathological craving for public attention, Picasso remained fond of him, even after the surrealists accused Dalí of being a Nazi sympathizer.[4] They shared arcane Spanish jokes and exchanged bizarre greetings. Amazingly, this friendship would survive Dalí's *dégringolade* into militant fascism. Picasso would not break with him once and for all until 1953, when Dalí told a journalist that he wanted to send a submarine to Cannes to kidnap Picasso and have him returned to Barcelona, where the cardinal would celebrate a high mass for his soul.[5] In mocking the religious tradition they shared and setting himself up as a judicial authority, Dalí infuriated Picasso. "Nobody paints the smell of shit better than Dalí," Picasso said. That was that. They never spoke again.

In January 1937 a group of Spanish government representatives, including Renau, convened at the artist's rue la Boétie apartment to ask him to paint a mural that would proclaim their cause to the world. Picasso hesitated.[6] The committee included his

friend José Bergamín, the pavilion's architect, Josep Lluís Sert, as well as writers and poets, among them Max Aub and Juan Larrea, who served as the press attaché for the Spanish embassy. They were confident that they could get Picasso to collaborate with them. Most evenings Sert and company would continue to bring pressure on Picasso during his nightly visits to the Café de Flore, until he finally overcame his reluctance and decided to commit himself by executing the great panel to be called *Guernica*.[7] Months would go by before the artist started work.

On January 8, Picasso came out with a vituperative indictment of Franco and his Fascists: *Sueño y mentira de Franco* (Dream and Lie of Franco)*, an etching comprised of two sheets of nine sections each.[8] The first depicts a fat little Generalissimo Franco in comically degrading scenarios: mounted on a pig, attacking a sculpture, and in drag as a maja fanning herself.[9] In one of the final scenes of the first sheet, Franco presides over a slimy expanse of serpents and toads. The second sheet has an identical layout but includes a different set of images. One of them shows Franco transformed into a horse that has been gored by a bull.

Black humor gave way to tragedy in the final vignettes of *Dream and Lie,* which depict Franco's victims—dead children and howling mothers.[10] These images were not executed until June 7, well after the bombing of the Basque town of Guernica, and their motifs derive from the great mural Picasso was painting in response to that terrible event.[11] The artist emphasized the fury he had poured into these etchings when he described them to a journalist as "an act of execration" against the suffer-

Picasso. *The Dream and Lie of Franco,* January 8–9, June 7, 1937. Etching and aquatint with chine collé, plate: 31.5 x 42.2 cm. The Museum of Modern Art, New York, The Louis E. Stern Collection. These etchings appeared at the Paris World's Fair in July 1937. They were sold to raise funds for the Republic and Spanish refugees.

"le Livre d'Art"

Ubu Roi

ou les Polonais

DRAME EN CINQ ACTES

Restitué en son intégrité tel qu'il a été représenté par les marionnettes du Théâtre des Phynances, en 1888.

PERSONNAGES :

PÈRE UBU.	CONJURÉS ET SOLDATS.
MÈRE UBU.	PEUPLE.
CAPITAINE BORDURE.	MICHEL FÉDÉROVITCH.
LE ROI VENCESLAS.	NOBLES.
LA REINE ROSEMONDE.	MAGISTRATS.
BOLESLAS...	CONSEILLERS.
LADISLAS... } leurs fils.	FINANCIERS.
BOUGRELAS..	LARBINS DE PHYNANCES.
LE GÉNÉRAL LASCY.	PAYSANS.
STANISLAS LECZINSKY.	TOUTE L'ARMÉE RUSSE.
JEAN SOBIESKY.	TOUTE L'ARMÉE POLONAISE.
NICOLAS RENSKY.	LES GARDES DE LA MÈRE UBU.
L'EMPEREUR ALEXIS.	UN CAPITAINE.
GIRON.....	L'OURS.
FILE } Palotins.	LE CHEVAL À PHYNANCES.
COTICE	LA MACHINE À DÉCERVELER.

Ubu Roi, in *Le Livre d'Art*, no. 2, April 18, 1896. Illustration by Alfred Jarry. The Morgan Library & Museum, New York.

ing inflicted on his countrymen. "This series was asked of me so that it could be sold for the benefit of the Spanish people, and I did it with pleasure. I only intended to do two or three prints. And then it just came to me, I don't know how, and I made a lot."[12]

When Alfred Barr questioned Picasso about the source of Franco's repellent image in these etchings, the artist replied "l'étron," French for "turd."[13] The figure also resembles Dora's iconic 1936 photograph, *Père Ubu*, which borrows its title from Alfred Jarry's 1896 play *Ubu Roi*, an absurdist satire about a vulgar and greedy official who usurps the Polish crown and murders his subjects en masse. Picasso's turdlike Franco and Dora's eerie armadillo seem to share a common source: Jarry's woodcut of *Ubu Roi*'s title character as a paunchy, pinheaded buffoon.

Opening with a shout of "Merdre!" (a variant of the French word for "shit"), the play outraged its audience on opening night. Just as Jarry believed that his antihero represented the French public's "ignoble other self," Roland Penrose saw in Picasso's parody of Franco a reflection of the artist's inner monster. When he asked Picasso to sign his copy of *Dream and Lie*, Penrose "was astonished to see that the capital letter with which he commenced his own signature had fundamentally the same form as the twisted grotesque head that he had invented for the man he hated most."[14]

At the Paris World's Fair in July 1937, Picasso's etchings would be sold in an edition of one thousand to raise funds for the Republic and Spanish refugees. They included a poem by the artist:

> . . . cries of children cries of women cries of birds cries of flowers cries of wood and stones cries of bricks cries of furniture of beds of chairs of curtains of casseroles of cats and papers cries of smells that claw themselves of smoke that gnaws the neck of cries that boil in cauldron . . .[15]

Ten days after Picasso began work on *Dream and Lie*, Franco's Moroccan troops, reinforced by Mussolini's blackshirts, bombed and laid siege to the artist's birthplace, Málaga.[16] Picasso retaliated with a rage-filled painting castigating Spain's ultra-

Catholic aristocracy—in the form of a hideous hag—for promoting their view of Christ as a fervent Fascist.[17] He added an inscription: "Portrait of the Marchesa of the Christian Ass tossing a coin to the Moorish soldiers defending the Virgin." The turkey-necked marchesa leans over a balcony, waving Franco's Fascist flag.[18] Her dress and preposterous scrotum of a hat are covered in crosses, confirming Picasso's mockery of the church for honoring Franco.[19]

As the anticlerical scion of a clerical family, Picasso was all the more eager to expose the Catholic nobility as the enemy. However, when it came to his son's Catholic education, Picasso was surprisingly conventional. He left this to Olga. As a result, Paulo had been forced to attend three Catholic schools after his parents' separation. His father's attitude toward the church would apparently rub off on the boy, as Kahnweiler revealed: "Paulo of course was already antagonistic to his teachers because he knew the position his father had taken in Spain. So he succeeded each time in getting himself expelled. He simply behaved in a way that meant that they couldn't keep him."[20]

B y mid-January 1937, Picasso was so captivated by Dora that he agreed to move Sabartés, his oldest friend, for whom she had developed a jealous loathing, out of the rue la Boétie. The devoted Catalan relocated with Mercedes to a small attic apartment at 88 rue de la Convention in the distant fifteenth arrondissement. Sabartés would continue working for Picasso during this lull in their lifelong relationship, and by spring 1938 he would be back in favor.[21] Picasso had missed his whipping boy, and Sabartés would spend the rest of his life fulfilling this role. Every night he would make a point of checking Picasso's trash can; thieves had been rifling the contents for discarded anything that might bear traces of the artist's work. One evening, Picasso and Dora got there first. Emptying the can, Picasso left a note that read, "Sabartés, tu es un con," then put the trash back on top of it. Such was their rapport. Picasso's jokes had a sadistic tinge.

In early 1937, Picasso took to spending weekends at a house in the country owned by Ambroise Vollard. On September 9, 1936, the dealer had written directly to Marie-Thérèse, who had been longing to leave the city, offering her the use of his house at Le Tremblay-sur-Mauldre, less than an hour's drive from Paris.[22] She was delighted by the offer, as was Picasso. The Boisgeloup studio, where he had worked so gloriously, would soon be ceded to his wife as part of their separation agreement.[23] Vollard had originally bought the Tremblay house as a refuge within easy reach of Paris where his artists could work in peace. In his memoir, he described it as "an old house surrounded by a big garden . . . I was seduced by the pilasters of the gate surmounted by two bouquets cut in the stone, to which time had given a mellow patina.

The rather rustic house, with its old wells, belonged to that period when everything, even peasant rooms, was done with such pleasing taste. A huge barn attracted my attention. What could be simpler than to transform it into a studio!"²⁴ The painter-printer Georges Rouault had stayed there once to use the studio, but since then it had been empty. The loan to Picasso would prove much more advantageous for both artist and dealer. As Sabartés noted, "To Picasso it was an oasis: near Paris but far enough away to keep importunate people at a respectable distance."²⁵

I can vouch for the charm of Vollard's house. One summer in the 1950s his heirs lent it to Douglas Cooper and myself for a week or two. It was old but not ancient, and comfortably furnished. There was no longer any trace left of Picasso or Marie-Thérèse or anyone else. But the barn was still there, filled with large, dusty packages. What might they contain? We fantasized works by Cézanne and Gauguin but didn't dare check. The extensive garden was still lovingly tended by Vollard's aged gardener, whom Picasso had befriended. He told us that Picasso loathed flowers but loved vegetables, especially peas, potatoes, and carrots if they were picked very young. For years to come, Picasso would receive baskets of vegetables and fruit from the old gardener.

Picasso, Marie-Thérèse, and Maya settled into Vollard's house in December 1936. Henceforth, mother and daughter remained at Le Tremblay. Picasso would join them most weekends. During the week he lived with Dora back in Paris. This arrangement lasted until Vollard's death in 1939. Many years later, Marie-Thérèse recalled this phase of her life in an interview with Pierre Cabanne: "Picasso would come from Friday to Sunday evening. He worked and worked, like an angel. We lived this way for years."²⁶ It was at Le Tremblay on February 25, 1937, that their daughter Maya took her first steps, an event celebrated in a photograph and drawing by Picasso.²⁷

Most of the paintings he would do in the country bear the stamp of Marie-Thérèse's nurturing love. A few days before Christmas 1936 at Le Tremblay, he painted her wearing an ultra-chic hat redolent of Dora (December 19). Marie-Thérèse usually wore a Hermès beret with a pompom. Dora's hats, with chic surreal trimmings, identify her as well, but on

Picasso. *Marie-Thérèse Walter Wearing a Hat,* December 19, 1936. Oil on canvas, 46 x 38 cm. Private collection.

Picasso. *Two Nude Women at the Beach,* May 1, 1937. Ink and gouache on wood, 22 x 27 cm. Musée National Picasso, Paris.

occasion Picasso enjoyed confusing his mistresses in his portraits, seeing them in terms of each other's hats. Depending on his mood, he mocks, beautifies, or blends the two women. Dora's only appearance in paintings from Le Tremblay is a mocking one: she is portrayed outside the house, her face pressed against a window peering at a large jug on a table within (February 12).[28] However, in another work Marie-Thérèse is the one on the outside, pressing her hand against the window (April 3, 1937).[29]

Nostalgia for the *plage* seems to have struck Picasso in the depths of winter 1937, as seen in three monumental canvases of sculptural figures on the beach. The first of these takes the form of a figure toying with her toes, her breasts bigger than her buttocks. A ball-shaped head simulates the sun in the pale blue sky.[30] This figure reappears two days later playing with a toy boat beside a motherly version of herself, her pincer-like arms squeezing her pregnant belly.[31] A head looks on just over the blue wall that represents the sea. In a vertical painting dated February 18 Picasso squashes his nude into a tangle of limbs, her head bent over as she reads a book, supported by her legs akimbo.[32] Two and a half months later, on May 1, Picasso reverts to this theme. Surrealism has left its mark. The artist has brought his two figures to life in the form of sexual organs—scrotum-like heads and penile limbs. They are devouring a meal of viscous mess on the floor.[33] *Guernica* will be his next painting.

A view of the Hôtel Duprat, 7 rue des Grands-Augustins, Paris. Picasso's studio would occupy the top two floors from 1937 to 1955. Photograph by Charles Lansiaux. Paris Musées, Musée Carnavalet, Paris.

13

7 Rue des Grands-Augustins

To tackle the vast canvas he had been commissioned to paint for the Spanish Pavilion at the World's Fair, Picasso required a spacious studio in Paris. Since returning from Mougins the previous summer, he had been working in Dora's photography studio at 29 rue d'Astorg. In February 1937, he took a lease on the two top floors of 7 rue des Grands-Augustins, a seventeenth-century mansion in the sixth arrondissement.[1] After signing the rental agreement, Picasso began renovations to make the space more functional and comfortable. In March and April, he installed a water heater, new bathroom fixtures, and a stronger electric lighting system.[2] None of these improvements diminished the rooms' antique charm. The journalist Georges Sadoul visited the artist's work space a few months later and was captivated by the "splendid decay of this ruined palace. On the ceiling, beautiful and ancient beams were visible. On the floor were worn, broken tiles, old as history, like the pavements of Gallo-Roman villas. High and beautiful windows, huge whitewashed walls that were cracked and peeling had the antique air of an Alsatian village."[3]

This historic building at the very heart of the Left Bank had been one of the settings for Balzac's 1831 novel *Le Chef-d'oeuvre inconnu*, the story of an obsessive old painter, Master Frenhofer, and his masterpiece, *La Belle Noiseuse*. After laboring for ten years on the canvas, Frenhofer believes he has attained perfection, "the utmost limit of our art on earth." Yet when he shows the work to his fellow artists Poussin and Porbus, they see only "a multitude of fantastical lines that go to make a dead wall of paint." As they look closer, "a bare foot emerges from the chaos of color, half tints and vague shadows . . . Its living delicate beauty held them spellbound."

Like Cézanne before him, Picasso identified with Balzac's brilliant but misunderstood protagonist. In 1927, he made a series of etchings to illustrate Vollard's deluxe folio edition of *Le Chef-d'oeuvre inconnu*. After taking his new studio in 1937, Picasso told Brassaï that he loved the idea of becoming a successor to Frenhofer, apparently unaware that in Balzac's novel 7 rue des Grands-Augustins is the site of Porbus's

studio, not Frenhofer's.[4] Details notwithstanding, his direct link to *Le Chef-d'oeuvre inconnu* excited the artist just before he undertook a masterpiece of his own.[5]

Dora later claimed that she had found the Grands-Augustins studio for Picasso, and, indeed, she knew the space well.[6] In January 1936, she had attended two meetings there of the left-wing group Contre-Attaque founded by André Breton and her former lover Georges Bataille. As noted earlier, the previous tenant, actor Jean-Louis Barrault, had used it for rehearsals of the Socialist theater troupe Octobre.[7] Barrault's memoirs give a sense of how the space was arranged and shared with his fellow actors. "Three bizarre rooms with some magnificent exposed beams. The first room was forty-six by twenty-six feet. This is where I set up my studio and where we had performances. The second room, fifty by thirteen, became the communal room: a dormitory, dining room, bathroom, and junk room combined. I can remember a sign, 'LE LAVABO DOIT RESTER BO' [keep the sink pretty]. The last room, I kept for myself but would often, upon returning late at night, find people in my bed."

One of Barrault's theatrical successes rehearsed in the attic of 7 rue des Grands-Augustins was an adaptation of Cervantes's 1582 epic play *The Siege of Numantia*, the legend of an ancient Iberian town that chooses suicide over subjugation to Rome. Barrault reveled in the political and dramatic implications of staging this little-known classic: "On the social plane I would be bringing my contribution to the Spanish Republicans; in that play the individual was respected, liberty glorified. On the plane of the metaphysics of the theatre I would be going right into the world of the fantastic, death, blood, famine, fury, frenzy."[8] Given his acquaintance with Barrault, as well as with poets Robert Desnos and André Masson, who worked on the production, Picasso is likely to have seen the play. Echoes of its tragic plot have even been detected in his early designs for *Guernica*.[9]

To reach the attic of 7 rue des Grands-Augustins, visitors were obliged to climb a cramped spiral staircase, which took them to the floor below the studio, formerly occupied by a weaving workshop. The vast canvas for *Guernica* barely scraped through the studio's doorway, and had to be tipped forward when Picasso worked on its topmost part. British painter Lucian Freud remembered yet another hidden staircase when he and his young wife, the Guinness heiress Lady Caroline Blackwood, visited the Grands-Augustins in the early fifties. Picasso insisted she squeeze into a tight chimneylike space to see Paris from the roof. He would support her from below. This interlude took longer than it should have. Freud was not pleased.

· · ·

Renovations on Picasso's new studio were still under way in March 1937 when Penrose and Éluard paid a visit. Penrose had come over from London hoping for the chance to purchase Picasso's *Nude Woman Lying in the Sun on the Beach*, a 1932 painting that had recently been illustrated in *Cahiers d'Art*.[10] When he asked the artist if he could buy it from him directly, Picasso replied: "Well, first you must see it. It's at Boisgeloup." According to Penrose, "Within a few minutes Marcel the chauffeur had been summoned and with all those present, Éluard, his wife Nusch, Dora Maar, Paulo (Picasso's son) and Picasso himself, I climbed into the spacious vintage Hispano and we set out for Boisgeloup."[11]

Penrose was thrilled by what he saw on his first trip to Picasso's country house. The artist took his guests through the former stables that had, until 1935, been his sculpture studio; then into the château itself, past the huge hippopotamus skull in

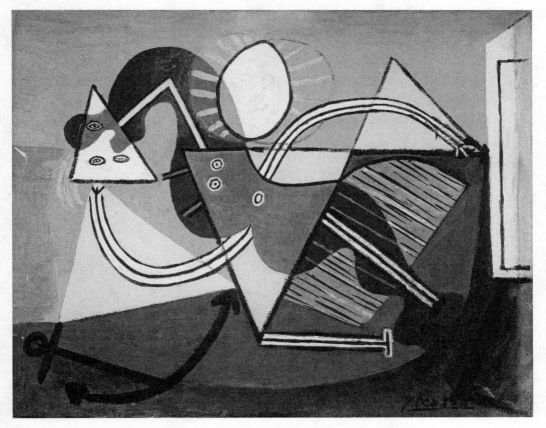

Picasso. *Nude Woman Lying in the Sun on the Beach,* March 28, 1932. Oil on canvas, 33 x 40 cm. Courtesy The Penrose Collection, National Galleries of Scotland, Edinburgh.

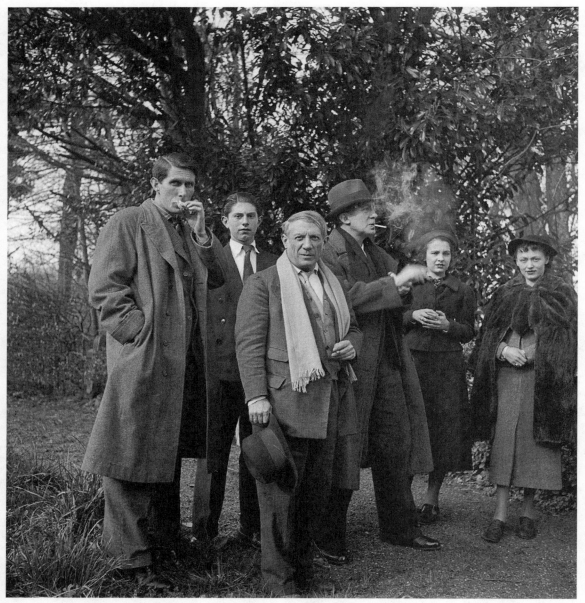

Dora Maar. At Boisgeloup, left to right: Roland Penrose, Paulo, Picasso, Paul Éluard, Cecile Éluard, and Nusch Éluard, March 1937. Musée National d'Art Moderne, Centre Georges Pompidou, Paris.

the entryway and upstairs to see the rooms filled with stacks of canvases. When Picasso presented the work they had come to see, Penrose was surprised but not disappointed. Though it was much smaller than he expected, "the magic was all there," he later wrote, "I had found my dream painting . . ." Picasso was impressed by Penrose's enthusiasm for an image Paul Rosenberg had spurned. Shocked by the depiction of the bather's splayed legs, the dealer had famously told the artist, "Non, je refuse d'avoir des trous du cul dans ma galerie" ("No, I refuse to show assholes in my gallery").[12] Picasso agreed to sell it to Penrose for a remarkably low price. Before returning to Paris, everyone gathered outside the château in their winter coats and scarves for a group photo by Dora.[13]

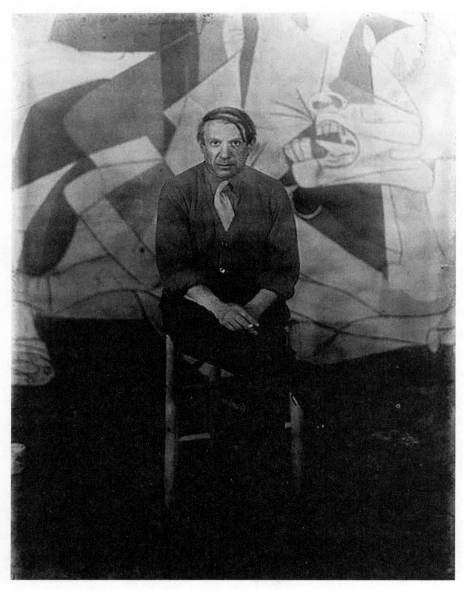

Dora Maar. Photograph of Picasso seated in front of *Guernica* in his studio,
7 rue des Grands-Augustins, May–June 1937. Musée National d'Art Moderne,
Centre Georges Pompidou, Paris.

14

Guernica

In his 2015 book, *Gernika, 1937: The Market Day Massacre,* the historian Xabier Irujo revealed the hitherto unknown fact that the destruction of the historic Basque town of Guernica was planned by the Nazi Reichsminister Hermann Göring as a gift for Hitler's birthday, April 20.[1] Guernica, parliamentary seat of Biscay province, had not as yet been dragged into the Spanish Civil War and was without defenses. Logistical problems delayed Göring's master plan. As a result, Hitler's birthday treat had to be postponed until April 26.

Besides celebrating the Führer's birthday, the attack on Guernica served as a tactical military and aeronautical experiment to test the Luftwaffe's ability to annihilate an entire city and crush the morale of its people. The Condor Legion's chief of staff, Colonel Wolfram von Richtofen, painstakingly devised the operation to maximize human casualties. A brief initial bombing at 4:30 p.m. drove much of the population into air-raid shelters. When Guernica's citizens emerged from these shelters to rescue the wounded, a second, longer wave of bombing began, trapping them in the town center, from which there was no escape. Low-flying planes strafed the streets with machine-gun fire. Those who had managed to survive were incinerated by the flames or asphyxiated by the lack of oxygen. Three hours of coordinated air strikes leveled the city and killed over fifteen hundred civilians. In his war diary, Richtofen described the operation as "absolutely fabulous . . . a complete technical success."[2] The Führer was so thrilled that two years later, he ordered Richtofen to employ the same bombing techniques, on an infinitely greater scale, to lay waste to Warsaw, thereby triggering the Second World War.

The morning after the bombing, Radio Bilbao broadcast a statement by the Basque president, José Antonio Aguirre, breaking the news to the world that Guernica had been annihilated by the Luftwaffe. The Basque and Spanish communities in Paris went into immediate action. The Basque painter José María Ucelay claimed to have told Juan Larrea, cultural attaché at the Spanish embassy, about Guernica's destruction when the two men ran into each other outside the Champs-Élysées metro. Larrea immediately jumped into a cab and raced to the Café de Flore to find Picasso.

The town of Guernica in ruins after the bombardment of April 26, 1937. Musée National Picasso, Paris.

As an ardent promoter of Spain's pavilion, Larrea realized that the obliteration of Guernica would provide the artist with the very subject he had been seeking. When, according to Ucelay, Picasso said he no idea what a bombed town looked like, Larrea replied, "Like a bull in a china shop, run amok."[3] On April 29 the artist read George Steer's firsthand account of the bombing in the Communist Party paper *L'Humanité*: "When I entered Guernica after midnight houses were crashing on either side, and it was utterly impossible even for firemen to enter the centre of the town."[4] The following day, the artist saw heartrending photographs of corpses amid Guernica's ruins, published in *Ce Soir* and other French dailies.[5]

Meanwhile, Franco and his Nazi allies denied that any bombing had taken place. Instead, they claimed that the Basques had destroyed their own city and blamed Nationalists in order to win international support for the anti-Fascist cause. A statement to this effect was released to foreign journalists: "Guernica was destroyed with fire and gasoline. It was set afire and reduced to ruin by the Red hordes in the criminal service of Aguirre, the President of the Basque Republic." For months after the massacre, the right-wing press in France would maintain this false version of events.[6] Even the Vatican, presented with eyewitness accounts from Basque clergymen, failed to denounce Franco for attacking civilians.[7]

Until the bombing of Guernica, Picasso had not settled on a subject for his World's Fair commission. His twelve preliminary sketches (April 18–19) depict a studio scene with a painter and his model, one of the artist's favorite themes.[8] After April 26,

Picasso. Study for *The Studio: The Painter and His Model.* Le Tremblay-sur-Mauldre, April 18, 1937. Pencil on paper, 18 x 28 cm. Musée National Picasso, Paris.

Picasso. Study for *The Studio: The Painter and His Model.* Le Tremblay-sur-Mauldre, April 19, 1937. Pencil on paper, 18 x 28 cm. Musée National Picasso, Paris.

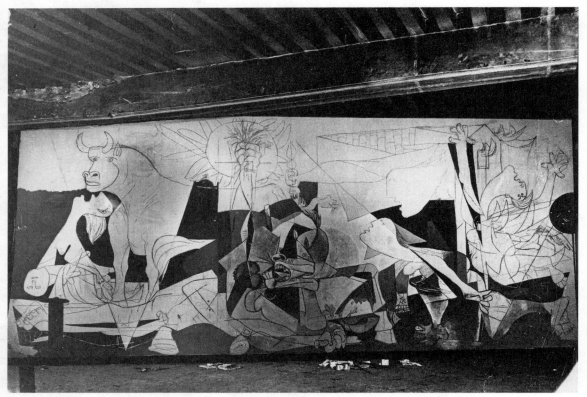

Dora Maar. Picasso's painting *Guernica* during its execution in the studio of the Grands-Augustins, Paris. May–June 1937. Musée National Picasso, Paris.

however, Picasso abandoned his early designs for one that reflected the awful reality of the massacre. He ordered an enormous canvas in mid-May from his preferred art-supply store, Castelucho Diana, on rue de la Grande-Chaumière. Like Picasso and many of his other Spanish clients, the proprietor, Antonio Castelucho, had attended La Llotja, Barcelona's school of art and design. Castelucho sent the young Catalan painter Jaime Vidal to deliver Picasso's canvas and stretcher. He arrived at 10 a.m. at the rue des Grands-Augustins, where he found that "Picasso was already up and overexcited, asking me why I was arriving so late and shouting at me. We unrolled the canvas and stretched it, then nailed it to a frame. On the floor lay a dozen drawings. I barely had time to fix the first half of the canvas when Picasso climbed on a ladder and started drawing with charcoal."[9]

The raised arm with a clenched fist seen in the first state of *Guernica* (May 11) makes plain Picasso's political sympathies at this crucial moment. The Communist salute was used in Spain during the civil war as a gesture of anti-Fascist solidarity.[10] Picasso may have considered using the motif in deference to his patrons in Spain's Popular Front government, who expected a clear and powerful political statement.

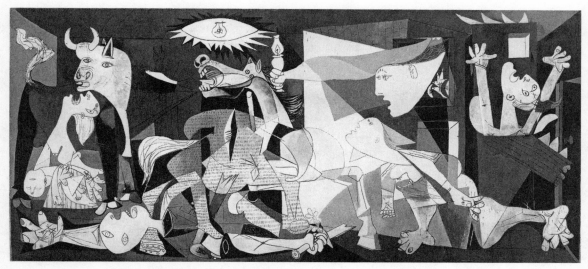

Picasso. *Guernica*. Paris, c. May 1–June 4, 1937. Oil on canvas, 349.3 x 776.6 cm. Museo Nacional Centro de Arte Reina Sofía, Madrid.

Juan Negrín, the Socialist politician about to become Spain's prime minister, believed that "the presence of a mural painted by Picasso is the equivalent value in propaganda terms of a victory at the front."[11] Ultimately, the artist did not want his work to have a Soviet tinge, and the fist soon disappeared from the composition.[12]

Instead he dealt with the subject of Guernica by personalizing it, albeit in code. Generations of art historians have obsessed over the painting's meanings and sources in countless publications. Like many of his other masterpieces, *Guernica* is pervaded with Picasso's own problems and preoccupations. Understanding the artist's votive obsession and the significance of his broken vow, we can now identify the image of his long-dead sister, Conchita. She makes an appearance in the first sketches for *Guernica* and would survive all the subsequent variations. Conchita no longer figures as a child, as she does in *Minotauromachie*, but has been transformed into an adult who thrusts out the sacred lamp clutched in her hand in order to have it lit by the Mithraic sun.[13] This gesture was echoed in one of the five sculptures that appeared with *Guernica* at the pavilion: Picasso's over-life-size 1933 *Woman with a Lamp*, which he had recast for the World's Fair. So meaningful was this sculpture to Picasso that he would later arrange for a bronze cast to preside over the place where he had chosen to be buried, in the garden at his country residence, the Château de Vauvenargues.

Years later, in 1992, I interviewed Dora Maar, who had witnessed and documented the making of *Guernica*. Picasso had told her: "I know I am going to have terrible

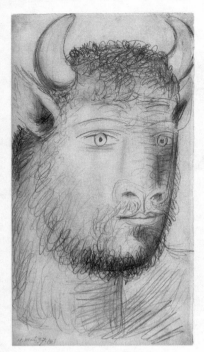

Picasso. *Bull Head with Human Face:* study for *Guernica,* May 10, 1937. Graphite on paper, 45.4 x 23.9 cm. Museo Nacional Centro de Arte Reina Sofía, Madrid.

problems with this painting, but I am determined to do it—we have to arm for the war to come."[14] Dora confirmed that the seemingly ironical addition of a light bulb inside the Mithraic sun in *Guernica* was a reference to her electrical equipment that littered Picasso's studio on the rue des Grands-Augustins.[15] However, it also recalls a haunting passage in Louis Delaprée's "Bombs Over Madrid" in which "the beam from an electric flashlight illuminates the corpse."[16] At the World's Fair, where *Guernica* was first seen by the public, electricity would be celebrated as a sign of modernity. While Picasso painted his canvas for the Spanish Pavilion, Raoul Dufy executed an immense mural commission mythologizing the history of electric power for the Palais de la Lumière et de l'Electricité. Picasso's depiction of electricity— exposing the devastation of war in stark grisaille—could not be farther in tone from Dufy's multicolored fairy tale.

Dora's expertise behind the camera helped Picasso to eschew color and give *Guernica* the black-and-white immediacy of a photograph. Her images of it became the first photographic record of the creation of a modern artwork from start to finish.[17] Picasso did not want the painting to have a shiny surface, so he asked the manufacturers of Ripolin whether they could develop an ultra-matte house paint. They succeeded, and according to Dora, *Guernica* would be the first time it was used.

Dora revealed to me that she had painted the short vertical brushstrokes that differentiate the horse's body and legs.[18] The artist had told her that the dying horse in *Guernica* stands for pain and death—"la douleur et la mort"—and is also an allusion to the horses of the Apocalypse. The upturned horseshoe next to the head of the dismembered soldier (bottom left) refers to the sacred crescent of Islam and Picasso's fear of Franco's Moroccan troops. He inveighed against the prospect of yet another Moorish occupation of Spain.

Though Dora claimed that the bull represents the people of Spain, the fact that it is based on magnificent drawings of Picasso in the role of a bearded Minotaur suggests that it had a more personal significance.[19] In the painting he portrays himself as a bull/Minotaur who coolly turns away from the carnage, seemingly unfazed by the mother figure holding a dead baby in her arms as she screams up at him.[20] Dora referred to the table where there is a bird as a sacrificial altar. The bull and the bird are sacrificial victims.

Dora also told me that she had been the inspiration for the woman on fire (top right) as well as the long-legged woman in the foreground. In his memoir, the British

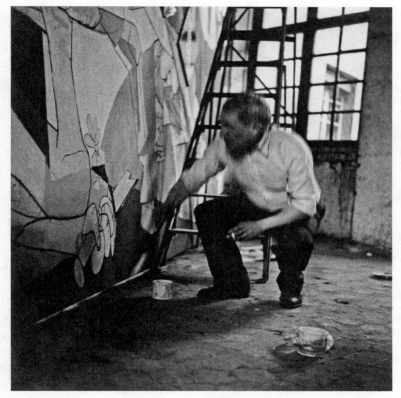

Dora Maar. Photograph of Picasso working on *Guernica*, 1937. Musée National Picasso, Paris.

sculptor Henry Moore describes how a group consisting of Éluard, Breton, Penrose, Giacometti, Max Ernst, and himself had lunched with Picasso, who took them to the studio to see what breakthroughs he had made.

> *Guernica* was still a long way from being finished. It was like a cartoon just laid in black and grey, and he could have colored it as he colored the sketches. Anyway, you know the woman who comes running out of the little cabin on the right with one hand held in front of her? Picasso told us that there was something missing there, and he went and fetched a roll of [toilet] paper and stuck it in the woman's hand, as much as to say that she'd been caught in the bathroom when the bombs came.[21]

The artist then announced to his guests: "There, that leaves no doubt about the commonest and most primitive effect of fear."[22] Moore commented: "That was just like him, of course—to be tremendously moved about Spain and yet turn it aside with a joke."

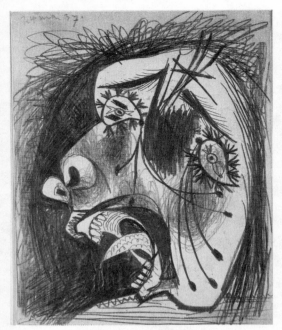

Picasso. *Study for Weeping Head (II):* sketch for *Guernica,* Paris, May 24, 1937. Graphite and gouache on tracing cloth, 29.2 x 23.2 cm. Museo Nacional Centro de Arte Reina Sofía, Madrid.

Zervos had commissioned Dora to make a photographic record of *Guernica*'s progress for an upcoming issue of *Cahiers d'Art*.[23] She photographed every major change in its astonishingly rapid development. Her photographs of the successive states of the painting are not dated, but their order is self-evident. Picasso brought the great canvas to completion on June 4th. It had taken twenty-five days. Apparently eager to promote the painting for the sake of the anti-Fascist cause, Picasso uncharacteristically allowed a select number of friends, fellow artists, and influential politicians to watch him at work.[24] These studio visits generated a notable buzz around the painting well before its unveiling at the World's Fair. *Guernica* was yet unfinished when Renau came to the rue des Grands-Augustins for the last time. He recognized a masterpiece in progress. Alone with Picasso, Renau proposed what he later called a "museographic blasphemy." "What would he think, I asked him, if after the war, we prepared a special gallery at the Prado in which *Las Meninas*, his *Guernica*, and [Goya's] *Third of May* were exhibited together?"[25] Though this would never come to pass, *Guernica* would establish Picasso as the world's most celebrated modern artist.

After breaking with Picasso, Dora would become a fervent born-again Catholic who rarely spoke about her photographic career or the role she played in the making of *Guernica*. It was her masochistic nature that Picasso had evoked in his most harrowing studies for *Guernica*, and above all in the Weeping Woman series begun on May 24, before the great painting was finished.[26]

As he later stated, Picasso could never have portrayed Dora laughing: "For me she's the weeping woman. For years I've painted her in tortured forms, not through sadism, and not with pleasure either; just obeying a vision that forced itself on me. It was a deep reality, not a superficial one."[27] Smeared lipstick, smudged eye makeup, tears seemingly wired to the eyes, and the soaked handkerchief clutched in her spiky-fingernailed hands capture her extreme states of agony, mental as well as physical. The Weeping Woman images emerged from *Guernica*. They, too, personalized the horrors of the Spanish Civil War in the form of Dora's suffering. In letters from 1937,

she regrets her own emotional volatility. After a fraught weekend spent with Picasso at Boisgeloup in April, Dora begged him to forgive her for "those scenes, do not take them seriously, you have to take them lightly, as a joke. I will try to correct myself. Behave with me as you have behaved with me before, that is, if I haven't already ruined everything; come find me whenever you want, I will wait for you as long as you want me to, years if you so desire . . . I will not cry, I will not scream, that is over now."[28] This was a promise that Dora could not keep.

The Weeping Women are nearly identical in pose but executed in all kinds of media. The final work in the series (October 26) was the most highly finished: an oil-on-canvas that Roland Penrose would give to the Tate Gallery.[29] It is not nearly as gut-wrenching as its predecessors. Penrose claimed it was one of the "masterpieces of the century," with an "unprecedented blend of realism and poetic magic. For a while the impact of this small brilliant canvas left us speechless, but after a few enthusiastic exclamations I heard myself say to Picasso, 'Oh! May I buy that from you?' and heard in a daze his answer: 'And why not?' "[30] That this painting has become a popular icon helps explain why Picasso parted with it so soon and for a remarkably low price. By far the most worked-up of the Weeping Women as well as the most often reproduced, it lacks the pathos that animates most of the dazzling drawings, etchings, and paintings that constitute some of Picasso's most disturbing imagery.

While working on *Guernica* at the rue de Grands-Augustins, Picasso kept Marie-Thérèse tucked away at Le Tremblay, where he continued to spend most of his weekends. There, on June 24, he did a portrait of Marie-Thérèse, wearing a wreath of white flowers in her hair and an expression of utter contentment.[31] Her image is the antithesis of the weeping Dora, illustrating the difference between Picasso's paternal love for the one and his Sadeian love for the other. When he showed Dora some works he had done during his idyllic weekends with Marie-Thérèse and Maya, Picasso cruelly told her, "You see I am not only occupied with gloom."[32]

The peace of the countryside and the soothing presence of his motherly mistress and young daughter triggered a series of seemingly straightforward still lifes which have hidden depths and spirituality not manifested in his recent work. Thirty years later Picasso would recall: "Every chance I got to take a break, I would go out into the country for a breather. But I would begin to draw and paint from the moment I got there. And what did I paint, coming fresh from the work on *Guernica*? Flowers and fruit—never anything else."[33] Lydia Gasman has observed that the motifs repeated in these still lifes—fruit bowls, pitchers, candlesticks, and doorknobs—evoke seventeenth-century Spanish *bodegón* paintings. Like Zurbarán, Picasso endows humble objects with mystical meanings. Indeed, as he explained to Françoise Gilot: "I want to tell something by means of the most common object . . . For me it is a vessel in the metaphorical sense, just like Christ's use of parables."[34]

World's Fair, Paris, 1937: View of the exhibition grounds with the German Pavilion on the left and the Soviet Pavilion on the right. Süddeutsche Zeitung Photo.
BOTTOM Josep Lluís Sert in front of the Spanish Pavilion under construction, Paris, May 25, 1937. Ministry of Culture and Sports, Documentary Center of Historical Memory, Spain.

Interpreting these quasi-sacred works in the context of the Spanish Civil War, Gasman argues that Picasso, as a passionate pacifist, aimed "at bringing peace to his ravaged homeland by portraying peace. He painted peace so many times in the still-lifes that they seem to be an incantation, a wish, a eulogy of the good with propitiatory ends, and a prayer."[35] In other words, these works are deceptive. Picasso has used the most run-of-the-mill objects for profound private musings.

The Paris Exposition Internationale des Arts et Techniques dans la Vie Moderne was intended to promote the pacifying role of art and technology in society. The French were at pains to demonstrate their cultural and technological superiority. They had demolished the old Trocadéro Museum and replaced it with an expansive modernistic building at the center of immense colonnaded wings on either side of a commemorative basin studded with fountains. On May 6, Douglas Cooper sent gallerist Pierre Matisse (the artist's son) an ironical report of the work under way: "In Paris disorder reigns. Everywhere there are skeletons of buildings, strikes, preparations, parades . . . It is only the Belgians, of course, who are ready to open."[36] The Nazis and the Soviets seemingly dominated the 250-acre exposition grounds with towering pavilions topped with vast sculptures (a Nazi eagle clutching a swastika for the Germans and a pair of giant workers wielding a hammer and sickle for the Russians). These were not only the tallest of the forty-four national pavilions designed for the fair, but were among the first to be completed. No more than five pavilions were ready for the grand opening on May 25. The rest, including the host country's, were still under construction.[37]

The modest, three-story pavilion designed for the Spanish Republic by Josep Lluís Sert and Luis Lacasa opened seven weeks late, on July 12, due to wartime delays in the delivery of materials and equipment. Only thirty-four years old, Sert already had a reputation for his work with the famed Swiss architect Le Corbusier. For the Spanish Pavilion he and Lacasa envisioned a modern metal-and-glass structure built inexpensively from prefabricated elements using the latest construction methods. Spanish leaders hoped the pavilion would establish the Republic's international legitimacy by emphasizing the depth and vibrancy of its culture. This, according to Ambassador Luis Araquistáin, would distinguish the Republic from "the rebellious armed minority that has neither time nor talent for anything but the destruction of life and human values."[38] Thus, the pavilion was planned, inside and out, as a platform for propaganda that would make this distinction plain to the world.[39]

Four sculptures stood along the building's exterior: two by Picasso (cement casts of his 1931 *Head of a Woman* and 1933 *Woman with a Lamp*)[40]; as well as Julio González's *Montserrat*, a life-size iron figure of a proud peasant woman holding her

World's Fair, Paris, 1937: Spanish Pavilion, with *Guernica* by Picasso and the *Mercury Fountain* by Alexander Calder. Photograph by Henri Baranger. Médiathèque de l'Architecture et du Patrimoine, Paris.

baby in one arm and a sickle in the other; and Alberto Sanchez's towering totem entitled *The Spanish People Have a Path That Leads to a Star.* A short stairway led into the entrance portico, where Picasso had supervised the installation of *Guernica.* His feelings for the work made a strong impression on Sert: "He was in love with his picture and he really considered it very important and a part of himself. . . . He brought the *Guernica* to the pavilion. He put it on the concrete floor and put it on a stretcher and put it on the wall."[41]

Guernica was the first image one saw when entering the pavilion.[42] Directly opposite Picasso's mural hung a large image of Federico García Lorca, literary martyr, with the words "Poet gunned down in Grenada." A sculptural fountain by Alexander Calder stood at the center of the portico, flowing with Spanish mercury from the mines of Almadén, a vital source of wealth for the Republic.[43] Nearby, on the first floor, were a stage used for dance performances and film screenings—including Buñuel's civil war documentary, *España 1936*—as well as a kiosk selling posters and prints (*Dream and Lie of Franco*), and a patio café serving Spanish specialties.

From there, a curving ramp brought visitors directly to the third floor, devoted to artisanal crafts and the visual arts. Three more Picasso sculptures were on view in this section: two plaster heads of Marie-Thérèse made at Boisgeloup and a bronze bather.

After *Guernica*, the largest artwork inside the pavilion was Miró's *Catalan Peasant in Revolt*, also called *The Reaper*, eighteen feet high and painted directly on a wall above the stairs between the second and third floors. Miró's studio was too small to paint the work on canvas, as Picasso had done with his commission. At the end of the fair, *Guernica* would be returned to Picasso; Miró's mural was dismantled with the rest of the Spanish Pavilion and later lost or destroyed in transit to Valencia.[44]

In addition to the national pavilions, the World's Fair offered an extensive program of cultural events and exhibitions. On June 17 the Petit Palais opened a spectacular show called *Les Maîtres de l'art indépendant*, curated by Raymond Escholier, a popular modernist art historian. Picasso was well represented with a gallery of his own filled with thirty-two mostly major works, among them *Les Demoiselles d'Avignon*, unseen by the public since 1916.[45] This was a significant contribution, but only half as many works as Henri Matisse exhibited at the show. Even more numerous were the classicist sculptures by Aristide Maillol, whose work Picasso had come to loathe.

"Well, the last time I saw [Picasso]," Maillol recalled, "in 1937 I think it was, he would hardly speak to me. For my part I was very pleasant . . . He never even answered . . . My statue was standing just there. I said to him, 'Have a look at it and tell me what you think.' Would you believe it? He turned his back on me and walked off without so much as a glance. Do you call that an artist? Do you think Michelangelo would have turned his back if I had asked him for advice? He would have given it to me. And kindly, too."[46] In the middle of the Spanish Civil War, Picasso reviled Maillol's tranquil idealism as well as his popularity among Fascist artists and critics. Arno Breker, for example, official sculptor of the Third Reich, considered Maillol his hero and mentor.[47]

In his review of *Les Maîtres de l'art indépendant*, Louis Gillet of the Académie Française voiced some of the prevailing opinions of Picasso among conservative critics. After lauding Maillol and Matisse, Gillet sought to denigrate Picasso with the rumor of Jewish ancestry, calling him "one of the 'mixed-bloods' who have always been on the eastern coast of the Iberian peninsula . . ." His recent works, wrote Gillet, revealed "a kind of despair, a curse as it were, of a sort which never befell an artist before, and properly belonging to the torments of Hell: the wretchedness of not loving, of painting without love. M. Picasso's tragedy is that in him are thrown together . . . unheard-of virtuoso talent—and absolute nihilism."[48]

Had Gillet bothered to see *Guernica*, he might have formed a very different opinion. Entirely lost on the academician was Picasso's deep-seated love for Spain and its people, not to mention his anything but nihilistic devotion to their freedom, demonstrated beyond doubt at the Spanish Pavilion.

Dora Maar. Photograph of Picasso on the balcony of the Hôtel Vaste Horizon, Mougins, 1937.
Musée National d'Art Moderne, Centre Georges Pompidou, Paris.

15

Summer at Mougins (1937)

After installing *Guernica* at the World's Fair in June, Picasso did not attend the opening ceremony of the Spanish Pavilion on July 12. Two weeks later, he and Dora drove off in the Hispano-Suiza, once again headed for Mougins. Marcel's presence behind the wheel was important, given the accident in Penrose's car the previous summer. The Hispano was loaded with canvases and painting materials. As before, Picasso and Dora stayed at the Vaste Horizon. This year, their room had a balcony.[1]

There had also been several additions to the group that had joined them the previous year. Penrose had replaced his tiresome French wife with Lee Miller, a young American photographer, whom he had recently met at a fancy-dress ball in Paris organized by the Rochas sisters. According to Penrose, these "elegant high-fashion girls" had thrown the party while their father was away. He and Max Ernst arrived together, dressed as beggars, and found one of their hostesses wearing "little more than strands of ivy." Penrose was drawn to the "blond, blue-eyed, and responsive" Lee Miller, and he was not alone. Dora's former lover Georges Bataille, also in attendance, considered Lee the most beautiful woman he had ever seen.[2] The party came to an abrupt end when the hostesses' father, "who disapproved categorically of entertaining surrealist artists," returned home and chucked them out. Already struck by a *coup de foudre*, Penrose arranged to meet Lee again the following evening. This exceedingly gifted woman—adored by her lovers but few others—was still married to an Alexandrian tycoon, whom she would not divorce for another two years. Earlier, Lee had been the lover and pupil of Man Ray, who transformed her into a fervent surrealist.

Man Ray would also return to Mougins in summer 1937, this time with his gorgeous girlfriend from Guadeloupe, Adrienne Fidelin, called Ady. One of his portraits of this model and muse would be published in the September 1937 issue of *Harper's Bazaar*, making Ady the first black woman to appear in a major American fashion magazine.[3] When the guileless Guadeloupian was first introduced to Picasso, she embraced him warmly and said, "I hear you are quite a good painter."[4] The

TOP Joseph Bard on the terrace of the Hôtel Vaste Horizon, Mougins, September 1937. Photograph by Eileen Agar. Tate Gallery, London. BOTTOM Lee Miller. Photograph of Marcel Boudin, Picasso's driver, Mougins, 1937. Lee Miller Archives, England.

TOP Lee Miller at the Hôtel
Vaste Horizon, Mougins,
September 1937. Photograph
by Eileen Agar. Tate Gallery,
London. BOTTOM Photograph
by Lee Miller of Man Ray and
Adrienne Fidelin, Mougins, 1937.
Lee Miller Archives, England.

Argentine-born British painter Eileen Agar also came to Mougins with her Hungarian writer husband, Joseph Bard.

Before returning to the South of France, Penrose rallied his troops (Lee, Man Ray and Ady, the Éluards, Agar and Bard, Max Ernst and Leonora Carrington, and the Belgian surrealist E. L. T. Mesens) for a month or more in the romantic depths of Cornwall, where his brother Beacus owned a house called Lambe Creek, a remote fairy-tale hideaway in a tangle of woods and waterways. Agar described the Cornish sojourn as "a delightful surrealist house party with Roland taking the lead, ready to turn the slightest encounter into an orgy. I remember watching Lee taking a bubble bath, but there was not quite enough room in the tub for all of us. The surrealists were supposed to be such immoral monsters, but I for one did not go to bed with everybody who asked me. When would I have had time to paint?"[5] In fact, Eileen was having a flagrant affair with Éluard while her husband was sleeping with Nusch.

Éluard and Penrose tried to tempt Picasso into joining them in Cornwall. They sent the artist a postcard, signed by everyone in the group, promising pleasure and relaxation: "Really, you would feel great here and, if you were here, we would feel better! Nature is very intimate to those who love each other."[6] Éluard also wrote to Dora, perhaps hoping that she might convince Picasso to make the trip: "This country is pure marvel. If you and Picasso would decide to come, know that we are waiting endlessly and that we would receive you with all the love that you deserve."[7] Despite such pressure, Picasso stayed in Paris. It seems a terrible row with Dora had made the trip to England impossible.[8] A year had passed since their idyllic first summer together, and the tenor of their relationship had changed. Henceforth, violent arguments would occur more often, brought on by explosions of anger and jealousy.

Nevertheless, Picasso's name was seldom off the lips of the surrealists in Cornwall, and their incessant *partouses* honored him. Lambe Creek also served as a hideaway for Max Ernst. He was wanted by the British police, not so much for the "obscenity" of his show at London's Mayor Gallery, which had been the official charge, but for his affair with the twenty-year-old Leonora Carrington, later to become a novelist, painter, and a major member of the Mexican surrealist movement. Her rich and powerful father had prodded the police into taking action against Ernst on a less newsworthy offense. Penrose had rescued him and the girl by hiding them away in darkest Cornwall.

Before going their separate ways Penrose's gaggle of surrealists had made plans to reassemble in early August at Mougins, where their get-together, under Picasso's guidance, was much more productive. "After the morning on the beach," Man Ray recorded, "and a leisurely lunch, we retired to our respective rooms for a siesta and perhaps love-making. But we worked too. In the evening Éluard read us his latest poem, Picasso showed us his starry-eyed portrait of Dora, while I was engaged

Adrienne Fidelin, Lee Miller, Picasso, and Nusch Éluard, Mougins, 1937. Photograph by Roland Penrose. Lee Miller Archives, England.

in a series of literal and extravagant drawings . . . As for Dora, having photographed Picasso at work on *Guernica* in Paris, she now abandoned her camera and turned to painting."[9] Dora did indeed revert to painting, the medium she had studied at art school in the late twenties. She began by emulating Picasso's images of her as the Weeping Woman. Anne Baldassari observes that Dora's prominent signature on these canvases identify her as both the artist and the subject; the Woman Who Weeps is now also the Woman Who Paints.[10]

Dora did not, however, completely abandon her camera at Mougins. In fact, her photographs of Picasso and the surrealists lounging on the balcony of the Vaste Horizon, their bodies striped by the shadows

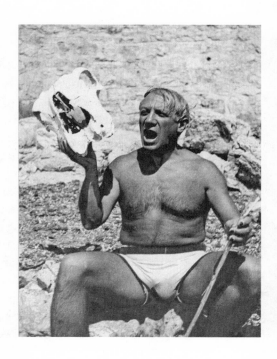

Dora Maar. Photograph of Picasso on the beach. Juan-les-Pins, 1937. Musée National Picasso, Paris.

Man Ray. Photograph of Dora Maar, Picasso, and Adrienne Fidelin, Mougins, 1937.
Musée National d'Art Moderne, Centre Georges Pompidou, Paris.

of the cane trellis above, are among her best-known portraits. Dora also took sexy snapshots of Picasso in scanty shorts, clutching the skull of an ox. Still photographs by others in the group provide a day-by-day record of their life at Mougins, such as Man Ray's famous shot of Ady sitting on Picasso's shoulders while Dora tends to his feet. To this day, these images celebrate Picasso's aura and his ability to transform a banal beach scene into a magical occasion.

The previous summer Picasso had limited himself to a few works on paper, all of them portraits of Dora, including one supremely erotic gouache. This year he had brought a lot more canvases, an easel, and paints. The hotel's big room and its balcony became his studio. Aside from a few views of local buildings and a somewhat conventional harbor scene, one of his first images is a small painting of himself and Dora in front of the railing outside their room. Picasso depicts himself as a naked, brawny Minotaur. Dora is surrealistically depicted as bits of a dress held together and humanized by no more than tufts of armpit hair attached to her stocking-like arms. Picasso Picassified people. He got inside them and re-created them. This painting looks ahead to the surrealistic tinge of the work done later this summer.

As the Lambe Creek gang resumed last year's beach-and-bed activities, Picasso concentrated on painting—what else but portraits, which took comical liberties

with gender and identity? He was particularly intrigued by Lee Miller—Penrose's wife-to-be. Virtually all of Picasso's Mougins portraits of women depict them in the traditional dress and the idiosyncratic coif of an Arlésienne.[11] He was inspired by the portraits van Gogh and Gauguin made of Madame Ginoux, owner of Arles's railroad café, who had befriended the two artists in 1888. Arles had been sacred to van Gogh, who was sacred to Picasso. His love of the Dutchman's work had been rekindled by a major show installed at the 1937 Paris World's Fair. Filling one wing of the Palais de Tokyo, the van Gogh retrospective had proved far more of a draw than *Guernica* at the Spanish Pavilion, which would not find widespread favor in the art world until World War II revealed how prophetic Picasso had been. The strong reactions that the exhibition provoked in the press reflected van Gogh's posthumous conquest of public taste.

I was present in the 1950s when Picasso revealed the depth of his van Gogh obsession by persuading the director of Arles's Musée Réattu to obtain the original newspaper report of van Gogh having chopped off his left ear with a razor in 1888. This scrap of newspaper would

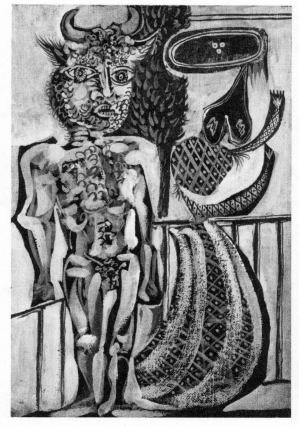

Picasso. *Minotaur and Woman,* August 10, 1937. Oil on canvas, 33 x 22 cm. The Robin Trust.

remain in his wallet until his death. It constituted a palpable link to his beloved van Gogh.

Besides reflecting the influence of van Gogh, Picasso's Mougins portraits are conceptual mockeries of his friends.[12] In one of them Éluard appears as a jolly green-faced woman suckling a kitten.[13] Penrose recognized the "diabolical playfulness" of these farcical caricatures.[14] Might Picasso have been mocking surrealism? Years later, he would ridicule leaders of the movement for having lost their surreal zeal.

Agar recalled that their Mougins holiday "was presided over by *le Peintre Soleil* himself, Picasso the Master, who was indubitably boss of the roost, his thoughts and moods somehow setting the ruling temperature." The simple accommodations at the Vaste Horizon required guests to share bathrooms located in the corridors between rooms. One morning, Bard bumped into Picasso leaving the loo. "It was no small

matter to follow the minotaur to his secret lair, and Joseph tried to back away in order to return later, but no, Picasso caught him by the arm, bowed him in with mock solemnity, pulled out a large silk handkerchief and wiped the seat. Then made Joseph sit down, and laughing and bowing, closed the door behind him."[15]

This summer, Picasso had acquired a monkey from a Mougins pet shop and named it Beretzof. He spent so much time teaching him tricks that Dora became jealous. One day, while playing on the beach, Beretzof bit Picasso's finger. After he was told that king Alexander of Greece had died from a monkey bite in 1920, Picasso lost no time in returning Beretzof to the pet shop.[16]

Sometime in August, Picasso took Dora, Man Ray, and Ady to visit the entrepreneurial art patron Marie Cuttoli and her husband, Paul, a senator from Algiers and an experienced puller of political strings. Although on holiday, Picasso had much to discuss with the Cuttolis. They had been collecting his work for at least ten years. Marie Cuttoli had also commissioned tapestry designs from Picasso, the last and most important of which would materialize in spring 1938: the vast *Women at Their Toilette*, a striking assemblage of multipatterned, multicolored wallpapers. Man Ray took photographs of the group on the steps of the Cuttolis' villa at Antibes. Everyone looks cheerful, except for Dora who is evidently sulking.

The summer had started badly for Dora. She not only had quarreled with Picasso in July but had managed to alienate her closest friend, Jacqueline Breton, in August. Letters between them reveal that the Bretons felt insulted by their exclusion from the Mougins trip, particularly since they had been making plans to travel south with Picasso and Dora. When they learned that the latter had left in the middle of the night with the Éluards instead, Jacqueline took it personally: "To hell with Mougins and the Midi where I wanted so much to go. As for the Éluards, I say again that they are poor fools. You deserve better than their friendship."[17] Naturally, her husband's long-standing rivalry with Paul Éluard for Picasso's attention made things worse. In the end, Dora took the blame for their sudden departure and promised to explain in person, which she presumably did. Jacqueline would put aside her grievance and join them on the Riviera the following summer.

Meanwhile, Dora had other reasons to be uncomfortable. Her melancholy temperament darkened beside the younger, free-spirited fashion models Ady and Lee—herself a talented photographer—who, to the delight of their male companions, seemed to relish the summer's louche ambiance. That Picasso took an obvious interest in these women deepened Dora's fear and insecurity. So much so, in fact, that she once again felt it necessary to apologize for her outbursts after they had returned to Paris. "My fits of jealousy drive me crazy and stupid with pain. Have a little more patience . . . and I'll make amends, I'm so afraid of losing you that I can't hold back from making those awful scenes."[18]

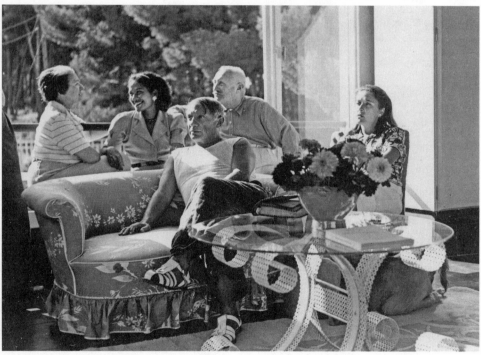

TOP Adrienne Fidelin, Marie Cuttoli, Man Ray, Paul Cuttoli, Picasso, Dora Maar, Antibes, 1937. BOTTOM Adrienne Fidelin between Marie and Paul Cuttoli, Picasso, and Dora Maar, 1937. Photographs by Man Ray. Musée National d'Art Moderne, Centre Georges Pompidou, Paris.

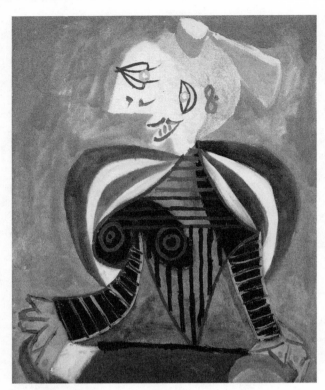

Picasso. *The Arlésienne (Lee Miller),* September 20, 1937. Oil on canvas, 81 x 65 cm. Musée Réattu, Arles, from the Musée National Picasso, Paris.

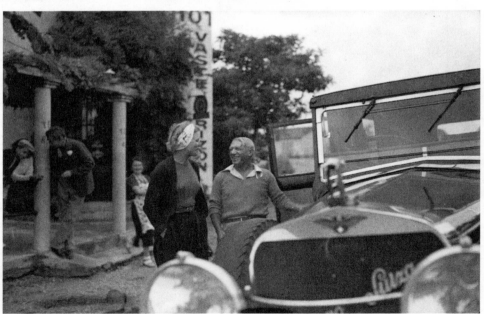

Man Ray. Lee Miller and Picasso beside his Hispano-Suiza, at the Hôtel Vaste Horizon, Mougins, 1937. Musée National d'Art Moderne, Centre Georges Pompidou, Paris.

None of Picasso's or the surrealists' homosexual friends had ever been included in their Mougins get-togethers. In the past, gay friends had played a major role in Picasso's Mediterranean beach life. In the 1920s he and Olga had enjoyed Diaghilev's gay entourage on the Riviera, not to mention Cocteau's. What had transpired? Many of the French surrealists around Picasso in the late thirties were homophobic. None more so than the movement's founder, Breton, who had openly accused homosexuals of "mental and moral deficiency."[19] Why were the wildly avant-garde surrealists so prudish in this respect? Maybe it was a manifestation of bourgeois guilt and fear of contamination.

During these two months in Mougins, Picasso would luxuriate with friends, in hiding from the storm of praise and criticism that *Guernica* had generated. According to Agar, "He did not say a word about [*Guernica*]. But I think he was deliberately keeping quiet then, since he was not at all sure how it would be received."[20]

Despite Picasso's fame, the French press virtually ignored *Guernica*. Even Louis Aragon, star of the Communist newspaper *L'Humanité*, failed to mention it. Only the artist's publisher Christian Zervos celebrated the painting in an impeccably illustrated issue of *Cahiers d'Art*. It featured Picasso's preliminary sketches as well as Dora's photographs, with commentaries by French and Spanish intellectuals, Bergamín, Larrea, and Éluard among them. The most moving and memorable words came from the ethnographer Michel Leiris: "Picasso sends us our letter of doom: all that we love is going to die, and that is why it is necessary that we gather up all we love, like the emotion of great farewells, in something of unforgettable beauty."[21]

When *Guernica* went on display at the World's Fair, the Spanish Pavilion's organizers questioned its merits. Some disapproved of its modernist style and clamored for its removal. As a result, Max Aub, cultural attaché to the Spanish embassy in Paris and a fervent backer of Picasso, felt compelled to defend *Guernica*: "This art may be accused of being too abstract or difficult for a pavilion like ours that wishes to be above all and before everything else a popular expression. But I am certain that with a little will, everyone will perceive the rage, the desperation and the terrible protest that this canvas signifies."[22]

Other Spanish officials did indeed feel that *Guernica* was too avant-garde for the average visitor to understand, let alone appreciate, and did their best to replace it with a piece of sensationalist propaganda commissioned for the pavilion: Horacio Ferrer de Morgado's corny *Madrid 1937 (Black Aeroplanes)*. This painting exploited some of the same motifs used by Picasso—air-raid victims and gutted buildings—but its kitschy vision of them was more to the taste of the public than Picasso's bleak monochrome modernism. The raised fists and red-scarved figures depicted by

Ferrer de Morgado also had far more appeal to Spanish Communists. Prominently displayed, *Black Aeroplanes* was described to Republican leaders as "the greatest popular success" of the pavilion.[23] Whereas *Guernica*, according to Le Corbusier, "saw only the backs of visitors, for they were repelled by it."[24]

Some eminent Spanish modernists also took against *Guernica*. Luis Buñuel later confessed: "I can't stand *Guernica*, which I nevertheless helped to hang. Everything about it makes me uncomfortable—the grandiloquent technique as well as the way it politicizes art. Both Alberti and Bergamín share my aversion. Indeed all three of us would be delighted to blow up the painting."[25] Hindsight suggests that Buñuel was deceiving himself.

Even more surprising was the Basque government's reaction. According to one report, Picasso had offered *Guernica* to the Basque people, but their president declined. The Basque artist Ucelay, who loathed the painting, believed the commission should have gone to a fellow Basque, and denounced *Guernica*: "As a work of art it's one of the poorest things ever produced in the world. It has no sense of composition, or for that matter anything . . . it's just 7 x 3 metres of pornography, shitting on Guernica, on Euskadi [Basque country], on everything."[26]

As expected, the Nazis reacted to *Guernica* with contempt. The German guide to the World's Fair called the painting a "hodgepodge of body parts that any four-year-old could have painted."[27] Ironically, the opening of the Spanish Pavilion in Paris roughly coincided with the opening of the *Entartete Kunst* (Degenerate Art) exhibition in Munich, filled with contemporary works the Reich condemned. The show, including a number of Picassos, traveled to major cities in Germany where it was seen by over three million people. Many young German modernists welcomed the opportunity to admire works they had previously not been allowed to study.

On November 1, Paris's World's Fair closed and *Guernica* was returned to Picasso. Eight days later, he attended the annual ceremony at the Père Lachaise cemetery in honor of Apollinaire (d. 1918), who had been the closest and most influential of his poet friends. Hitherto, Picasso's magnificent model for a monument in honor of the poet had failed to find favor with Apollinaire's widow and *retardataire* memorialists. Admirers from all over Europe attended the ceremony. Larrea recorded a dramatic confrontation between Picasso and Filippo Tommaso Marinetti, the founder of futurism and "Fascist Italy's bigwig intellectual, rather a curiosity to those hanging around him. Not far, in another group of more modest appearance, stood Picasso whose place was precisely to be there at that moment. All of a sudden, full of himself and arrogant, the bearer of Fascist infamy approached the Spanish painter, his hands outstretched and saying for everyone to hear: 'I assume that in front of Apollinaire's tomb you won't see any inconvenience in shaking my hand.' To which Picasso replied, 'You seem to forget that we're *at war*.'" The poet Iliazd witnessed the incident and

wrote to Picasso: "How do I praise the lesson you taught me that morning in front of Apollinaire's tomb. For years you have been my guide. But today, your step was so judicious and just that I was ashamed of myself." Picasso's actions, he added, showed him the error of trying to remain neutral "behind the screen of intellectual non-intervention."[28]

The war in Spain had politicized Picasso. Neutrality was not an option when his homeland was torn apart by civil strife. In a statement sent to the American Artists' Congress, published in *The New York Times* on December 19, 1937, he declared that "artists who live and work with spiritual values cannot and should not remain indifferent to a conflict in which the highest values of humanity and civilization are at stake."

Dora Maar. Photograph of Paulo Picasso, c. 1937. Musée National d'Art Moderne, Centre Georges Pompidou, Paris.

16

Bern and Vézelay

*G*uernica had left Picasso with neither enough time nor energy to face the ongoing horror story of his distraught wife, whom he was still trying to divorce, and troubled sixteen-year-old son. Exasperated by Paulo's behavior and frightened for the boy's physical and mental well-being, Olga begged Picasso for help in a letter of October 29: "Why didn't Paulo go to the doctor's office? He knew very well that he had a five o'clock appointment. I waited almost an hour for him. Can't you make him understand that one can't make light of these things . . . Call me and tell me what you think and what I should do because, as you know, I've tried everything without any results . . . I'm so worried that I will do everything you say."[1]

Paulo's violent reaction to Olga's oppressive mothering had become dangerous. "He bears a deep hatred toward her," Kahnweiler wrote to the Swiss collector Hermann Rupf, one of his earliest clients and a lifelong friend. "[Paulo] spent night after night with criminals, with thieves, drug dealers, pimps, whom he admired totally."[2] Paulo's carousing eventually landed him in poor health and on the wrong side of the law. The gravity of the situation, and Olga's hectoring, finally forced Picasso to take action.[3] Treatment in Switzerland, probably involving drug rehabilitation, would enable Paulo to avoid prosecution for petty offenses in Paris. With the artist's approval, Rupf and Bernard Geiser—a Swiss protégé of Kahnweiler's who had published the catalogue raisonné of Picasso's prints—arranged for Paulo to receive care at the Lindenhofspital, a private clinic in Bern.

Just before ten o'clock on the evening of November 26, 1937, Picasso and Paulo boarded an overnight train to the Swiss capital. When they arrived, around half past eight the following morning, they found Geiser waiting for them at the railroad station.[4] He greeted them cheerfully, but Paulo looked dejected. After checking in and lunching at the Bellevue Palace Hotel, they headed for the clinic, where Paulo would be treated for a little over a month. When Olga visited her son in late December, she could not help interfering in the boy's treatment. Kahnweiler had warned Rupf of her arrival: "You have known Russian women in the past but never one as crazy as this—and who can nevertheless present herself as so sensible."[5] A week later, Rupf

reported that Paulo "treats her in the most shameless way and cannot stand her and she clings to him and achieves nothing."[6] To Rupf's dismay, Olga would remain in Bern for several weeks. "The woman is insane," he moaned to Kahnweiler, "and belongs in a mental hospital. Of course Picasso isn't the man to bring the boy up, and he's probably too lazy and comfortable for it."[7]

The day after his arrival in Bern, Picasso had plans to visit Paul Klee, Switzerland's greatest modern painter. The two artists had met once before—on October 26, 1933, while Klee was in Paris to authorize his contract with Kahnweiler. When the dealer invited him to Picasso's rue la Boétie studio, Klee accepted and recorded the event in his agenda. Four years later, Kahnweiler would arrange another meeting, this time in Klee's Bern studio, and it was Geiser's job to get Picasso there on time.[8] With hours to spare before the four o'clock appointment, Geiser took Picasso to see the celebrated Burgundian tapestries at Bern's Historical Museum. The artist was enthralled. Geiser could hardly pull him away from these masterpieces of late medieval weaving. Little wonder that Picasso would embark on his most complex tapestry project, *Women at Their Toilette*, the following spring.

Picasso dawdled for hours studying the museum treasures that whetted his curiosity. "But what is there to see over there?" he would ask, and disappear into another gallery. "Useless to try to rein him in," Geiser recalled, so Picasso wandered down a staircase to the basement. Geiser hurried after him: "I ran through several rooms without catching sight of him. At last I found him. 'Voyez ça,' he cried out to me and his eyes were sparkling. Now he had found something that seemed especially to excite him: an ancient wooden house that came from the Bernese lake district. . . . Picasso feasted on the unfamiliar sight, lovingly touched the beautiful bands of ornamentation and pressed his nose against the round [window] panes."

Geiser repeatedly reminded Picasso that they were going to be late for their date with Klee, to no avail. He insisted on seeing every gallery until the museum closed. When they finally left to get a taxi, Picasso spotted something in a shop window and went inside. "They are marrons glacés," he told Geiser, "don't you know them?" Before he could respond, Picasso had popped one into his mouth. "Let's go eat them and have something to drink," he suggested. Again Geiser invoked their lateness. No luck. Next, Picasso insisted on stopping at the station café for a half-liter of red wine.

They arrived at Klee's house hours late. The punctilious Swiss artist had assumed they were not coming and had changed into his robe and slippers. "He would never have presented himself to Picasso like this during the day," Geiser observed. Nevertheless, Klee took them into his studio and asked whether Picasso would like to see some of his recent work. Yes, Picasso replied, and was shown folders of small watercolors and drawings. "It would, of course, have been better to look at all this in daylight," Klee remarked. Picasso liked what he saw, but according to Geiser

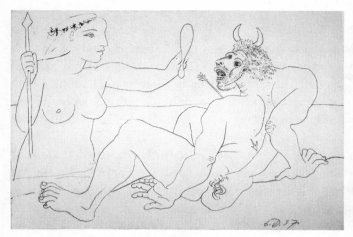

LEFT Picasso. *The End of a Monster,* December 6, 1937. Pencil on paper, 38.6 x 56.3 cm. National Galleries of Scotland, Edinburgh. Purchased with the support of the Heritage Lottery Fund and the Art Fund, 1995. RIGHT Picasso. *Marie-Thérèse with Orange Beret and Furry Collar,* December 4, 1937. Oil on canvas, 61.2 x 46.1 cm. Collection of Sam Rose.

"he said nothing, as if it would have been inappropriate to praise Klee." Klee's son, Felix, remembered the visit as a very unpleasant incident. To save the situation, Klee's musical wife, Lily, sat down at the piano and played Bach until Rupf arrived to pick up Picasso. Geiser recalled: "Our farewell to Klee was warm. His earlier bad mood seemed to have vanished." Picasso, who had evidently enjoyed himself, said he hoped they would meet again in Paris. They didn't. Already ill, Klee would die in 1940.

As for Paulo, he would remain at the Lindenhofspital until the first week of January whereupon he was released into the care of Geiser and his wife while plans were made for him to resume his education at a suitable school in the mountains. Olga lingered in Switzerland through February, but refused to visit Paulo after he left the clinic. She blamed the Geisers for turning her son against her, according to Rupf, who sent Kahnweiler troubling news of her deterioration: "She eats nothing and this is ruining her. . . . The boy has to be taken away, the woman is literally not accountable for her actions. She would always say the same phrases to us for hours on end, and when he was in Bern last Monday she said that she didn't want to see Paulo." Moved by Rupf's reports, Kahnweiler urged the artist to intervene: "It was this insanity that drove Picasso to the separation. Certainly Picasso ought to look after the boy. I told him three days ago that it was his duty. . . ."[9] The dealer gave a grim forecast of Paulo's future: "The boy really has a heavy burden in his ancestry—son of a genius and a madwoman. I believe that with kindness he can still be rescued, but it will always be difficult."[10] Kahnweiler proved all too prescient.

ack from Switzerland, Picasso went straight to Le Tremblay and set to work on a series of affectionate portraits, of Marie-Thérèse in a fur-collared coat and a beret topped with a pompom. The beret is in sharp contrast to Dora's farcically chic hats that Picasso parodied and embellished in mocking portraits of her. These paintings of Marie-Thérèse, done over three days (December 3–5), reflect his joy at their reunion.[11]

By Thursday, December 6, Picasso was back in Paris. He switched to classical allegory and portrayed Marie-Thérèse as a beautiful naiad who confronts a wounded Minotaur on a beach, all too clearly himself, who has been struck through the heart by an arrow.[12] She holds a mirror up to his face. During the first week of January he would explore this theme in a series of six paintings. In one of them, the Minotaur

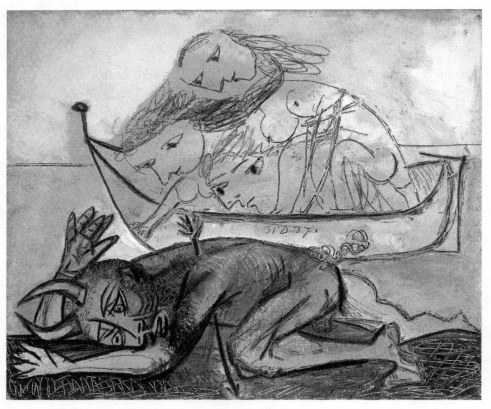

Picasso. *Boat with Naiads and Wounded Faun,* December 31, 1937. Oil and charcoal on canvas, 46 x 55 cm. Private collection.

is crawling along the shore, near death, when three Marie-Thérèses materialize in a boat to rescue him.[13]

A head-and-shoulders portrait of Dora dated December 8 is unusually flattering, but Picasso's reunion with her cannot have gone well, given her next manifestation in his work: a small, brightly colored panel known as *The Suppliant* (December 18).[14] Might Christmas have activated Dora's latent Catholic faith? That could explain his vision of her as a screaming marchesa in seventeenth-century dress inspired by Velázquez. Her stiff black dress can be read alternatively as a prie-dieu, an upholstered prayer stool. Other clues to the meaning of the work include the feet—one bare, the other shod—and the breasts, one of which pops out voluptuously from a rigid corset. Picasso may have had in mind Ferrer de Morgado's *Madrid 1937 (Black Aeroplanes)*, which had recently been exhibited to popular acclaim alongside *Guernica* in the Spanish Pavilion at the World's Fair. Is Picasso's *Suppliant* a mocking reference to the emotionalism of Morgado's painting, in which a bare-breasted young mother screams and shakes her fist in the midst of a bombing raid?

The bloodiest battle of the Spanish Civil War broke out in December. During the coldest winter on record, Republican forces launched a campaign to recapture the remote Aragonese mountain town of Teruel. As Paul Preston points out, "In the freezing conditions, morale was sapped. Deaths from the cold were high on both sides, many troops dying in their sleep as the effects of the alcohol they had consumed to stay warm wore off." After two months of fighting in ice and snow, the Republicans had lost more than sixty thousand men and were forced to retreat. The Nationalists suffered fifty thousand casualties, but, as Preston observes, "Franco had an overwhelming advantage in terms of men and equipment. His exploitation of that superiority in regaining Teruel made it the military turning point of the Civil War."[15]

There are no overt references to the Teruel disaster in Picasso's work. However, the grotesque agony of it is expressed in the so-called *Woman with a Cockerel* (February 15).[16] This is implied by the knife ready on the floor, the hand clasping the wings, the feet tied together, and the cup ready to catch the blood that is about to flow. The allusive painting hints at different explanations, killing several birds with one ambivalent stone. The eminent art historian Meyer Schapiro was first to perceive that the woman is self-referential. Gasman calls the subject a "girl-Picasso who performs a magical-primitive sacrifice."[17] The sacrificial rooster evokes the atmosphere of helplessness and hysteria soon to become reality not only in Spain but throughout Europe.

The rooster, a popular symbol of the French Republic, would fascinate Picasso

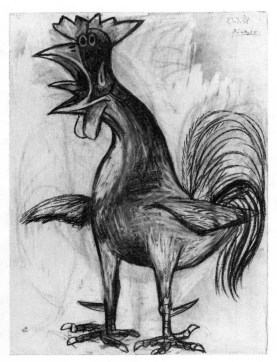

LEFT Picasso. *Woman with a Cockerel,* 1938. Oil on canvas, 145 x 120 cm. Staatsgalerie, Stuttgart.
RIGHT Picasso. *The Cock,* 1938. Charcoal on paper, 76.9 x 56.9 cm. The Museum of Modern Art, New York. Gift of Mr. and Mrs. David Rockefeller.

and reappear in his work several times through the end of March. In a drawing of March 23, the bird crows violently, flapping its wings and straining its neck, a knife-like tongue protruding from its gaping beak.[18] The Spanish-American painter Xavier Gonzales was present when Picasso worked on the image and recalled: "We had just left Don Pablo. He was doing a large charcoal drawing of a terrifically dramatic rooster. 'Roosters—' he said, 'we always have roosters, but like everything else in life we must discover them. Just as Corot discovered the morning and Renoir discovered little girls. . . . Roosters have always been seen but seldom so well as in American weathervanes.' "[19]

Picasso sold *Woman with a Cockerel* to the American sculptor and collector Mary Callery, known as Meric. Born to an affluent Pittsburgh family, Callery had moved to Paris to study sculpture in 1930, after divorcing her first husband, the New York lawyer and Republican politician Frederic Coudert Jr. Callery befriended members of the Parisian avant-garde and assembled an outstanding collection of modern art with her second husband, Carlo Frua de Angeli, head of the Italian rayon manufacturing

Picasso. *The Farmer's Wife,* March 23, 1938. Charcoal and oil on canvas, 120 x 235 cm.
Musée National Picasso, Paris.

company SNIA Viscosa. Their marriage only lasted a few years, but the sculptor and
the industrialist would remain close friends.

By the time she acquired *Woman with a Cockerel,* Callery had become a major
collector of Picasso's work. The quality of her holdings is revealed in an ecstatic let-
ter from the writer and dealer André Level to Picasso: "Yesterday I went to Madame
Callery's home where I counted twelve of your canvases, most of them huge and half
of them I did not know. It was astonishing. Such beautiful selections for such large
walls! It outshines your exhibition at [Galeries Georges] Petit. Thank you for making
me aware of this collection. It has a surpassing grandeur that puts the collections of
my country to shame."[20] Callery would lend several of her Picassos to the artist's 1939
retrospective at the Museum of Modern Art and, as we will see, provide valuable help
from Paris to Alfred Barr as he organized the exhibition in New York.

In March 1938, Callery and Frua de Angeli drove down with Picasso and Dora to
visit Christian and Yvonne Zervos's new country house, La Goulotte, near Vézelay, a
town famed for its Romanesque basilica, where pilgrims had flocked since the twelfth
century to revere relics of Mary Magdalene. The collector and her ex-husband had
become financial backers of Zervos's publishing house, Cahiers d'Art, which pro-
duced the art journal of the same name as well as Picasso's ongoing catalogue rai-
sonné. Snapshots show Zervos and his guests in the garden of La Goulotte and on
Vézelay's medieval streets.

After returning to Paris, Picasso did a large painting of a woman lying naked in a meadow, *The Farmer's Wife*.[21] Her raised knee, outstretched legs, and large buttocks suggest Vézelay's topography. Indeed, Zervos described a later version of this composition as "a transposition of the Vézelay landscape. The two feet represent the two roads, the left one leading to Clamecy and the right to Avallon. The belly represents the Place de la Foire and the entry into the small city. The two arms recall the two roads, which lead to the Basilica and the head recalls the Basilica itself."[22]

On March 16–18 waves of Italian airplanes repeatedly bombed Barcelona, where Picasso's mother and sister lived and where his genius had first emerged. Working-class districts of the city were the hardest hit, and the artist feared for the safety of his family. "My mother is perhaps dead," he told friends in Paris, "my loved ones are perhaps dead."[23] The bombardment of Barcelona would inspire Picasso to give immense sums to Spanish relief agencies. The artist made charitable contributions exceeding anything he had done before. In 1938, his donations to the National Committee of Assistance to Spain totaled 400,000 francs, and he put many thousands more toward the building of children's aid centers in Barcelona and Madrid.[24] This was in addition to the support he provided to Spanish and Catalan refugees, often strangers, who called on him in Paris.[25]

Though Picasso did not directly experience the physical and psychological trauma of an air raid, he identified with those who had. "It was their martyrdom that deep down martyred him," Gasman remarks.[26] Images of death from the sky recur in Picasso's writing from the civil war years. In one poem, "black liquid [rains] . . . the dead fall drop by drop"; in another, "clouds shit . . . horror and despair." The bombardment of Barcelona inspired visions of a hot-air balloon filled with corpses and hourglasses that hovers over "the entrails of the disemboweled horse rotting on the lawn for centuries." On November 12, in his last poem of 1938, "as if lost in a mystical and superstitious trance," says Gasman, he repeated the word "sky" sixty-six times, imploring the heavens to change from black to blue.[27]

In March Gertrude Stein published her often preposterous though sometimes astute book about Picasso. Egomania too often smudges her portrait of the artist. "I was alone at this time in understanding him, perhaps because I was expressing the same thing in literature, perhaps because I was an American and . . . Spaniards and Americans have a kind of understanding of things which is the same."[28] Picasso's decision three years earlier to give up painting for writing had infuriated her. How dare he? Did she, one wonders, realize that his way with words was far more avant-garde than hers? The Spaniard's writing had more in common with the Irishman James Joyce. Stein insists that "Picasso was always possessed by the necessity of emp-

tying himself, of emptying himself completely, of always emptying himself, he is so full of it that his existence is the repetition of a complete emptying, he must empty himself, he can never empty himself of being Spanish but he can empty himself of what he has created."[29] In fact, Stein's defecatory explanation of Picasso's approach applies much more to her own work than to his. Nevertheless, he was always grateful for Gertrude's backing in his cubist years, and her efforts to spread his fame.

At heart, Picasso preferred Gertrude's long-suffering girlfriend, Alice B. Toklas. She was much nicer, quieter, and wiser. Besides having a wry sense of humor, she was a famously good cook. Some years after Gertrude's death, Picasso had Alice down for lunch at his villa in Cannes. I happened to be around when the tiny old lady appeared, her face hidden under a huge black mushroom of a hat with a black ostrich feather attached to it. She had shrunk but so had he. Picasso whisked the hat off her head and teased his dog with it. The more Alice squealed, the more he kept on. This was evidently an old ritual. Ancient gossip over lunch brought us back to the rue de Fleurus like a time machine.

Picasso. *The Coiffure*. Paris, March 22, 1938. Oil on canvas, 57 x 43.5 cm. Musée National Picasso, Paris.

On March 22, Picasso painted a head-and-shoulders image of yet another female travesty of himself.[30] The lips are rouged and two ghostly sets of fingers are about to dig a sharp-toothed comb into his/her scalp and long black hair. The artist has managed to convey the appreciative look a woman gives a mirror, but the disembodied hands of the hairdresser are full of foreboding. Gasman sees these hands as "those of malevolent destiny." She and other art historians agree that this creepy coiffeur is fraught with menace, presaging both the defeat of the Republicans in the civil war and the start of World War II.[31]

One of the most puzzling paintings of this period is, at first sight, the mocking image of a young boy wearing a sailor suit and cap emblazoned with the artist's name, *The Butterfly Catcher* (April 2).[32] Could the odd-looking child be the artist's profligate seventeen-year-old son? Unlikely. Paulo had dark hair. When later asked about the image, Picasso stated: "It's me," and, opening his shirt, added "that he had painted himself as a sailor because he always wore a sailor's striped jersey as an

Picasso. *Maya in a Sailor Suit,* 1938. Oil on canvas,
121.6 x 86.3 cm. The Museum of Modern Art,
New York. Gift of Jacqueline Picasso.

undershirt."[33] Despite this pronouncement, another one of Picasso's children claims
it's of her. Maya Widmaier-Picasso told the scholar Elizabeth Cowling that "to please
her, Picasso dressed her like her favourite doll—she did not have a sailor suit herself.
And lest anyone mistake the boisterous child for a boy, Picasso stamped the log seen
between her open legs with a vagina-shaped knot."[34]

Hitler's triumphant annexation of Austria (March 12–15) left the rest of Europe
in a panic. A second Great War was inevitable. Still agonizing over the mas-
sacre at Teruel, which had enabled Franco to capture Catalonia, Picasso set about
depicting his fear in a coded, quasi-surrealist composition almost as vast as *Guernica*.
Women at Their Toilette is an immense maquette for a tapestry commissioned by his

benefactor Marie Cuttoli.[35] Everything about it is ironical, not least the title, which parodies *dix-huitième* paintings of elegant ladies being dressed by their maids—works that look both trivial and poignant in the light of the revolution to come. Picasso latched on to this irony. The tapestry cartoon reflects his anguish at the prospect of further world war in the light of a fanciful *haute bourgeoisie* setting.

The central figure is unquestionably Dora, crouching uncomfortably on the floor and sobbing. She is being combed by a kneeling hairdresser on the left, who wears sheets of wallpaper printed with maps of the world's continents. The hairdresser looks anxiously back at a bunch of emblematic flowers on an elaborate stand. A maid on the right holds a mirror up to her mistress. Reflected is a pale blue, skull-like image of Picasso.

To achieve these effects he took the technique of papier collé to new extremes, covering his vast surface with multicolored scraps and sheets of wallpaper from a decorator's book of samples. The commission enabled Picasso to modernize the weaver's art. In a recent study of *Women at Their Toilette*, Cécile Godefroy has opened our eyes to the daunting technical challenge that Picasso set the weavers: "The numerous details and rich variety of shades required a complex and large-scale composition on a twelve-square-meter surface, which the low-warp technique used at Aubusson [tapestry works] could not transcribe."[36] The complexity of the composition and the interruption of the Second World War delayed the completion of Cuttoli's tapestry project by thirty years.[37]

On assignment for *Life* magazine in September 1939, Brassaï visited Picasso at the rue des Grands-Augustins. The place once occupied by *Guernica* was now taken up by *Women at Their Toilette*. The photographer recalled: "I made a portrait of him, standing in front of this unfinished work. The creases and folds of his raincoat seem to be a part of the 'collage' itself, and an arm which is actually on the canvas seems to belong to his own body."[38] The work existed only as a maquette until 1967 when Picasso finally consented to have it woven by the Gobelins.

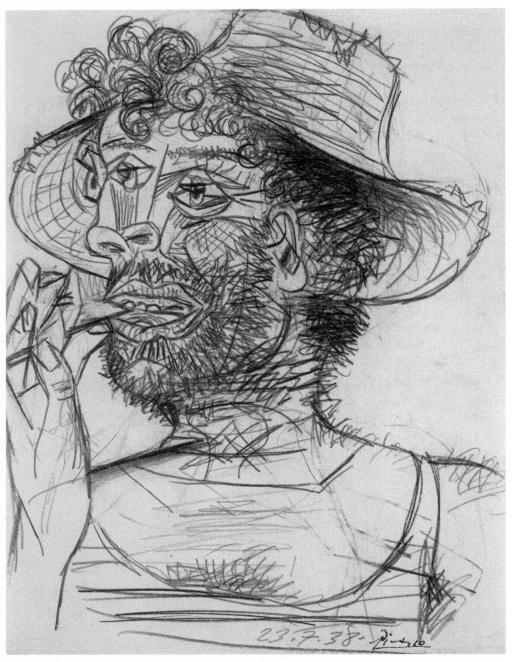

Picasso. *Man with a Lollipop,* 1938. Pencil on paper, 30.8 x 23.2 cm. The Metropolitan Museum of Art, New York. Jacques and Natasha Gelman Collection, 1998.

17

Last Summer at Mougins (1938)

Late in April 1938, on the boulevard Saint-Germain, Picasso bumped into Sabartés. They had seen much less of each other since Sabartés had moved out of the rue la Boétie apartment. At Picasso's request, Sabartés stopped by the apartment on July 5 to help entertain the Spanish ceramist Paco Durrio. After that visit, Sabartés did not see Picasso again until the first week of November, when the artist invited him to resume his role as daily companion. Sabartés's memoirs make no mention of Dora whatsoever—and no wonder. She had displaced him from Picasso's inner circle, but the artist had brought him back. Henceforth, Sabartés's domain would be the rue la Boétie; Dora's the rue des Grands-Augustins.

For the third year in a row, Picasso and Dora spent their annual Mediterranean holiday at Mougins's Hôtel Vaste Horizon with Paul and Nusch Éluard.[1] Picasso worked as intensively this year as he had done the previous summer, despite the absence of Penrose and his international surrealists. He devoted the summer to portraiture, head-and-shoulders representations of himself in the guise of the Mouginois farm workers—young men wearing tattered straw hats. These images reveal the extent of van Gogh's hold on Picasso's imagination when he returned to the Midi. Back in van Gogh country, Picasso's vision fell under the Dutchman's spell. But instead of smoking Vincent's pipe, Picasso's alter ego is sucking on a lollipop or licking an ice-cream cone. A few days after his arrival, Picasso painted a handsome, van Gogh–like portrait of himself in a straw hat but with a prominent chin and green lips that smack of Dora (July 31).[2] A week later, he did a second version in which their features seem to merge.

There is no record of the Mougins group visiting Arles, but Picasso did not need to go, since van Gogh was enthroned in his visual memory. Irving Stone's best-selling biographical novel about van Gogh, *Lust for Life*, was having worldwide success, not least in France, where it had just been published by Flammarion.[3] Though mostly a bromide of misinformation, the book generated a cult of the artist among young readers, including the teenaged author of these pages.

Besides reflecting on van Gogh, Picasso edged toward Mithra. From the top-right

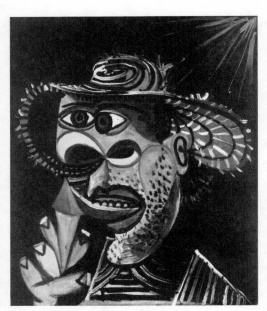

Picasso. *Man with Ice-Cream Cone,* August 14, 1938. Oil on canvas, 61 x 50 cm. Private collection.

corner of the August 14 painting, the bright Mithraic sun lights up the darkness and reveals the unshaven artist eating an ice-cream cone with a scared look in his eyes.[4] These "self-portraits" have little more than a vestigial likeness to Picasso. Some are handsome and idealized, others are grotesque, and he also experimented with a varied range of expression—jovial, noble, hysterical, cool, grouchy, angry, and dotty.

At the end of August, Picasso painted four portraits of Nusch Éluard[5] before reverting to images of Dora. Some of the latter bear an unflattering resemblance to Kazbek, Picasso's Afghan dog, described by Sabartés as emaciated, with a "sharp snout that was pointed toward the ground; his ears, covered with very long hair, resembled drooping wings."[6] Portraits of Dora also evoke the dried-up vegetation gathered by harvesters. In the August 29 portrait, her breasts and dress have the whirligig look of cornstalks.[7] This bizarre baroquerie would reappear in Picasso's work during his last two weeks in Mougins.

In the first week or so of September, Picasso and Dora were left to themselves. A stark drawing of September 8 shows Dora seated with a barbed-wire necklace attached to the knobs of her chair. Devastating news that Fascists were on the rise across Europe may have nurtured Picasso's feelings of darkness and death—as had a recent turn in his legal battle with Olga. She had strongly opposed his divorce suit from the start and in May 1938 managed to have the case extended yet again with a new round of hearings. Olga's appearance in a surreal crucifixion scene from late August, in which she drinks the blood of the impaled figure, suggests that Picasso's marital torment had followed him to Mougins.[8] Not long thereafter the artist abandoned his hopes for divorce and began to seek a judicial separation instead.

By the time he returned to Paris in mid-September, Europe was on the brink of war. France had begun mobilizing, a familiar and frightful development for those who remembered the buildup to the First World War. On September 25, Éluard put his worries in a letter to Gala: "We were told once before, in 1914, that mobilization is not war. Officers of all ages (up to 58) have been called up. And a great number of men."[9] Éluard himself would soon be activated by the military and posted to the supply corps at Mignères.[10] His former friend and surrealist comrade André Breton was also called up, and assigned to the medical corps at Poitiers.

LEFT Picasso. *Kazbek.* Notebook 43, folio 4 recto, dated 10/26/1939–9/19/1940. Pencil on graph paper, 16.3 x 22.3 cm. Musée National Picasso, Paris. RIGHT Picasso. *Seated Woman with a Hat,* 1938. Oil and sand on wood, 54.9 x 46 cm. The Menil Collection, Houston.

Rather than remain in Paris, Picasso headed straight for Le Tremblay to reunite with Marie-Thérèse and their daughter. The latter promptly reappeared in his work. The war threat was temporarily averted by the disastrous French and British policy of appeasement. The Munich Pact, signed September 30, gave Germany the Czech Sudetenland. Hitler would soon dishonor the agreement when he annexed the rest of Czechoslovakia without a shot being fired. Appeasement also spelled doom for the beleaguered Spanish Republic, as it could no longer hope for help from Europe's other democracies. Franco chose this moment to press his advantage and gained a decisive victory in November at the battle of Ebro. After heavy losses on both sides, the Republican army fell apart, allowing the fascists to take Catalonia.[11] Picasso remained committed to the Spanish struggle to the bitter end. Even as the chances of a Republican victory steadily diminished, he continued making contributions of money and art to worthy causes in his homeland. In November he donated a print of *Minotauromachie* to Barcelona's modern art museum and gave two hundred thousand francs to feed hungry children there and in Madrid.[12]

In another act of charity, he allowed *Guernica* to tour England to raise awareness of Spain's suffering. Days after Hitler and Neville Chamberlain signed the Munich Pact, the great mural and most of the studies for it went on view at the New Burlington Galleries in London's Mayfair. The exhibition had been organized by Penrose and E. L. T. Mesens to support the National Joint Committee for Spanish Relief.

Penrose repeatedly tried to get Picasso over for the opening in October, but the artist stayed away. Éluard went to London in his place and found that *Guernica* was shown to greater advantage, thanks to better lighting, in the New Burlington Galleries than at the Spanish Pavilion.[13] Penrose was pleased by the splash *Guernica* made in the British press but admitted to Picasso that attendance was lower than he had hoped. "I think the [Czechoslovakian] crisis and general demoralization which followed are responsible for this in large part."[14]

The friendship between Penrose and Éluard had recently deepened over the opportune sale of the latter's art collection. In June, financial problems had forced Éluard to part with the modern masterworks he had acquired over many years. These included ten Picassos, among them the 1936 mixed-media drawing *Le Crayon qui parle* and a rare cubist still-life construction, both gifted to him by the artist. Penrose bought Éluard's collection for a song (£1,600), skimmed the cream for himself, and used the rest to stock the London Gallery, of which he was part owner.[15]

Guernica's arrival in London caused a sensation, reigniting a battle in the press that had begun the previous fall between two formidable intellectuals: Anthony Blunt and Herbert Read. In October 1937 Blunt had published a review in *The Spectator* entitled "Picasso Unfrocked," accusing him of painting "abstruse circumlocutions" incomprehensible to ordinary people. *Guernica*, he wrote, "is not an act of public mourning but the expression of a private brainstorm."[16] From 1947 to 1974, Blunt would serve as director of London's Courtauld Institute, where he transformed his students into some of the most brilliant museum curators and professors of art history—not least John Golding, whose groundbreaking history of cubism has never been surpassed. In 1979, to the amazement of the British art world, the greatly respected Blunt was unmasked as a Russian spy. Golding stood by him. The government stripped Blunt of his knighthood and professorship at Trinity College.

Read, on the other hand, was one of Britain's foremost modernist critics. In his response to Blunt's attack on *Guernica,* he staunchly defended Picasso's devotion to the Spanish struggle. He extolled *Guernica* as "the modern Calvary," and characterized Blunt as one of those "middle class doctrinaires who wished to use art for the propagation of their dull ideas."[17] Read's praise was echoed by other commentators when *Guernica* moved from Mayfair to the Whitechapel Gallery in London's East End, where it would reach a much wider audience. The awe was more tangible. At the opening in January 1939, Labour Party leader Clement Attlee, newly returned from the Spanish front, stood before the painting and delivered a diatribe against fascism. Many of the fifteen thousand visitors to the show paid their admission by donating a pair of boots for Spanish soldiers fighting Franco. Penrose proudly wrote to Picasso of "the profound impression your works have made on these simple people."[18]

I was fourteen at the time but lucky in that Stowe School, where I was a student,

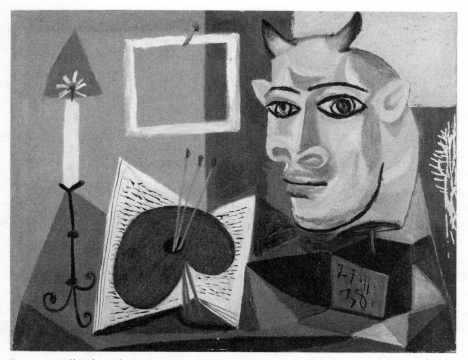

Picasso. *Still Life with Minotaur and Palette*. Paris, November 27, 1938. Oil on canvas, 73 x 92 cm. Fundación Almine y Bernard Ruiz-Picasso para el Arte, Madrid.

had employed two modernist art teachers, Robin and Dodie Watt. They encouraged us to go to London and see the Picasso show. Although no more than a teenager, I was so struck by the power of *Guernica* that I decided to find out more about this overwhelmingly exciting artist.

While *Guernica* was being exhibited in London, Picasso was becoming obsessed by the war in Spain. In November 1938, his ruminations inspired four allegorical still lifes. Their format is virtually identical: a sculpted Minotaur head on the right, a lit candle on the left, and a palette with a clutch of paintbrushes on top of a book. In the second one (November 19), the Minotaur is replaced by a black bull; above the candle a white shape hovers like a kite.[19] In the third (November 26), the red bull's left eye has a golden ring around it.[20] This small but vivid detail is surely a reference to the red and yellow colors of Spain, used as much by the Republicans as by Franco's Fascists. In the fourth painting (November 27), the bull's head crowned with horns is evidently self-referential.[21]

Once again, Gasman comes up with a perceptive explanation of these baffling works. She sees them as "eucharistic" and "mithraic."[22] Her arguments are convincing, but a biographical reading is also revealing. The palette and brushes that figure in the foreground suggest a more simplistic interpretation. The painter's palette on top of an open book is virtually the same in each version, but in the fourth the artist has added an empty frame hanging over it. Was this a reference to his former switch from painting to poetry?

Upon the resumption of Sabartés's secretarial duties in the first week of November, Picasso assigned him the task of typing his handwritten poetry. Later that month, the two men drove to the house at Le Tremblay, which neither Sabartés nor Dora had ever been allowed to visit. A huge accumulation of canvases lined up against the studio walls astounded the secretary. The recent works, portraits and allegorical still lifes, were unlike anything he had seen before: "What a festival of colors! In addition to the canvases there were numberless drawings and some objects made with sticks and strings . . . What I saw confused me, paralyzed my senses and dazzled me."[23] To have identified or described the works was out of the question. Sabartés reserved his comments for portraits of himself.

Although nudging sixty, Picasso had been remarkably free of illness, until the very end of this year. On December 20, back in Paris, sciatica struck. He was in agony. Christmas night was particularly painful. In his memoir, Sabartés recounts how he soothed his master's suffering by chatting away in Catalan. "We talked for the sake of talking, to while away the time."[24]

Inevitably, they also spoke of art and Picasso reflected on how his ideas changed during a painting's progress: "My original idea has no further interest, because in realizing it I am thinking about something else." Sabartés asked, "But then, what do you do when the picture is finished?" To which the artist replied, "Woe unto you the day it is said that you are finished! To finish a work? To finish a picture? What nonsense! To finish it means to be through with it, to kill it, to rid it of its soul, to give it its final blow; the most unfortunate one for the painter as well as for the picture."[25] This harangue could conceivably be applied to one of his own recent works: the highly finished portrait of Dora as the Weeping Woman (October 26, 1937), whose popularity with the general public has much to do with its readability. As usual, Dora is never mentioned in Sabartés's account, but this does not mean that she never visited Picasso. On the contrary, when the secretary left at the end of the day, Dora took over and spent most nights with him.

Picasso's sciatica steadily worsened. A doctor was called who prescribed massages, compresses, and three months in bed. Useless. Fortunately, the dealer Pierre Loeb enlisted his uncle, Dr. Klotz. His expertise involved an old-fashioned technique called centrotherapy—the cauterization of nasal nerves to alleviate pain elsewhere.

Picasso. *Jaime Sabartés as a Gentleman in the Age of Philip II*. Paris, December 25, 1938. Graphite pencil on printed paper on the verso, 28.7 x 20.7 cm. Museu Picasso, Barcelona. Gift of Jaime Sabartés.

It worked. "Picasso jumped out of bed, stood on one leg, then on the other . . . As he appeared to be dancing, he ended the performance bowing like a circus artist and then dropped on his bed murmuring, 'Now that the pain is gone I can have peace.' "[26]

Sabartés devoted an entire chapter of his book to this incident, seemingly to publicize the three flattering drawings Picasso did of him as a sixteenth-century nobleman and monk during his six days of suffering.[27] Amusing and slightly mocking, these touching pastiches were all the more cherished for the displeasure they would give to Dora. Picasso enjoyed playing his secretary and his mistress off against each other. This game would last until Dora's reign ended, as would the war, in 1945.

Dora Maar, wearing a crown of flowers, with Jacqueline Lamba, Antibes, summer 1939. Picasso's shadow is visible on the door. Photograph by Picasso. Musée National Picasso, Paris.

18

Night Fishing at Antibes (1939)

Over the first weeks of 1939, Picasso ruminated on the different characters of his two mistresses. A portrait of Dora painted on January 1, 1939, is black-haired and big-chinned, but in most other respects it is a portrait of Marie-Thérèse.[1] Her breasts bulge out and her expression is bland and cheerful, the antithesis of Dora's usual demeanor. Besides juggling the two women's features, Picasso has disconcertingly juggled their identities. He imposed the personality of one mistress onto the image of the other. A week later (January 7), he used an identical pose (inspired by Ingres's great portrait of Madame Moitessier), with her hand up to her face, for a languorous image of Marie-Thérèse.[2]

On January 21 he again painted contrasting portraits of his two women, each reclining in the same pose in a setting suggestive of Le Tremblay.[3] Picasso reveals his very different feelings for these very different women—the one so spiky, so complex, so dark; the other so serene, so loving, so peaceful. The latter's curvaceous body is at rest. Her arms squash an open book. Out of the window there is nothing but a pale green backdrop. Dora, on the other hand, is electrifying, a hideous caricature dressed up in a parody of chic. Outside the window two trees are in blossom. The painting of Dora is much more exciting. Her jaggedness and darkness anticipate the eruption about to afflict the world. "Dora m'a toujours fait peur" ("Dora has always scared me"), he later said by way of explaining why he depicted her again and again as mercilessly as if she were his antagonist in some titanic struggle.[4] His heads of Dora from 1939 to 1944, which carry on from the weeping heads of *Guernica*, are often pretexts for the expression of the artist's disquiet, disgust, or despair.

On the morning of January 13, Picasso's eighty-three-year-old mother, Doña María, suffered a serious fall in her Barcelona apartment.[5] She died that afternoon. Her son had been devoted to her, but also at times very angry, above all in 1930 when she let herself be conned by a crook into selling hundreds of his early works stashed in her attic. The crook claimed that he had rescued the old lady from neglect and penury. After an interminable court case, Picasso had only just gotten the drawings back and forgiven his mother. He respected rather than loved her for the immense

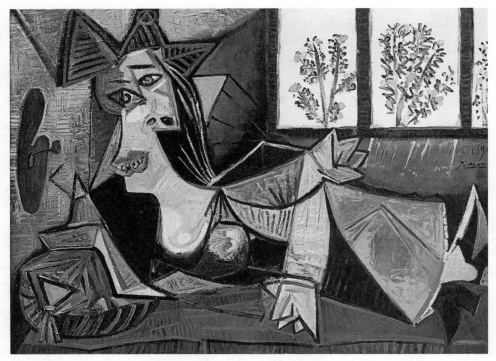

Picasso. *Woman Lying on a Couch (Dora Maar),* 1939. Oil on canvas, 97.1 x 130.2 cm.
Art Gallery of New South Wales, The Lewis Collection.

strength she had passed on to him. He also enjoyed grumbling about her. Sentimentality never afflicted him.

With good reason, Picasso chose not to attend his mother's funeral. Francoists were advancing on Barcelona and the artist, had he gone, would have risked being captured or killed. Instead, he mourned her in Paris in three allegorical still lifes. In the first (January 15), a bull's skull and a jug sit on top of a wacky table.[6] Everything is off-balance in this memento mori. A second one (January 28) is more evolved: two peaches have been added to the composition. The third version is a masterpiece (January 29) in which the bull's head has been excoriated and battered into two sections.[7] The top part has round gaping holes in place of eyes; the bottom, cracked teeth and jawbone. The hideously ornate jug is set between two peaches, one of them cut in half to reveal the stone. Beyond the window is a blue sky and a glimpse of greenery around a mysterious white orb filled with white flowers. This is conceivably a reference to his dead mother, who figures so seldom in his work. These haunting images appear to mourn two tragedies: his mother's death and the Fascists' capture

Picasso. *Reclining Woman Reading.* Tremblay-sur-Mauldre, January 21, 1939. Oil on canvas, 96.5 x 130 cm. Musée National Picasso, Paris.

of Barcelona. On January 26, this city, which had always meant so much to Picasso, finally surrendered to Franco.

Two and a half weeks later, Franco's regime imposed the tyrannical Law of Responsibilities, accusing the defeated Spanish Republic of military rebellion and condemning its supporters to brutal repression. Estimates of those killed in judicial executions in Spain during the post-civil-war years would exceed 130,000. This figure does not include the tens of thousands more murdered without any semblance of a trial.[8]

On February 27, France and Great Britain shamefully recognized Franco's government. Half a million Catalan and Spanish refugees crossed the border into filthy French concentration camps in what became known as La Retirada (the Retreat), one of the worst mass exoduses in modern history. Among them were Picasso's nephews J.Fín, twenty-two, and Javier, seventeen, his sister Lola's sons, who had been part of the Republican militia in Barcelona. These young men had escaped Spain in January, been arrested by the French, and interned in one of the most notorious of these camps, at Argelès-sur-Mer. Conditions were appalling. Refugees lived in tents on

the sand enclosed by barbed wire and battered by extreme coastal weather. Denied proper bathing and toilet facilities, many died of typhoid and dysentery.[9] On February 23, Picasso finally succeeded in rescuing J.Fín and Javier. They stayed in Paris and would join the artist in Antibes later that summer.

Another refugee from Barcelona was the sculptor Apel·les Fenosa, whom Picasso had befriended and set up with a dealer in 1924, when the handsome young Catalan came to Paris for the first time. In May 1939, Fenosa fled Fascist Spain for France, where he, too, was detained at the border, but not for long. During a late-night card game, Fenosa so thoroughly charmed his captors that in the morning the guards released him with new identity papers and some pocket money to ease his entry into France. Back in Paris, the sculptor received a warm welcome at the rue la Boétie. Delighted to see a friend and countryman, Picasso proposed cooking a paella for Fenosa on the floor of the apartment. He had also arranged a surprise. Picasso asked Fenosa if he had received an invitation to an exhibition opening that very afternoon. Fenosa replied that he had not, so Picasso told him that he couldn't see the show. When Fenosa protested, Picasso gave way. "Fine, but this is the last time. Sabartés, show him in." The secretary opened the dining-room doors to reveal a comprehensive collection of Fenosa's pre-1929 works that Picasso had found and collected. The sculptor was bowled over.[10]

As he had in the 1920s, Fenosa once again enjoyed the help and protection of Picasso's Paris connections. That summer, Cocteau introduced Fenosa to Coco Chanel, who would fall for him and commission him to sculpt her. She moved Fenosa, sixteen years her junior, into her suite at the Ritz but its luxury horrified this Communist exile who had survived the deprivations and atrocities of the Spanish Civil War. "Fifty-two Coromandel screens," Fenosa complained of Chanel's décor, "each one worth a million [francs]." [11] Cocteau, who did not share Fenosa's distaste for opulence, soon arranged a swap. He would take the room at the Ritz offered by Chanel and Fenosa would take Cocteau's apartment on the Place de la Madeleine.[12]

On January 17 Paul Rosenberg opened a show of thirty-three Picasso still lifes painted between 1936 and 1938, works described by Sabartés as "a kind of narrative of the intimate life of the man in terms of familiar objects, of what he ate and drank, and loved to keep before his eyes and could not part with."[13] The dealer had purchased these canvases from the artist the previous November—a sale that helped Picasso fund his ongoing contributions to Spanish and Catalan relief agencies. Little did he know then that this would be his last show with Rosenberg after a hugely profitable twenty-year partnership. The exhibition was a sensational success.

George Hoyningen-Huene. Photograph of Apel·les Fenosa and Coco Chanel, 1939. George Hoyningen-Huene Estate Archives, Stockholm.

Praise poured in from Picasso's friends and fellow artists. "Each canvas," wrote Cocteau, "puts you under a spell, and the ensemble under another spell."[14]

The German-Jewish artist Otto Freundlich recognized the political significance of the recent still lifes. "I see the spark of freedom in all the paintings exhibited at Rosenberg," he wrote in an eloquent letter to Picasso. Sharing the Spaniard's agony over the bitter outcome of the civil war, Freundlich felt "ashamed for the people of France who did not force their government to send arms and enough food to the sublime republican men and women of Catalonia."[15] Picasso so admired Freundlich's work, as well as his anti-Fascist ideals, that he had signed a 1938 petition urging the French state to purchase one of his canvases. Freundlich's modernism, like Picasso's, was anathema to the Third Reich in his native Germany, which had used one of his sculptures for the cover of the *Degenerate Art* exhibition guidebook in 1937. In 1943, Freundlich's life would end in a Nazi death camp.

Around the time of the Rosenberg opening, collector Meric Callery became an

Time magazine cover with Dora Maar photograph of Picasso, February 13, 1939.

unofficial Paris agent for Alfred Barr, who was planning his own major Picasso exhibition at New York's Museum of Modern Art. Barr asked Callery to take a "sympathetic interest in the rather complex problem of maneuvering through the devious intrigues which surround Picasso." Knowing the artist to be "capricious and irresponsible," Barr wanted Callery to keep him informed of Picasso's "state of mind and also of the attitude of other key persons involved such as Rosenberg, Reber and the others."[16] Callery consented to spy for Barr. On February 17 she wrote to him of Picasso's doings, reporting that Rosenberg's show "is surprising in that it is so pretty, colorful, and gay. They have had over six hundred people per day to see it. Rosie is in a state of great excitement, it is as though the pictures were painted specifically to his taste." Completely missing the meaning of the still lifes, she called them "a lesson in color and composition to Matisse and Braque but hardly a satisfaction to us who admire Picasso for quite a different quality."[17]

The success of Rosenberg's show inspired *Time* magazine to put Picasso on its cover for the first time. The photograph, by Dora, shows the artist standing against a large 1932 painting of Marie-Thérèse. The accompanying feature article called Picasso "Art's Acrobat," and claimed that his name was one of only two things that millions of people know about modern art—"the other being that they don't like it. But the show at Rosenberg's had a new significance, because it came at the full tide of a new period both in Picasso's work and in appreciation of it."[18] The artist had long been a hero to American modernists and, indeed, was about to be honored by Barr's mammoth retrospective. But a "new period"? The *Time* article treated the artist's oeuvre as a sequence of disparate chapters, making his career seem like one gimmick after another instead of a constant flow of ever changing concepts.

Picasso was keen to keep details of his personal life and domestic troubles out of *Time* magazine.[19] And for good reason. The courts had not yet settled the terms of his separation from Olga, and Paulo was still unwell. In May 1939, at the recommendation of Paulo's godmother, Misia Sert, Picasso sent his son to a posh Swiss sanitarium, Les Rives de Prangins, which catered to the rich and famous (Zelda Fitzgerald had spent over a year there in the early thirties). "Guests," as the clients were called, were housed in private villas on one hundred manicured acres with gardens, farms,

tennis courts, and swimming pools. The doctors, who lived on site with their wives and children, treated patients like part of their family. One French psychiatric journal compared the program at Prangins to "a vacation for teenagers entrusted by their wealthy parents to refined tutors for a graceful initiation into the practice of living."[20]

Olga also came to the sanitarium, perhaps to oversee Paulo's care or, more likely, to receive some herself. Paulo would remain at Prangins through the following year.[21] Picasso complained to Dora that keeping his wife and son in Switzerland "was costing him a pile of money, but it was worth it to have them both out of the way."[22]

Early in May, Picasso set off in the Hispano-Suiza driven by Marcel to Royan, a resort on the Atlantic coast favored by prosperous bourgeois families. Dominating the flowerbed-lined promenade along the beach was an imposing casino, which would later be flattened by Allied bombers. The city is still a popular resort, but less genteel than it had been in Picasso's day. The artist went there to arrange safe accommodation for Marie-Thérèse and Maya in the event of war. He rented the second floor of the Villa Gerbier de Jonc where Marie-Thérèse would live with her sister, Geneviève, their mother, and Maya. They would arrive on July 10 and come to feel very much at home at Royan. Only after war broke out in September would Picasso decide to join them there.[23]

Rather than return to the hotel at Mougins where he had stayed the previous three summers, Picasso spent July and August 1939 at Antibes, on the French Riviera. Having frequently visited the Cuttolis, he knew the town well. Dora also liked the idea. Their old friend Man Ray turned out to have an apartment in the Palais Albert I that he was ready to rent.[24] The decoration was garish, but the place was flooded with light. It also had a living room that would work as a studio and a terrace overlooking the Mediterranean. On July 8, Man Ray gave Picasso the key.

From Antibes, Picasso deluged Marie-Thérèse with passionate love letters. On July 16 he wrote: "My love, I love you more every day. You mean everything to me. And I will sacrifice everything for you, and for our love, which shall last forever. I love you. I can never forget you, my love and if I am sad, it is because I cannot be with you, as I would like to be."[25] Letters to his other women seldom reached this pitch of affection or corniness.

On July 22, Picasso received news that Ambroise Vollard, his friend and dealer, had been killed in a car crash. A Maillol bronze on the backseat was said to have shot forward and brained him when the chauffeur, who was unhurt, came to a sudden stop. Some believed Vollard's death to have been a murder motivated by the incalculable value of his vast stock of major works by Cézanne, Gauguin, Renoir, Picasso, Matisse, and others. Vollard's collection was divided between his dubious

Dora Maar. Photograph of Picasso in Antibes, summer 1939.
Musée National Picasso, Paris.

brother Lucien, his two sisters, and his diminutive but beautiful mistress, Madeleine de Galéa. Much was made of the fact that Lucien Vollard was "a curious character later described as perpetually insolvent and possibly a drug addict."[26] His portion of Vollard's considerable estate would end up in the hands of Martin Fabiani, a colorful but crooked dealer who had formerly worked for Vollard and would make a vast fortune trading in works seized from Jewish collectors and doing deals with the Nazi occupiers during the war.

Picasso, who had a superstitious fear of death, raced back to Paris for Vollard's funeral at the church of Sainte-Clotilde on July 28.[27] Besides being a close friend, Vollard had marketed most of Picasso's major engravings. Vollard's loan of his house at Le Tremblay had consoled Picasso for the loss of Boisgeloup to Olga. Besides the emotional strain of the funeral, Picasso experienced some kind of physical distress while in Paris. Had the debilitating sciatica that struck him several months prior started to act up again? Dora, anxious, wrote from Antibes: "Are you still in pain? Did you have time to see Dr. Gutmann? Based on your telegram, I understood that you had traveled all night. I'm afraid that this trip will tire you. I really would like you to stay healthy."[28] She signed the letter "Dorita the photographer (insufferable

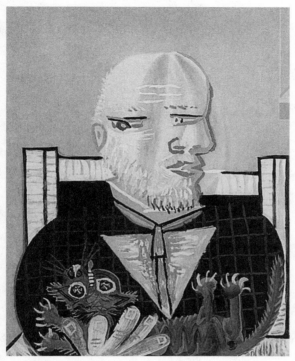

Picasso. *Portrait of Ambroise Vollard with His Cat.*
Paris, 1937. Oil on canvas, 61 x 46 cm. Archives
Succession Picasso.

and ugly singer)"—a sad choice of words for a woman trying to reinvent herself as a painter.[29]

The day after the funeral, Picasso returned to the south. Meric Callery, closely monitoring his movements for Alfred Barr, had sent the artist a wire from Fréjus, on the Mediterranean coast, where she had attended a bullfight.[30] There was to be another corrida there the following day. Picasso took Sabartés. The secretary recalled that they arrived in the morning "to watch the bulls being transferred from their cages to the corral. Like two street urchins we stood up on a wall, clinging to the bars which shut off the alley." Picasso was unimpressed by the bulls. "Just little lambs, don't you think? You can be sure that no blood will be spilled. The bullfighters of today know how to do everything with precision. Everything is measured, calculated. Emotion is out of style."[31]

After driving around the coast for a few days with Sabartés, Picasso returned to Antibes and the company of Dora and Jacqueline Breton, who had joined them.[32] Penrose and Lee Miller, Meric Callery, and Paul Rosenberg also came to Antibes that summer. They found the artist intent on painting. He loathed the tacky clutter of Man Ray's apartment, and with Sabartés's and Marcel's help, stashed away the gaudy

pictures and furniture. The salon became the studio that Picasso soon filled with painting materials as well as his usual junk. There was nothing to be done about the kitschy floral wallpaper, so he blotted it out with large bare canvases, one of which he would transform into a masterpiece, *Night Fishing at Antibes*.[33]

Picasso's evening walks with Dora and Jacqueline gave him the idea for *Night Fishing in Antibes*. Their destination was usually a small rocky harbor where fishermen worked by night, in the bright light of acetylene lamps. These lamps attracted fish, which fishermen in boats or on the rocks would spear with tridents, as does the central figure in *Night Fishing*. Picasso gloried in the gorgeous colors and blinding light in the midst of darkness. The two towers, top left, represent the Château Grimaldi, which would later house Antibes's Picasso museum. The painting is filled with personal references: the freakish image of Dora on the jetty on the right, her legs entwined with her bicycle, licking testicular scoops of ice cream with a pointed blue tongue. She has a penile head, large heart-shaped breasts, and a vaginal bicycle seat is indicated on her purple skirt. The louche girl beside her is Jacqueline, whose right arm reaches toward the sun.[34] To her husband's horror, Jacqueline liked to dye her hair green from time to time—a striking detail caught by Picasso for caricatural effect.[35]

The cruel and comical touches in this great painting hint at its elusive depths. Like *Guernica*, *Night Fishing* is Mithraic. The incongruous sun, with a cometlike tail, illuminates the nocturnal darkness. *Night Fishing* is one of Picasso's most profoundly spiritual works, as art historian Timothy Anglin Burgard has demonstrated. Burgard identified the source for some of the imagery in the Bibliothèque Nationale's illuminated manuscript *Apocalypse of Saint-Sever,* with its medieval Spanish commentary on the Revelation of Saint John. The manuscript's Second Trumpet folio is close to *Night Fishing* in that it depicts men in boats working by the light of the stars. "The falling stars of the Apocalypse . . . so prominent in this folio," states Burgard, "suggest a similar interpretation for the five geometric objects that hover around the two fishermen in Picasso's painting."[36]

Work would never stop Picasso from taking a morning swim. Every day he joined his friends on the beach, read the papers to stay informed, and discussed the political nightmare. His presence and daily routines at Antibes became the subject of a short article in *Les Nouvelles Littéraires*. The journal reported that "one could see him at the *bijou-plage*, a cozy little corner beyond Juan-les-Pins, walking the beach, wearing only a simple little bathing suit, like van Dongen. But the afternoons were devoted to work."[37] The defeat of the Spanish Republic had depressed Picasso, but some relief came with the arrival at Antibes of his young nephews J.Fín and Javier. Their youthful antics and wit enlivened the spirits of their gloomy uncle and his entourage in the days before Hitler invaded Poland.[38]

On August 26, the French government ordered the full mobilization of the military. Picasso and his group met at a café on Antibes's main square to make arrangements for getting home to Paris, London, and New York. They worried about what the future held for them. Joining the army? Sheltering in the country? Escaping to the United States? Soldiers had already begun setting up machine-gun posts to protect Antibes's harbor. Though this popular tourist resort had virtually emptied, Picasso was not ready to leave. His great painting was not finished. Typical of the enemy, he joked, to start a war just when his work was going so well. In the end, he had no choice.

After an abrupt farewell to friends, unsure of when he would see them again, Picasso started to pack. An immense task. Wherever he worked, he accumulated a mass of stuff. There would have been no room in the car with the vast *Night Fishing at Antibes* rolled up on the backseat, so he got tickets for himself, Dora, and Sabartés on an overcrowded train to Paris. A day or two later Marcel followed in the Hispano-Suiza with studio impedimenta and the mammoth painting.

The day after his arrival in Paris, Picasso resumed his ironical complaint. "If it's to annoy me that they make war," he asked Sabartés, "they are carrying it too far, don't you think? They might at least have told me. Why should they kill so many people for such a small matter? But honestly, don't you think this is fate? First Vollard and then—just as I was beginning to do something . . ."[39]

Although war would not be officially declared until September 3, warnings went out of an impending air attack. Many had decided to flee the city, including Gertrude Stein. In a frantic effort to protect her art collection, Stein had called Kahnweiler for help. He arrived at her apartment on rue Christine to find Alice B. Toklas trying to pry Cézanne's portrait of his wife from its frame with her foot. "I stopped her, and set myself to unframing this magnificent work in a less violent manner. They wanted to carry away with them only this picture and the portrait of Stein by Picasso, despite my protestations that they should take at least some small Picassos which would be very easy to wrap and would take up very little room."[40] The next day, Stein and Toklas left for their country house in Bilignin, outside Belley, where they would safely spend the war.

Picasso too made up his mind to quit Paris and go to Royan, urging Sabartés to come with him: "Don't you know that there is danger that German planes will fly over Paris tonight?"[41]

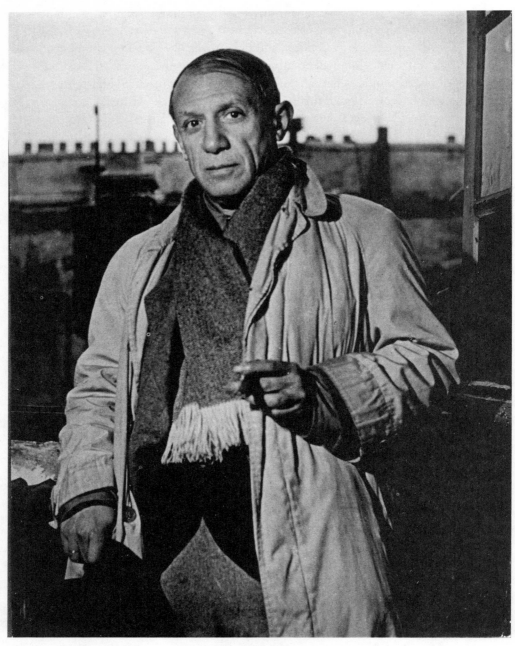

Brassaï. Photograph of Picasso at the window, rue des Grands-Augustins, Paris, 1939.
Musée National Picasso, Paris.

19

Between Royan and Paris

Around midnight on September 1, Picasso set off for Royan with Dora, Sabartés, Mercedes, and Kazbek. Marcel drove at top speed and by dawn they had reached the town of Saintes where they stopped for croissants and coffee, served by waiters in army uniform. As they approached Royan, Picasso was struck by the number of horses on the road, requisitioned by the military. These horses would haunt him.

Far from moving into one of Royan's *hôtels de luxe*, Picasso and Dora settled into the scruffy Au Tigre hotel. They took three rooms: one for themselves, one for Sabartés and Mercedes, and one for Marcel. Dora remembered Royan as hell. Letters to her mother indicate that she was miserable from nearly the moment they arrived.[1] Dora soon realized why Picasso was always disappearing to the nearby Villa Gerbier de Jonc: not only had Marie-Thérèse been lodged there with her sister, mother, and Maya since early July, but the artist had also taken a studio in the same house. The owner, a widow who lived on the ground floor, needed the income and was glad to let Picasso paint in her dining room. The room was small and dark, shaded by trees that lined the street, hence the smallish size of most of his canvases for the next six months. Dora, meanwhile, set up a small studio of her own in the space she shared with Picasso at the hotel.

In the memoir that Sabartés began writing while at Royan, he gives a detailed but inaccurate account of this period, inaccurate insofar as he omitted any reference to the artist's mistresses. Picasso's Royan entourage included six women, most of whom had likely never met nor known of each other's existence—not officially at least—let alone that they would be living in the same town for almost a year.[2] Picasso had always been at pains to keep the women in his life unaware of his other relationships. Divide and rule. Neither his mistresses nor his staff knew what was in store for them. At first Picasso's two *ménages* operated separately but, little by little, the two groups got to know each other, and, except for Dora and Marie-Thérèse, everyone apparently got on well.

A vintage postcard of the Au Tigre hotel, Royan.

During one of his first walks around Royan, Picasso was disturbed to see an announcement posted on the walls of public buildings directing foreigners who had arrived after August 25 to leave the city. In order to stay, he would need a special residence permit from officials in Paris, and so on September 7 he, Dora, and Sabartés drove back to the capital just for the day. Concerned that the French might send him back to Spain if Franco sought his extradition, Picasso had recourse to André-Louis Dubois, Paris's former chief of police, now deputy director of the French Sûreté. This liberal civil servant would be one of the first to lose his post when the Vichy regime took over, but would continue to operate undercover for writers, actors, and artists. He granted Picasso's permit to live at Royan and would later take pains to protect him throughout the German occupation.

Before leaving Paris, Picasso, Dora, and Sabartés had stopped by the rue la Boétie when they heard air-raid sirens and were obliged to spend an hour in a bomb shelter. The sudden threat of death from the sky gave Picasso his first direct experience of what he, while painting *Guernica*, had called "the commonest and most primitive effect of fear."

That fear is felt in two of the first drawings he did at Royan, depicting horses led by a strapping farmhand. The horse on the left of the September 11 drawing[3] recalls his 1906 masterpiece *Boy with a Horse*, and the one on the right looks more recalcitrant. Later that day, he did an ink-wash night scene that is permeated with death. As Elizabeth Cowling observes, this work was inspired by Géricault's spectacular 1817 *Race of the Riderless Horses on the Corso, Rome*.[4] Picasso was evidently moved by the military horses he saw on the road to Royan, many bound for the battlefield.

What would he have felt, one wonders, if the horses had been destined for the bullring?

Later that fall, Picasso again left Royan for Paris, this time to see Brassaï. *Life* magazine planned a feature article to celebrate Picasso's upcoming MoMA retrospective and had commissioned Brassaï to photograph the artist in Paris.[5] In his memoirs, Brassaï recalled that the city "had already assumed her mournful wartime look, shrouded in black every night, all of her lights extinguished."[6] Daytime life went on as usual. Brassaï photo-

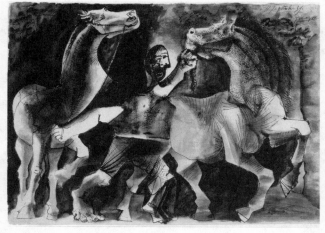

Picasso. *Man with Horses,* 1939. China ink and paper, 45.5 x 64.5 cm. Museum Ludwig, Cologne.

graphed Picasso at his favorite haunts—Brasserie Lipp, where Matisse's son Pierre joined them, Café de Flore, and above all at the rue des Grands-Augustins studio. Brassaï's images had fascinated Picasso. Since photography had liberated painting "from all literature, from the anecdote, and even from the subject," he asked Brassaï, "shouldn't painters profit from their newly acquired liberty, and make use of it to do other things?"[7]

Back in Royan, Picasso attacked a dark new subject triggered by the sheep heads he bought for Kazbek from the local slaughterhouse. Hence the magnificently morbid sequence of wash drawings and paintings, some of them seemingly smeared with blood.[8] Before Kazbek cleaved all the meat from the bone, the skulls were red and meaty, like Goya's late still lifes of animal parts. By the time Kazbek had finished gnawing on them, they looked all the more dead, bleak and colorless—memento mori.

Goya had often haunted Picasso, but never more than now that he, too, was a Spanish exile in France. In old age, Goya had fled to Bordeaux, the major seaport eighty miles south of Royan, for political reasons. Might Picasso have had in mind the Goya still life with a sheep's head, ribs, and loin, which the Louvre had acquired from Paul Rosenberg three years earlier?[9] Like Goya, Picasso empathizes with these hunks of flesh and bone. Picasso also painted and drew Dora's chopped-up face under a bat-winged hat, presenting us with a gruesome skull, one eyeball still in place and a mouth full of white teeth, some of them smashed.[10] This many-layered allegory reflects Picasso's terror at the violence soon to decimate Europe.

After the skulls, Picasso resumed painting his extended family: a portrait of Marie-Thérèse's mother, Émilie Marguerite Walter (October 21).[11] Despite the distortion of her features—not least the nose attached to her cheekbone—the chuckle of her pert little mouth has a sweetness he seldom bestows on his subjects. Far from resenting

LEFT Brassaï. Picasso in the Café de Flore, Paris, 1939. RIGHT Brassaï. Picasso with portraits of Dora Maar in his Grands-Augustins studio, Paris, 1939. Both Musée National Picasso, Paris.

him for having seduced her seventeen-year-old daughter twelve years earlier, Mémé loved Picasso, and, as the portrait confirms, he was very fond of her.[12]

The day after painting Mémé's portrait, Picasso did an even more fanciful one of Sabartés, in glasses and a massive ruff as a sixteenth-century Spanish nobleman.[13] He gets the same treatment as Mémé's image: a displaced nose and pouty mouth. Sabartés writes at length about the genesis of this work, how the artist told him to go see a movie so that he could work on it in private. When Sabartés returned, Picasso unveiled the portrait, smiling like a naughty child. "You don't like it?" he asked. Sabartés "looked at it coldly" and replied "Why shouldn't I like it? Because I don't break forth into exclamations? You know quite well I'm not like that." Picasso put him at ease: "The portrait which I am going to do next will be bigger, a full portrait, in oil, to season up that escarole of the collar with salt and pepper and all the dressings which please your palate, as well as the nude woman, the hound, and the full regalia which you used to wear when you strutted proudly through the corridors of the Escorial."[14]

The same day he painted Sabartés (October 22), Picasso submitted Dora to a somewhat different transformation. He depicts her seated naked on the floor with her arms raised to dress her voluminous hair. He also endows her with massive callipygian buttocks. He had already tried this out on a smaller scale a few days earlier in bright blues and yellows, colors that would obsess him for the next week or so. The striking variety of the Dora paintings from October and November suggests that he was on the brink of a stylistic change. The drawings of her done before his next trip to Paris carry the formal distortions to such an extreme that they don't always work.

Picasso. *Sheep Skull,* October 1, 1939. Ink and oil paint, 46 x 64.7 cm. Musée National Picasso, Paris.

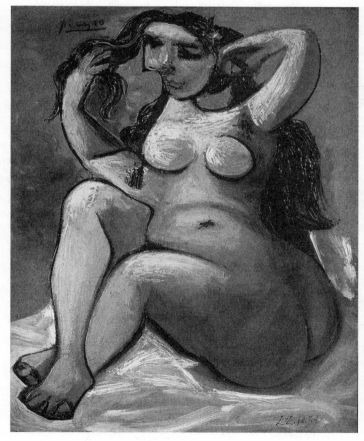

ABOVE Picasso. Study for *Woman in Hat Holding a Sheep's Head,* notebook 42, folio 49 recto, dated 09/30/1939– 10/29/1939. Pencil on graph paper, 21.7 x 16.7 cm. Musée National Picasso, Paris. RIGHT Picasso. *Seated Nude (Dora Maar),* October 22, 1939. Oil on canvas, 41 x 33 cm. Laurence Graff OBE.

LEFT Dora Maar. Photograph of Jaime Sabartés with his portrait by Picasso, 1939. Musée National d'Art Moderne, Centre Georges Pompidou, Paris. RIGHT Picasso. *Portrait of Émilie Marguerite Walter*. Royan, October 21, 1939. Oil and crayon on canvas, 41 x 33 cm. Private collection.

Picasso had been in such a hurry to leave wartime Paris that he had not had time to make long-term arrangements for the vast amount of paintings, sculpture, drawings, prints, and much else scattered around various studios, homes, and dealers' storage spaces, not to mention loans. During his visits to Paris throughout fall 1939, he sought to remedy this by filling a safety-deposit room he had rented at the Banque Nationale pour le Commerce et l'Industrie with his vast collection of his own work and that of other artists. Dora began a photographic inventory of the room's contents. Wise moves: Picasso's collection would survive the war intact.

Meric Callery claimed to have seen Picasso's vault in 1939, shortly before she returned to New York, and later described the visit in an article for *Art News*: "The last time I saw Picasso's pictures with Picasso was . . . in a subterranean world. He had a great corridor to himself, with rooms leading off it, and in those rooms the paintings and drawings were stacked in their familiar order." The artist evidently enjoyed examining his collection with friends. As Callery recalled: "Again he pulled out undreamed-of treasures. Again his eyes sparkled with amusement showing something he had carefully hidden from the public eye."[15]

On November 15, New York's Museum of Modern Art opened *Picasso: 40 Years of His Art,* a retrospective encompassing every phase of the artist's career with over three hundred and fifty works in various media that traveled to eight venues in

the United States.[16] The most comprehensive exhibition of Picasso's work to date was a remarkable achievement for MoMA director Alfred Barr who had, as Marga said, "hoped and worked and schemed" for years to make the show a reality.[17] Along the way Barr had to overcome resistance from both the artist and his domineering dealer Paul Rosenberg. Callery had warned Barr that Rosenberg could be a problem: "He has a way of knowing how to poison Picasso's mind. I have seen him at it many times."[18] Only months before the scheduled opening, and after the exhibition had been announced in the American press, Rosenberg threatened to kill the project by refusing loans from his gallery's stock.

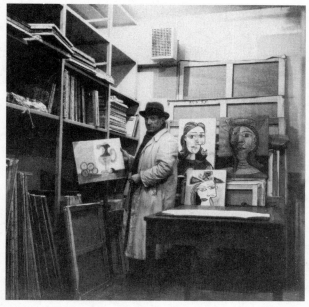

Dora Maar. Picasso in the safe of the Banque Nationale pour le Commerce et l'Industrie (BNCI), Paris, 1939. Musée National Picasso, Paris.

Barr patiently coaxed the dealer into cooperating by giving him a greater say over which works would be exhibited. As he wrote to Rosenberg: "We must all work together. The result could be something that both the artist and yourself would be proud of—especially if you could both be persuaded to come to America for the exhibition!"[19] Neither Picasso nor Rosenberg was prepared to cross the Atlantic, but they supported Barr's plans with dozens of loans—forty from the dealer and thirty-three from the artist, including *Guernica* and most of the studies for it. The public's interest in these works exceeded Barr's expectations. Elated by the attendance figures, he cabled Picasso: "COLOSSAL SUCCESS. IT ATTRACTS ENORMOUS CROWDS, 60,000 VISITORS, SURPASSING [1935] VAN GOGH EXHIBITION."[20] Barr's only disappointment was the absence of Picasso's recent sculptures. Plans had been made to have these recast and sent to New York, but the outbreak of war had made this logistically impossible.[21]

Though the exhibition relied heavily on American lenders, Barr had also managed to secure loans from Britain and France—no small feat considering how many collectors had, like Picasso, already locked away their treasures in bank vaults and other safe places to protect them from wartime dangers. This accomplishment, observes the art historian Michael FitzGerald, "would signal the passing of artistic leadership from Europe to America as the Paris School collapsed and war swept across the Continent . . . The combination of the Modern's growing stature and the war's destruction of Rosenberg's long alliance with Picasso would cause an abrupt shift of power."[22]

Instead of savoring the news of his triumph in New York, Picasso lapsed into a

depression. Kahnweiler found him "bitter and sarcastic, in other words, in a very bad frame of mind."[23] Franco's ongoing cruelties in Spain tormented the artist, as did the possibility of being extradited. In late November, these worries prompted him to see Albert Sarraut, the Popular Front politician serving as France's minister of the interior, whom he knew through Dubois. As naturalization seemed the surest way to protect himself, Picasso took steps to become legally French.

He made another trip to Paris on December 5 and stayed two weeks, seemingly to stock up on painting materials—a difficult task as they were already in short supply—and above all an easel. Hitherto he had been painting on the floor "in a squatting position, his stomach tight against his thighs" in his cramped Royan studio, while using an old chair as an easel. He also used the seat of a chair as a palette. When Sabartés insisted that he abandon this way of working, Picasso refused: "Of course not, man! Don't you see that I am accustomed to it by now?"[24]

On December 28–29, Picasso drew three bullfight scenes.[25] No way these corridas could have taken place in wintery Royan, except in his imagination. An attack of tauromachic nostalgia had apparently struck him more than a month earlier, as witness a simple corrida painting of November 8[26] and a series of drawings of bulls and horses. In the past, his bullfight imagery had been inspired by the hope of seeing the real thing over the course of the summer. This year, that would be out of the question.

Picasso. *Bull,* notebook from Royan (Notebook 202), November 3–9, 1939. Pencil on vellum paper, 11 x 17 cm. Museo Picasso Málaga. Donation of Bernard Ruiz-Picasso.

On Christmas Eve 1939, while continuing to paint and draw prolifically, Picasso returned to poetry for the first time since June. The poem is divided into nine sections and consists, as usual, of a string of images, many of them recurrent and visceral: "the eagle vomits its wings," "the loaf of excrement," and "the ripped skin of the house." The house likely refers not to the hotel where he lived but to his dark studio in the Villa Gerbier de Jonc. Given the prospect of a horrendous war, Picasso's poems are prophetic as well as perversely comical. They are also visual in that the handwriting is as varied and intricate as his drawings. On Christmas Day, the artist/poet wrote a continuation of the previous day's text, as well as a festive, theatrical monologue which hints at the dark side of Christmas chaos and ends with:

> tell me my dears my loves my little piggies have you ever counted by holding your nose until 0 and if not repeat with me the list of losing of all the lotteries

His New Year's Eve poem is short and to the point:

> the lightning falls asleep lazily under the great bells ringing ringing with all their might

Over the next eight months at Royan, Picasso's poetry proliferated as never before. And no wonder. Outside his own circle, he had virtually no friends in the neighborhood, and no cafés or bars as congenially bohemian as the Flore where he could meet people. At the time Picasso lived there, Royan was filled with refugees, among them lonesome girls whose loved ones had gone to war. That Sabartés never hints at anything salacious in his memoir does not imply that Picasso was faithful to his two mistresses. The secretary was too cagey to tell us anything outside of his relationship with the artist—their daily drills, identical walks around the town, stopping off at the same junk shops to buy odds and ends that Picasso would seldom put to their proper use. However, who knows what the artist got up to when he unleashed himself from his obsessively discreet secretary?[27]

Picasso. *Marie-Thérèse Seated*. Royan, December 30, 1939. Ink and gouache, 46.2 x 38.3 cm. Musée National Picasso, Paris.

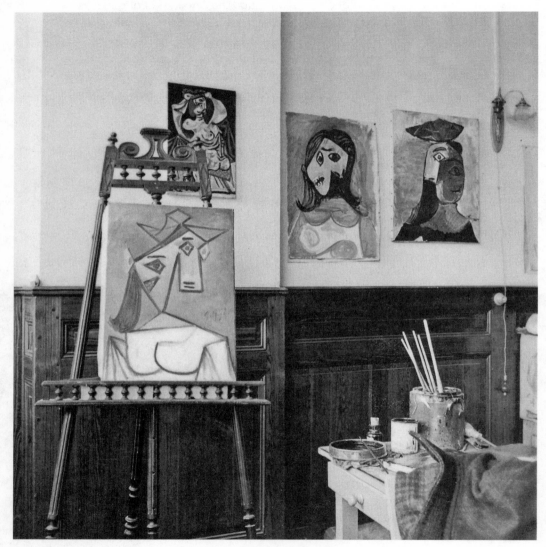

Dora Maar. Picasso's studio with portraits of Dora at Villa Les Voiliers, Royan, 1940.
Musée National d'Art Moderne, Centre Georges Pompidou, Paris.

20

Villa les Voiliers

In January 1940, needing greater workspace in Royan for large paintings, Picasso went in search of a suitable studio and found a suite of rooms on the top floor of Villa Les Voiliers, an imposing building adjoining the Grand Hôtel de Paris. The light was good, and it had a view of the sea. "Ideal for someone who considered himself a painter, don't you think?" Picasso joked to Sabartés.[1]

They scoured the town together for odds and ends to furnish the rooms. Dora's photos of the Les Voiliers studio from that summer show that on one wall Picasso hung a Matisse still life that he had purchased from Vollard the previous spring and taken with him to Royan.[2] Higher on the same wall was a bicycle seat, bulkier than the one he would conjure into a celebrated bull's-head sculpture two years later.

In the 1960s, Les Voiliers' owner, Andrée Rolland, would write a memoir with a description of Picasso's studio in her building.[3] At the center of this "Holy of Holies," as Rolland called it, was Kazbek's bed, an old armchair, and two small tables covered with tubes of paint and photos of little Maya. In one corner she noticed a small painting of fishermen by an unknown artist that Picasso had found in a Royan junk shop. Scattered throughout were piles of cigarette butts on the white plates he used as ashtrays.

Meanwhile, Dora, who hated life at Royan, drowned her misery in paint in the cramped little room that served as her studio at the comfortless Au Tigre hotel. Picasso's decision to take a studio farther from the hotel left her increasingly isolated and suspicious of his activities. She probably hoped that the January arrival of Jacqueline Breton and her daughter, Aube, at Royan would relieve her boredom and loneliness, but in the end it made things worse.[4] Dora's jealousy flared as Jacqueline made friends with Marie-Thérèse. Maya and Aube were the same age and liked to play together. The bond that formed, with Picasso's encouragement, between the mothers and daughters was a painful reminder of Dora's apparent infertility.[5]

Jacqueline stayed at Royan for seven months at Picasso's expense. He paid her room and board at the Au Tigre, enabling her husband—serving as an auxiliary army doctor at Poitiers, a two-hour train ride away—to spend his leaves with her

Postcard with a view of Picasso's studio from Royan's harbor, c. 1940. He marked its location with an arrow. Musée National Picasso, Paris

and Aube. War had deprived Breton of his livelihood and pushed the couple, perennially short of funds, to the brink of bankruptcy. Despite his literary fame, Breton had never earned much, and the money he sometimes made as an advisor and dealer to wealthy collectors often went to fund his own compulsive art buying. Jacqueline would later lament the "years spent with no money surrounded by a priceless collection."[6] Their situation was so precarious in January 1940 that Breton considered selling that collection, and accepted Marcel Duchamp's help finding a buyer.[7] Duchamp arranged for Peggy Guggenheim to take some of Breton's finest surrealist works before Picasso came to the rescue by giving Breton a painting to sell instead.[8]

The artist's generosity also extended to one of the more valiant of Breton's followers, the poet Benjamin Péret. A Dadaist in the early 1920s, Péret became an ardent surrealist (and an editor of *La Révolution surréaliste*); in 1931 his adopted country, Brazil, expelled him for being a Trotskyite. Péret had also joined Spain's Communist-sponsored International Brigades and fought with the Republicans in the civil war—a fact Picasso would have known when he received a January 24 letter in which Péret begged for two thousand francs to save him from being evicted from his Parisian lodgings. A week later, money from Picasso arrived. "I thank you with all my heart for the check I received," Péret wrote. "It has removed from my foot a thorn the size of Sainte-Chapelle's spire, of the Eiffel Tower, or something close to that."[9]

On February 5, Picasso, Dora, and Sabartés left Royan for Paris where they would remain for the rest of the month. On arriving, he received a worrying letter from

Olga, asking him to decide the problem of Paulo's nationality—French, Russian, or Spanish—in order to absolve the boy from military service.[10] Picasso put this aside for a time to deal with a more pressing legal matter. On February 15, the court officially granted his judicial separation from Olga. Devastated by the decision, which she had long opposed, Olga soon withdrew to the same Swiss sanitarium that had been treating Paulo, Les Rives de Prangins.[11] Over the next three years, she would twice appeal the separation ruling, but her challenges were dismissed as dilatory or baseless.[12]

After a few days back in Royan, the artist returned to Paris again by mid-March. Dora accompanied him but, for once, Sabartés was left behind.[13] This time Picasso stayed on for two months in an attempt to obtain French nationality. After submitting an application on April 3, the artist was interrogated by the police at the rue la Boétie. They also obliged him to sign an oath of loyalty to France and provide details of his finances and properties. While gathering the documents required for naturalization, Picasso went to work in his Grands-Augustins studio. He revealed his reaction to this anxious time in letters to Sabartés. On April 3: "I have worked, I have done three still lifes with fishes, weighing scales, a big crab, and eels. In short, I'm homesick for Royan's marketplace."[14] Then, a few days later: "I am working; I am painting;

LEFT Dora Maar. Picasso's studio at Villa Les Voiliers, with his reflection seen in the mirror. Royan, 1940. Musée National d'Art Moderne, Centre Georges Pompidou, Paris. RIGHT Dora Maar. Another view of the studio. Royan, 1940. Matisse's *Bouquet of Flowers in a Chocolate Pot* (c. 1902) hangs to the right of the door. Musée National Picasso, Paris.

and I'm fed up. I would like to be at Royan; but everything takes too long."[15] His March 19 painting depicts a creepy crab and eel on the right and a slithery, dead-eyed rascasse on the left.[16] Perhaps on the same day, he did a lighter-hearted version of the same subject.[17] The pop-eyed crab has comically taurine claws waving in the air. Eight days later, Picasso resolved the composition. The claw-waving crab, fish, and writhing eels look terrifyingly alive.[18]

Under normal circumstances, the artist might have given Paul Rosenberg the first opportunity to buy these works. Rosenberg, however, had already fled Paris in anticipation of the German advance. It would appear that on April 11, Kahnweiler purchased the three *fruits-de-mer* paintings for 150,000 francs.[19] One week later they were shown alongside several other recent Picasso works in an exhibition organized by Yvonne Zervos at the Galerie M.A.I.[20] From his temporary refuge at Floirac, Rosenberg wrote often to Picasso in the first months of 1940 seeking news, and paintings, from the artist. Neither was forthcoming.

While in Paris, Picasso also received letters from his chauffeur, Marcel, who had now been drafted into the army and stationed at Camp de Coëtquidan in Brittany. "The last eight days have felt like eight thousand. I've already shed some fat and my big belly has taken a hit, at least for now." If his diet did not return to normal soon, complained Marcel, he would be reduced to skin and bones. The morale of his fellow soldiers was very low, and he implored Picasso to help exempt him from military service or at least to get him stationed closer to the capital.[21] Marcel's absence had restricted Picasso's movements. As Éluard wrote on April 8: "Aren't we going to free Marcel? Because if he was with you by now you would have come to spend a few days with me."[22]

Picasso. *Le Chapeau aux Fleurs* (*Hat with Flowers*), April 10, 1940. Oil on canvas, 72 x 60 cm. Musée National d'Art Moderne, Centre Georges Pompidou, Paris.

In Paris, Picasso resumed doing portraits: on April 10, *Le Chapeau aux Fleurs,* maybe of Nusch,[23] followed by a series of Dora portraits that are lacking in passion. Dora was used to being caricatured, humiliated, and tortured by Picasso—graphically, but hitherto agelessly. Sometime in May, Picasso did a drawing of her looking handsome and well coiffed but seemingly old, as if she had caught sight of herself in a mirror thirty or forty years later, a chic hag in a rage. Heavy chin, Kazbek-like nose, desperate eyes as well as her neck and breasts are

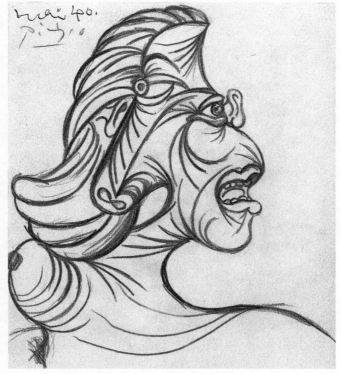

Picasso. *Female Head,* 1940. Pencil on paper, 22.5 x 18.7 cm. The Museum of Modern Art, New York. Gift of Justin K. Thannhauser.

hideously wrinkled. Dora was only thirty-three, but for Picasso that was already middle-aged.

All of a sudden on May 2, Picasso switched back to neoclassicism in a sequence of drawings. Their subject seems to have begun as the three ages of man. The first represents a handsome young faun (given his horns and tail) seated on a bed, gazing at the supine girl beside him, her buttocks reflected in a mirror on the wall.[24] In the next drawing, the faun has become human and has grown a beard. He looks down lovingly at the girl, whose head is thrown back voluptuously, masses of hair flowing over her pillow.[25] In yet another drawing done that day, much more *travaillé* than the others, the motif takes a violent turn. The girl is being ravished, but her reaction seems ambivalent. She shoves the man's bearded head away with an upward thrust, but her right leg is wrapped around his waist.

Did Picasso envision this image as a rape of Europa? German forces had occupied Norway and Denmark in April and were about to enter France and the Low Countries. Later in the month, Picasso revealed his anxiety over these events when he ran into Matisse on the rue la Boétie. Matisse described their conversation in a letter to

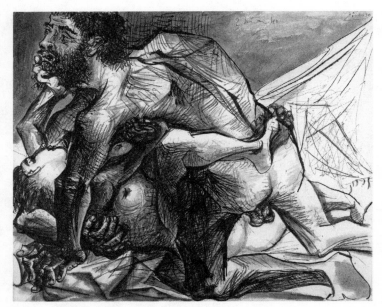

Picasso. *The Rape*. Paris, May 2, 1940. Pen and ink, brush and ink, wash on paper, 38.1 x 45.7 cm. Yageo Foundation, Taiwan.

his son Pierre: "I met Picasso, who, on seeing my red face beaming with pleasure said to me: 'What's wrong with you? Don't you know the Germans have reached Reims?' 'No,' I replied. 'So where are our armies and generals?' 'At the École des Beaux-Arts,' Picasso answered. He was quite right."[26] Ineptitude was indeed the cause. Picasso was fed up with the French generals who had failed to repel the German invasion. Matisse told him that he, too, was hiding his treasures in a bank vault, and that he was planning to go to Brazil—a voyage he never took. Picasso promised to guard his vault for him.[27] Instead of going to Brazil, Matisse left for his apartment in Nice where he would spend most of the war.[28]

After two months in Paris, Picasso decided to return to Royan in mid-May. Since Marcel was still in the army, Rosenberg wrote to Picasso on May 9 proposing the loan of his car and driver back to Royan.[29] But the roads were crowded with refugees fleeing the Germans, so Picasso and Dora wisely took the train on May 17.

As May turned into June, a flood of bad news reached the artist in Royan, none worse than the result of his efforts at naturalization. No luck. His application was denied on the basis of a trumped-up report submitted to the Renseignements Généraux (French intelligence), claiming that Picasso, at a Saint-Germain café, had

LEFT Picasso. *Seated Nude with Raised Arms,* from a notebook, dated 01/09/1940–5/26/1940. Pencil on graph paper, 10.5 x 17.5 cm. RIGHT Picasso. Study for *Woman Dressing Her Hair*, from a notebook, dated June 6, 1940. Pencil on paper, 16.3 x 22.3 cm. Both Musée National Picasso, Paris.

been overheard criticizing French institutions and openly supporting the Soviet Union. The report also accused the artist of having told associates that he intended to bequeath his entire collection to the Russian government. The source of this rubbish was supposedly a Polish officer in civilian clothes who claimed to have reprimanded Picasso for these statements. In the file compiled by the police, events from Picasso's past were also cited as reasons to refuse his application: in 1905 he had been identified as an anarchist; he had failed to fight for France in World War I; he supported the Republicans in the Spanish Civil War; and despite his considerable wealth, he had recently tried to have his rent reduced. Without French citizenship, the fear of extradition would continue to hang over the artist's head.[30]

Around this time, Picasso also learned that the Château de Boisgeloup had been ransacked. A letter arrived from Alfred Réty, the caretaker, stating that French soldiers had taken over the property, which had belonged to Olga since the separation. Réty had done his best to communicate with her, to no avail. "I can't warn her," he worried. "I think Madame is staying in Switzerland and that my letters may never reach her."[31] Picasso hired the bailiff Alfred Payen to visit Boisgeloup and report on its condition. On July 31, Payen informed him that the château had been "pillaged from the basement to the attic." Much of the furniture had been slashed open and searched or thrown in the stables. Payen attributed the damage to French soldiers

Dora Maar. Photograph of Picasso and Jaime Sabartés with *Woman Dressing Her Hair* at Villa Les Voiliers, Royan, 1940. Musée National d'Art Moderne, Centre Georges Pompidou, Paris.

and people in the neighborhood rather than to the Germans, who, he said, had not entered the house. He concluded his report on a positive note: "The building hasn't suffered. Though many bombs have fallen nearby, none have done any harm."[32] Picasso wrote back, authorizing Payen to do everything he judged necessary to safeguard the house, the studio, and the sculptures stored there.

Elsewhere in France, a German air raid had nearly taken the life of Picasso's publisher, Christian Zervos, who was determined, despite the war, to complete the second volume of the artist's catalogue raisonné[33]: "I will finish this book unless I'm dead—something almost happened to me last Saturday." Zervos recounted the har-

rowing experience of driving through the country and finding himself in the midst of a bombardment by the Luftwaffe: "I left my car immediately to lie down in a field." The bombs exploded less than a thousand meters away, giving Zervos "an unpleasant sensation as if my stomach was coming up to my throat and choking me."[34]

Beset with worries over the safety of his friends and his property, Picasso immersed himself in his work. Now that he had a spacious studio at Royan, he embarked on the masterpiece that he had been planning for the previous eight months: *Woman Dressing Her Hair*, the only major painting he completed during his time at Les Voiliers.[35] The composition was conceived sculpturally, as a large figure squashed into a very small space. His original sketches depict a naked woman fixing her hair in a mirror, as if we, the onlookers, were the mirror.

Everything about the painting is paradoxical: Is she smirking or snarling, monumental or claustrophobic? She is both extremely bony yet extremely fat. Cowling remarks: "This has the effect of making her seem simultaneously malevolent and pathetic, the evil enemy and the innocent victim, Death and Death's prey."[36] Dora's massive left foot seemingly kicks us out but also drags us in. Of all the images that this masochistic model-mistress had inspired, this is one of the most revealing in its implications. As Picasso finished the painting, Nazi troops took Paris (June 14) and steadily pushed west toward Royan, giving him reason to wonder if "this might be his last ever major statement as an artist."[37]

On June 22, France's prime minister, Henri-Philippe Pétain, signed the armistice ending hostilities with Germany. Nazi troops arrived in Royan the following day and took over the hotel next door to Picasso's studio. As he watched the motorcade of tanks and trucks enter the city, Picasso remarked philosophically to Sabartés: "So many troops, so many machines, so much power, so much noise to get here! We arrived more quietly . . . What nonsense! Why can't they do what we did? They probably even think they have conquered Paris! But we, without moving from here, took Berlin a long time ago and I believe they will not be able to dislodge us."[38]

Parisians like Picasso who had decamped to the Atlantic coast at the outset of the war now faced difficult decisions: whether to return to the occupied capital, and if so, when. In a letter dated June 27, Picasso's banker Max Pellequer, who had been living at Bordeaux, urged the artist to come back to Paris right away.[39] As director of the Banque Nationale pour le Commerce et l'Industrie, Pellequer understood that Picasso's Paris assets, including the contents of his bank vault, were at greater risk of confiscation if he could not account for them in person. The artist said this was impossible. As he complained to Zervos, "I'm here for I don't know how long. Foreigners can't move."[40] Zervos believed Picasso was better off at Royan: "[Paris] is dead, petrified. No people, no cars, no buses, nothing . . . Please do not come back here, you won't be able to live or work."[41]

Picasso. *Skull with Poetry,* from a notebook, dated July 24, 1940. Ink on paper, 16.3 x 22.3 cm. Musée National Picasso, Paris.

Ten days later, Zervos wrote again, stressing the grimness of life in Nazi-occupied Paris. "All day, German planes fly over our roofs with an appalling din. Le Bourget [Airport] has been bombed by the British. They came again the day before yesterday. This brings home to us the fact that we're at war." Zervos worried about friends in other parts of France, and cited the case of the eminent Jewish writer and critic Carl Einstein, who had killed himself out of fear of falling into the Nazis' clutches. Once again, Zervos warned Picasso to stay put at Royan, where "at least you have some air, some light. Here we're in prison. All we hear about is food and bread, etc. There is almost nothing to eat and people are getting angry. I'm afraid that this will go on for a long time, because it seems the Germans want to punish us for all they have suffered in the past."[42]

Picasso took Zervos's advice and stayed on at Royan for two months after the Germans arrived, writing poetry almost every day and filling a sketchbook with drawings of grotesque skulls and heads of Dora. On July 24 he mixed media to combine image and words in a wash drawing of an ox skull and tongue on which he composed a fourteen-stanza poem in tiny, albeit legible handwriting quite unlike his usual flamboyant scrawl. Far from being consecutive, these poetic notations are mostly ecstatic and repetitive: "ox tongue of the metal quaking in the crystal cup enveloping the wounded head of the bouquet of flowers with so much tender love." The ambiva-

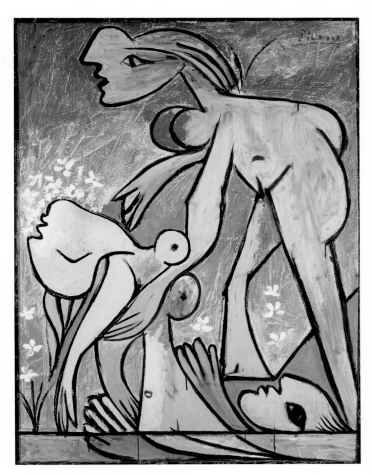

Picasso. *The Rescue (Le Sauvetage)*, December 18, 1932. Oil on canvas, 130 x 97.5 cm. Fondation Beyeler, Riehen/Basel, Beyeler Collection.

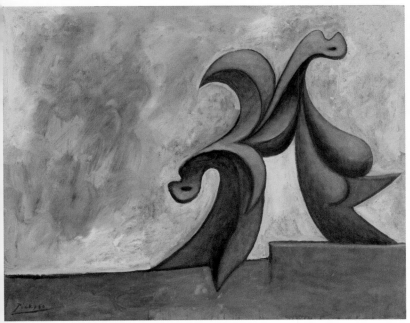

Picasso. *The Rescue (Le Sauvetage)*, January 11, 1933. Oil on canvas, 73 x 92 cm. Fondation Jean et Suzanne Planque, on deposit at Musée Granet, Aix-en-Provence.

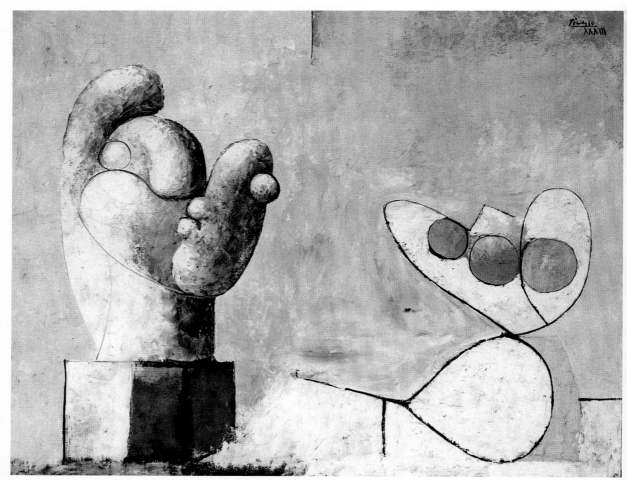

Picasso. *Plaster Head and Bowl of Fruit,* January 29, 1933. Oil on canvas, 73.3 x 92.1 cm. Harvard Art Museums/Fogg Museum, Cambridge. Gift of Mr. and Mrs. Joseph Pulitzer, Jr.

Picasso. *Head of a Warrior*, Boisgeloup, 1933.
Bronze with patina, 121 x 69 x 32 cm. Fundación
Almine y Bernard Ruiz-Picasso para el Arte, Madrid.

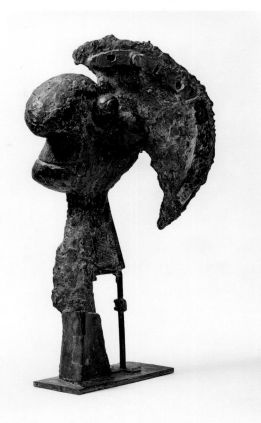

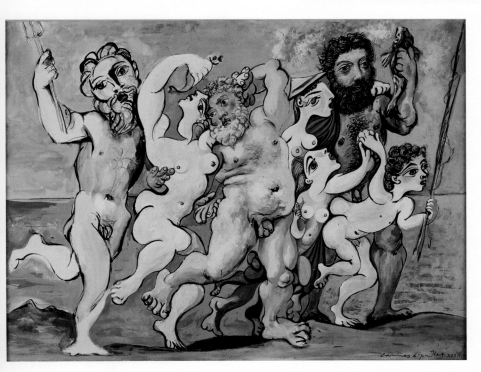

Picasso. *Silenus
Dancing*, 1933.
Gouache and ink on
paper, 34 x 45 cm.
Nationalgalerie,
Museum Berggruen,
Staatliche Museen,
Berlin.

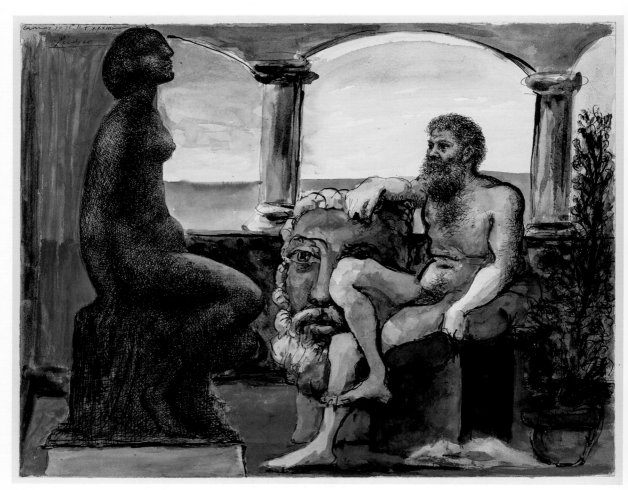

Picasso. *The Sculptor and His Statue*, July 20, 1933. Ink, watercolor, and gouache on paper, 39.5 x 50 cm. Nationalgalerie, Museum Berggruen, Staatliche Museen, Berlin.

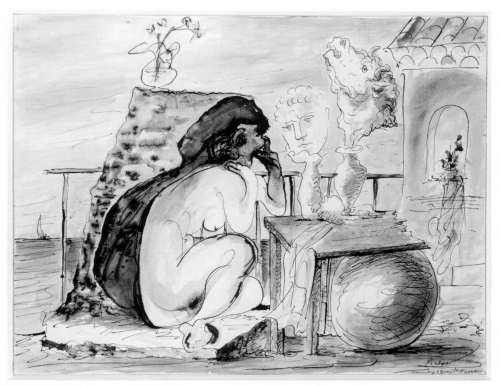

Picasso. *Nude in a Landscape*, July 29, 1933. Watercolor, pen and India ink on paper, 40.5 x 51 cm. Museum Ludwig, Cologne.

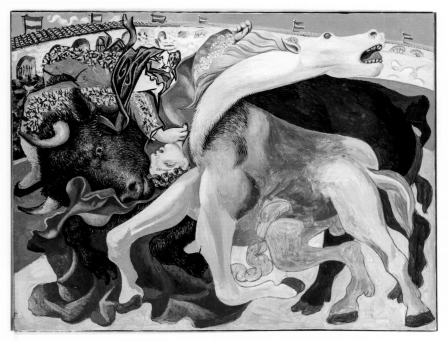

Picasso. *Bullfight: Death of the Toreador,* September 19, 1933. Oil on wood, 31 x 40 cm. Musée National Picasso, Paris.

Picasso. *Two Figures (Marie-Thérèse and Her Sister Reading),* April 10, 1934. Oil on canvas, 100.3 x 81.6 cm. Koons Collection..

Picasso. *Nude with Bouquet of Irises and Mirror*, Boisgeloup, May 22, 1934. Oil on canvas, 162 x 130 cm. Musée National Picasso, Paris.

Picasso. *Reclining Nude Before a Window,* February 8, 1934. Watercolor over pen and ink on paper, 26 x 32.7 cm. Museum Collection Rosengart, Lucerne

Picasso. *Nude in a Garden,* Boisgeloup, August 4, 1934. Oil on canvas, 162 x 130 cm.
Musée National Picasso, Paris.

Picasso. *Bull's Head*, April 14, 1935. Colored pencil on paper, 23.7 x 18.9 cm. Archives Succession Picasso.

Picasso. *Minotaur and Wounded Horse*, April 17, 1935. Pen and brush and black inks, graphite, and colored crayons on cream laid paper, 34.3 x 51.5 cm. The Art Institute of Chicago.

Picasso. *La Minotauromachie,* state VII, 1935. Etching and scraping, 49.8 x 69.3 cm. Musée National Picasso, Paris.

Picasso. *Woman with Hat*, 1935. Oil on canvas, 60 x 50 cm. Musée National d'Art Moderne,
Centre Georges Pompidou, Paris.

Picasso. *Dora Maar with Green Fingernails*, 1936. Oil on canvas, 65 x 54 cm. Nationalgalerie, Museum Berggruen, Staatliche Museen, Berlin.

Picasso. *The Pencil That Speaks*, January 11, 1936. Watercolor, pastel, color crayon, ink and pasted paper, 33.6 x 50.8 cm. Private collection.

Picasso. *Portrait of a Young Girl*, Juan-les-Pins, April 3, 1936. Oil on canvas, 55 x 46 cm.
Musée National Picasso, Paris.

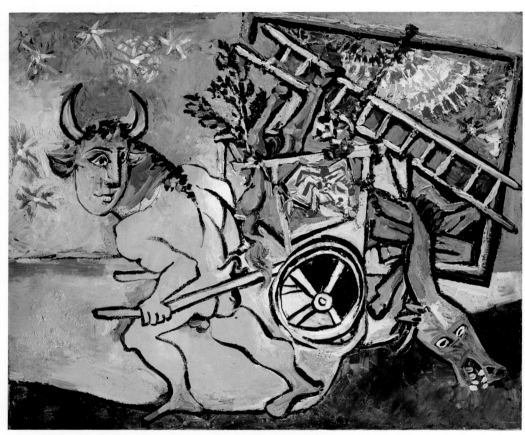

Picasso. *Minotaur with a Wheelbarrow*, April 6, 1936. Oil on canvas, 45.5 x 54.5 cm.
Archives Succession Picasso.

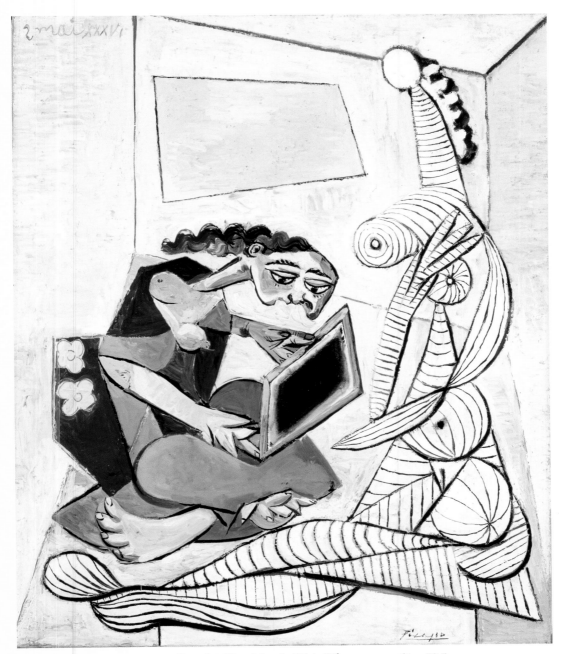

Picasso. *Women in an Interior*, Juan-les-Pins, May 2, 1936. Oil on canvas, 61 x 50.5 cm.
Musée National Picasso, Paris.

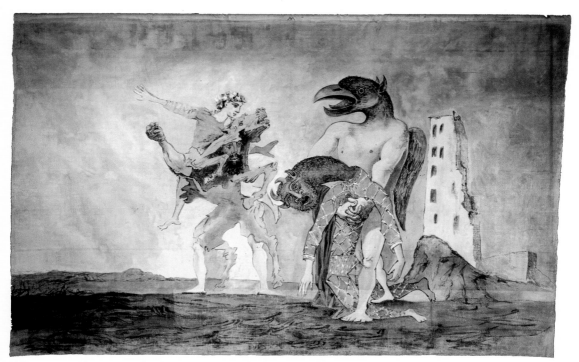

Picasso. *The Remains of the Minotaur in a Harlequin Costume.* Curtain for *Le Quatorze Juillet* by Romain Rolland, May-July 1936. Protein glue tempering on unbleached cotton canvas, 830 x 1325 cm. Musée des Augustins, Toulouse.

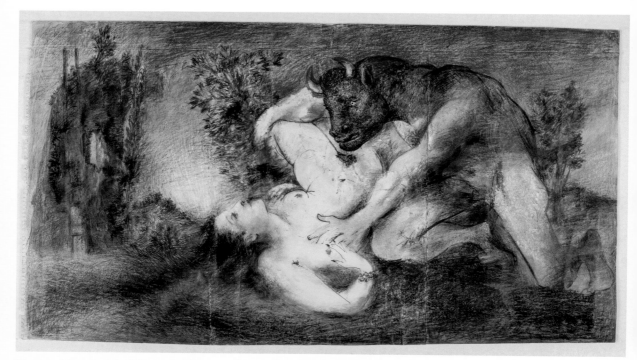

Picasso. *Dora and the Minotaur,* Mougins, September 5, 1936. Colored crayons and black ink, 40.5 x 72 cm. Musée National Picasso, Paris.

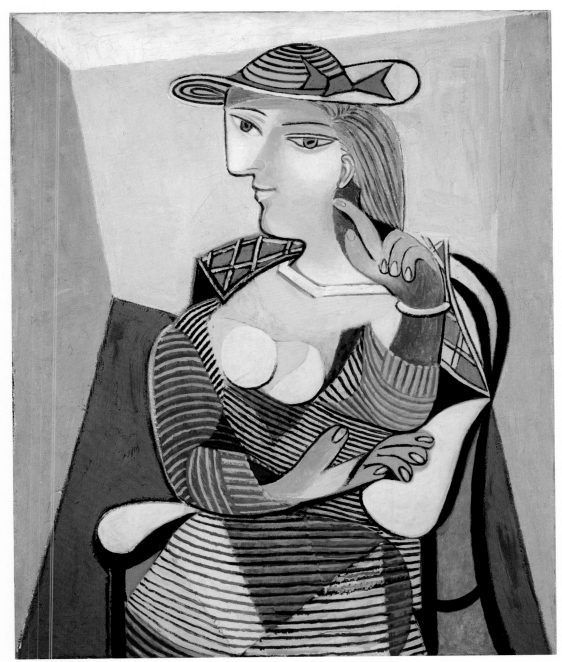

Picasso. *Portrait of Marie-Thérèse*, Paris, January 6, 1937. Oil on canvas, 100 x 81 cm.
Musée National Picasso, Paris.

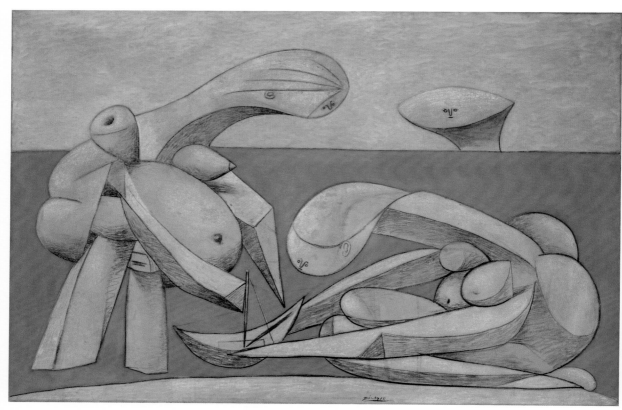

Picasso. *On the Beach*, February 12, 1937. Oil, conté crayon and chalk on canvas, 129.1 x 194 cm.
Peggy Guggenheim Collection, Venice.

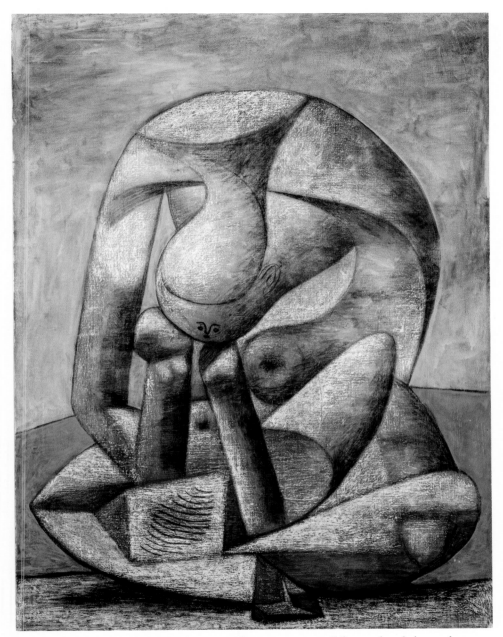

Picasso. *Large Bather with a Book*, Paris, February 18, 1937. Oil, pastel and charcoal on canvas, 130 x 97.5 cm. Musée National Picasso, Paris.

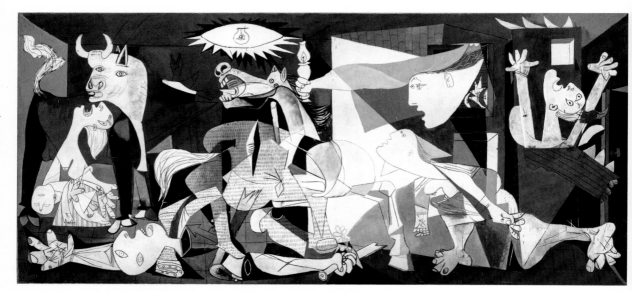

Picasso. *Guernica*, Paris, May 1—June 4, 1937. Oil on canvas, 349.3 x 776.6 cm. Museo Nacional Centro de Arte Reina Sofía, Madrid.

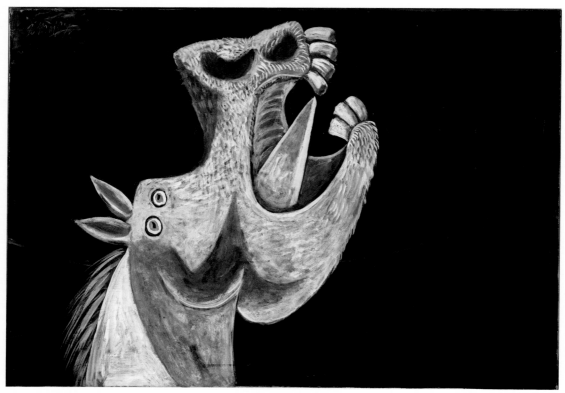

Picasso. *Horse Head*, preparatory drawing for *Guernica,* Paris, May 2, 1937. Oil on canvas, 65 x 92 cm. Museo Nacional Centro de Arte Reina Sofía, Madrid.

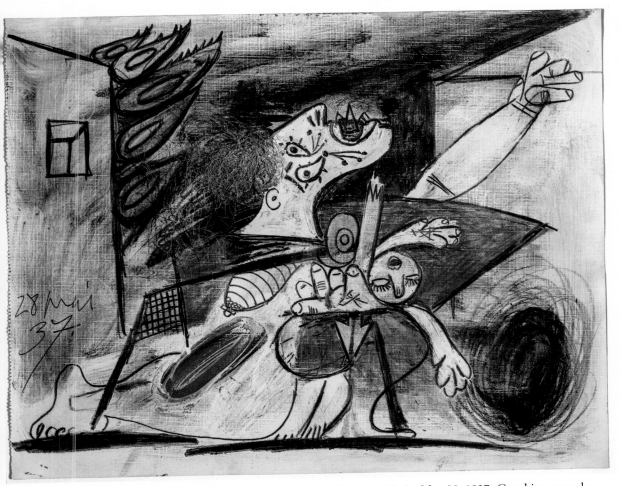

Picasso. *Mother with Dead Child (IV)*, preparatory drawing for *Guernica,* Paris, May 28, 1937. Graphite, gouache, collage and color bar on tracing cloth, 23.1 x 29.2 cm. Museo Nacional Centro de Arte Reina Sofía, Madrid.

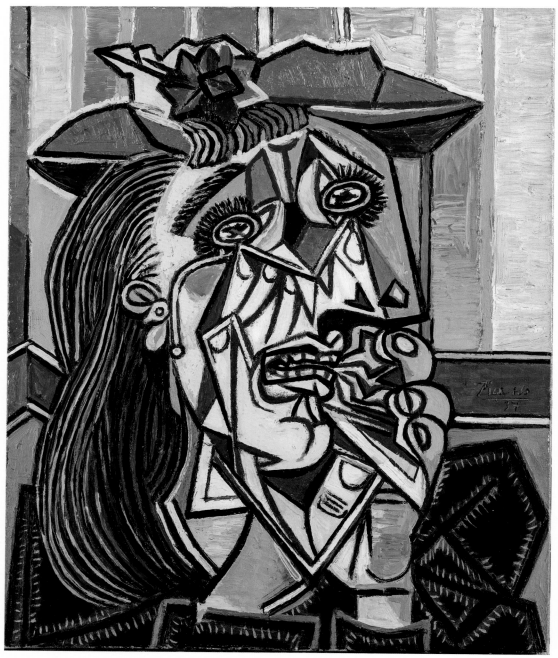

Picasso. *The Weeping Woman*, Paris, October 26, 1937. Oil on canvas, 60.8 x 50 cm.
Tate Gallery, London.

Picasso. *Lee Miller*, 1937. Oil on canvas, 81 x 60 cm. National Galleries of Scotland, Edinburgh. Long loan in 1985. Courtesy the Penrose Collection, England, 2021.

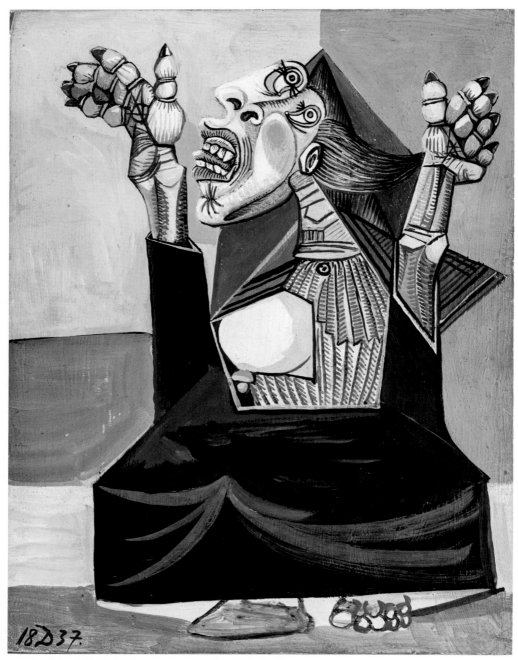

Picasso. *The Supplicant*, Paris, December 18, 1937. Gouache on wood, 24 x 18.5 cm.
Musée National Picasso, Paris.

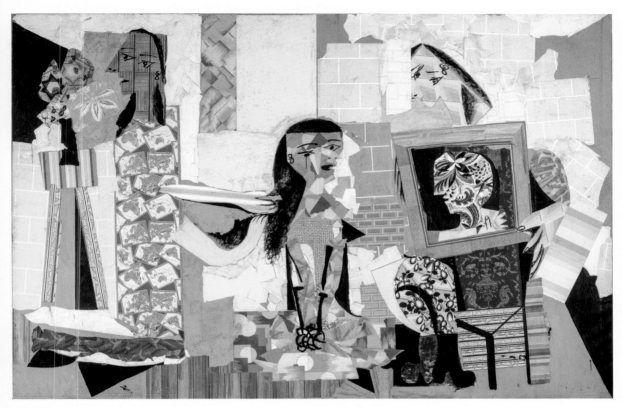

Picasso. *Women at Their Toilette*, winter 1937-1938.
Paper, gouache, and painted paper collage,
299 x 448 cm. Musée National Picasso, Paris.

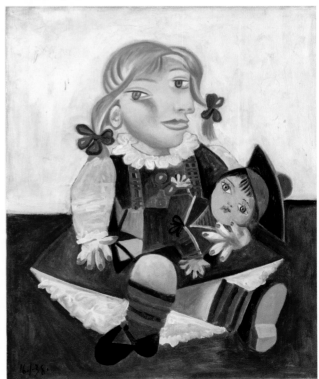

Picasso. *Maya with a Doll,* Paris, January 16, 1938.
Oil on canvas, 73.5 x 60 cm. Musée National
Picasso, Paris.

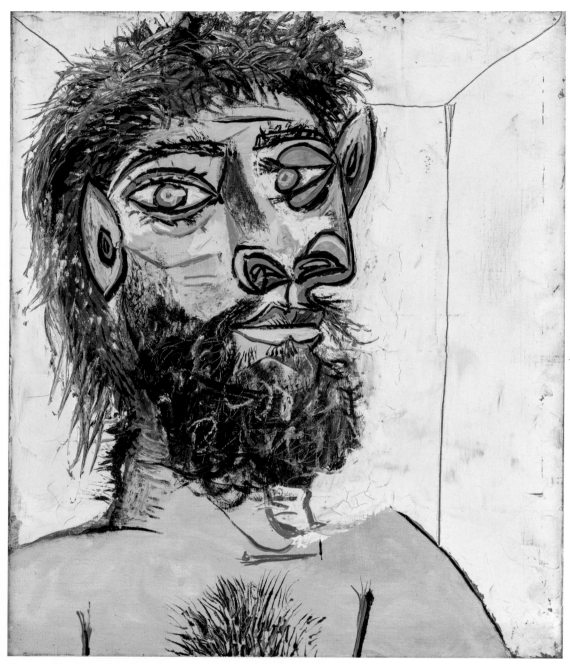

Picasso. *Head of a Bearded Man*, 1938. Oil on canvas, 55 x 46 cm. Musée National Picasso, Paris.

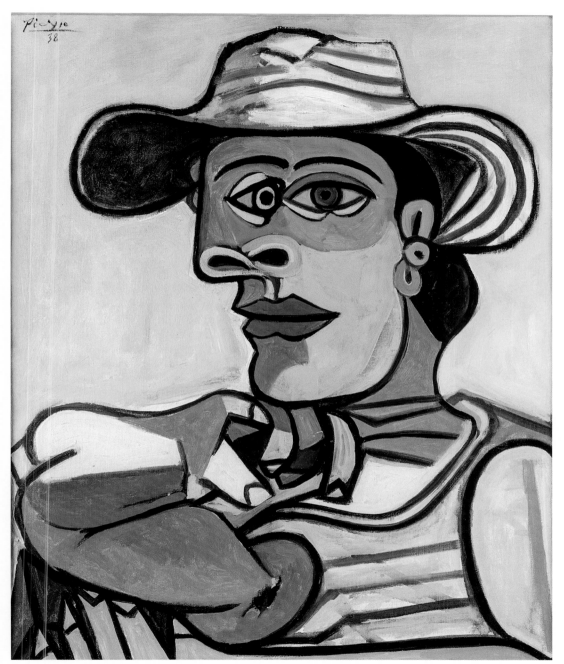

Picasso. *The Sailor*, Mougins and Paris, 1938. Oil on canvas, 60 x 50 cm. Nationalgalerie, Museum Berggruen, Staatliche Museen, Berlin.

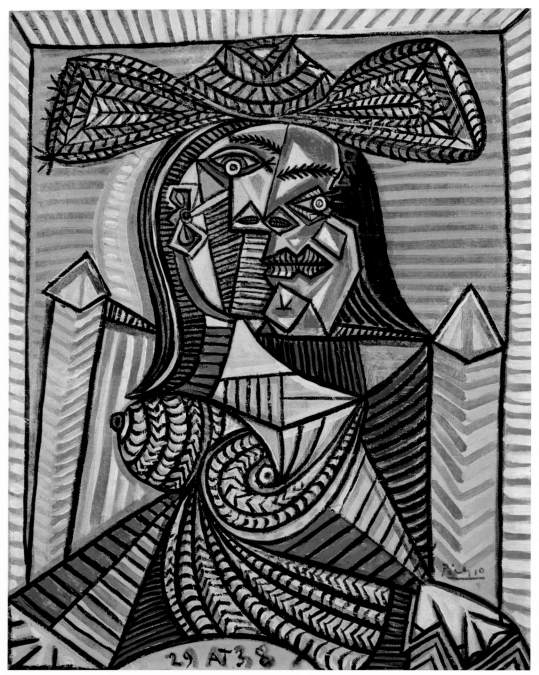

Picasso. *Seated Woman (Dora Maar)*, August 29, 1938. Oil on canvas, 65.1 x 50.2 cm.
Private collection, courtesy of The Heller Group.

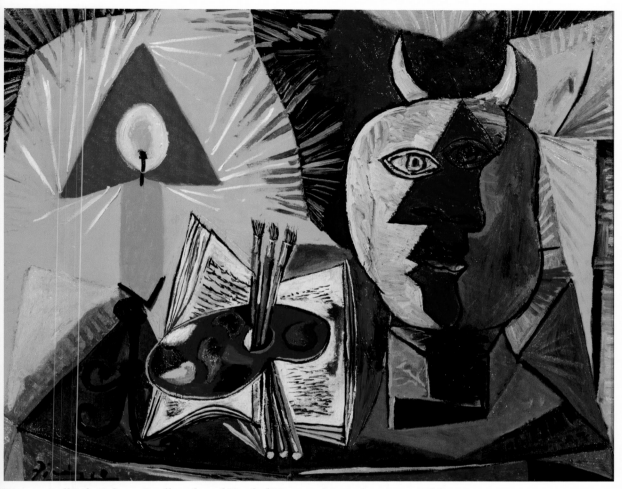

Picasso. *Still Life: Palette, Candlestick, and Head of Minotaur,* November 4, 1938. Oil on canvas, 73.7 x 90.2 cm. The National Museum of Modern Art, Kyoto.

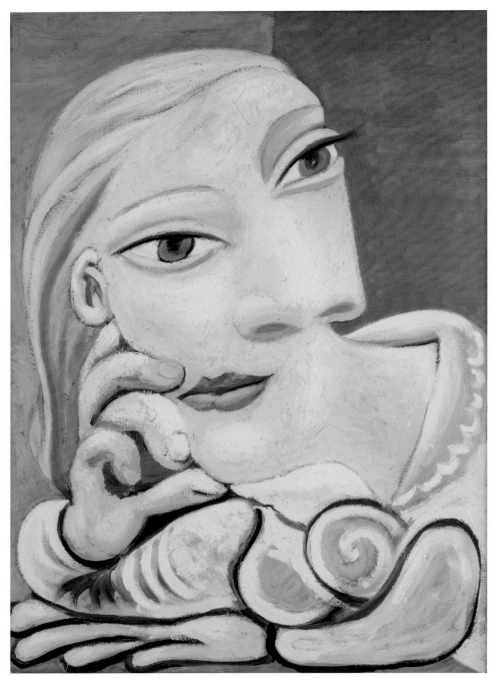

Picasso. *Marie-Thérèse Leaning on One Elbow,* January 7, 1939. Oil on canvas, 65 x 45 cm. Private collection.

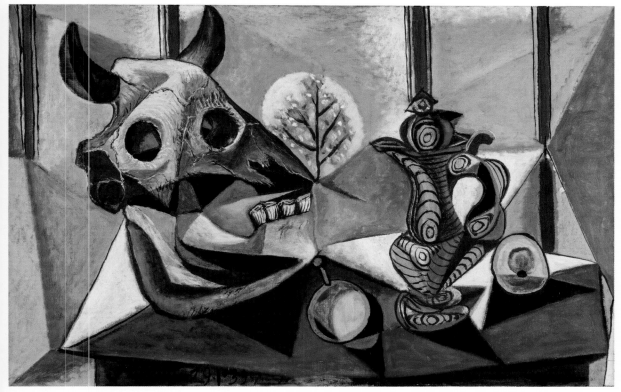

Picasso. *Bull Skull, Fruit, Pitcher,* 1939. Oil on canvas, 65 x 92 cm. Courtesy of The Cleveland Museum of Art.
Leonard C. Hanna, Jr. Fund

Picasso. *Cat Devouring a Bird,*
April 24, 1939. Oil on canvas,
97 x 129 cm. Acquavella Galleries.

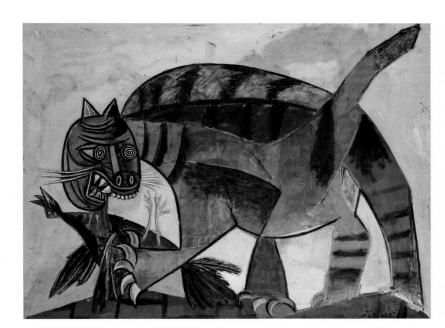

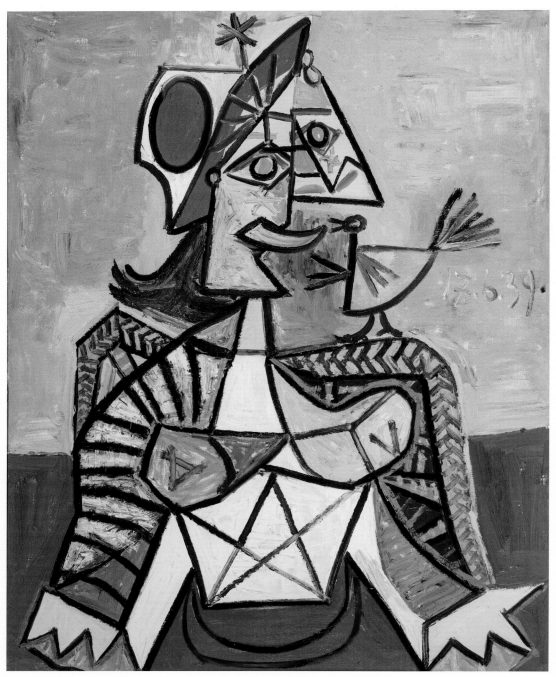

Picasso. *Woman with a Bird (Dora Maar)*, Paris, June 17, 1939. Oil on canvas, 92 x 73 cm.
Private collection.

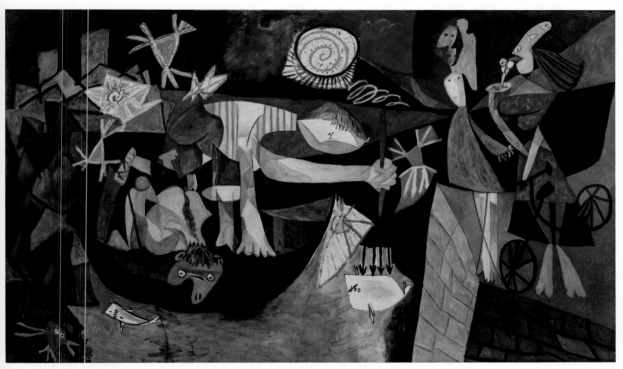

Picasso. *Night Fishing at Antibes*. Antibes, August 1939. Oil on canvas, 205.8 x 345.4 cm. The Museum of Modern Art, New York. Mrs. Simon Guggenheim Fund.

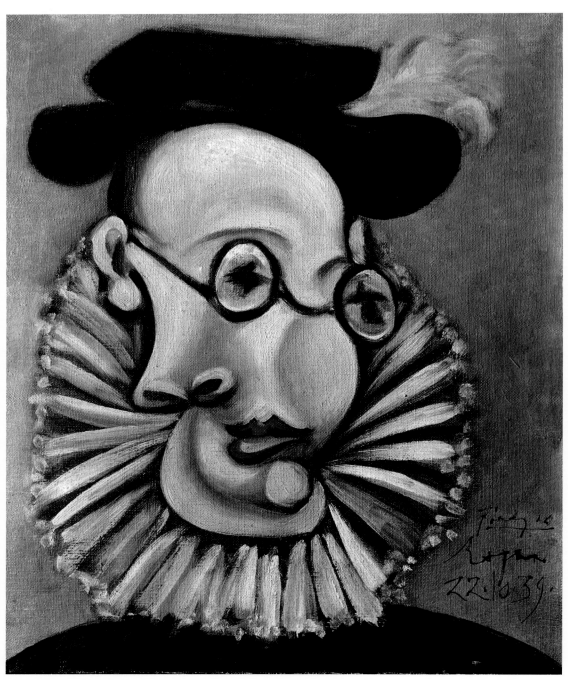

Picasso. *Portrait of Jaime Sabartés*, 1939. Oil on canvas, 46 x 38 cm. Museu Picasso, Barcelona.

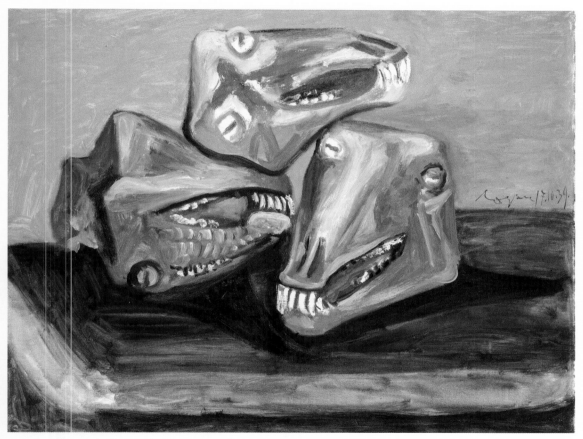

Picasso. *Three Lamb's Heads,* Royan, October 17, 1939. Oil on canvas. 65 x 89 cm. Museo Nacional Centro de Arte Reina Sofía, Madrid.

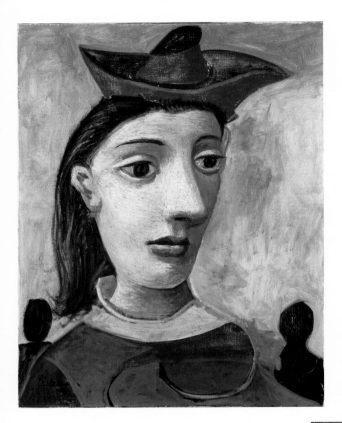

Picasso. *Woman with a Green Hat*, October 29, 1939. Oil on canvas, 65 x 49.5 cm. The Phillips Collection, Washington, DC. Gift of the Carey Walker Foundation.

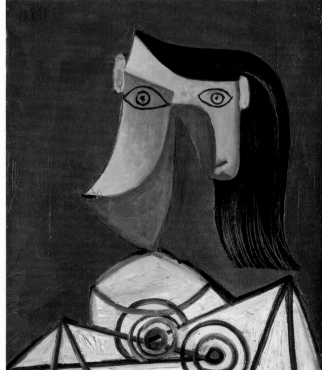

Picasso. *Head of a Woman*, Royan, November 30, 1939. Oil on canvas, 65 x 54.5 cm. Musée National Picasso, Paris.

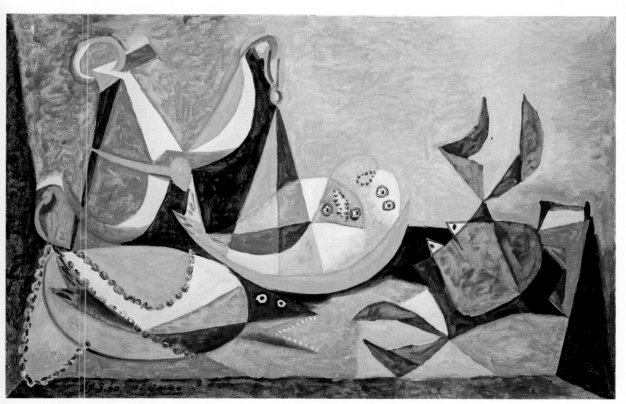

Picasso. *The Soles*, March 29, 1940. Oil on canvas, 60 x 92 cm. National Galleries of Scotland, Edinburgh.

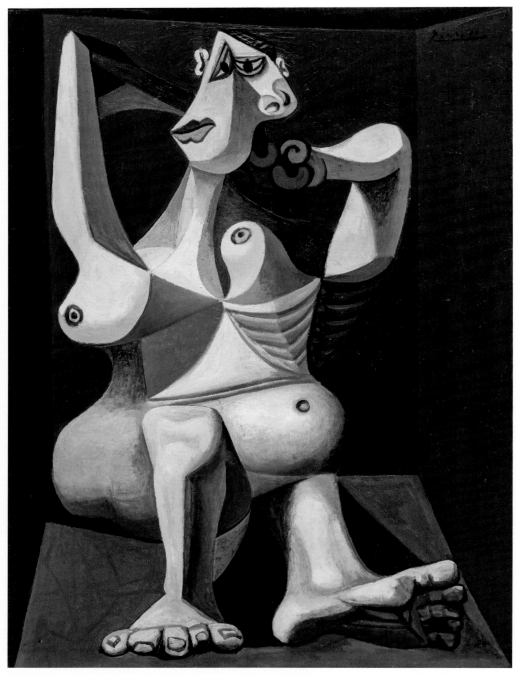

Picasso. *Woman Dressing Her Hair*, Royan, June 1940. Oil on canvas, 130.1 x 97.1 cm.
The Museum of Modern Art, New York. Louise Reinhardt Smith Bequest.

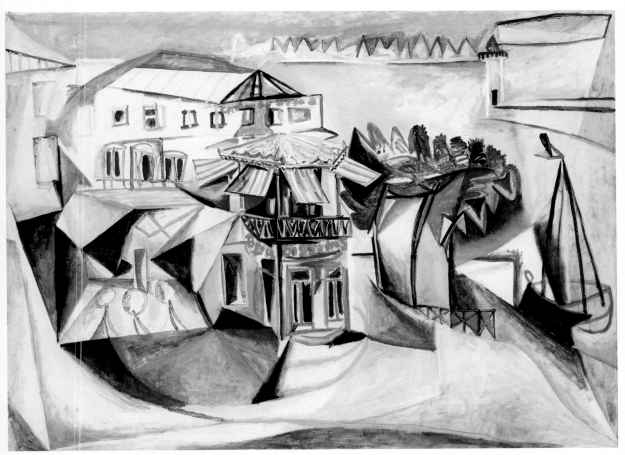

Picasso. *Café des Bains.* Royan, August 15, 1940. Oil on canvas, 97 x 130 cm. Musée National Picasso, Paris.

Picasso. *Flowers and Lemons*, July 8, 1941. Oil on canvas, 92 x 73 cm. Emil Bührle Collection, Zurich.

Picasso. *Woman with an Artichoke*, 1941. Oil on canvas, 195 x 130 cm.
Museum Ludwig, Cologne.

Picasso. *Seated Woman with Hat (Dora Maar)*, Paris, 1941-1942. Oil on canvas, 130.5 x 97.5 cm. Kunstmuseum Basel.

Picasso. *Seated Woman with Fish-Hat*, 1942. Oil on canvas, 100 x 81.5 cm.
Stedelijk Museum, Amsterdam.

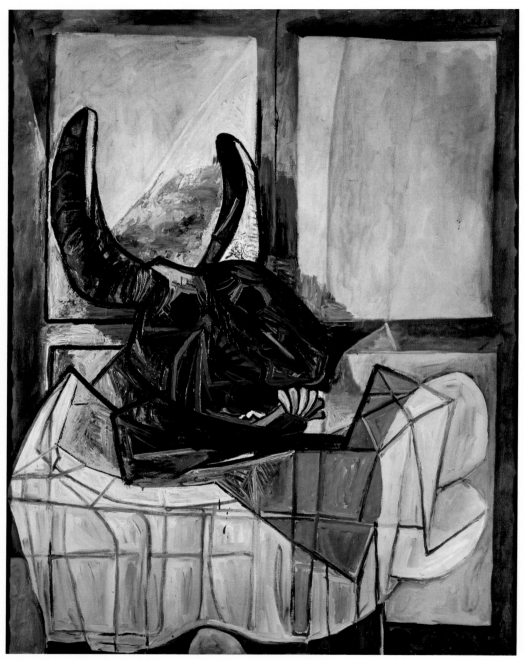

Picasso. *Head of a Bull,* 1942. Oil on canvas, 116 x 89 cm. Pinacoteca di Brera, Milan.

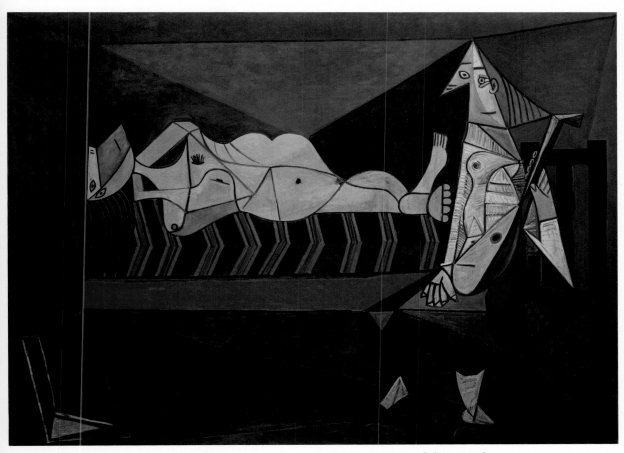

Picasso. *The Aubade,* May 4, 1942. Oil on canvas, 195 x 265 cm. Musée National d'Art Moderne,
Centre Georges Pompidou, Paris.

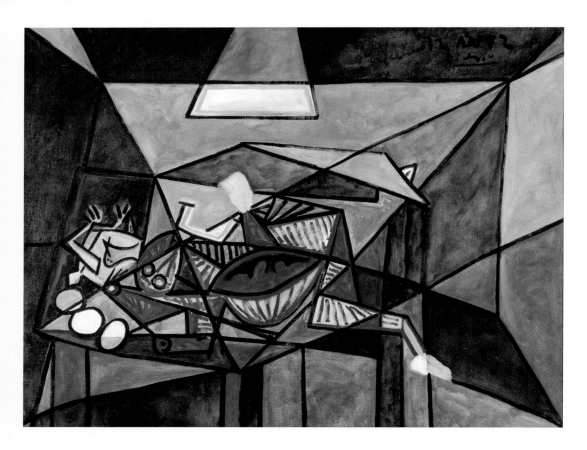

Picasso. *Still Life,* August 12, 1942. Oil on canvas,
89 x 116 cm. Würth Collection, Künzelsau.

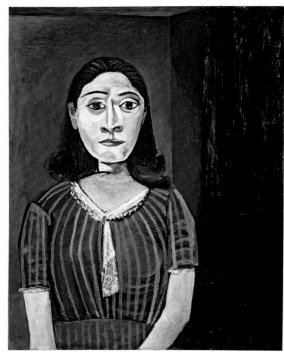

Picasso. *Woman in Satin Bodice (Portrait of Dora Maar),*
October 9, 1942. Oil on panel, 92 x 73 cm.
Private collection.

Postcard showing the view from Picasso's studio at Villa Les Voiliers, with Royan's Harbor, Café de Bains, and boulevard Thiers.

lence of his writing—the love and fear, tenderness and cruelty, laughter and tears—entitles the artist to be recognized as a formidable surrealist poet.

On August 15 Picasso executed numerous sketches and a painting of the view from his studio window: Royan's popular Café des Bains, the beach below, and a sailboat.[43] The artist had been captivated by the charm and serenity of his surroundings. He told Sabartés that the panorama seen from Les Voiliers was "a magnificent spectacle, for one willing to be seduced . . . I have spent the afternoon watching that lighthouse before me and the comings and goings of the ferry."[44] Yet, even as he worked on this seemingly straightforward postcard scene, conditions at Royan had deteriorated. The night of August 14, a German sentry had been shot and killed while guarding the Kommandantur at the Hôtel du Golf, near Picasso's studio. The vengeful Germans plastered the town with notices forbidding dogs, Jews, and French natives from using the beach. The day after the sentry was shot, another bullet was fired, this time whizzing through the window of Andrée Rolland's salon at Les Voiliers, on the floor below Picasso's studio. It had bounced off a wall and fallen to the floor. The artist thought that it must have come from a German plane doing stunts over the harbor.[45] The anguish that assailed him around this crucial moment permeates two revealing self-portrait drawings. One of them is pensive and the other is possibly the most harrowing and piercing image of himself that he would ever do.[46]

Unnerved by Nazi restrictions, stray bullets, and Picasso's neglect, Dora desperately yearned to quit Royan once and for all. The highs and lows and twists and turns of the artist's feelings had demolished her. As early as January 21, he depicted her in

LEFT Picasso. *Self-portrait,* August 11, 1940. Pencil on paper, 16 x 11 cm. Archives Succession Picasso. RIGHT Picasso. *Head of a Woman,* from a notebook, dated 05/30/1940–02/19/1942. Pencil on graph paper, 41.3 x 30.5 cm. Musée National Picasso, Paris.

a passionate corrida drawing as a mad picador attacking the self-referential bull while a young girl (Maya?) rushes in to protect him. His angst-filled drawings of Dora that fill a black-bound sketchbook dated May 30 oblige us to wonder why he had shut himself away with her in a second-rate hotel, when he could easily have found more comfortable quarters. By way of a studio, all she had was a squalid little room that doubled as storage for Picasso's paintings. Nearby, her rival, Marie-Thérèse and her family lived in a cozy house where Picasso could enjoy the company of his daughter in a traditionally homey way. The situation had set off Dora's paranoia, making her stormy affair with the artist that much more combative. According to Gérard Dufaud, a recent chronicler of Picasso's Royan period, the quarrels between them "were daily and the rages more frequent, often ending with an exchange of blows."[47]

As she had done in the past, the distraught Dora implored Picasso to excuse her eruptions of jealousy: "I'm doing everything to not be loved and I think that indeed you don't love me. Forgive me for everything I beg you. I'm crazy in love, really crazy in love for you. I don't know how to write letters, I'm writing because it makes me feel good to tell you that I love you and admire you."[48] At some point, it seems Picasso took to avoiding Dora so often that she had to ask him in writing just to meet

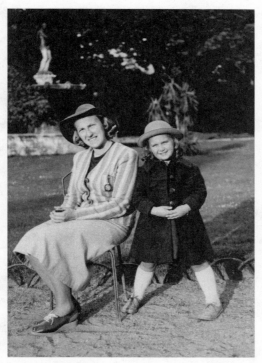

Marie-Thérèse Walter and Maya, c. 1940.
Musée National Picasso, Paris.

her at the hotel café for a conversation. "It would really make me happy to feel that you are totally free with me. So don't come, come only if you feel like it, I don't want any constraints between us." She signed the note coldly, "Your friend, Dora."[49]

Picasso's last Royan painting of her (August 22), unlike the rest of his recent work, has the look of an African fetish. Back to primitivism? The elongated head contains almond-shaped eyes and ears. Floods of tears, one blue, one white, stream down her face. A sketchbook drawing of her done the same day, her mouth closed tightly with an X mark, is scary in its muteness.[50]

Dora's neuroses were probably one of the factors that prompted Picasso's return to Paris. Another may have been the news that his friends Paul and Nusch Éluard had come back to the capital.[51] On August 25, 1940, Picasso departed in the Hispano-Suiza with Marcel, who had finally been released from the military, at the wheel. At Les Voiliers, the artist and Sabartés loaded the car with the canvases, watercolors, and drawings made over the previous year before picking up Dora and Mercedes at the Au Tigre hotel. Marie-Thérèse, her daughter, sister, and mother were left behind at the Villa Gerbier de Jonc. They would not depart until December, when they moved into a house owned by Mémé in the Paris suburb of Alfortville.[52]

Brassaï. Photograph of Picasso seated by the stove in his rue des Grands-Augustins studio, Paris, 1939. Musée National Picasso, Paris.

21

Wartime Paris (1940–41)

Picasso's decision to return to Paris from Royan at the end of August was the more risky given his failure to obtain French citizenship. On arriving, he was dismayed to discover that Franco's representatives had posted notices on the front doors of his residences and studios, putting those properties under their "protection" and claiming authority to confiscate his works in lieu of unpaid Spanish taxes.[1] An empty threat: no action was ever taken. Also, Spanish Fascists had seemingly encouraged German authorities to forbid Picasso from exhibiting in France. Other artists who had taken a public stand against fascism—such as Fernand Léger, an ardent Communist who had emigrated to America—suffered the same interdiction, along with all Jewish artists.[2] Nevertheless, Picasso's dealers managed to show his work discreetly, under cover, after hours, when galleries were supposedly closed. In retrospect, Zervos described the drastic shortage of Picasso's work from the art market as a blessing in disguise. It ensured that his prices would hold up during the war.[3]

The position Picasso had taken during the Spanish Civil War now left him vulnerable to potential dangers. Spanish expatriates who had supported the Republic, such as himself, were being extradited, often kidnapped, from France and sentenced to death by Franco's thugs.[4] Among the victims was the former Catalan president Lluís Companys, who had been imprisoned by the Nazis and turned over to Spain for trial and execution. For a time, it looked like the same might be in store for Picasso. Writing from New York, Pierre Matisse told his father of an alarming newspaper report that Franco had ordered Picasso's extradition.[5] Despite the risks, the artist settled back into occupied Paris and resumed his old habits. He laid low but would not hide. Worldwide renown apparently saved him.

In fall 1940, Picasso abandoned the elegant rue la Boétie residence that he had shared with Olga and began living in his studio/apartment at 7 rue des Grands-Augustins, where he had painted *Guernica.* It was at the heart of Saint-Germain-des-Prés, close to the hangouts where he continued spending most of his evenings.[6] Henceforth, he seldom went to rue la Boétie. After the war, he would take his next mistress, Françoise Gilot, to inspect the place. The salon was exactly as it had been

in 1940: Olga's chattels, stacks of periodicals, armchairs, ashtrays, and teacups, all covered with a thick layer of dust. The time warp disconcerted him. Picasso said the rooms brought back memories of Diaghilev's polylingual dancers jabbering away, and the scent of their Russian cigarettes.

Besides all the works in his Paris collection, Picasso also needed to recover hundreds of paintings and drawings still stashed away at Le Tremblay, the house that Vollard had lent him four years earlier, before the dealer was killed in a car accident. Picasso had loved living there with Marie-Thérèse and Maya, away from the Paris art world, not to mention his worsening relationship with Dora. Le Tremblay had been requisitioned by the Germans but Delarue, the caretaker, kept Picasso informed of the occupiers' routines. When the soldiers were off on maneuvers, the artist was able to sneak in and rescue his stash of work.[7]

By the time Picasso settled back in Paris, most of his friends—among them Braque, Éluard, Zervos, and Leiris—had done the same thing. Matisse had originally planned for a month in Brazil but, as he wrote his son, "when I saw the endless line of people leaving I had not the least desire to go . . . I would have felt like a deserter. If everyone of any worth runs away, what will remain of France?"[8] Many of Picasso's friends and fans had begged him to flee to the United States, but he insisted on staying in Paris. American liberals had organized the Emergency Rescue Committee to save European artists, writers, and musicians by giving them U.S. visas. Heading this mission was Varian Fry, a thirty-two-year-old journalist, who had been equipped by MoMA's director, Alfred Barr, with the names of key artists to seek out and rescue in France. As Fry explained: "I didn't know them personally, but I felt a deep love for these people and gratitude for the many hours of happiness their books and pictures and music had given me. Now they were in danger. It was my duty to help them, just as they—without knowing it—had often helped me in the past."[9]

Besides American offers of asylum, Picasso received proposals from Mexico's star artists. José Clemente Orozco and Diego Rivera had worked to obtain a special visa for Picasso, and some mistakenly believed that he had accepted their invitation.[10] Matisse wrote to his son on November 10, 1940: "When I heard for a moment that Pablo was in Mexico, it really upset me. I felt that France was poorer for it."[11] In fact Picasso had refused to budge from Paris. Later in the war, he would tell Françoise Gilot:

> I'm not looking for risks to take, but in a sort of passive way I don't care to yield to either force or terror. I want to stay here because I'm here. The only kind of force that could make me leave would be the desire to leave. Staying on isn't really a manifestation of courage; it's just a form of inertia. I suppose it's simply that I prefer to be here. So I'll stay whatever the cost.[12]

In a recent discussion, Gilot informed me that Picasso's inertia was anything but "passive." It was proof of his implacable strength of mind. Remaining in Nazi-ruled Paris required considerable courage on the part of the principal perpetrator of "degenerate art," and a passionate enemy of Franco, whom he had vilified as a grotesque maja in his *Dream and Lie of Franco* cartoon. Picasso's emasculation of Franco would prove all too accurate. He was a Fascist tyrant but no "Generalissimo." Compared to his fellow monsters—Hitler, Göring, and Mussolini—Franco had little charisma. The artist would dismiss him as an *étron* (turd). Franco dared not touch him.

Throughout the German occupation Picasso's principal obsession was his work. Despite the war, his prices were rising in occupied France, as well as in America, thanks to the success of the 1939 MoMA retrospective. As a result he would take every possible precaution to safeguard his work from wartime looters and thieves. A few weeks after Picasso's return to Paris, the German Kommandantur decreed that all owners of bank vaults must open up their safe deposits for an inventory. This included the vaults at the Banque Nationale pour le Commerce et l'Industrie which Picasso and Matisse had been canny enough to fill with treasures from their collections. Matisse had authorized Picasso to be his proxy. Picasso described the bank-vault inspection to Gilot. His theatrical ability to transform himself into a simpleton had enabled him to confuse and thwart the Nazis.

Since both he and Matisse were classified by Nazis as "degenerate" artists, there was all the more reason to be apprehensive. The inspectors were two German soldiers, very well disciplined but not very bright, he told me. He got them so confused, he said, rushing them from one room into the next, pulling out canvases, inspecting them, shoving them back in again, leading the soldiers around corners, making wrong turns, that in the end they were all at sea. And since they were not all familiar with his work or with Matisse's either, they didn't know what they were looking at, no matter which room they were in. He wound up by inventorying only one-third of his paintings, and when it came to Matisse's, he said, "Oh, we've seen these." Not knowing one painting from another, they asked him what all those things were worth. He told them 8,000 francs—about $1,600 in today's money [1964]—for all his paintings and the same for Matisse's. They took his word for it. None of his things or Matisse's were taken away. It must have seemed worth the trouble. "Germans always have a respect for authority," he said, "whatever form it may take. The fact that I was somebody everyone had heard of and I came there myself and gave them exact details of sizes, values, and dates—all that impressed them very much. And they couldn't imagine anyone telling them a story that might cost him very dear if he had been found out."[13]

Picasso had taken an enormous gamble and had won.[14] As Gilot has emphasized to me, "Picasso was impervious to fear." Parisians of her generation revered him for sharing their dangers during the Occupation. By autumn 1940, the city had become, as Brassaï recalled, "a Paris of queues and ration tickets, of curfews and jammed radios, of propaganda newspapers and films; a Paris of German patrols, of yellow stars, of alerts and searches, of arrests and bulletins of executions . . ."[15]

All too true, but prewar social routines would never entirely disappear from the Saint-Germain-des-Prés neighborhood. Despite the 10 p.m. curfew imposed by the Germans, Picasso was back at his old haunts, drinking and dining and gossiping with old and new friends, not least girls. At lunchtime, he was often spotted at the Catalan beside Dora, Éluard, and Cocteau. For dinner, he preferred the Café de Flore, the "well-heated refuge where he felt completely at home; better than he would have been at home," said Brassaï.[16] Simone de Beauvoir, another of the Flore's habitués, recalled that German soldiers never stepped foot in the place.[17]

In November 1940, Matisse learned from Pellequer that "Picasso is just as he always was—a true Bohemian, taking his meals here, there and everywhere . . . Pablo says that he will never—on any account—leave France. I was very glad to hear it." However, Matisse added, "it seems Dora Maar is no longer with him."[18] This was far from true. The torment Dora had suffered at Royan had left her a nervous wreck. Nevertheless, she still spent most of her days in Picasso's rue des Grands-Augustins studio. In the evening she returned to her mother's comfortable apartment on rue de Champerret. Sometime in 1940, Dora's father had moved back to South America for work, leaving Mrs. Markovitch to fend for herself in occupied Paris. She came to rely on Dora's help, her companionship, and the gifts of food she brought from Picasso's table.[19] The artist was fortunate to receive deliveries of fruits and vegetables from the gardens at Boisgeloup.[20]

Months before the Germans arrived in Paris, the Louvre had closed and emptied its galleries.[21] Over three thousand paintings had been hidden away in châteaus and sacred buildings in the south. The abandoned museum reopened in September 1940 with some classical and medieval sculptures on view. Theaters, cinemas, and restaurants also soon reopened for the enjoyment of the occupiers, not to mention the occupied. Jean Cocteau's biographer Claude Arnaud notes that for German Francophiles, "there was good wine and good food, and plenty of perfume, cognac, and ladies' underthings. . . . For the more sophisticated palates, there was jazz galore, Cubism in the galleries, Satie, and soon Messiaen in the concert halls, to say nothing of the many other art forms forbidden in Germany."[22] The arrival of loads of German tourists was a boon for the Parisian art market (modernist as well as old

masters). In June 1940, the value of the deutsche mark rose almost 70 percent against the French franc, prompting Parisians to sell their collections.[23] The celebrated auction house Hôtel Drouot had its most profitable year ever in 1941.[24] Ironically, some of the most sought-after works at auction were by those artists deemed degenerate by the Nazi authorities.[25]

Though galleries were officially forbidden to show such work, one courageous dealer, Jeanne Bucher, defied the prohibition by exhibiting blacklisted artists, including Picasso, Miró, and Kandinsky, among others.[26] Françoise Gilot remembered that during the Occupation, "I'd go to Jeanne Bucher's gallery before 6 p.m. and then, after it closed, she would show me her Ernst paintings." Born in Alsace in 1872, Bucher spoke fluent German and used it to scold the Nazi soldiers who dared mock the work they saw on display in her gallery. In the face of virulent anti-Semitism, Bucher also championed the work of the banned Jewish artist Jacques Lipchitz, after he had fled to America on a visa from Varian Fry's Emergency Rescue Committee. While the right-wing press denounced and demanded the removal of Lipchitz's 1937 commission for the Grand Palais, *Prometheus and the Vulture*, Bucher put on an exhibition of Lipchitz's drawings for the sculpture. Later in the war, she allowed the ground floor of her premises to be used as a secret printing shop for Resistance literature, and her attic became a safehouse for resisters on the run from the Gestapo. One of Bucher's protégés "was both amused and scared to find he was sleeping in a bed with Braques and Picassos underneath the mattress."[27]

While the Alsatian Bucher managed to operate her gallery more or less as she had done before the war, nearly all of the Jewish dealers in Paris had decided to flee before the German occupation. On February 7, 1940, Paul Rosenberg and his family quit their home and gallery at 21 rue la Boétie for a house at Floirac La Souys, near Bordeaux. For the next four months, Rosenberg conducted business from Floirac: visiting Picasso in Royan, acquiring new works from Matisse in Nice, and providing refuge to Georges and Marcelle Braque, who had left their seaside retreat in Varengeville-sur-Mer in Normandy when they heard the Germans were approaching. The dealer also rented a bank vault at the Libourne branch of the Banque Nationale pour le Commerce et l'Industrie to safeguard 162 cherished paintings he had taken with him from the Paris gallery. He kept dozens more on the walls and in the garage of the Floirac house.

As we've seen, Picasso succeeded in protecting the bank vaults belonging to him and Matisse. Their dealer was not so fortunate. On June 30, 1940, Hitler authorized the wholesale theft of artworks owned by Jewish families in France. Two months later, on September 7, Nazis opened Rosenberg's Libourne vault and seized the paintings inside. These, along with hundreds more left behind at Rosenberg's Paris gallery—which had been sequestered by the police on July 4—were sent to the Jeu de

Paume museum, which the Germans used as a clearinghouse for stolen Jewish property. From this hoard of looted treasure, Hitler selected artworks for the museum he planned to build in his hometown of Linz, Austria, and Göring chose others for Carinhall, his vast hunting lodge in the forest north of Berlin. With the help of unscrupulous dealers, works by Picasso and other modern artists were traded for old-master and nineteenth-century paintings that better suited the Nazi taste. Emptied of its artworks, Rosenberg's gallery was then taken over by the Germans. In May 1941, the building that had belonged to Paris's preeminent Jewish art dealer was transformed into the Institute for the Study of the Jewish Question, which disseminated anti-Semitic propaganda throughout the war.[28]

With no hope of recovering his business for the foreseeable future, and his family's safety threatened by the German advance, Rosenberg left France by car on June 16, 1940, after miraculously obtaining seventeen passports for every relative in his caravan.[29] He spent three months in Lisbon, then embarked for New York, arriving on September 20. Though deprived of some four hundred works of art by the Nazis in France, Rosenberg would soon establish a successful new gallery on Fifty-Seventh Street with the help of the thirty-three Picassos he had loaned to MoMA for the 1939 retrospective. They remained at the museum after the exhibition closed and could now be safely returned to Rosenberg. Despite the injustices he had recently suffered, the canny dealer, once resettled in New York, wasted no time trying to cultivate new business with Picasso. He telegrammed the artist in late 1940 with praise for his decision to stay in Paris and compliments for his "latest canvases which I would like to receive here. Give us news and don't forget your faithful old friend."[30]

While Rosenberg's decision to relocate to New York would enable him to prosper in the capital of the postwar art world, it would also sever his contract with Picasso. After the liberation, the artist resumed his alliance with the dealer of his cubist years, Daniel-Henry Kahnweiler, a German Jew, who had foreseen the German invasion and had taken precautions to stay in France if and when war broke out. To protect his gallery, Kahnweiler remained in Paris for as long as possible, but urged his artist friends to leave, writing to Braque (May 10, 1940): "A painter is not a businessman who has all his stock in one place and wants to stay in his shop."[31] On June 12, two days before the arrival of the Germans, Kahnweiler left for the country.

"Paradise in the shadow of the crematoriums" is how Kahnweiler described Le Repaire-l'Abbaye, a former monastery near the village of Saint-Léonard-de-Noblat, outside Limoges, where he would spend the first three years of the Occupation. There, he was joined by a group of Parisian writers, artists, and intellectuals who had also made Saint-Léonard their refuge. The poet Georges-Emmanuel Clancier recalled of his time at Le Repaire-l'Abbaye: "The knowledge and subtlety of Kahnweiler's conversations made his listeners forget for a moment the anguish of the

Dora Maar. Picasso with Michel and Zette Leiris, rue de Savoie, Paris. c. 1942–1943. Musée National d'Art Moderne, Centre Georges Pompidou, Paris.

times. He seemed to have transported his whole world to that remote corner of the Haute-Vienne, his friends and even his paintings, since canvases by Gris, Picasso, and Masson transformed the former abbey into a strange and marvelous museum in the fields."[32]

Kahnweiler kept informed of happenings in Paris. In the First World War, he had been deprived of his gallery and paintings because he was German. Now he was suffering another confiscation because he was a Jew. To avoid losing his business a second time, he arranged for his stepdaughter Louise—Zette—Leiris to purchase it. When her case came up before the commissioner of Jewish affairs, she made no attempt to conceal her relation to Kahnweiler: "Of course, it's true . . . But as you can see, I am clearly Aryan and I have worked in that gallery since 1920, for over twenty-one years. Who better than I should buy it?"[33] Directed by Zette with Kahnweiler's guidance, the Galerie Louise Leiris would thrive, in part by discreetly acquiring and selling Picasso's paintings throughout the war.

In 1926, Zette had married Picasso's close friend Michel Leiris. When Kahnweiler left Paris for Le Repaire-l'Abbaye, the Leirises moved into his Boulogne apartment and frequently had Picasso and Dora to dinner. Picasso would intentionally miss the

LEFT Picasso. *Portrait of the Artist,* from the 1945 facsimile edition of *Desire Caught by the Tail.* 31.5 x 23.8 cm. Musée National Picasso, Paris.

BELOW Picasso. Text and illustrations of act 1, scene 1 of *Desire Caught by the Tail,* from the 1945 facsimile edition of the 1941 original, 31.5 x 23.8 cm (single page). Musée National Picasso, Paris.

ten o'clock curfew imposed by the Germans so that they could spend the night in the Kahnweilers' bed instead of going home. Dora told me that Picasso insisted on having sex in these hallowed sheets, which according to him had never been put to their proper use.

O ver three days in mid-January 1941, Picasso set about writing a six-act play, *Le Désir attrapé par la queue (Desire Caught by the Tail)*, in a notebook. On the first page he did a drawing of himself seated at his desk, as if seen from above, with the words "Portrait of the Author." Act 1, scene 1 begins with another drawing; this time a curtain is drawn back to reveal a banquet table under which hang five sets of legs. The characters are listed in the left margin, and near the bottom Picasso has sketched a stage set.

What follows is a nonsensical farce that ranges in tone from sublime to scatological. Act 5, for example, opens with the main character, Big Foot, absorbed in writing what he calls a "love letter, if you like," but which reads very much like Picasso's imagistic poetry:

The blackness of the ink which envelops the sun's rays of saliva which strike upon the anvil of the drawing obtained at the price of gold develops, in the needlepoint of the desire to take her in one's arms one's acquired strength and the illegal means of achieving it. I run the risk of having her dead in my arms, full-blown and mad.[34]

Big Foot's lover, Tart, bursts into the scene, interrupting his contemplation and demanding affection:

And first kiss me on the mouth and here and here here here and here and everywhere. It must be that I love you to have come in this sloppy way, as a neighbor and stark naked to say hello to you and to make you believe that you love me and want to have me against you.[35]

Big Foot and Tart fall to the floor in a passionate embrace, after which, the stage directions say, "she squats in front of the prompter's box and, with her face to the audience, pisses and syphilises for a good ten minutes . . . she farts, refarts, tidies up her hair, sits down on the floor and starts skillfully demolishing her toes."[36]

Dora told me that the play, for all its surreal strangeness, reflects aspects of her life with Picasso during wartime. Hence why the characters are so often irritable, hungry, and, above all, cold. Act 2 begins with dialogue among the five pairs of feet, complaining of frostbite in separate rooms of an apartment. Nothing seems to have

vexed Picasso more during this first frigid winter of the Occupation than the terrible chill that filled his rue des Grands-Augustins studio. He tried to alleviate this with the enormous coal-burning stove he had found in an antique shop. Its great height and odd shape reminded him of African sculpture, but keeping it warm proved nearly impossible amid widespread fuel shortages.[37]

On account of these and other difficulties, Picasso would not resume painting for five months after returning to Paris. When he did, many of his images portrayed Dora, usually wearing a hat and seated in an uncomfortable wooden chair. In the years before the war, Picasso had done numerous paintings and drawings of her with ever-varying hats and hairdos. During the Occupation, his fetish for Dora's hats would play a more important role in his work. Women's clothes may have had a wartime dowdiness, but their hats had an eye-catching surrealist bravura. Dresses had become scarce and very expensive, but hats, which did not necessitate cloth, enabled enterprising women to indulge their passion for chic. "They also offered the most imaginative displays of French craftsmanship," notes Alan Riding. "There were hats variously made with celluloid, thin slices of wood and newspapers."[38] When Picasso

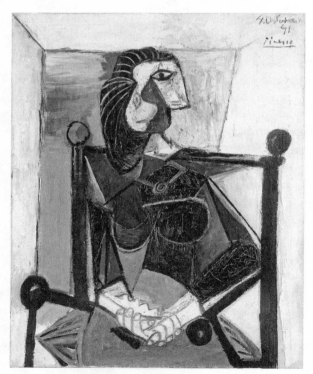

Picasso. *Seated Woman,* October 4, 1941. Oil on canvas, 100 x 81 cm. Henie Onstad Collection, Høvikodden.

met friends for a drink on the terrace of Le Catalan, near his studio, he would enjoy poking fun at the elaborate ladies' millinery that caught his attention.[39] His paintings, such as *Seated Woman with a Fish Hat,* make an ironical comment on home-front fashions.

Variations on Dora done during the Occupation are as powerful in their own way as the heartbreaking imagery of her as the Weeping Woman of the Spanish Civil War. In the painting of October 4, 1941, she appears as a scary woman caged in a claustrophobic space, looking as if an electric chair were about to be switched on.[40] The shock of these images goes back to van Gogh; so does the in-your-face challenge of them. These are not voluptuous mountains of flesh. They don't titillate; they bite. In paintings of October and November, Picasso drew upon the colors and composition of van Gogh's 1888 portrait of Madame Ginoux, as he had already done in his Arlésienne paintings of summer 1937.

Throughout the final, agonizing phase of his affair with Dora, Picasso fixated on the pictorial deformation of her face, both on canvas and in the series of newspaper paintings and drawings

Picasso. *Head of Woman (Dora Maar),* October 28, 1941. Oil on newspaper, mounted with a stretcher, 59.4 x 40.6 cm. Kunstmuseum Basel. Gift of Dr. Georg and Josi Guggenheim Foundation.

executed between 1941 and 1943. With striking consistency, these portray female heads in black and gray on pages of *Paris-Soir,* which had become a leading organ of the collaborationist press. While Picasso generally chose pages from the advertising and entertainment sections, political events sometimes appear. On October 28, for example, he painted a boxlike skull with hollow eye sockets and a rigid mouth over upside-down newsprint[41] reporting the funeral of a Nazi soldier killed by resisters: "The murderers of Bordeaux have assassinated a German—but the blows hit France." That Picasso partially obscured this headline may imply his sympathy with the assassins.[42] Taken together, his newspaper images constitute a kind of "war diary" in which he registered his rejection of German propaganda.[43]

Picasso also painted a series of still lifes inspired by the meager offerings at the bistros and brasseries he frequented in the neighborhood of his studio. He told Harriet and Sidney Janis that the *Still Life with Blood Sausage* (May 10, 1941) depicted a table he had seen at Le Savoyard during one of the darkest periods of the war.[44] Hence the grisaille and somber Spanish overtones. Picasso said he wanted to evoke

 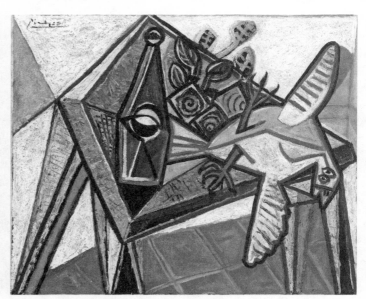

LEFT Picasso. *Still Life with Blood Sausage,* May 10, 1941. Oil on canvas, 92.7 x 66 cm. Collection Gail and Tony Ganz, Los Angeles. RIGHT Picasso. *Still Life with Pigeon,* November 13, 1941. Oil on canvas, 60 x 73 cm. Nagasaki Prefectural Art Museum, Nagasaki.

the penitential gloom and austerity of Philip II's life in the Escorial. He compared the twisted knives and forks in the open drawer to souls in purgatory crying out for mercy.[45] Wartime shortages are reflected in the unappetizing look of the food: the dried-up segment of Camembert and the sinister, rubbery coil of blood sausage. If the artichokes look menacing, it is because Picasso lifted them from Giorgio de Chirico: specifically from two "Metaphysical" still lifes with artichokes in the collection of the Vicomte and Vicomtesse de Noailles, friends from his Diaghilev days whom he continued to see during the war. Echoes of de Chirico give this painting an eerie surrealist resonance. On July 8 Picasso did a magnificent still life of hideous black and orange flowers stuck into a glass jug in such a way that their stalks resemble a row of teeth.[46] This effect gives the jug a horrendous leer. Behind the flowers is a sharply serrated window frame. The November 13 still life of a dead bird and a bottle is contained within the space of a kitelike tabletop. The bird's white wings hint at flight. Picasso's treatment of the tilted floor tiles recalls van Gogh's celebrated 1888 yellow chair in the National Gallery, London.

Meanwhile, Picasso had been devoting much of his time to sculpture. It is not always possible to date his 1941 sculptures precisely. Among the first of the series are *Head of a Woman*, *Death's Head*, and *Cat*. Shortage of fuel had obliged Picasso to make plaster casts in the bathroom of his Grands-Augustins apartment, "the only room you can heat in this big old barn," he told Brassaï.[47]

A unique glimpse into Picasso's return to sculpture in 1941 survives in the form

Dora Maar. Picasso in the bathroom used as a sculpture studio at rue des Grands-Augustins, beside *Head of Woman (Dora Maar),* and another view of *Head of Woman (Dora Maar)*, 1941. Both Musée National d'Art Moderne, Centre Georges Pompidou, Paris.

of an article by Pierre Malo in *Comoedia*, a conservative weekly art journal.[48] Usually so averse to speaking with critics, Picasso felt sufficiently at ease with Malo to welcome him into his workspace. " 'Come in,' Picasso said, 'You're a friend because I know you won't talk to me about my paintings. One does not discuss them. What would you have me say about them?' " Malo was impressed by the scale and layout of the studio: "It is an extraordinary succession of rooms which evokes bourgeois ostentation and Norman simplicity. Canvases piled up pell-mell on the floor. One risks tripping with every step."

Picasso then took Malo into the bathroom that had become the sculpture studio. The writer saw three sculptures: "A cat stretches out in the bathtub and a death's head chuckles away in the sponge-bowl. In front of the sink shines a goddess whose face Picasso has been working on for months. Plaster trickles in the sink and a red feather duster sticks out of the drain. 'I have brought all this back from the country,' " Picasso told Malo. " 'Might as well leave it like this. What's the point of tidying up?' "

Malo was amazed by what he called Picasso's "marvelous mess." "A Christ figure takes a position between the weights of a gigantic scale while an avalanche of books threatens to knock over a colony of busts. Picasso keeps his brushes in a pickle jar and uses a table covered in newspaper for a palette. 'A palette, why bother?' " Picasso asked. " 'When there is too much paint on the table, no sweat. I change the cloth.' "

Picasso was not alone in his search for sculptural materials. They were in short supply. His old friend Giacometti had also stayed on in Paris and frequently visited Picasso's studio. Some of Giacometti's style left a mark, albeit a faint one, on Picasso. They saw each other regularly, not least because Giacometti had begun a sculpture

LEFT Picasso. *Cat*. Paris, 1943. Bronze, lost-wax cast, 36 x 17.5 x 55 cm. Musée National Picasso, Paris.
RIGHT Picasso. *Death's Head*. Paris, 1943. Bronze, 25 x 21 x 31 cm. Musée National Picasso, Paris.

bust of Picasso. The sculptor wrote to his mother on January 21, 1941: "Picasso wants me to do his head and I've made a start."[49] Alas, nothing came of this project. Giacometti decided to return to his native Switzerland in December 1941. When he came back to Paris in 1945, the two artists resumed their friendship. But in the 1950s, when Michel Leiris suggested that his gallery represent Giacometti, Picasso would adamantly object, creating a rift with the sculptor that would never be repaired.

Brassaï would later ask Picasso how—besides acquiring the plaster to model his wartime sculptures—he had been able to cast so many of them in bronze. Picasso replied: "At first, I wouldn't even hear of having them cast in bronze. But Sabartés just kept saying, 'Plaster is perishable . . . You have to have something solid . . . Bronze is forever . . .' He's the one who persuaded me to have them done in metal. And at last, I gave in." Brassaï repeated his question: how on earth had he managed to have so many works cast in bronze in the teeth of the German occupiers' seizure of all available metal? Picasso would not divulge his source: "That's a long story. Some devoted friends moved the plasters to the foundry—at night, and in handcarts. But they risked a good deal more, bringing them back here in bronze, right under the nose of the German patrols. The 'merchandise' had to be very well camouflaged."[50]

Throughout the quasi-confinement imposed by the Germans, Picasso would continue writing poetry. Françoise Gilot, who has a unique understanding of the artist's idiosyncratic approach to poetry, told me it was written to be recited in a special way. Here is a characteristic example:

the windows four corners shred the day that dawns and wham a rain of dead birds hits the wall and bloodies the room with its laughter[51]

Alas, there are no recordings of Picasso reciting his poetry. Apart from Gilot, no one has learned how these surreal poems need to be read. It is a matter of breathing, she said. When read as Picasso intended, his poems become three-dimensional. Somehow the artist/poet has his words come together in the air.

Picasso's verse also has a pictorial vividness that few surrealist poets could equal, as witness his last poem of 1941:

drop of water hanging on the rampart of flames of the bunch of flowers waving around at the fingertips of the burning lips of the sound of the reeds scratch the night the cries the curses and the bursts of laughter the ribbons of mixed colors exalting the stench of the crabs rotting on the beach of the wing rising from the body abandoned to the will of the waves[52]

22

The Occupation (1942)

By the start of 1942, the war had cast a dark shadow over all aspects of Parisian life. Parts of the occupied capital emptied out as thousands had fled south to the free zone. Those who remained endured the humiliating presence of German soldiers and tanks patrolling boulevards now bannered with swastikas. Frequent air-raid warnings forced Parisians to hide underground, while worsening shortages of food and fuel made it harder to find basic necessities. Nazi censors tightened their grip on the French press, and the Gestapo's persecution of Jews and suspected rebels grew more severe.

It was in this oppressive atmosphere that on March 27, 1942, Julio González, the pioneer iron sculptor and friend of Picasso since Barcelona days, died of a heart attack. The two artists had first met as long ago as 1896, when they had both exhibited at Barcelona's Exposición de Bellas Artes é Industrias Artísticas. The fifteen-year-old Picasso had submitted his earliest major figure composition, *La Première Communion*, while the twenty-year-old González submitted a *Bouquet de fleurs* made of burnished wrought iron. More than thirty years later, when Picasso embarked on his own metal sculptures, he turned to González for assistance, inaugurating one of the most fruitful collaborations in twentieth-century art.[1]

On March 31, Picasso attended his friend's funeral at the parish church in Arcueil, just south of Paris, where González had lived and worked. In early April, he commemorated González's death in three memento-mori still lifes of a bull's skull on a table set before a barred window. In one of them, he included a spiky flower with leaves like sharp metal flanges. This is a paradoxical reference to González's iron flowers and to Picasso's favorite poet, Saint John of the Cross, who believed that flowers are emblems of man's mortal soul.[2] The paintings of April 5 and 6 are all the more powerful for being set against a cruciform ground.[3]

Picasso also memorialized González in a magnificent though more conventional still life. A mirror in a heavy gilt frame hangs above a table on which sit a guitar, a bowl of olives, a wineglass, and a cigar. A sword with a scarlet hilt leans against the

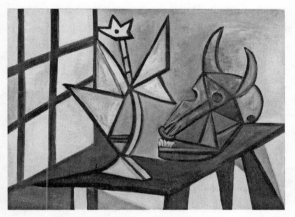

LEFT Picasso. *Still Life with Skull,* April 1942. Oil, 97 x 130.5 cm. Ohara Museum of Art, Kurashiki. RIGHT Picasso, *Bull's Head.* Paris, spring 1942. Assemblage, leather, metal, 33.5 x 43.5 x 19 cm. Musée National Picasso, Paris.

table. The huge shadow cast by the guitar and the daggerlike deadliness of the wine-glass confirm the underlying mournfulness of this *nature morte.*

Around the same time, Picasso reduced the handlebars and saddle of a bicycle into a trophylike skull of a stag's head—seemingly yet another memento mori for González. Trust Picasso to transform these simple elements into a heartfelt homage to his fellow Spaniard. The artist would later tell Brassaï that the idea of combining the bicycle parts into a bull's skull "just came to me before I had a chance to think. All I did was to weld them together."[4] Yet, given the photograph of a similar bicycle seat on his studio wall in Royan two years earlier, this claim does not ring true. He had apparently been visualizing this effect for a considerable time.

In April, Picasso allowed the surrealist collective La Main à Plume—whose activities he helped finance—to reproduce the sculpture on the cover of their journal, titled *La Conquête du Monde par l'Image (The Conquest of the World by the Image).* By changing the format, publication schedule, and title of each issue, the collective managed to get past the German censors. Raoul Ubac was sent to the rue des Grands-Augustins to pho-

Picasso. *Still Life with Guitar,* 1942. Oil on canvas, 100.5 x 81 cm. The Albertina Museum, Vienna. The Batliner Collection.

tograph the *Bull's Head* for the cover. As Ubac worked, Picasso grew impatient and complained, "It's taking you longer to photograph it than it took me to make it."[5]

Weeks later, in May, Picasso's work was also featured in an edition of Buffon's *Histoire naturelle* published by Martin Fabiani, who had inherited the project from Vollard. The volume included thirty-one aquatints of animals that the artist had made in spring 1936 at Roger Lacourière's Montmartre print studio. The long-delayed publication of the Buffon book seems to have brought Picasso closer to Fabiani—so close, in fact, that he allowed the dealer into his vaults at the Banque Nationale pour le Commerce et l'Industrie, an event that Fabiani vividly recounted in his memoirs.[6] The experience left him "with a very strange impression, as if I had taken part in the making of a film by Fritz Lang! The door was armored and equipped with an enormous steel wheel. A bank employee turned the wheel with great difficulty, and then inserted a long key . . . removed it again . . . inserted a second . . . then suddenly the armored door pivoted to reveal the treasure inside. There was a great pile of works by Picasso, Renoir, Rousseau, Cézanne, Modigliani, Matisse and many others."[7]

During the Occupation, Fabiani became not only one of the most active dealers in Paris but a prime conduit through which spoliated art reached the market. He made

millions selling works stolen or acquired crookedly from Jewish collectors. After the war, the British put Fabiani at the top of their official list of French dealers known to have traded with the Nazis, while a report from the American Office of Strategic Services called him "a Corsican adventurer, gigolo, and race track tout," as well as an "arch-collaborationist of the Paris dealer milieu."[8] Though Picasso could hardly have known the full extent of Fabiani's unscrupulous activities, he was not, as we'll see, oblivious to the risks of doing business with him.

Writing in his journal on May 26, 1942, Michel Leiris captured the ambience of Picasso's studio in the midst of the Occupation: "There was a large group of people. It was like seeing the room of a great matador with his court of admirers all

Picasso. *Martin Fabiani,* 1943. Pencil on paper, 50.8 x 33.0 cm. The Museum of Modern Art, New York. Gift of Sam Salz.

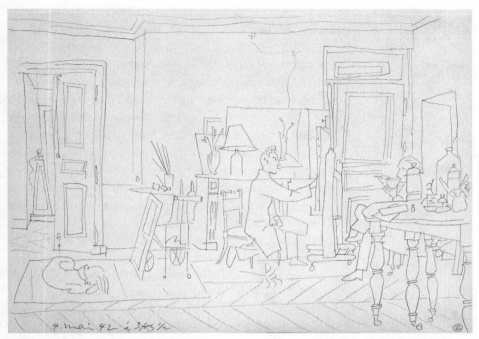

Picasso. *The Studio of Dora Maar,* 1942. Pencil on paper, 43 x 55 cm. Museum Berggruen, Nationalgalerie, Staatliche Museen, Berlin.

around him as he shaves. . . . I had never really noticed the Spanish—and particularly taurine—side of all this."[9] Two frequent visitors to the rue des Grands-Augustins in these years were Picasso's poet friends Jean Cocteau and Paul Éluard, who each represented different sides of France's political and ideological spectrum. Cocteau had sided with the sophisticated collaborationist gang of chic socialites and celebrities. Éluard, on the other hand, belonged to the left-wing circle of surrealist writers and clandestine Resistance activists. Surprisingly, these worlds occasionally overlapped, as seen in Picasso's drawing of May 4, of a get-together at Dora's new apartment on the rue de Savoie.[10]

Cocteau is seated at an easel as Éluard lifts a cup to his lips and Kazbek sleeps on the floor. Cocteau described this memorable afternoon in his journal: "I started a portrait of Éluard while Dora made coffee and Picasso embarked on a marvelous drawing of the whole room . . . After three hours of work, I'm exhausted. The likeness appears little by little. At six, I realize that I've been frozen from the beginning to the end of the session. My concentration prevented me from feeling the cold."[11] Cocteau went on to compare the asymmetry of Éluard's face to the irregularities of beautiful old buildings. His charcoal-on-canvas drawing of Éluard, and the one of

Jean Cocteau. *Portrait of Paul Éluard,*
1942. Pencil on gouache, 91 x 64 cm.
Private collection.

the apartment by Picasso, appear to have ended up in the collection of their hostess, Dora Maar.

By mid-1942, Éluard had put his life as well as his poetry in the service of the anti-German Resistance, which he had been slow to join after his release from the army.[12] The 1939 peace agreement between Moscow and Berlin had created a dilemma for Éluard and other leftist intellectuals linked to the Communist Party: how to defend France from Nazism when the "USSR, the self-proclaimed vanguard of anti-fascism had signed a non-aggression pact with the beast."[13] Hitler's decision to violate the pact by invading Russia in June 1941 had inspired French Communists to join the struggle against Germany. For Éluard, Nusch, and their surrealist friends, the news was a cause for celebration and a reason to fight.

In 1940, Éluard had begun his greatest poem of the war years, as an ode to his wife Nusch with the title "Une Seule Pensée." Originally, every stanza ended with her name. However, in the process of transforming the poem into a Resistance tract, Éluard replaced "Nusch" with the word "Liberté":

> And through the power of one word
> I restart my life
> I was born to know you
> To name you—Freedom.

Printed in Algiers in 1942 by the journal *Fontaine*, "Liberté" soon made its way to London, where it was reprinted en masse by the Gaullist press. British air force planes would drop thousands of copies of Éluard's poem over Occupied France. As German suppression of artists and intellectuals suspected of rebellion intensified throughout 1942 and 1943, Éluard rejoined the Communist Party and went underground. He wrote clandestinely, publishing his poems under pseudonyms and secretly distributing Resistance literature with the help of Nusch, who would avoid suspicion by hiding it in candy boxes. Nusch also worked with organizations that sought to help Parisian Jews, who were under deadly persecution from the French and German authorities.

On July 16, 1942, over twelve thousand Jews were arrested and removed from Paris by French police on orders from the Vichy regime. Families were torn apart and thousands of children separated forever from their parents. Victims of the roundup

were temporarily confined in terrible conditions at the Vélodrome d'Hiver, an indoor stadium used for bicycle races, before being relocated to internment camps outside Paris and, finally, deported to Auschwitz. There is no specific reference to these events in Picasso's wartime work. However his treatment of Dora's image throughout the Occupation has disturbing echoes of cruelty, confinement, and torture. An atmosphere of suffering permeates his imagery throughout 1942.[14] Even Gerhard Heller, the German lieutenant in charge of literary censorship, acknowledged this point after visiting Picasso's studio in June 1942. Heller would later write that "the horror of war (though never expressed)" was apparent in Picasso's canvases "in a way that was difficult to bear."[15]

Although Picasso was closer than ever to Éluard and other longtime Left Bank friends, curiosity and nostalgia provoked his occasional sorties into the *vie mondaine* where Jean Cocteau held sway. After a prewar phase in the shadows, the poet was reinventing himself as a social superstar, an even more openly gay one—the perfect target for Picasso's affectionate, though sometimes diabolical, mockery. For years, the artist loved to play games with Cocteau at a speed and a height unavailable to anyone else. And throughout the war Cocteau would always be on call. Picasso relied on his services as a court jester, and could seldom resist a derisory crack. Years later in 1957, Picasso would ask Douglas Cooper and myself to lunch at his home, La Californie. Cocteau wanted to join us but had been told to come in later for coffee. "Don't, for God's sake, let him embrace you," Picasso said to me more than once. "He's suffering from a nasty skin disease that he caught from the Germans during the war."

One of Cocteau's favorite wartime haunts, which Picasso occasionally visited, was the salon of morphine addict Misia Sert. Her ex-husband José Maria Sert had become Franco's ambassador to the Vatican. During the war, she came back into Picasso's life and, as before, provided him with entertainment. This time, friendship with Misia gave the artist a glimpse of right-wing collaborationist society. Picasso enjoyed the lavish food almost as much as the tawdriness of the guests.

Misia's pet companion and secretary was Boulos Ristelhueber—nicknamed "Ectoplasm" for his ghoulish white makeup—whose scandalous diary, only parts of which have been published, records the glitter and the darkness of their wartime world. The entry for December 20, 1940, describes a dinner with Picasso at Misia's apartment. She had recently seen Paulo, her godson, in Switzerland, where, according to Boulos, the boy told her "with a cynicism beyond praise, that he made a living selling drugs . . . She told him that rather than risk prison for paltry profits, he could make much more money by stealing one of his father's paintings and selling it. Picasso pretends to be revolted by this suggestion."[16]

Compared to most in occupied Paris, Boulos and Cocteau enjoyed lives of exceptional privilege, but on January 11, 1941, they resorted to petty theft to obtain some

Raymond Voinquel. Photograph of Jean Cocteau, 1942. Médiathèque de l'Architecture et du Patrimoine, Charenton-le-Pont.

scarce essentials. Boulos's diary reads: "We go, Cocteau, Jean Marais [Cocteau's lover, the future movie star], and I, to an all-night pharmacy to fill a prescription. While it is being made up, we notice a box of soap, a rare commodity that is not allowed to be sold. After long deliberation, in a bit of a cold sweat, Marais and I decide to steal it. At the door we show our loot to Jean. From his pocket he produces a tube of face cream that he has made off with on his own!"[17]

In Cocteau's milieu of luxe, gossip, and right-wing intrigue, celebrated actors, fashionistas, and gigolos thrived. Handsome German boyfriends were in great demand by both sexes. On returning from Royan, Picasso had kept this bitchy *galère*—headed by Coco Chanel and Marie-Laure de Noailles—at a distance. His contacts with this group went back to his Ballets Russes days and his marriage to Olga.

Marie-Laure and her husband, Charles, Vicomte de Noailles, lived at opposite ends of their enormous, art-filled Paris mansion, not out of any ill feeling—they loved each other and telephoned or wrote every day—but out of a need to lead separate lives. Marie-Laure would fall for a series of good-looking young musicians. In the 1930s, she had a passionate affair with Igor Markevitch, the handsome composer and conductor who had been the last great love of Diaghilev's and would later marry Nijinsky's daughter. At the height of the war Marie-Laure eloped to Évian with a faunlike young cellist named Maurice Gendron. They foolhardily took a boat across Lake Geneva to Switzerland, where they were promptly arrested and incarcerated in a detainment camp. According to Cocteau, Marie-Laure had to peel potatoes while Gendron cleaned out the latrines. After they were repatriated, she did something even sillier: she took up with an Austrian officer. Years later, Picasso would turn against Marie-Laure. In 1956, after spotting her at a bullfight with the painter Oscar Dominguez—a faker of Picasso's work—he told me that she looked exactly like Goya's hideous Queen María Luisa of Spain.[18]

Chanel, too, began a romance with one of the occupiers after her affair with Picasso's friend Apel·les Fenosa had fizzled. In 1940, she met the Nazi intelligence officer Baron Hans Günther von Dincklage. At forty-four, he was thirteen years younger than the fashion designer. Chanel used Dincklage's German connections in

an attempt to wrest ownership of her perfume company away from the Wertheimer family of Jewish investors, to whom she had sold a majority stake eighteen years earlier. In 1942, she went so far as to press her case before Kurt Blanke, the Nazi official in charge of seizing Jewish property in France. In the end, her plan failed. Before fleeing France and resettling in New York, the Wertheimers had aryanized La Société des Parfums Chanel by ceding control to a loyal, non-Jewish business partner. With their interests secure, they later moved production of the fortune-making Chanel No. 5 fragrance from Paris to Hoboken, New Jersey.[19]

Unbeknownst to him at the time, Picasso became indirectly linked to this affair through his association with Fabiani. When the artist agreed to buy a Douanier Rousseau painting, offered to him by Fabiani during the Occupation, he required the dealer to certify the sale's legality in writing. The document proved useful later on, when Picasso learned that the Rousseau had belonged to the Wertheimers. Reports compiled by Allied investigators implicated Fabiani in the liquidation of the Wertheimers' art collection.[20] After the war, the dealer was indicted for embezzlement and his assets frozen.[21]

Even more grandiose and pro-German than Marie-Laure or Chanel were the rich Argentine diplomat Marcello Anchorena and his wife, Hortensia. Their extravagant, surrealist behavior and lavish apartment on the avenue Foch endeared them to Cocteau and his friends, including Picasso. The Anchorenas' outrageously elaborate black-market lunches served by two butlers and two footmen in full livery were so totally out of sync with the shortage and dreariness of wartime life that Cocteau had no difficulty persuading Picasso to attend. Jean Hugo recalled joining Picasso and Dora at the Anchorenas' for a meal that consisted of "chicken wings and thighs speared between slices of veal on six golden swords, one per guest, planted in a dome of dough and accompanied by two oval-shaped pies with guilloche edges . . . and potato croquettes with dry black mushrooms to bring out their pallor. Then appeared a cauliflower with vinaigrette in a puddle of beurre blanc, whose strange efflorescence one could savor, surrounded by some galettes sprinkled with I don't know which rare spice. And finally, a pumpkin pie drizzled in clove syrup. Each dish provoked the surprise and admiration of the guests as well as the ironic smile of the waiters."[22]

The fact that a portrait of the Führer dominated the Anchorenas' library—and that their sacred trinity consisted of Hitler, Picasso, and the Duke of Windsor—was too absurd to be taken seriously. They embodied everything Picasso loathed, but in such a preposterously caricatural way that he had no problem perceiving them as clowns. It helped that they kept him in cigarettes. Claude Arnaud observes of chez Anchorena: "Picasso, who found the place even more hideous than Cocteau did—and said so very bluntly to their hosts—promised to [paint] the door to the

bathroom, which never ended up leaving his studio."[23] On January 17, 1943, Cocteau lunched with Picasso and Dora at the Anchorenas' apartment and recorded the event in his journal. The meal, as usual, was "too rich in sauces," and Picasso could not contain his contempt for his hosts' bad taste. Cocteau spent the afternoon embellishing the Anchorenas' piano with drawings in red, white, and blue chalk. Picasso closely watched Cocteau at work, and the latter could feel the artist's gaze grow colder at the slightest mistake.

Throughout the war, right-wing collaborators tried to impugn Picasso. All manner of malicious rumors were spread about the artist's activities and whereabouts. On June 6, 1942, in a letter to his son Pierre, Matisse refuted the false story that Picasso had been confined to an insane asylum. "It's disgusting, that rumor. It must have been started by the enemies of Picasso's paintings." Matisse further defended his friend and rival for leading "a dignified life in Paris. He works, he doesn't want to sell, and he makes no demands. He still has the human dignity that his colleagues have abandoned to an unbelievable degree."[24]

One colleague Matisse had in mind was the flashy fauve Maurice de Vlaminck, who that very day had viciously attacked Picasso in the art weekly *Comoedia*. This ruthless and spiteful operator had loathed Picasso for years. The latter loathed him back every bit as much. In 1917, Picasso had told the critic Adolphe Basler that he saw himself as a new Jacques-Louis David—the artist of the French Revolution— adding that when it came to Vlaminck, "I myself would like to be in charge of the guillotine."[25] By nature ultraconservative, Vlaminck had become a Nazi favorite, finally able to avenge himself on his enemy. His article in *Comoedia* was vituperative, calling Picasso "impotence incarnate" and accusing him of "borrowing from the masters of the past, and even contemporaries, the soul of creation which he has never had. . . . The only thing Picasso can't do is a Picasso that's really a Picasso." Vlaminck went on to denounce art critics for having been "stupefied, mystified, and misled by such hot air."[26] Cocteau wrote in his journal that Vlaminck's tirade provoked "universal disgust" among Picasso's friends.[27] In the end, Vlaminck hurt no one more than himself. After the Liberation he would be banned from showing his work, a punishment shared by a number of prominent French artists—among them André Derain, Charles Despiau, and André Dunoyer de Segonzac—who had joined Vlaminck on a Nazi-sponsored propaganda tour of Germany in October 1941.[28]

A powerful figure behind the scenes in wartime Paris was an exceedingly astute former assistant director of the Sûreté, André-Louis Dubois, who had switched to working undercover for the police force. Among the celebrities he guarded under his protective wing were Cocteau, Jean Marais, the Jewish painter Chaim Soutine, and, not least, Picasso. Dubois later wrote: "For five years I had a fixed appointment, almost daily, around 11:00 in the morning. It was the rue des Grands-Augustins."[29]

Dubois, who was homosexual, had ties to the Spanish ambassador to Vichy, José Félix de Lequerica, who surreptitiously helped to keep Dubois's protégés out of trouble.

Dubois arranged for Dora and Sabartés to have permanent telephone access to him, in case of any emergency that might befall Picasso. A wise precaution. One day Dubois received an SOS call from Dora: Gestapo agents were harassing Picasso in his studio. There were no cabs, so Dubois raced across Paris on foot, to be confronted by two Nazi officials in long green raincoats in the courtyard of 7 rue des Grands-Augustins. They demanded to see Dubois's papers, which were sufficiently impressive to drive them away. Dubois found Picasso's studio in disarray, paintings ripped and roughed up. The artist remained impassive, smoking a cigarette as he told Dubois: "They have insulted me as a degenerate, a Communist, a Jew. They kicked in my canvases and said to me, 'We're coming back. That's all for now.' "[30]

Although Dubois later wrote that the Germans never came back, Françoise Gilot says they returned regularly. One of the tricks they repeatedly played was to act as if Picasso's apartment belonged to the Jewish artist Jacques Lipchitz, despite the fact

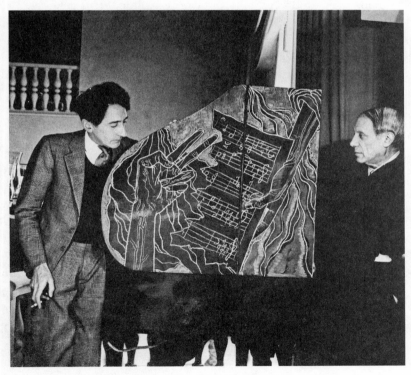

Cocteau and Picasso with the piano decorated by Cocteau at the Anchorenas' apartment, 1943. Bridgeman Images.

that Lipchitz had fled to America and had never lived at that address. Under this pretext, Nazis, led by a polite French-speaking officer, would search Picasso's studio every few weeks, keeping the artist under constant surveillance.[31]

Not all German callers were so menacing. On July 22, the novelist and Nazi officer Ernst Jünger came to the rue des Grands-Augustins. Jünger described the episode in his journal: "On a piece of paper, the little word 'ici' written on it in blue pencil was taped to the narrow door. I rang and a short man in a simple smock opened the door for me—Picasso himself." Among the artist's paintings, Jünger was struck by a series of asymmetrical heads, likely of Dora, which he found monstrous. When Jünger detected an "alchemical character" in Picasso's work, the artist replied cryptically: "There are chemists who spend all their time searching for the hidden elements in a piece of sugar. Well, I'd prefer to know what color it is." Jünger claimed that Picasso told him near the end of their meeting: "The two of us, sitting here together, could work out a peace treaty this very afternoon. By nightfall all men could turn on their lights."[32]

Despite intrusions and threats, Picasso was never physically harmed or arrested, thanks perhaps to Arno Breker, Hitler's favorite sculptor. This celebrated German hack sculpted on a gigantic scale described by the British as "buggers' delight": preposterously homoerotic heroes with buttocks and biceps pumped up to bursting point. In the 1920s, Breker had studied in Montmartre under Maillol, hence his familiarity with the Paris art world. When he returned to the French capital during the Occupation, he took over the Île Saint-Louis apartment belonging to the Jewish cosmetics entrepreneur Helena Rubinstein. She and her second husband had vacated the apartment when war broke out in 1939.[33]

Breker's work was decidedly antimodernist. Yet he recognized Picasso's significance and claimed to have intervened directly with Hitler to ensure the artist's safety.[34] Unfortunately, Breker cannot be relied upon. This fantasist once boasted that his Greek wife had taught him the secret methods of Phidias, the greatest sculptor of classical antiquity. Breker also claimed that he had prevented the Führer from melting down Parisian bronze sculptures—a time-honored feature of the city's streets, squares, and parks—after a French law was passed on October 11, 1941, authorizing the liquidation of public monuments. Breker may have saved some of the city's favorite sculptures, but others of lesser significance were lost. The French took for granted that the Germans had repurposed the metal—as well as the zinc countertops of virtually all Parisian bars—to fabricate not only armaments but also Breker's hunky nudes, which went on view in April 1942 for a spectacular show at the Jeu de Paume.[35] The French metal founder Eugène Rudier was released from the military prison at Fresnes and brought to Paris to cast the works for Breker's exhibition, using thirty tons of bronze.[36]

Charlotte Rohrbach. Photograph of Arno Breker and Jean Cocteau, 1942.

Photographs of the opening show Cocteau, who had known Breker since the 1920s, standing in a crowd beside uniformed SS officers. He soon returned to the exhibition with Marais, "thinking that Marais's physique might inspire Breker, and finally went so far as to applaud the sculptor in the press."[37] On May 23, 1942, *Comoedia* published Cocteau's "Salute to Breker" on the front page. Patriotic critics François Mauriac and Jean Paulhan were disgusted. Éluard castigated Cocteau in a letter: "Freud, Kafka, and Chaplin have been banned by the same people who honor Breker. You were believed to be among those forbidden. How wrong you have been to suddenly show yourself among these censors! The best of those who admire you and love you have had a painful surprise."[38]

Cocteau was certainly not alone in praising Breker.[39] The official sculptor of the German Reich was feted across Paris by collaborationist officials, critics, and artists, including Derain, who hosted a champagne reception for Breker at Fauchon.[40] Michèle Cone has suggested that the adulation for Breker may have served as a "diversionary tactic," distracting the public from Nazi war crimes: "While the French press

preoccupied itself with Breker's art, news of human interest—such as the Vél d'Hiv stadium roundup by the Gestapo . . . was nowhere to be found."[41]

On May 5, 1942, Picasso completed his largest painting of the war years, *L'Aubade,* or *The Morning Serenade* (77 x 104 inches).[42] Hundreds of preparatory studies done over the previous year suggest that he was out to challenge such old masterpieces as Titian's *Venus and Lute Player*, Ingres's *Odalisque and Slave*, and Goya's *Naked Maja*. The discrepancy between *L'Aubade*'s romantic title and the anything-but-romantic image is Picasso at his most devious. Though the subject could hardly be more traditional—a recumbent nude, evidently Dora, serenaded by a woman holding a mandolin—the painting sets out to unnerve rather than soothe. The figure on the bed, watching herself in the mirror, appears to be trussed up, while the musician, coiffed like a woman, may be self-referential—Picasso in drag. Harking back to cubism, the artist sees himself in caricatural mockery of his own sublime *Girl with a Mandolin*, painted in spring 1910.[43] Apropos the subterranean feel of the setting, remember that Picasso, like most Parisians, worried that air raids might oblige him to take shelter in the basement. *L'Aubade* epitomizes the fear and anguish that pervades his deepest, darkest wartime paintings.[44] In an interview for the American Socialist journal *New Masses* three years after painting *L'Aubade*, Picasso refused to interpret its meaning: "I painted it for myself. When you look at a nude made by someone else, he uses the traditional manner to express the form, and for the people that represents a nude. But for my part I use a revolutionary expression. In this painting there is no abstract significance. It's simply a nude and a musician."[45]

Nevertheless, Picasso would acknowledge to another interviewer that the war permeated everything that he had done during the Occupation.[46] And indeed, the war certainly makes itself felt in another large reclining nude dated September 30, 1942, four months after he had finished *L'Aubade*, portraying a naked, flayed-looking Dora stretched out on a mattress in a space as cramped and bleak and bare as a prison cell.[47] The painting is about the agony of confinement felt not just by Picasso and Dora but by all of occupied France. Although the artist and his mistress officially lived under separate roofs, the wartime curfew sometimes stranded her chez Picasso and condemned them to spend time cooped up together at night. This and the epidemic of fear that the Occupation unleashed took a toll on them both. And as the war dragged on, the images of Dora became ever more anguished. Picasso used her tears to stand for mankind's. In *Reclining Nude*, for instance, her face is set in a rictus of grief; her hands are clenched into fists that are as tight and spiky as that staple of wartime diet, the artichoke; and her legs are articulated to resemble crossbones, such as we find encoded in other images done during the Occupation.

Picasso. *Reclining Nude,* 1942. Oil on canvas, 129.5 x 195 cm. Museum Berggruen, Nationalgalerie, Staatliche Museen, Berlin.

Work on *Reclining Nude* coincided with a covert commitment on Picasso's part to the struggle against the Germans. Éluard, who had joined the Resistance and rejoined the Communist Party, had called on Picasso to help finance *Les Lettres Françaises*. It is surely no coincidence that *Reclining Nude* was executed ten days after the first issue of this celebrated underground newspaper.

The painting's cubist forms and color palette, as well as the pose of the figure with one arm behind her head, hark back to Picasso's reclining nude of spring 1910.[48] His fascination with this image of twenty-five years earlier likely stemmed from the second volume of Zervos's catalogue raisonné of Picasso's work. Despite the Occupation, the publisher and the artist had been organizing the proofs. While going through the plates for the catalogue, Picasso was apparently so struck by one of the only horizontal nudes of his cubist period that it became the basis of a new masterpiece. His earlier works frequently inspired Picasso, but seldom as strikingly as in this case.[49]

Endre Rozsda. Photograph of Françoise Gilot, c. 1942. J. M. Atelier Rozsda, Paris.

23

Epilogue

On January 5, 1943, the French high court finalized Picasso's separation from Olga, ending once and for all a legal process that had begun seven years prior. She could no longer challenge the decision. Even before the ruling came down, Picasso had urged her to return to Switzerland. Instead, it seems, Olga chose to stay in Paris, where she could remain part of her husband's life. He dreaded the times they had to meet at the bank to transfer alimony payments. "It's not like she's going to give *me* any money," he moaned to Cocteau before one such appointment.[1] As per the terms of the separation, he continued to support her and Paulo financially.[2]

Earlier in the war, Olga and Picasso had hoped to exempt Paulo from military service, but there was no way to do so. Strings were pulled and, as he loved to ski, Paulo joined the Chasseurs Alpins way up in the mountains between France and Switzerland, where, among other duties, he had to cope with a recalcitrant mule that supplied the unit with water.[3] Later on, he landed a job at the French embassy in Geneva, in the office that coordinated donations to the French war effort. He worked there until October 1946.[4] Picasso would not see his son for the duration of the war but supplied him with funds through Swiss friends. Matisse reported to his own son Pierre that Paulo had caused Picasso "a great deal of anxiety. Now that he is in Geneva, the boy goes to Skira's office and gets money for his immediate needs. He has been in a lot of scrapes, and has not changed his ways, either."[5] Painful relations with his parents tormented Paulo throughout his life. Nevertheless, he would develop into a loyal and lovable man who would serve his father as chauffeur and confidant over twenty years.

On January 17, Picasso walked over to Dora Maar's rue de Savoie studio to give her a belated Christmas gift: a copy of Buffon's *Histoire naturelle,* which had been published by Fabiani eight months earlier. Opposite the title page he made an ink drawing of Dora, big-busted and winged, with a punning inscription in Catalan: "Pour Dora Maar, tan rebufon" ("For Dora Maar, so super-charming"). This

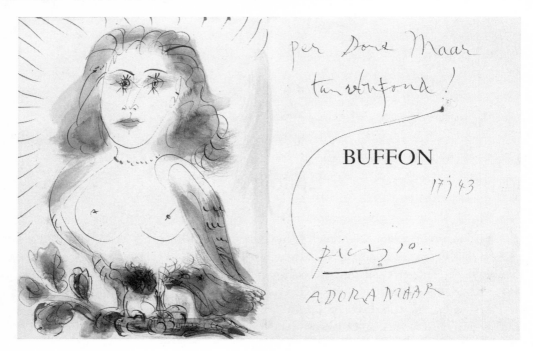

TOP Picasso. *Dora Maar as Sphinx,* 1942. Pen and india-ink wash, 37.2 x 56 cm. One of the forty-four original drawings made by Picasso in the copy of Buffon's *Histoire naturelle* given to Dora Maar. ABOVE, RIGHT Picasso. *Medusa Heads.* ABOVE, LEFT Picasso. *Skeletons and Sphinxes.* Bibliothèque nationale de France.

seemingly loving gesture was nothing of the sort. On the subsequent page he drew a macabre human skull with huge eye sockets mounted on a bird skeleton, a fiendishly cruel response to the affectionate sexiness of his frontispiece. On the next page Picasso went even further. He came up with a Medusa skull that seems to smile in a headpiece of hideous snakes. Picasso filled yet another blank page with the image of a handsome faun, presumably self-referential. He made over forty drawings in the book given to Dora, including a number of female heads, some of which bear a caricatural likeness to her.

Dora was becoming ever more melancholic and unbalanced. She had good reason. Apart from her deteriorating relationship with Picasso, her father was still in South America and her mother had recently been imprisoned in Dijon by German officials on the suspicion that her Croatian surname, Markovitch, might be Jewish. Letters to Dora record her experience: "I was arrested on July 19. I'm all right, send you lots of kisses. Send me some cookies." On August 22, 1942, Dora's tough old mother writes that she only gets one bowl of soup at nine in the morning and another, with bread, at nine at night. Still, she told her daughter to "be brave." On August 30, she was released.[6]

Six weeks later, Dora's mother, weakened by her time in jail and stricken with persistent headaches, died suddenly. Dora recounted the circumstances in a letter to her father: "I left my mother in an absolutely normal state of health a few hours before her death and found her at the foot of the bed due to a brain hemorrhage when I returned. The doctor told me that it is better this way because, had she survived, she would have been paralyzed."[7] Dora would later say that when Picasso saw her dead mother on the floor, he "made a circus of it, coming and going with his friends, Sabartés, Marcel, it was revolting. In order to belittle death, you see, because he's so terrified of it."[8]

A week before Madame Markovitch died, Picasso completed what is arguably his most lifelike and moving image of Dora.[9] She looks out at us, seemingly waiting for and willing to accept whatever her lord and master has in store for her. Picasso has dressed her penitentially in an anything-but-fashionable dress. The full-face ingenuousness—so unlike the many tortured images of his mistress—recalls Rousseau, a painter Picasso greatly admired and collected. Among his Rousseaus were a self-portrait and a pendant of the artist's wife, whose blank gaze and striped dress are mirrored in Picasso's image of Dora.[10] The artist told Brassaï that he originally painted the background with prison bars, a jug of water, and a piece of bread. Dora, anguished over her mother's recent imprisonment, objected to these details, and Picasso removed them.[11]

. . .

Picasso. *Paris. July 14, 1942.* Engraving and etching, 45.2 x 64.1 cm. Musée National Picasso, Paris.

The artist executed the largest of his wartime sculptures in spring 1943, *Man with a Lamb.* The concept had been evolving on paper for the previous eight months. According to Sabartés, the idea began with Picasso's etching of July 14, 1942, depicting a procession of men and women bringing gifts to a bearded, bare-chested male figure on the right. Among the crowd is an old woman carrying a lamb against her chest. "That's where the idea of the statue came from," said Sabartés. "Afterward, Picasso, to get a clearer idea, did a very large number of drawings, about a hundred perhaps."[12]

Dozens of studies done between July 1942 and April 1943 reveal Picasso obsessing over the pose, position, and proportions of a man holding a nervous lamb in his arms. These graphic experiments convinced the artist to execute the work in three dimensions: "I knew it couldn't be a painting; it had to be a sculpture. At that moment I had such a clear picture of it, it came forth just like Athena, fully armed from the brow of Zeus." The artist would describe to Brassaï how rapidly the over-life-sized figure took shape in the studio: "After I don't know how many sketches and months of reflection, I assembled that statue in a single afternoon." The work was not without

LEFT Picasso. Study for *Man with a Lamb,* October 26, 1942. Ink and ink wash on paper, 63.5 x 49.5 cm. Collection Gail and Tony Ganz, Los Angeles. RIGHT Picasso. Study for *Man with a Lamb,* February 13, 1943. Ink and gouache, 65.2 x 49.6 cm. Musée National Picasso, Paris

complications. Picasso needed the help of his chauffeur, Marcel, and Paul Éluard to save the sculpture from ruin when its armature began to buckle: "The statue started to wobble under the weight of the clay. It was awful! It threatened to collapse at any moment. I had to act fast . . . We took cords and anchored it to the beams, I decided to cast it in plaster immediately. It was done the same afternoon. What a job! I'll remember that one."[13]

The numerous preparatory drawings for the work have been analyzed by art historian Paul M. Laporte, who recognized the correspondence of Picasso's figure with the archaic *Calf Bearer* in Athens's Acropolis Museum.[14] Picasso's knowledge of this fifth-century BC prototype probably came from Zervos's 1934 book on ancient Greek art, *L'Art en Grèce*. To differentiate his sculpture, the artist has the man hold the lamb in front of him, whereas the Greek carries his calf over his shoulders. As we've seen elsewhere, the inspiration of ancient marble sculpture reached Picasso through photography.

Later that spring, a twenty-one-year-old artist named Françoise Gilot caught Picasso's eye while dining at Le Catalan. She was born in Neuilly-sur-Seine in November 1921 to a prosperous bourgeois family. An only child, she grew up close to her father, who took her to muse-

Picasso. *Man with a Lamb*. 1943. Patinated plaster, roman casting, 209 x 78 x 75 cm. Museo Nacional Centro de Arte Reina Sofía, Madrid.

ums. Her mother taught her to draw. She continued to develop as an artist as she completed her baccalaureate at the Université de Paris. After the outbreak of war, her father insisted she quit Paris and attend law school at Rennes in Brittany.

Back in Paris the following year, Françoise continued studying law. On November 11, 1940, for attending a students' gathering at the Tomb of the Unknown Soldier of World War I—and therefore an anti-German demonstration—she, along with many others, had her name taken by the police and was put under "city arrest," obliged to

Picasso. *Head of Woman (Dora Maar),*
May 16, 1943. Oil on canvas, 27 x 16 cm.
Archives Succession Picasso.

report each day to the Kommandantur. Law students were under particular suspicion, so to regain a measure of freedom she switched to studying fashion design at the high-fashion atelier of Lucien Lelong, where her mother was a customer.

In 1942, again at the insistence of her father, Françoise resumed her law studies, but frequently skipped class to paint under the tutelage of an original and gifted Hungarian painter named Endre Rozsda. Brassaï, who first met Françoise in Rozsda's studio, was impressed by the young woman's "vitality, her tenacity in overcoming obstacles," as well as by her "desire to show Picasso her paintings."[15] Later in 1942, she and Rozsda enrolled at the Académie Ranson on the Left Bank but her father soon pressured her to complete her second year of law school.[16]

Meanwhile, Geneviève Aliquot—her best friend and fellow painter—had arrived from the former Free Zone to organize a joint exhibition with Françoise, which opened on May 8. One evening the girls waited backstage to meet the famous actor Alain Cuny, whom Geneviève fancied. Cuny took her to dinner at Le Catalan on

May 12, 1943, and, out of shyness on Geneviève's part, Françoise was invited to join them. This was the first time she came face-to-face with Picasso, who approached her table proffering a bowl of cherries. Cuny proceeded to introduce Geneviève as "the pretty one" and Françoise as "the intelligent one." The artist was instantly struck and Françoise invited him to visit her exhibition.[17] He did so and would embark on an affair with her later in the year.

As the war drew to its close over the following two years, Françoise's youthful incursion into Picasso's life would rejuvenate his psyche, reawaken his imagery, and inspire a brilliant sequence of paintings. Her arrival on the scene brought about the long denouement of Dora Maar's reign as *maîtresse-en-titre* and self-sacrificial victim. Dora had thrived on punishment; Françoise was not at all masochistic. Picasso's love for her, and hers for him, would turn out to be that of master and pupil rather than master and slave.

Over time, Dora's mental health would decline. On February 6, 1943, Picasso did a painting of her in which her diabolically twisted face forms a figure eight. Her agonized features have an excruciating mobility.[18] Is she laughing or screaming? This "portrait" ushered in a series of contorted faces that engendered more twists than ever before. In another poignant work, from May 16, Dora's face resembles a wonky mauve jug with eyelashes cavorting above two nostrils on the jug's spout and an open mouthful of broken teeth placed vertically at the base.[19] Her ear doubles as a handle—a comical and at the same-time heartrending image of the mistress he would eventually replace with the beautiful Françoise Gilot, who would never suffer the cruelty meted out to Dora.

However, Françoise's lack of tragic impulses, her youthfulness and strength, would not inspire the harrowing masterpieces her predecessor had done. Picasso's art tended to thrive on the dark side. He had destroyed Dora, beaten her to bits, and cut her up in paint. He would tell Françoise that he had never loved Dora. He had sacrificed her on the altar of his art. Her tears and suffering had galvanized his work.

After the war, Dora would suffer successive nervous breakdowns from which she would be partially, though not totally, restored by Dr. Lacan. She would transform herself from a leftist-radical to a passionate Catholic conservative who dabbled in social life but, despite long hours on her knees in prayer, spent most of her time painting in a style that owed nothing to her former lover. It's no wonder Dora turned to religion. As she would later confess, "After Picasso, there is only God."

ACKNOWLEDGMENTS

This book would not have been possible without the great generosity of John's friends and patrons Janet Ruttenberg and Larry Gagosian, whose financial support meant the research and writing of this volume could continue until its completion.

The Picasso family's support for John's volumes began long ago with the artist himself and his second wife Jacqueline. It continued with his son Claude, head of the Picasso Administration, and his daughter, Paloma, whom John knew since they were small. Their mother, Françoise Gilot, has been a unique source of information about the artist, which she shared in a series of long and lively lunches, along with her other daughter, Aurelia Simon, at John's loft in New York. And Marie-Thérèse Walter's daughter Maya Widmaier Picasso and her family were also enormously helpful. She and her daughter Diana generously lent archival photographs for this volume, and John drew upon her son Olivier's book, *Picasso: The Real Family Story*, to confirm certain details.

As with volume III, John's greatest debt is to Bernard Picasso and his wife Almine. For volume IV, Bernard made previously unpublished archival documents and photographs from his grandmother Olga's archive available which were an invaluable contribution to the book. John and Bernard enjoyed a close friendship and when he came to New York—if they were not having lunch or dinner—Bernard would stop by the loft with Almine and their children. Through the establishment of Fundación Almine y Bernard Ruiz-Picasso para el Arte or FABA, Bernard and Almine have furthered Picasso scholarship and organized and supported contemporary art exhibitions.

Christine Pinault at The Picasso Administration was not only generous with her time, but endlessly patient, and tireless in helping us track down the many images and authorizing them for this book. At FABA, Ellenita de Mol deserves our thanks for getting the many photographs to us quickly and efficiently, as does Thomas Chaineaux, a former archivist at FABA.

At the Musée Picasso, Paris, help came from Director Laurent Le Bon and his predecessor Anne Baldassari, as well as from curator Emilia Philippot, while archivists Violette Andres and Pierrot Eugène made invaluable documents that were needed

available. Jean-Louis Andral, director of Antibe's Picasso Museum, and Stéphane Guégan of the Musée d'Orsay offered both advice and encouragement.

In London, Tate Gallery curators Achim-Borchardt Hume and Nancy Ierson, and National Portrait Gallery director Nicholas Cullinan kindly shared their time and knowledge.

As always, New York's Museum of Modern Art proved an invaluable resource, thanks to director Glen Lowry and curators Ann Temkin and Anne Umland who discussed their recent work on Picasso's sculpture. At the Metropolitan Museum of Art, appreciation is owed to Stephanie D'Alessandro and Sheena Wagstaff.

Heartfelt gratitude goes to current and former staff of the Gagosian Gallery—with whom the author organized six major Picasso exhibitions from 2009–2017—particularly Michael Cary and Valentina Castellani. Now a Picasso authority in his own right, Michael not only provided essential curatorial support but a decade of devoted friendship. Alison Mcdonald and her team in the gallery's publications department produced the beautiful exhibition catalogues in which some of the themes of this volume were first explored.

The late Robert Silvers always wanted to publish a bit of whatever John was working on, and that included some material from this volume, which appeared in *The New York Review of Books*.

This volume draws upon the input of authors and experts on both sides of the Atlantic. Claude Arnaud, biographer of Jean Cocteau, provided his perspective on Picasso's friendship with the poet and their experience in wartime Paris. Hispanist Gijs van Hensbergen offered his deep knowledge of the culture and politics of Picasso's homeland. Charlie Stuckey contributed much on the history of the Surrealist movement and Picasso's connections to it. Mary Anne Caws' insights on French poetry informed the treatment of Picasso's verse throughout his volume. Michael FitzGerald's work was essential for understanding Picasso's place in the early market for modern art, as was Gertje Utley's for grasping Picasso's politics. Vérane Tasseau clarified key points about D.-H. Kahnweiler and his gallery, while Cécile Godefroy and Laurence Madeline answered all manner of Picasso questions. Crucial information about Dora Maar came from conversations with her definitive biographer Victoria Combalia, as well as from Louise Baring and Brigitte Benkemoun. Art historians Elizabeth Cowling, John Elderfield, Pepe Karmel, and Kenneth Silver helped in many important ways. Thanks are also due to the late Lydia Gasman whose theories on the mystical aspects of Picasso's art and poetry provoked new ideas.

At home John's support team included his ex-husband, Kosei Hara, and Sonam Chodon—the only person he really listened to and trusted—and Taeko Miyamoto. Rob Grover was an incredible right hand, setting the course for those came after him as assistant: Jeremy Bleeke, Jonathan Coward, and Darrell Maupin. At his former

home in Connecticut, John relied upon the help of Andy Carollo, Karina Serrano, Marianne Winslow, Alex Fox, and Fred Balling.

The following were among those who in John's words "contributed more than they may have realized" to volume IV. Donna and William Acquavella; Eleanor Acquavella; Staffan Ahrenberg; Sheikh Hamad bin Abdullah Al-Thani; Charles Allsopp; Henry Allsopp; Wyatt Allgeier; François-Marie Banier; Dr. Gaetano Barile; the late Pierre Bergé; Olivier Berggreun; Marie-Laure Bernadac; Ian Buruma; Mercedes Bass; Derek Blasberg; Anya Bondell; Alex and Eliza Bolen; Hamish Bowles; Emily Braun; Eliza Callahan; Richard Calvocoressi; Nell Campbell; Campbell Carey; Graydon Carter; Francesca Casadio; Serena Cattaneo Adorno; Maria La Cava; the late Lucien Clergue; Dr. Stanley Chang; David and Rose Cholmondeley; Steve Cohen; Bob Colacello; Virginia Coleman; Elizabeth de Cuevas; Jeffrey Coploff; David D'Arcy; David Dawson; Annette and the late Oscar de la Renta; Christian Derouet; Barry Diller; the late Grace Dudley; Anne Dunn; Dr. Tim Dutta; John Eastman; Chris Ely; Tracey Emin; Chrissie Erpf; Mica Ertegun; Eugene (the barber); Rupert Everett; Hector Feliciano; John Field; Martin Filler; John Finlay; Princess Firyal; Mark Fisch; Sharon Flescher; Cornelia Foss; Jack Flam; Mark Francis; the late Lucian Freud; Bella Freud; Tony and Kate Ganz; the late John Giorno; Nelly Godrey; Betsy Gotbaum; Michael Grossman; Camilla Guinness; Daphne Guinness; Hugo and Elliott Guinness; Violet and Isabella Guinness; Peggy Guinness; Agnes Gund; Jerry Hall; Dakin Hart; Nicky Haslam; Andres Hecker; the late Drue Heinz; Mr. and Mrs. Jorge Helft; Olga Henkin; Thomas Heneage; Catherine Hesketh; Carolina and Reinaldo Herrera; David Hockney; Ed Howard; Robin Hurlstone; Monica Incisa; Dr. Seth Jerabek; Robert Kashey; Hélène Seckel Klein; Ömer M. Koç; Jeff Koons; Bernard Lagrange; Pierre Lagrange; the late Kenneth Lane; the late Carolyn Lancher; Dominique Lassalle; Wayne Lawson; Melissa Lazarov; Brigitte Léal; Jane Longman; Jeffrey Loria; Robert Lubar; Luise Mahler; Gabriel Manzon; Joann Mastroianni; Rachel Mauro; Boaz Mazor; Tobias Meyer; the late Kynaston McShine; Gita Mehta; Adam McEwen; Peter McGough; Luanne McKinnon; Michael Meagher; William Meagher; Charles Miers; Keith Milow; Beatrice Monti della Corte; David Mortimer; Lily Mortimer; Francis Naumann; Lynn Nesbit; Andreas Neufert; Victoria and the late S. I. Newhouse; Nicolas Niarchos; Philip Niarchos; Stravros Niarchos; Martin d'Orgeval; Pilar Ordovas; Allen Perl; Jed Perl; Jack Pierson; Joachim Pissarro; Stefan Ratibor; Hannah Rothschild; Jacob and the late Mrs. Jacob Rothschild; Charlie Rose; Carlos Picon; Christine Piot; Philip Reeser; Daniel Romualdez; Ugo Rondinone; Lisa Rosen; Jane and the late Robert Rosenblum; Angelica Rudenstine; Kathy Ruttenberg; Nicky Samuel; John Sare; Edward St Aubyn; Lucian St Aubyn; Jenny Saville; Alexandra Schlesinger; Charles Scheips; Julian Schnabel; Richard Shone; John Silberman; John Stefanidis; Percy Steinhart; Mark Stevens; Mr. and Mrs. Tom Stoppard; Annalyn

Swan; Luke Syson; André Leon Talley; James Tarmy; Princess Gloria von Thurn und Taxis; Genevieve Turnier; the late Brian and Sidney Urquhart; Diane von Furstenberg; Carol Vogel; Linda Wachtner; Lynn Wagenknecht; Alice Walton; Lyn Bolen Warren; Gary Waterston; Kenneth Wayne; Bruno Wollheim; Dr. Genevieve Yuen; and Dasha Zhukova.

Enormous gratitude is owed to Knopf's late editor in chief Sonny Mehta, to whom this book is dedicated, and who overaw the flawless production of John's work, as well as to Knopf's publisher Reagan Arthur and to the rest of the amazing team who were responsible for this book: Katherine Hourigan, Anne Achenbaum, Andy Hughes, Romeo Enriquez, John Gall, Maggie Hinders, Kevin Bourke, Erinn Hartman, Tatiana Dubin, and Morgan Hamilton.

And I know John was very grateful to Andrew Wylie and Jeff Posternak who were always there to deal with whatever complicated issues might arise. Phyllis Stigliano, who also worked on volume III, was tireless in the face of many obstacles in pursuing the art that was needed.

Finally John could not have done this book without his collaborators Delphine Huisinga and Ross Finocchio who were responsible for all the brilliant research, taking up where Marilyn McCully left off.

As John said in volume III, if we have left anyone out, we hope we will be forgiven.

—The Editor

NOTES

ABBREVIATIONS

Abbreviations of archives where original documents are located:

Archives Picasso Picasso Archives at the Musée Picasso, Paris
JR Archives John Richardson Archives, New York
MoMAArchives The Museum of Modern Art Archives, New York
FABA Archives Olga Ruiz-Picasso, Fundación Almine y Bernard Ruiz-Picasso para el Arte, Madrid

Short titles of catalogues used to identify works by Picasso:

Baer Brigitte Baer. *Picasso: Peintre-Graveur.* 7 vols. (Original editions of vols. I–II by Bernhard Geiser.) Bern: Kornfeld, 1933–96.
P.F.IV Josep Palau i Fabre. *Picasso, 1927–1939: From the Minotaur to "Guernica."* Translated by Graham Thomson and Sue Brownbridge. Barcelona: Ediciones Polígrafa, 2011.
Z Christian Zervos. *Pablo Picasso.* 33 vols. Paris: Cahiers d'Art, 1932–78.

CHAPTER 1
The Home Front

1. Richardson, *A Life: Prodigy*, 79–81.

2. Letter from Nina Tamrouchi to Olga, FABA, quoted in Philippot et al., *Olga Picasso*, 44.

3. See letter from Nina to Olga, August 2, 1931, FABA, quoted in Philippot et al., 68.

4. Richardson, *A Life: Triumphant Years*, 216–17.

5. Philippot, "Olga à l'écran," in Philippot et al., 196 n. 17

6. Olivier, *Picasso et ses amis.*

7. Richardson, "Epilogue," 283.

8. Richardson, "Epilogue," 284.

9. G. Stein, *Autobiography of Alice B. Toklas*, 25.

10. G. Stein, *Everybody's Autobiography*, 15.

11. Richardson, *A Life: Triumphant Years*, 487. See also Diana Widmaier Picasso, "Rescue," 210–13.

12. Z.VIII.68.

13. Z.VIII.57–59.

14. Gaudí's authoritative biographer, and *Guernica*'s erudite commentator, Gijs van Hensbergen, is convinced that Picasso's votive obsession derives not only from his family's ties to the priesthood but also from his early friend the Catalan Santiago Rusiñol, the painter who not only headed the Catalan *modernista* movement but also was a

generous patron, poet, dramatist, actor, journalist, and impresario. Nowadays, Rusiñol's *modernista* paintings look anything but modern. However, a series of works depicting death or morphine addiction, for which Rusiñol himself had to be treated, may have confirmed Picasso in some of the morbid preoccupations that preceded the Blue Period. Rusiñol's handsome Gothic villa, Cau Ferrat (the Iron Lair) at Sitjes, twenty-five miles south of Barcelona, is now a museum. One of Rusiñol's weekend amusements was to make spoof ex-votos, some of which are exhibited in its galleries.

15. In conversation with the author.

16. See also Richardson, "Picasso's Broken Vow."

CHAPTER 2
Brassaï at Boisgeloup

1. Brassaï, *Letters*, xvii.

2. Brassaï, *Letters*, 207.

3. Brassaï, *Artists*, 156.

4. See Richardson, *A Life: Triumphant Years*, 350–53, 419–20, 432–33.

5. Brassaï, *Artists*, 158.

6. Brassaï, *Conversations,* 64.

7. In 1931, Picasso had made his own photographs of the plaster sculptures at Boisgeloup. See Richardson, *A Life: Triumphant Years*, 443–48. See also Cowling, "The Image," 262: "Having documented his work himself, Picasso was more receptive to the idea of a professional photo-essay that would not merely record the sculptures one by one, but show them in dynamic relation to one another within their place of origin."

8. Brassaï, *The Artists*, 158.

9. Brassaï, *The Artists,* 170.

10. Dominique Jando, "Cirque Medrano (Paris)," www.circopedia.com. For more on *Le Cirque sous l'eau,* see Medrano, 97–105.

11. Their ticket stubs survive. See Musée National Picasso, 46.

12. Z.VIII.86–89, 151.

13. Palau i Fabre, *Picasso: From the Minotaur to "Guernica,"* 140.

14. Brassaï, *Conversations*, 15.

15. Z.VIII.84.

16. Z.VIII.92.

17. Z.VIII.91.

18. PF.IV. 424–33.

19. Richardson, *A Life: Triumphant Years,* 20–30.

20. Zervos, "Conversation avec Picasso," as quoted in A. Barr, *Picasso: Forty Years*, 18.

21. Gilot and Lake, 41.

22. Baer 324–32.

CHAPTER 3
Minotaure

1. A. Warnod, "En peinture," as quoted in Bernadac and Michaël, 53.

2. D.-H. Kahnweiler, "Conversations avec Picasso," February 5, 1933, as quoted in Bernadac and Michaël, 91.

3. Richardson, *A Life: Triumphant Years,* 229–30.

4. Richardson, *A Life: Triumphant Years,* 244.

5. Doucet had promised to bequeath the work to a museum.

6. It was the first of four installments on this subject by Breton that would be republished together in book form as *Le Surréalisme et la peinture.*

7. Angered at being so often characterized as a surrealist, Picasso used the occasion of his Paris retrospective in 1955 to authorize Kahnweiler to clarify his position vis-à-vis the movement. He had never been influenced, he said, by the surrealists, except during a "brief period of darkness and despair (in 1933) before his final break with Olga." See *Picasso-Peintures 1900–1955* (Paris: Musée des Arts Décoratifs, 1955), [n.p.] following no. 40.

8. Daix, *Picasso,* 221.

9. Bataille published the novel in 1928 under the pseudonym Lord Auch.

10. Leiris, "Toiles récentes," 62.

11. Quoted in Adès, Baker, et al., 224.

12. Leiris, *Manhood*, 137.

13. Leiris's memoir of meeting Griaule has been published for the first time in Brett Hayes Edwards's introduction to his new translation of *Phantom Africa* (Calcutta: Seagull Books, 2017): "What inspired Griaule to take me on as a col-

laborator? For what secret reasons did he have confidence in me, when at that time I was perhaps at a particularly low point, suffering from a nervous depression from which, I might add, I have hardly extricated myself even today? This remains unclear to me; but for it I will always be grateful to Griaule, or to the demon that inspired him."

14. Letter from Leiris to Olga, May 20, 1932: "Elle [Zette] me raconte dans sa dernière lettre que Paulo vient de faire sa première communion et aussi qu'à Boisgeloup, il joue à la mission." Archives Picasso.

15. Reproduced in Madeline, 42.

16. Madeline, 221.

17. See Richardson, *A Life: Triumphant Years*, 426–31.

18. J. Warnod, "Visit," 245, quotes Tériade: "I left *Cahiers d'Art* to found a new magazine, my intention being to secure the participation of the Surrealists, to react against purist Cubism, to stir up ideas and join the plastic arts to poetry, philosophy, psycho-analysis, literature, ethnology and even music . . . Zervos was against this project, for he saw in me a competitor."

19. See Surya, 192.

20. J. Warnod, "Visit," 245.

21. Éluard, *Letters*, 172.

22. Surya, 193.

23. J. Warnod, "Interview," 246.

24. Arthur J. Evans, *The Palace of Minos: A Comparative Account of the Successive Stages of the Early Cretan Civilization as Illustrated by the Discoveries at Knossos* (New York: Biblo and Tannen, 1964; reprint of 1921–38 edition).

25. Surya, 526 n. 6.

26. P.F.IV.443.

27. Brassaï, *Conversations*, 9.

28. Picasso gave the collage to his dealer Paul Rosenberg's son, Alexandre, for his twelfth birthday. Alexandre donated it to MoMA in 1974.

29. J. Warnod, "Visit," 245.

30. Baer 365; P.F.IV.482.

31. Baer 366.

32. Baer 369.

33. Gilot and Lake, 42.

34. Baer 333–36.

35. Richardson, *A Life: Triumphant Years*, 486–87.

36. "Comment l'image, sublime d'hypocrisie symbolique de *L'Angelus*, obsession des foules, aurait-elle put se soustraire à une si flagrante 'furie érotique' inconsciente?"

37. Éluard, *Letters*, 173.

38. Suleiman, 39–50.

CHAPTER 4
Summer at Cannes and Barcelona

1. Richardson, *A Life: Triumphant Years*, 233–39.

2. P.F.IV. 496.

3. Z.VIII.120.

4. P.F.IV.495.

5. Z.VIII.124.

6. P.F.IV.507.

7. Z.VIII.129.

8. P.F.IV.509–10.

9. Z.VIII.118.

10. Room 507, presumably a suite.

11. See Richardson, *A Life: Triumphant Years*, 403–11.

12. Cabanne, "Picasso et les joies."

13. Richardson, *A Life: Prodigy*, 209–11.

14. Executed in 1963. See Richardson, *A Life: Prodigy*, 288–90.

15. See Nicole Fenosa, "Biography" [of Apel·les Fenosa], www.http://fundaciofenosa.org (first published in *Apel·les Fenosa: Catalogue raisonné de l'œuvre sculptée* (Barcelona: Ediciones Polígrafa, 2002).

16. In a February 4, 1934, letter to Picasso, Manolo Ortiz states his hope that Olga has recovered from her summer illness. Archives Picasso.

17. Jaime Passarell, "Picasso a Barcelona," *La Publicitat* (Barcelona), August 24, 1933.

18. Quoted in Greeley, 239 n. 83.

19. See Richardson, "How Political Was Picasso?"

20. Z.VIII.138.

21. Dominique Dupuis-Labbé, in *Picasso: Horses*, 30: "We are now at the very heart of a violent, tumultuous sexual battle. Within the context of Picasso's passion for Marie-Thérèse Walter, who, in Picasso's prints of her could take on an appearance of ineffable sweetness, the trio of

bullfighter or woman bullfighter/bull/ripped open horse reveals the urge towards bestiality that seizes man during the sexual act, in particular in the light of the innocence of the woman-bullfighter who closes her eyes in a yielding, submissive manner, fearless as to her fate, even desiring it."

22. Alex Niño, "Juanita Cruz, postrera venganza," *El País* (Madrid), November 2, 1993.

23. Z.VIII.214.

24. Ozvan Bottois, "Corrida: La Morte du torero," in *Guernica* (Paris: Musée Picasso, 2017), 34.

25. For more on Mazeppa's popularity in nineteenth-century art and literature, as well as the homoeroticism of his legendary horse ride, see Patané, 23: "Certainly such violable nudity and the sadomasochistic gratification of being wholly at the mercy of another, titillated the prudery of all those in the nineteenth century, forced to repress their own impulses, who rode (or were ridden) in their imaginations in place of Mazeppa, who, thanks in particular to a host of painters from Géricault to Horace Vernet, won a particular place in the erotic fantasies of many in those decades."

26. In conversation with the author, c. 1956. On the correspondence of horse and woman, see Dupuis-Labbé in *Picasso: Horses*, 28, who quotes Antoine Furetière's 1960 *Dictionnaire universel* of the French language: "Horse: a four-legged animal that neighs and is of great service to man [. . .]. To be any good a horse has to have three parts corresponding to three parts of a woman: breast, buttocks and hair, in other words a good breast, a rounded rump and long mane."

27. See Kahnweiler.

28. Kosmadaki, 242–43.

29. See "Témoignages de poètes, peintres, architectes, et écrivains d'art contemporains" in Zervos, *L'Art en Grèce*.

30. Farnoux, 62: "Zervos sometimes supervised the photography on site, and at other times commissioned photographs for each book's illustrations. He worked with either Greek photographers such as Émile Seraf and Nikolaos Tombazis or with French photographers such as Jean Lavaud."

31. Read, 190–91.

32. Aristophanes.

33. A. Barr, *Picasso: 50 Years,* 192.

34. Baer 394; Z.VIII.156.

CHAPTER 5
Last Trip to Spain

1. Brenan, 270.

2. Quoted in Pierce, 87.

3. Brenan, 275.

4. Z.VIII.149.

5. For more on reactions to the Papin murders, see Kamenish.

6. Lacan.

7. Conversation of November 30, 1933, quoted in Clark, 35. See also Kahnweiler.

8. Breton et al., *Violette Nozières.*

9. Z.VIII.171–82.

10. Z.VIII.190–94.

11. Z.VIII.197.

12. Z.VIII.205.

13. Z.VIII.210.

14. Z.VIII.239.

15. Baer 431.

16. P.F.IV.652.

17. Rosenblum, 362.

18. Baer 432.

19. Z.VIII.216.

20. Z.VIII.228.

21. Z.VIII.226.

22. "Ante el traslado a Madrid de los restos de Pablo Picasso," *La Gaceta Literaria,* March 1, 1931.

23. Giménez Caballero, 140.

24. Giménez Caballero, 142.

25. Giménez Caballero, 142.

26. Otero, 181.

27. Giménez Caballero, 140. Giménez Caballero asserted that Miguel Primo de Rivera had made this statement in a North American newspaper which cannot be found.

28. "GU: Sociedad de Amigos del Arte," *El Pueblo Vasco* (San Sebastián), August 30, 1934.

29. Otero, 181–82.

30. Leiris would reference the event when dedicating his 1943 book of poems to Picasso: "En souvenir de la corrida du 9 Septembre 1934 à Barcelone, 6 toros de Albarran (dont 1 retiré) et

1 toro de Bautista, por Jaime Noain et Carnicerito de mejico, mano a mano, Affectueusement, Michel Leiris." Reproduced in Bernadac, "Picasso, Leiris," 99.

31. Carles Capdevila, "Picasso, al Museu," *La Publicitat* (Barcelona), September 6, 1934.

CHAPTER 6
Minotauromachie

1. Baer 437. Four etchings on this theme would become part of the *Vollard Suite* of prints.

2. Penrose, *Picasso,* 91.

3. Richardson, *A Life: Triumphant Years,* 351–52.

4. *Purgatorio,* canto IX, 52–63.

5. Brenan, 284.

6. Greeley, 33–34, 51, 207 n. 1.

7. Parinaud, 138. Quoted in Etherington-Smith, 181.

8. Born Mary Phelps Jacob, Caresse and her second husband, Harry Crosby, had decided to change her name in 1924. She first considered calling herself Clytoris before passing that name on to their dog.

9. Baer 573.

10. Z.VIII.189.

11. At the palace of Knossos in Crete, Arthur Evans restored frescoes from the fifteenth century BC depicting a tauromachic ritual in which young men and women leap over a bull. It is not known whether Picasso was aware of this. See Martin Ries, "Picasso and the Myth of the Minotaur," *Art Journal* 32, no. 2 (Winter 1972–73): 143–44.

12. In conversation with the author.

13. Brassaï, *Conversations*, 66.

14. M. Barr, 42.

CHAPTER 7
Painter into Poet

1. Z.VIII.244.

2. P.F.IV.720.

3. Gold and Fizdale, 286–87.

4. Z.VIII.247. See Stuckey, 252 n. 8.

5. Z.VIII.269.

6. Gold and Fizdale, 287.

7. Letter from Réty to Picasso, July 5, 1929, Archives Picasso.

8. Quoted in FitzGerald, *Making Modernism,* 235.

9. O. Widmaier Picasso, 58.

10. Letter from Stein to Picasso, August 8, 1935, Archives Picasso.

11. Letter from Pellequer to Picasso, August 8, 1935, Archives Picasso.

12. Letter from Paulo to Picasso, July 18, 1935, FABA.

13. Letter from Braque to Picasso, August 19, 1935, Archives Picasso.

14. Z.VIII.270.

15. Picasso, "*The Burial,*" 2. Unless otherwise indicated, all subsequent translations of Picasso's poetry are from this source.

16. Jerome Rothenberg, "Preface," in Picasso, "*The Burial,*" viii.

17. M. Barr, 42.

18. Leiris, "Picasso the Writer," viii.

19. Quoted in Rothenberg, "Preface," in Picasso, "*The Burial,*" xv.

20. Sabartés, 118.

21. Sabartés, 119.

22. Jean Paulhan, editor of *La Nouvelle Revue Française*, inquired about publishing Picasso's poetry as early as October 14, 1936. On December 21, the painter Marie Laurencin wrote to Picasso reiterating Paulhan's admiration: "Jean Paulhan voudrait faire paraître vos poèmes dans *La Nouvelle Revue Française.* Etant persuadé comme moi qu'ils sont très beaux." Archives Picasso. See Musée National Picasso, 121.

23. Since he was writing to someone whose husband had been persecuted by the Nazis for supporting modern art, Zervos raised the question of whether Picasso had Jewish blood, as anti-Semites had suggested: "I have discussed this with Picasso and he formally proved to me that this was a lie. In the previous four generations, there were no Israelite antecedents on his mother's side and none for five generations on his father's side. He was not prepared to go back any further to satisfy his accusers. On his mother's side, it had been rumored that he came from Genoese stock, because there had been a Genoese painter

called Picasso. But he maintained that his mother descended from a Spanish family." Copy in JR Archives. For Picasso's family tree, see Richardson, *A Life: The Prodigy,* 476; and Richardson, *A Life: The Triumphant Years,* 557 n 5.

24. Letter from Breton to Picasso, September 29, 1935, Archives Picasso. See Musée National Picasso, 212.

25. G. Stein, *Everybody's Autobiography,* 37.

26. O. Widmaier Picasso, 58–59 n. 50: "Before the reform of January 3, 1972 promulgated in August 1972, a married man or woman could not recognize a child born outside marriage, no matter what their personal situation. The child of a woman who was already married was legally considered to be the child of her husband and of no one else. In the case of adultery, no subsequent establishment of filiation was authorized by the law on the part of anybody, be it father, mother or child. The reform of 1972 in particular, together with laws of 1993 and 2001, did away with any differentiation between legitimate, natural, and adopted children."

27. Cabanne, "Picasso et les joies."

28. Daix, *Picasso,* 233.

29. Olga's grandson Bernard Ruiz-Picasso has restored her immense Vuitton cabin trunk and its contents and given them a place of honor at Boisgeloup, where it memorializes her. See Ruiz-Picasso, 9–14.

30. Sabartés, 105.

31. Penrose, *Picasso,* 255: "Members of the ADLAN group had been to Paris, and thanks to their youth and enthusiasm they had managed to get Picasso's cooperation in assembling what was to be the first exhibition of his work in Spain since 1902."

32. Sabartés, 119.

33. The exhibition consisted of seventeen oil paintings, three papiers-collés, two drawings, one watercolor, one pastel, and a tapestry design. From Barcelona it traveled to Madrid. See Domènech et al., 258–59.

34. Z.VIII.273.

35. Éluard, "Je parle," *Cahiers d'Art* 10, nos. 7–10 (dated 1935 but published in 1936): 165–8. Quoted in McCully, 194. In Barcelona, Sert translated Éluard's speech into Catalan.

36. Salvador Dalí, untitled invitation to the Picasso exhibition, Barcelona, *Cahiers d'Art* 10, nos. 7–10 (dated 1935 but published in 1936): 187–88. Quoted in McCully, 191–92.

37. Julio González, "Desde Paris," *Cahiers d'Art* 10, nos. 7–10 (dated 1935 but published in 1936): 242. Quoted in McCully, 193–94.

38. André Breton, "Picasso Poète," *Cahiers d'Art* 10, nos. 7–10 (dated 1935 but published in 1936): 187–88. Quoted in McCully, 197–99.

39. A. Barr, *Picasso: Forty Years,* 13–16.

CHAPTER 8
Dora Maar

1. Dudley and Ungar, 399, n. 17. Anne Baldassari considers it "very likely" that Dora traveled to Moscow with Octobre: see her *Picasso: Life with Dora Maar,* 34.

2. Baldassari, *Picasso: Life with Dora Maar,* 34.

3. Barrault, 77: "Breton and Georges Bataille asked me to let them hold their assemblies at the Grenier." Breton does not seem to have attended either of the Contre-Attaque meetings at 7 rue des Grands-Augustins.

4. Surya, 222.

5. See Jason Earle, "Les Deux Cents Familles: A Conspiracy Theory of the Avant-Garde," *The Romantic Review* 104, nos. 3–4 (May–November 2013): 333–52.

6. Baring, 133.

7. Gilot and Lake, 85–6. Victoria Combalía, the definitive biographer of Dora Maar, maintains that the scene at Deux Magots must have happened in the spring of 1936. See Combalía, 151 n. 12. Baldassari (*Picasso: Life with Dora Maar,* 37–64) believes it happened earlier, based in part on images of "splinters, hairpins and knives, allied to tears and the colour pink," as well as photographic references, in Picasso's poetry of autumn 1935.

8. Breton, *Mad Love,* 41–42.

9. American author James Lord later claimed in an unpublished interview that this was not the only time Dora stabbed at her fingers in Picasso's presence. "Dora told me that she was in the habit of doing this . . . and it's sort of a tic, you know."

Lord stated that at the beginning of their relationship, Picasso took Dora to Chartres cathedral to "admire the statuary and so on, and go inside and see the windows. And Dora said, 'Oh I'm not in the least interested in seeing this Cathedral,'" and refused to get out of the car. On the drive back to Paris, "she produced her pocket knife, and just held her hand up, and began going like that, with the pocket knife between her fingers. And Picasso was so irritated by this, that he snatched the pocket knife out of her hand, and threw it out of the window of the moving car, and that was the last she ever saw of the pocket knife." JR Archives.

10. For Paalen's biography, see Andreas Neufert, *Auf Liebe und Tod: Das Leben des Surrealisten Wolfgang Paalen* (Berlin: Parthas Verlag, 2015).

11. PF.IV.737.

12. Cut from a promotional announcement, the print reads: "Vous présente sa dernière création 'LE CRAYON QUI PARLE' en nombreuses séries de 18 charades chacune, qui vous instruiront en vous amus[ant]."

13. Twelve days later he also gave them a photograph of himself as a child, inscribed with the words: "Pour Nusch, mon seul portrait, Paris, March 23, XXXVI."

14. March 20, 1936, Archives Picasso.

15. Picasso attended the May 15 opening of Wolfgang Paalen's exhibition at Galerie Pierre. See Gateau, 21.

16. March 25, 1936, Archives Picasso.

17. Cabanne, *Pablo Picasso,* 254.

18. July 28, 1936, Archives Picasso.

19. See Caws, 68.

20. August 3, 1936, Archives Picasso.

21. The voyage began on February 13 and ended in Bombay on April 8. See Orban, 106.

22. See Colvile, 102–8.

23. July 28, 1936, Archives Picasso.

24. Combalía, 153.

25. Quoted in Baldassari, *Picasso: Life with Dora Maar,* 124.

26. Museo de Arte Moderno.

27. See Musée National Picasso, 112–14.

28. The original was in the author's collection.

29. G. Laporte, 10.

30. Gilot and Lake, 129.

31. March 3, 1936, FABA.

32. June 22, 1936, FABA.

CHAPTER 9
Juan-Les-Pins

1. Sabartés, 121, describes the scene: "Everyone remained quiet, in ecstasy; everyone silently tried to curb his emotion; but at times one felt like breaking the enchantment with a fierce shout. Fantasy transcended the unsuspected and unsuspecting limits of the fantastic."

2. FitzGerald, *Making Modernism,* 240.

3. FitzGerald, *Making Modernism,* 241.

4. *Compotier et Guitare I,* February 13, 1932 (Z.VII.375), acquired by Cooper from Rosenberg in 1935; and *Nature Morte,* April 1934 (Z.VIII.196).

5. See Richardson, *Sorcerer's Apprentice.*

6. Sabartés, 126.

7. Picasso's whereabouts remained a mystery even to his closest friends. Éluard wrote to Gala Dalí on March 31, 1936: "Picasso est brusquement parti pour longtemps—destination inconnue (Picasso has left for a long time, destination unknown)." Quoted in Cowling, *Visiting Picasso,* 349, n. 8.

8. Sabartés, 127.

9. O. Widmaier Picasso, 60.

10. Letter from Max Pellequer to Picasso, April 1936, Archives Picasso.

11. Sabartés, 127, identifies the house: Villa Sainte-Geneviève, avenue du Docteur Hochet, Juan-les-Pins (Alpes Maritimes). Picasso had last stayed at Juan-les-Pins in 1930 and 1931, with Olga and Paulo, and with Marie-Thérèse hidden nearby. See also Andral et al., 138–39.

12. Letter of March 23, 1936. Quoted in Daix, *Picasso,* 239.

13. Sabartés, 129.

14. PF.IV.751.

15. PF.IV.769.

16. See drawing of April 11, 1936, Z.VIII.274.

17. Sabartés, 128.

18. PF.IV.789.

19. PF.IV.791.

20. Quoted in Palau i Fabre, 248.

21. Sabartés, 129.

22. The author's unpublished interviews with Dora Maar, 1991–92, JR Archives.

23. Baer 606.

24. Goeppert, 104–7.

25. September 22, 1936, Archives Picasso. See Musée National Picasso, 285.

26. Baer 607.

27. Sabartés, 131.

28. Baer 608.

29. In October, four months after the artist and poet collaborated on the plate, it would be published in Éluard's next book of poetry, *Les Yeux fertiles*. See Goeppert, 80–81.

30. Baer 609; PF.IV.817.

31. Gilot and Lake, 216.

32. Éluard, *Letters*, 214.

33. Baldassari, *Surrealist*, 244.

34. Cowling, *Visiting Picasso,* 24.

35. Penrose, *Scrap Book,* 62.

36. For Rolland's politics, see Fisher.

37. Cooper, 68–69, notes that the proposal to paint the commission came through Picasso's friends Jean Zay (then minister for national education), Jean Cassou, and Léon Moussinac.

38. Z.VIII.287.

39. In a letter to Max Jacob of July 3, 1936, Kahnweiler states that Picasso has still not made the curtain. At that time, it seemed to Kahnweiler that Picasso would not complete the commission. See Seckel, 240 n. 14.

40. Utley, 15, argues that the May 28 watercolor was "specifically created" for *Le Quatorze Juillet,* "as much of its imagery derives from the Rolland text." Utley cites the scene in act 3 when the rebel leader, Hoche, storms the Bastille with the young heroine, Julie, on his shoulders.

41. Max Ernst, *Une Semaine de bonté, ou Les Sept Éléments capitaux* (Paris: Bucher, 1934).

42. Baldassari, *Picasso: Life with Dora Maar,* 121: "Among the materials in the Dora Maar archives are a series of photos, contact sheets and negatives from a photographic documentary Dora made of the actual fabrication of the large stage curtain in early July 1936. These photos back our assumption that Dora already had close ties to Picasso, or else he would not have granted her such a privilege, especially considering that up to then he had never let anyone record how he worked as a painter. They allow us, moreover, to verify that it was indeed Picasso who painted the main characters on the canvas and that he was even involved in the execution of some of the details of the different figures . . . This exceptional photographic document thus indicates that the painter and his photographer had a common aim of revealing the process of painting."

43. Utley, 16; 221 n. 33.

44. Quoted in Wilson, 49.

45. Quoted in Meyer-Plantureux, 197.

CHAPTER 10
War in Spain

1. Quoted in Preston, 127.

2. Preston, 120.

3. Quoted in Preston, 121.

4. Quoted in Preston, 125.

5. A July 25, 1936, letter from Picasso's mother describes scenes of death and destruction taking place around the family's home in Barcelona. On July 29, Eugenia Errázuriz wrote to Picasso: "How I think of you and Barcelona. It makes me terribly sad, the news that your family is frightened. One cannot help but think of so many friends now who are suffering." Archives Picasso.

6. Sabartés, 134.

7. Quoted in Cowling and Baldassari, 379.

8. August 19, 1936. See Musée National Picasso, 97.

9. Gibson, 468, 516 nn. 83–84. Gibson notes that although "no fully trustworthy accounts of Federico's last moments has come down to us . . . the possibility that Lorca was tortured in this way before the squad completed the job cannot be excluded."

10. Gilot and Lake, 129: "Paul and Nusch had 'discovered' Mougins in the thirties and induced Pablo, he told me, to spend a part of his vacation there in 1936, 1937, and 1938."

11. Richardson, *A Life: Triumphant Years,* 289–92.

12. Baldassari, *Picasso: Life with Dora Maar,* 193. A train ticket stub in the Archives Picasso confirms the date that he left for the south.

13. Letter from Nusch to Picasso, August 14, 1936: "We are in an absolutely marvelous place where we will be staying until August 3rd or 4th and then we will meet up with Mrs. Deharme near St-Tropez . . . We are going to a place that was offered to us by a friend of Man Ray, located 7 km from Cannes. Dear Lion, how are you, I would love to hear from you. The Zervoses are, I think, in Paris and it's mostly through them that we hear of you. I hope you haven't forgotten us. The weather is so nice here and the sky is huge. That is about it. . . . I'm sending you the address in case you feel like visiting us." Archives Picasso.

14. Telegram from Rosenberg to Picasso, September 5, 1936, Archives Picasso.

15. Though Man Ray's film is often dated summer 1937, the presence of Cécile Éluard and Valentine Boué confirms that it was made the year prior. See Orban, 106.

16. Telegram from Paul Éluard to Dora Maar, August 6, 1936: "Nous partons aujourd'hui chez Lise [Deharme]. On espère que tu y viendras t'y baigner." Quoted in Combalía, 155.

17. Archives Picasso; Combalía, 157: "Il existe au Musée National Picasso de Paris une facture de l'hôtel Vaste Horizon datée du 6 au 13 septembre 1936 au nom de Dora Maar"; 163 n. 17: "La photographe logea dans une autre chambre, pendant sept jours ce qui ne l'empêcha pas de loger dans la chambre de Picasso quelques jours de plus."

18. Combalía, 156.

19. Z.VIII.289.

20. Z.VIII.296.

21. Brassaï, *Conversations*, 51.

22. Penrose, *Picasso*, 261–62.

23. Quoted in Orban, 106.

24. Penrose blamed the other driver for "coming towards us on the wrong side of the road." See his *Picasso,* 262. See also Cowling, *Visiting Picasso*, 350, n. 18: "In February 2004, however, Nicola Polverino, a local Mougins man who was a boy at the time, told Anthony Penrose that it was Picasso who was driving when the accident occurred: irked by the teasing about his inability to drive, Picasso insisted on taking the wheel and crashed into a wall. (There is no support for this colorful story in the Penrose Archive, regrettably.)"

25. Sabartés, 135.

26. Archives Picasso. Quoted in Baldassari, *Picasso: Life with Dora Maar,* 126.

27. Penrose, *Picasso*, 263.

28. Archives Picasso. See Musée National Picasso, 229.

CHAPTER 11
Prado Director

1. Letter from Kahnweiler to Picasso, September 14, 1936: "Avez vous appris votre nomination comme directeur du Prado? Je suppose que oui . . . je suppose aussi que cette histoire ne doit pas vous amuser tant que ça. Je crois que le Directeur du Prado nommé maintenant ne restera pas longtemps en fonction." Zervos to Picasso, September 15, 1936: "Vous avez du voir (Temps Septembre 14th) que le directeur du musée du Prado a été mis à la porte et que vous avez été nommé à sa place. J'espère que vous me faciliterez le travail photographique dans votre musée. Demain se décide mon voyage à Barcelone, Valence, Madrid (à titre pacifique)." Archives Picasso.

2. Éluard, *Letters*, 220.

3. Greeley, 154. Renau's offer was officially seconded by Azana on September 19, 1936. Picasso held the position until the end of the Spanish Civil War.

4. For more on Renau's life and work, see Cabañas Bravo, *Josép Renau.*

5. Cabañas Bravo, "Renau," 144–45.

6. Alix, 21–22.

7. The exhibition ran from December 9, 1936, to January 17, 1937, and included six paintings by Picasso from American collections.

8. M. Barr, 48.

9. Z.VIII.310; PF.IV.827.

10. Gasman, *Mystery,* 1202.

11. The author's unpublished interviews with Dora Maar, 1991–92, JR Archives.

12. *Cahiers d'Art*, 6–7, 1937. Quoted in Richardson et al., *Picasso and the Camera*, 257.

13. "Picasso, Photographe," *Cahiers d'Art*, 6–7, 1937. Quoted in Richardson et al., *Picasso and the Camera*, 254.

14. Utley, 16.

15. Unpublished notes by Gijs van Hens-

bergen: "The brilliant essayist José Bergamín, who had grown close to Picasso in the months before creating *Guernica,* had endeared himself to Picasso a decade earlier in 1927 when celebrating the trinity of Picasso, Manuel de Falla and the future Nobel poet Juan Ramón Jiménez as spearheading a transcendent '*andalucismo universal.*'" JR Archives.

16. For more on Alberti's role in the Prado evacuation, see Colorado Castellary.

17. Cabanne, *Pablo Picasso,* 291: "When the poet [Bergamín] mentioned having unrolled a canvas to discover it was Velázquez' *Las Meninas,* Picasso was deeply moved: 'How I would have liked to see that!'" On October 13, 1936, Clive Bell wrote to Mary Hutchinson: "Picasso has disappeared, Mary, and they say—that is Marie-Laure de Noailles says—he has gone to take up his post at Madrid. That I don't believe. For one thing it would take him all his time to get there nowadays, for another—if he got there he would surely be done in by Franco's blacks—and Picasso, for all his 'vie tourmenté' has no wish to be done in." Harry Ransom Center, University of Texas at Austin (copy in JR Archives).

18. Cowling, *Visiting,* 27.

19. Gascoyne, 40–41.

20. Quoted in Cowling, *Visiting,* 27.

21. November 26, 1936, Archives Picasso. Quoted in Baldassari, *Picasso: Life with Dora Maar,* 195.

22. Zervos, *Catalan Art,* 28–36. Zervo's monograph would serve as the catalogue to an exhibition of medieval Catalan art that opened at the Jeu de Paume in Paris on March 18, 1937. Picasso joined the organizing committee. The show generated enough interest to reopen on a slightly larger scale on June 22 to coincide with the Paris World's Fair.

23. Quoted in Minchom, 136–40. On January 8, Delaprée's suppressed dispatches from Spain, detailing the horrors of aerial bombardment, were published as a pamphlet, *The Martyrdom of Madrid.* The Communist newspaper *L'Humanité* republished the reports with the author's scathing epigraph: "Christ said: 'Forgive them for they know not what they do.' I feel that after the slaughter of the innocents in Madrid, we should say: 'Do not forgive them for they know right well what they are doing.'"

24. PF.IV.853.

CHAPTER 12
Dream and Lie of Franco

1. Seckel, 240.

2. Quoted in Cabañas Bravo, "Renau," 145.

3. Cabañas Bravo, "Renau," 146–47.

4. Éluard, *Letters,* 322.

5. Jean Cocteau, *Le Passé,* 193 (July 10, 1953): "Dalí avait voulu organiser, décorer et costumer une messe à Barcelone pour l'âme de Picasso, pour le ramener au catholicisme. Le gouvernement avait accepté. L'église s'y opposa"; 317 (November 9, 1953): "Et Picasso. Ramener Picasso en Espagne. Qu'il assiste à sa fameuse corrida avec sous-marin et hélicoptère. Le ramener et le kidnapper au besoin s'il se risque jusqu'à Perpignan."

6. Greeley, 235 n. 21: "The words Picasso is paraphrased as having used are: 'que no sabía podría pintar tal obra' [that he did not know if he could paint such a work]." Utley, 21, attributes Picasso's reluctance to his concerns about "strife between the factions within the Popular Front," and "the Communists' violent suppression and eradication of the revolutionaries in the anti-Fascist militias."

7. Sert, 42.

8. Greeley, 156, considers it "no coincidence" that Picasso began work on *Dream and Lie of Franco* only a few weeks after Éluard published his first political poem, "Novembre 1936." Picasso would later tell Pierre Daix how important Éluard's poem had been to him. See Philippe Blanc, "Éluard, Picasso et le livre: Jalons pour une bio-bibliographie," in Guigon et al., 35.

9. Baer 615.02BC.

10. Baer 616.05BC.

11. The format of *Sueño y mentira de Franco* may derive from traditional Spanish prints known as aucus, in which a narrative—such as the delusional adventures of Don Quixote—is divided into a series of framed scenes printed on a single sheet and accompanied by text. See C. B. Lord, 459–60.

12. Sadoul.

13. A. Barr, *Picasso: Fifty Years*, 263–64. See also Utley, 19–20; 221 n. 41.

14. Penrose, *Picasso,* 268, continues: "The desire to implicate himself by means of his own initial could not be more convincing. Just as formerly he had often based the image of the hero, Harlequin, on an idealized self-portrait, here in reverse the subconscious origin of the shape he gave to the man he most hated was equally personal." For more on Picasso's admiration of Jarry and *Ubu Roi*, see Richardson, *A Life: Prodigy*, 361–67.

15. January 15–18, 1937.

16. Cabanne, *Pablo Picasso*, 293: "Arthur Koestler, who witnessed the weeks of battle [in Málaga], was to recount the event to Picasso, telling how over a hundred thousand refugees fleeing the city were strafed and shelled by Italian planes and ships. The squadron commanded by André Malraux fought one of its last engagements over Málaga."

17. Z.VIII.375.

18. The marchesa's face with its hefty chin is evidently a caricature of Dora, to whom Picasso gave the painting.

19. See Minchom, 181–82. Picasso was also turning the tables on the pro-Fascist cartoonist Ralph Souphault, who had just published a cover of the right-wing weekly *Le Charivari* (January 9). It depicts an emblematic vulture stamped with the Communists' hammer and sickle and perched on Delaprée's coffin. Blood is dripping from the vulture's beak while it feasts on Delaprée's corpse. The *Charivari* cover, observes Minchom, may have inspired Picasso's *Marchesa* painting: "To *Le Charivari*'s dark evocation of Bolshevik machinations, Picasso is offering the riposte, much used on the Republican side, that the Nationalist generals have built their 'Christian' crusade on the military might of the Moorish soldiers of the Army of Africa." These thoughts would soon figure in code in *Guernica*.

20. Kahnweiler to Herman Rupf, January 4, 1938, copy in JR Archives.

21. Sabartés seems to have kept in friendly contact with Picasso after moving out of the artist's apartment. See his letter to Picasso, September 22, 1937 (Archives Picasso), announcing the publication, in Italian, of his book about the artist:

"Attached is an egg-colored tomato [the book]. It bears your name by title and mine by signature. It is the study we spoke of eight months ago. . . . As always, wishing you Happy Easter and new year, your friend, who is, Sabartés."

22. Archives Picasso. See Musée National Picasso, 285.

23. Picasso continued to have access to Boisgeloup through the following year.

24. Quoted in Sabartés, 136.

25. Sabartés, 137.

26. Cabanne, "Picasso et les joies."

27. Dufaud, 28.

28. Z.VIII.341.

29. Z.VIII.353.

30. Z.VIII.345.

31. Z.VIII.344.

32. Z.VIII.351.

33. Z.IX.217.

CHAPTER 13
7 rue des Grands-Augustins

1. See March 1937 rental agreement between Picasso and the Compagnie de Huissiers de la Seine for 5,600 francs per month. Archives Picasso.

2. Archives Picasso contain invoices for the following: March 10, 1937, Milkovic (lighting); March 25, 1937, Société Generale de Constructions Électriques & Mécaniques (water heater); April 7, 1937, Confort Sanitaire (plumbing); April 18, 1937, G. Bruleaux (metalwork); April 29, 1937, Compagnie Parisienne de Distribution d'Électricité (wiring and electrical).

3. Sadoul.

4. Brassaï, *Conversations,* 53. See also Cary, 149–52, who observes: "On recounting her first visit to the rue des Grands-Augustins, Françoise Gilot quotes Picasso telling her, 'That covered spiral stairway you walked up to get here . . . is the one the young painter in Balzac's *Le Chef-d'oeuvre inconnu* climbed when he came to see old Pourbus, the friend of Poussin who painted pictures nobody understood.' Close but not quite: they are Porbus's stairs, but he was not the old painter with the unintelligible canvas."

5. Brassaï, *Conversations*, 53: "And on the site of the *Unknown Masterpiece* he had painted the 'well-known masterpiece' *Guernica*."

6. Contrary to Dora's claim, Brassaï, *Conversations*, 53, states: "As a matter of fact, it was that actor [Barrault] who had told Picasso that these odd rooms were available, and Picasso was immediately won over. They reminded him of the Bateau-Lavoir, for which he was secretly nostalgic all his life, but they were even more spacious." Van Hensbergen, 30: "Received wisdom has always credited Dora Maar with finding him 7 rue des Grands-Augustins. However, Fernando Martín Martín in his doctoral thesis *El Pabellón Español (The Spanish Pavilion)* points out that it belonged to the Labalette brothers, who were builders employed by Sert and Lacasa for the construction of the Spanish Pavilion, and used by them as a store for their materials. It was Juan Larrea who negotiated the acquisition of rue des Grands-Augustins for one million francs by the Spanish government for Picasso's exclusive use." See also Gilot and Lake, 161: "The building in the Rue des Grands-Augustins had once been— at least according to Pablo—part of the Spanish Embassy."

7. Though soon to become a major star on stage and film, Barrault so admired Picasso that when the two men met in November 1935, the actor was apparently too intimidated to speak. Days later, he apologized for his nerves and offered Picasso a private reading of a new play. See his letter to Picasso of November 20, 1935, Archives Picasso.

8. Barrault, 89.

9. See Brunner, 68–71.

10. Z.VII.353.

11. Penrose, *Scrap Book*, 68–69.

12. Borchardt-Hume and Ireson, 104–5.

13. Penrose, *Scrap Book*, 69. See also Cowling, *Visiting Picasso*, 29–31.

CHAPTER 14
Guernica

1. Irujo, 25.

2. Irujo, 82.

3. van Hensbergen, 32–33.

4. Steer's report first appeared in *The Times* (London) on April 27.

5. See Minchom, 196–216. Picasso could have already learned what bombed towns looked like from reading Louis Delaprée's "*Bombs Over Madrid*." Minchom argues that Delaprée's report and another detailing the March 31 bombing of Durango informed Picasso's design for *Guernica*.

6. Basque President José Antonio Aguirre passionately replied to these accusations in a radio broadcast of April 29, 1937: "Before the offensive shamelessness of the rebel elements, affirming that we have set afire our towns, I raise before the world the most energetic and vigorous protest, appealing to the testimony of journalists and consular representatives who, with terror, have contemplated that the instincts of destruction of the mercenaries at the service of the Spanish rebels know no limit. Before God and History, which will judge us all, I affirm that for three hours and a half German airplanes bombed with inconceivable cruelty the defenseless civilian population of the historic town of Gernika, now reduced to ashes, machine-gunning women and children, many of whom perished, while the rest escaped and fled in terror." See Irujo, 125–26.

7. See Southworth, 142–45, 177, 239.

8. For further discussion and reproductions of these sketches, see Chipp, 58–69.

9. See Albert Marie, "Il y a 80 ans, Picasso peignait fiévreusement *Guernica* sous les toits de Paris," *Le Monde*, April 26, 2017.

10. On April 19, one week before the bombing of Guernica, Picasso had sketched this motif on a copy of *Paris-Soir*, perhaps, as both Chipp and Greeley argue, to protest the cover story about France's nonintervention policy in Spain. See Chipp, 68, and Greeley, 175.

11. Quoted in van Hensbergen, 35.

12. Greeley, 180: "With the collusion of the Spanish Communist Party, under orders from Stalin, Negrín's Frente Popular did all it could to assure the Non-Intervention governments that Spain would not go communist. France had closed its borders with Spain against refugees and had refused to send aid to the beleaguered Spanish Popular Front government. At the very moment

that Picasso was painting the canvas, the Communist Party systematically destroyed the anarchist and Trotskyite groups in Spain, thus disastrously weakening leftist resistance against Franco. For Picasso to have left the upraised fist in *Guernica* would have embroiled the painting directly in these struggles within the Frente Popular and within the Spanish Pavilion itself."

13. In a February 1988 interview, Dora pointed out the similarity between this figure and the torch-bearing allegory of Justice in Pierre-Paul Prud'hon's 1808 painting in the Louvre, *Justice and Divine Vengeance Pursuing Crime*. See Marín, "Conversando con Dora Maar," 120.

14. The author's unpublished interviews with Dora Maar, 1991–92, JR Archives.

15. Dora told Marín, 116, that the lamps used to illuminate *Guernica* at the rue des Grands-Augustins came from the photography studio she had shared with Pierre Kefer. She apparently arranged for Picasso to have the lamps and for Kefer to receive a drawing in exchange. In the end, Kefer was too shy to collect the drawing from Picasso. The artist's electric bills in May and June 1937 indicate that he made ample use of these lights, probably while painting at night. See Combalía, 181 n. 13

16. Quoted in Minchom, 138.

17. Her first photograph of the canvas dates to May 11.

18. The author's unpublished interviews with Dora Maar, 1991–92, JR Archives.

19. Z.IX.20, 23, 28–29.

20. Dora believed that Picasso had Marie-Thérèse and Maya in mind as he painted the mother and dead child, and recalled that Maya had been sick, perhaps with pneumonia, at that time. See Marín, 118. Gilot and Lake, 194–95, recorded Picasso's infamous account of a confrontation between Dora and Marie-Thérèse that took place while he painted *Guernica*: "Marie-Thérèse dropped in and when she found Dora, she grew angry and said to her; 'I have a child by this man. It's my place to be here with him. You can leave right now.' Dora said, 'I have as much reason as you to be here. I haven't borne him a child but I don't see what difference that makes.' I kept on painting and they kept on arguing. Finally Marie-Thérèse turned to me and said, 'Make up your mind. Which one of us goes?' It was a hard decision to make. I liked them both, for different reasons: Marie-Thérèse because she was sweet and gentle and did whatever I wanted her to do and Dora because she was intelligent. I decided I had no interest in making a decision. I was satisfied with things as they were. I told them they'd have to fight it out themselves. So, they began to wrestle. It's one of my choicest memories." See also Richardson, "Picasso and Marie-Thérèse Walter," 50: "This fight is commemorated in Picasso's otherwise puzzling *Oiseaux dans une cage* [Z.VIII.363], once owned by the designer Elsa Schiaparelli. . . . The painting portrays Marie-Thérèse and Dora as doves in a cage far too small for them. Dora, the ferocious black one, claws at the serenely beautiful white dove nestling on a clutch of eggs. Picasso made his preference very clear, but seemingly shrugs his shoulders."

21. Quoted in van Hensbergen, 51–52.

22. Penrose, *Picasso*, 275.

23. Before their publication by Zervos in *Cahiers d'Art*, Dora's photographs of *Guernica* first appeared in Josep Renau's journal *Nueva Cultura* 3, nos. 4–5 (June–July 1937), together with the *Dream and Lie of Franco* prints. These works visually affirmed the journal's announcement that Picasso had "put his art and person at the service of the fight for the country's independence." In 1977, Renau proudly claimed to have received Dora's photographs and permission to publish directly from Picasso. See Cabañas Bravo, "Renau," 154–56.

24. Spurling, 373, states that Matisse visited Picasso several times during the spring and summer of 1937.

25. Quoted in Cabañas Bravo, "Renau," 156, n. 48.

26. For more on this series, see Freeman.

27. Gilot and Lake, 114.

28. Combalía, 154.

29. Z.IX.73.

30. Penrose, *Scrap Book*, 88.

31. See Freeman, 46.

32. Cowling, *Visiting Picasso*, 132.

33. Quoted in Carlton Lake, "Picasso Speaking," *The Atlantic Monthly,* July 1957, 39.

34. Gilot and Lake, 66.

35. Gasman, *Mystery,* 1212.

36. Quoted in Perl, 519.

37. van Hensbergen, 58.

38. Quoted in Josefina Alix, "From War to Magic: The Spanish Pavilion, Paris 1937," in William H. Robinson et al., *Barcelona and Modernity: Picasso, Gaudí, Miró, Dalí* (Cleveland: Cleveland Museum of Art, 2007), 451.

39. While *Guernica* hung in the Spanish Republican pavilion designed by Josep Lluís Sert, the pontifical pavilion exhibited a pro-Franco painting by Sert's uncle, celebrated muralist José Maria Sert, entitled *Saint Teresa of Avila Offering Spanish Martyrs to Christ Crucified.*

40. Picasso had decided to show these sculptures at the fair before he started to paint *Guernica.* See April 30, 1937, invoice from the moldmaker M. Renucci: "Molding pieces and stamping plaster models at Boisgeloup, a two-meter face and the three large busts. A plaster copy of each. Price agreed upon—10,000 francs." Archives Picasso. See Temkin and Umland et al., *Picasso Sculpture,* 147.

41. Quoted in Freedberg, 661.

42. Éluard's poetic tribute to the ruined Basque town, "*La Victoire de Guernica,*" composed around the same time as Picasso's painting, was displayed on another floor of the pavilion.

43. See Perl, 519–20, for the circumstances in which Calder, an American, got the fountain commission for the Spanish pavilion.

44. On April 25, 1937, Miró wrote to Pierre Matisse with news that "the Spanish government has just commissioned me to decorate the Spanish Pavilion at the 1937 Exposition. Only Picasso and I have been asked; he will decorate a wall 7 meters long; mine measures 6. That's a big *job*! Once the Exposition is over, this painting can be taken off the wall and will belong to me." Quoted in Rhodes, 192.

45. See Rosenberg's letter of March 20, 1937, urging Picasso to start planning his part of the exhibition, and offering to show him a floor plan of the galleries. Braque, he writes, has already chosen which works he will show. Archives Picasso.

46. Quoted in O'Brian, 315.

47. See Cowling, *Picasso: Style and Meaning,* 630–31.

48. Louis Gillet, "Trente ans de peinture au Petit Palais," *Revue des deux mondes* 107 (August 1, 1937): 562–78.

CHAPTER 15

Summer at Mougins

1. Combalía, 165.

2. Penrose, *Scrap Book*, 104–5.

3. For more on Ady's life, see Grossman.

4. Agar, 136.

5. Agar, 133.

6. Undated 1937 postcard. Archives Picasso. See Musée National Picasso, 229–30.

7. Undated 1937 postcard from Éluard to Dora. See *Les Livres de Dora Maar*, Maison de la Chimie, Paris, sale October 29, 1998, lot no. 262.

8. Combalía, 161.

9. Man Ray, 179.

10. Baldassari, *Picasso: Life with Dora Maar,* 202.

11. For more on this series, see Fondation Vincent van Gogh.

12. Penrose, *Picasso,* 279, states: "The 'portraits' were most frequently of Dora Maar, but at other times he would announce that his model was Éluard or Nusch or Lee Miller." But see Grossman, who argues that Ady was the model for Picasso's painting of September 8, 1937, *Femme assise sur fond jaune et rose II (Portrait de femme).*

13. Z.VIII.373.

14. Penrose, *Picasso,* 279.

15. Agar, 137.

16. Penrose, *Picasso,* 280.

17. Quoted in Combalía, 168.

18. September 27, 1937. Archives Picasso. Quoted in Combalía, 170.

19. See Breton's comments from the first session of "Recherches sur la sexualité," January 27, 1928, reprinted in José Pierre (ed.), *Investigating Sex: Surrealist Discussions* (London: Verso, 2011), 3–16.

20. Agar, 140.

21. Michel Leiris, "Faire-part," *Cahiers d'Art* 12, nos. 4–5 (1937): 152–53.

22. Quoted in Basilio, 101.

23. Basilio, 102.

24. Quoted in Marín, 121.

25. Buñuel, 82.

26. Quoted in van Hensbergen, 72.

27. Quoted in van Hensbergen, 72.

28. November 9, 1937. Archives Picasso. See also Utley, 226 n. 50.

CHAPTER 16
Bern and Vézelay

1. FABA.

2. January 4, 1938, copy in JR Archives.

3. Olga to Picasso, November 12, 1937, FABA: "I called the doctor to give Paulo a check-up but Paulo refused to go. I'm afraid he is having a major relapse like in Evian. He has to see the doctor immediately. Can you please answer me whether you will talk to him and when? You must understand that we have to do something and that you can't leave him without any care. It may be very serious."

4. The date is confirmed by a receipt from the train's dining car stamped November 26, 1937. Before leaving, Picasso jotted down the departure and arrival time, as well as the address of Geiser and Rupf, on a scrap of paper. Archives Picasso.

5. December 22, 1937, copy in JR Archives.

6. January 2, 1937, copy in JR Archives.

7. February 26, 1938, copy in JR Archives.

8. JR Archives contain a copy of Geiser's memoir of the day with Picasso.

9. February 28, 1938, copy in JR Archives.

10. February 28, 1938, copy in JR Archives.

11. PF.IV.1070–81.

12. PF.IV.1088.

13. PF.IV.1087.

14. PF.IV.1086.

15. Preston, 279–81.

16. Z.IX.109.

17. Gasman, *Mystery,* 696.

18. Z.IX.114.

19. Quoted in Ashton, 34.

20. November 20, 1938, Archives Picasso.

21. Z.IX.78.

22. Derouet, 158–60.

23. Gasman, "Death," 58.

24. See letters from Victoria Kent and Diego Martínez to Picasso, November 16 and 24, 1938, Archives Picasso. See also O'Brian, 338–39; O. Widmaier Picasso, 100; and Utley, 83 and 228 n. 133.

25. See "Artistes républicains espagnols aidés par Picasso," in Bouvard and Mercier, Musée National Picasso, 254–59.

26. Gasman, "Death," 56.

27. Gasman, "Death," 57–59.

28. G. Stein, *Picasso,* 16.

29. G. Stein, *Picasso,* 32–33.

30. PF.IV.1135.

31. Gasman, *Mystery,* 696.

32. Z.IX.104.

33. Seckler, 5.

34. Cowling, *Picasso Portraits,* 152–53.

35. Z.IX.103.

36. Godefroy, 167–68.

37. Brassaï, *Picasso and Company,* 45: "When I asked Marie Cuttoli the reasons for this recently (1963), she told me that Picasso insisted that the cartoon should not be taken out of his studio, and that all the work of transcription must be done there. But for technical reasons, this was not possible."

38. Brassaï, *Picasso and Company,* 45.

CHAPTER 17
Last Summer at Mougins

1. Sabartés, 139. Sabartés reported that Picasso's annual Mediterranean holiday in summer 1938 was a spur-of-the-moment decision made one evening in a café with Éluard. Supposedly, "they rushed home, packed their suitcases, met an hour later, and left immediately, long past midnight, bound for Mougins." In fact, though Picasso and Dora had indeed left suddenly with the Éluards in summer 1937, this year the two couples traveled separately. Éluard had made his plans in advance and sent them to his ex-wife, Gala, days before heading south in August 1938. Picasso and Dora returned to the Hôtel Vaste Horizon, where

the Éluards joined them seemingly some days later.

2. Z.IX.191.

3. As *La Vie passionnée de Vincent van Gogh.*

4. Z.IX.206.

5. Z.IX.202, 207–8, 210.

6. Sabartés, 138.

7. Z.IX.211.

8. Z.IX.193.

9. Éluard, *Letters*, 236.

10. Daix, *Picasso*, 261.

11. Preston, 290, notes that the Spanish Republic "was virtually sentenced to death by the British reaction to the Czechoslovakian crisis."

12. See letter from José Lino Vaamonde to Picasso, December 3, 1938, Archives Picasso.

13. Postcard from Éluard to Picasso, October 7, 1938, Archives Picasso.

14. November 6, 1938, Archives Picasso.

15. Éluard proposed the price paid by Penrose. See Cowling, *Visiting Picasso*, 44. See also Johan Popelard, "Les Picasso d'Éluard," in Guigon et al., 87, 90.

16. *The Spectator* (London), October 8, 1937.

17. Read's letter to the editor appeared in *The Spectator* the following week, October 15, 1937. See also Read, "Picasso's *Guernica*," *London Bulletin* 6 (October 1938); reprinted in McCully, 209–11.

18. January 21, 1939, Archives Picasso; quoted in van Hensbergen, 94.

19. Z.IX.240.

20. Z.IX.239.

21. P.F.IV.1249.

22. Gasman, *Mystery,* 1306–10.

23. Sabartés, 142.

24. Sabartés, 143.

25. Sabartés, 146.

26. Sabartés, 159.

27. P.F.IV.1256–57, 1259.

CHAPTER 18
Night Fishing at Antibes

1. P.F.IV.1262.

2. P.F.IV.1261.

3. Z.IX.252–53.

4. Richardson, "Picasso and L'Amour Fou," 68.

5. Dufaud, 34: "Sa mère, née en 1856, agée de quatre-vingt-trois ans, meurt à Barcelone. Elle a fait une chute dans la matinée et est décédée l'après-midi même."

6. Z.IX.237.

7. Z.IX.238.

8. Preston, 296–97.

9. Ros Coward, "Franco refugees still haunted by the past: 'We were cold, hungry and scared,'" *The Guardian*, February 9, 2019: https://www.theguardian.com/world/2019/feb/09/franco-spain-refugees-haunted-by-the-past-retirada#maincontent

10. Nicole Fenosa. "Biography" [of Apel·les Fenosa], www.http://fundaciofenosa.org (first published in *Apel·les Fenosa: Catalogue raisonné de l'œuvre sculptée* (Barcelona: Ediciones Polígrafa, 2002).

11. Garelick, 304.

12. Garelick, 303.

13. Sabartés, 142.

14. February 1939, Archives Picasso. See Bernard et al., 77.

15. January 27, 1939, Archives Picasso. See Musée National Picasso, 293.

16. January 27, 1939, MoMA Archives.

17. Quoted in FitzGerald, *Making Modernism,* 242–43.

18. "Art's Acrobat," *Time*, February 13, 1939.

19. In a letter to Picasso of February 22, 1939, Breton felt obliged to defend the American *Time* correspondent, and Marxist comrade, Sherry Mangan against the accusation of being a "spy" and revealing too much of Picasso's private life. Archives Picasso.

20. P. Courbon, "Le Congrès des médecins aliénistes et neurologistes de Lyon," *L'Aliéniste* 15, no. 8 (October 1934): 505–6.

21. See the "attestation médicale," May 9, 1939, from Dr. Forel: "Je soussigné, certifie que Monsieur Paul Picasso est en traitement dans la maison de santé 'Les Rives de Prangins' à Prangins près de Nyon. . . . L'état de santé de Monsieur Paul Picasso fait prévoir une cure de plusieurs mois." Reproduced in Daix and Israël, 100.

22. The author's unpublished interviews with Dora Maar, 1991–92, JR Archives.

23. Dufaud, 40–42.

24. Man Ray, 181: "I did not like to paint outside of my studio, so I acquired a permanent apartment with a terrace in Antibes where I could retire and paint, whenever I could get away from my photographic work in Paris."

25. Quoted in Daix, *Picasso,* 259.

26. Karrels, 509.

27. According to Cabanne, *Pablo Picasso,* 321, the superstitious Picasso avoided his own chauffeur for a while since he had the same name, Marcel, as Vollard's driver.

28. July 27, 1939. Quoted in Combalía, 184.

29. In an undated letter to Jacqueline Breton from summer 1939, Dora conveyed her difficulty: "For me it is the same effect as the body aches you get after physical exercise when you start [painting] again." Quoted in Combalía, 183.

30. July 28, 1939. See also letter of July 31, 1939, Archives Picasso. Callery, on Barr's behalf, was trying to secure the loan of Picasso's sculpture.

31. Sabartés, 177.

32. Before leaving for Antibes, Dora had invited Jacqueline to join their summer holiday: "Regarding the Midi, for me, my strongest desire would be that you come. I'm trying to arrange something but I know nothing as usual and nothing is less sure [than this trip]." Quoted in Combalía, 183.

33. Z.IX.316.

34. Maar identified herself and Lamba as the two women in the painting. See Burgard, 659.

35. Combalía, 184.

36. Burgard, 663.

37. "Picasso du soleil à la nuit," *Les Nouvelles Littéraires,* September 9, 1939.

38. Letter from Picasso to Marie-Thérèse, August 16, 1939: "Mon amour, Je ne vis que de ton souvenir que tous les jour le nourrit de l'amour que tu me procures avec la pensée qui ne me quitte pas de toi. J'ai bien des ennuis encore en Suisse. Ici j'ai mes neveux qui sont venus me voir. Je vais bientôt commencer à travailler inévitablement. Je pense à toi à notre fille et je t'aime. Je salue ta mère. Je suis à toi." Quoted in Dufaud, 48–49.

39. Sabartés, 184.

40. Quoted in *G. Stein and Wilder*, 244–45 n. 1.

41. Sabartés, 188.

CHAPTER 19
Between Royan and Paris

1. In September, Dora's mother wrote: "My child, I felt a lot of sadness in your letter. It pains me." Quoted in Combalía, 186.

2. Cabanne, *Pablo Picasso,* 326: "One day Marie-Thérèse saw Pablo get out of a car with Jaime [Sabartés] and a young brunette she did not know. He came over to her and kissed her, much to Dora's surprise. The next day, Marie-Thérèse wanted to know who the woman was, and he evasively mumbled, 'Some Spanish refugee . . .'" This contradicts Picasso's "choicest memory," told to Gilot, of watching Dora and Marie-Thérèse wrestle in front of *Guernica* in 1937.

3. Z.IX.319.

4. Cowling, *Picasso: Style and Meaning,* 617–18.

5. The article would not be published until March 1940.

6. Brassaï, *Conversations,* 49.

7. Brassaï, *Picasso and Company*, 47–48. Brassaï also relates how German censors prevented him from sending to *Life* magazine a photograph of Picasso mixing paints on an issue of *Paris-Soir.* The paint partially covered an article about the pope. Brassaï wondered, "What was there in this that could have upset the censors? Did they imagine a deliberately sacrilegious act in Picasso's hand smearing paint over . . . the Supreme Pontiff? Did they want to avoid a diplomatic incident with the Vatican? Did they scent some kind of joke, which, in view of the situation, they could not permit? Whatever their reason, my photograph was denied a permit to cross the Atlantic, and confiscated."

8. Z.IX.348–51; Z.X.122.

9. Cowling, *Picasso: Style and Meaning,* 619–22.

10. Z.IX.352.

11. Z.IX.367.

12. Forty-four years later, this painting would inspire David Hockney's portrait of the writer

Christopher Isherwood. "The displacement and repetition of facial features in such paintings," Hockney finds, "are not a distortion but actually an accurate description of how a face or body can appear when seen close-to." See Beechey, Stephens, et al., 210.

13. Z.IX.366.

14. Sabartés, 202. Sabartés told Brassaï (*Conversations,*128): "I always dreamed of being painted by Picasso as a sixteenth-century gentleman during the age of Philip II, as he was dressed at the Escurial. My wish did not fall on deaf ears. In 1938, on rue la Boétie, he first made a few drawings for me with this ruff whose starched muslin flounces amused him. He was thinking of painting me full-length, life-size in this costume of a Spanish grandee with the starchy ruff. I thought he had given up the idea when, one day, he surprised me with this portrait in Royan. Did you notice the tones of Spanish paintings of the time?"

15. Mary Callery, "The Last Time I Saw Picasso," *Art News* 21, no. 2 (March 1942): 36.

16. The exhibition was organized in conjunction with the Art Institute of Chicago.

17. M. Barr, 55.

18. February 17, 1939, MoMA Archives. Quoted in FitzGerald, *Making Modernism*, 246.

19. March 20, 1939, MoMA Archives. Quoted in FitzGerald, *Making Modernism*, 249.

20. December 15, 1939, MoMA Archives.

21. A. Barr, *Picasso: Forty Years,* 6: "The most serious disappointment caused by the war is the absence of a large and very important group of Picasso's recent sculpture some of which was being cast especially for the show. Even the photographs of these have been delayed." See also Barr's letter to Picasso, September 12, 1939: "Some weeks ago, well before the outbreak of war, we asked Mlle. Maar to send photographs of the sculptures. We also asked Mme. Callery to be of whatever assistance she could, but she may no longer be in France." MoMA Archives; reproduced in Temkin and Umland, 182.

22. FitzGerald, *Making Modernism*, 251.

23. Letter from Kahnweiler to Rupf, December 1, 1939, copy in JR Archives.

24. Sabartés, 197.

25. Z.IX.376.

26. Z.IX.378.

27. Brassaï once criticized Sabartés for not saying more about Picasso's personal life: "The only reproach I can make is that you say absolutely nothing about Picasso's love affairs. Nothing about women, as if they did not exist. That discretion distorts somewhat the facts . . ." Sabartés replied: "But is it necessary to talk about women? To enumerate the women who counted in his life? I don't think so. Women come and go, art remains." See Brassaï, *Conversations,* 289–90.

CHAPTER 20
Villa Les Voiliers

1. Sabartés, 203.

2. Matisse's painting (*Bouquet of Flowers in a Chocolate Pot*) can be seen in Dora's photographs of Picasso studio. Matisse could not remember which painting Picasso had bought from Vollard and asked the artist for a sketch of it in a letter of July 14, 1940. See Baldassari, *Picasso: Life with Dora Maar,* 238; see also Cowling and Baldassari, 381.

3. Rolland, unpaginated.

4. Benkemoun, 38–39.

5. Benkemoun, 39, states that Dora "had seen a doctor in Royan and had learned that she was infertile. What she had suspected was now a certainty: she would never have children."

6. Quoted in Grimberg, 7.

7. See Riding, 36.

8. Writing from the military post at Poitiers on March 26, 1940, Breton thanked Picasso for "offering me your help in such a simple way." Archives Picasso. See Musée National Picasso, 218.

9. Archives Picasso. See Musée National Picasso, 242.

10. FABA.

11. See Daix and Israël, 101–03.

12. O. Widmaier Picasso, 59–60.

13. By this time, Sabartés had moved out of the Au Tigre hotel and settled in his own house with his wife in Royan.

14. Sabartés, 216.

15. Quoted in Daix, *Picasso,* 261.

16. Z.X.376.

17. Z.X.375.

18. Z.X.377.

19. A note from Kahnweiler to Picasso, April 11, 1940, confirms purchase of three still lifes with "poissons" for 50,000 francs each. Archives Picasso.

20. The exhibition ran from April 18 to May 19. On February 29, during this previous visit to Paris, Picasso and Sabartés met with Yvonne Zervos at her gallery in preparation for the show. See Nash, 212. According to a receipt drawn up by Yvonne on April 2, 1940 (Archives Picasso), Picasso lent her twenty-four drawings, watercolors, and gouaches. Zervos seems to have kept these works for Picasso, as well as some sculptures, after the arrival of German forces in Paris.

21. March 27, 1940, Archives Picasso.

22. Archives Picasso.

23. Z.X.383.

24. Z.X.515.

25. Z.X.516.

26. Quoted in Baldassari, *Picasso: Life with Dora Maar*, 239.

27. Flam, 188, 194.

28. Flam, 189: "Matisse and Lydia left for Bordeaux. The countryside was already full of refugees, and the hotels were so full that schools and brothels were being used to lodge people. Matisse and Lydia could not get back to Nice until the end of August, around the time that Picasso and Dora returned to Paris. Both artists received offers to immigrate to the United States or Mexico, and both refused."

29. Archives Picasso.

30. See Daix and Israël, 105–31.

31. May 21, 1940, Archives Picasso.

32. Archives Picasso.

33. The volume was published in September.

34. May 25, 1940, Archives Picasso. Quoted in Derouet, 161.

35. Z.X.302.

36. Cowling, *Picasso: Style and Meaning*, 629.

37. Cowling, *Picasso: Style and Meaning*, 627.

38. Sabartés, 219–20.

39. June 27, 1940, Archives Picasso.

40. July 19, 1940; quoted in Derouet, 162. Contrary to Picasso's assertion that "foreigners can't move," Pellequer assured him that he needed nothing more than a "pièce d'identité" to travel by train. Pellequer to Picasso, July 29, 1940, Archives Picasso.

41. Zervos to Picasso, July 24, 1940, Archives Picasso; quoted in Derouet, 162–63.

42. August 8, 1940, Archives Picasso; quoted in Derouet, 163. Dora's mother also complained of food shortages in Paris in a letter of August 13. See Combalía, 191.

43. Z.XI.88.

44. Sabartés, 203.

45. Dufaud, 176–78.

46. Z.XI.81–82.

47. Dufaud, 182.

48. Quoted in Combalía, 188.

49. Quoted in Combalía, 188.

50. Z.XI.35.

51. Utley, 222 n. 71.

52. In spring 1941, Picasso installed Marie-Thérèse and Maya in a Paris apartment on boulevard Henri IV, where he would visit them every Thursday and Sunday throughout the Occupation.

CHAPTER 21
Wartime Paris

1. Letter from Zervos to Picasso, July 24, 1940: "On the door of your apartment at rue la Boétie and Grands-Augustins the embassy of Spain has posted a notice putting those two places under its protection." Archives Picasso; quoted in Bernard et al., 117.

2. Goggin, 17.

3. Zervos to Callery, January 13, 1945: "Picasso a passé tout le temps de l'occupation à Paris. Il était interdit d'exposer ses oeuvres dans les galeries, sur la demande, paraît-il, du gouvernment de Franco. Comme toujours cette difficulté a tourné à son avantage, ce qui fait que tout le monde, après la libération, s'est attaché à lui et a cherché à se l'attacher." Quoted in Derouet, 172.

4. In 1941, Franco's ambassador to France,

José Félix de Lequerica, gave Vichy authorities a list of eight hundred Spanish "delinquents" to be arrested. See L. Stein, 125.

5. May 13, 1941. Quoted in Baldassari, *Picasso: Life with Dora Maar*, 240.

6. Around this time, he rented additional space at 25 rue des Grands-Augustins for storing the sculptures he had done at Boisgeloup in the early 1930s.

7. Dufaud, 189.

8. Quoted in O'Brian, 349.

9. Quoted in Riding, 73.

10. van Hensbergen, 134.

11. Quoted in Cowling and Baldassari, 381.

12. Gilot and Lake, 38.

13. Gilot and Lake, 37.

14. The dealer Pierre Colle, who accompanied Picasso to the inspection, recounted that the German soldiers were amazed by "what were to them nothing but daubings." See Cabanne, *Pablo Picasso,* 332.

15. Brassaï, *Picasso and Company*, 48.

16. Brassaï, *Picasso and Company*, 48.

17. Combalía, 194.

18. Letter from Matisse to his son Pierre, November 28, 1940, quoted in Cowling and Baldassari, 381.

19. Letter from Mrs. Markovitch to her husband, January 25, 1941: "Dora continues to live her life, I see her in the morning and evening." Quoted in Combalía, 192.

20. See letters from Alfred Réty, Archives Picasso.

21. Riding, 34.

22. Arnaud, 616.

23. Riding, 62.

24. Utley, 34–35.

25. At the auction of the George Viau collection at the Hôtel Drouot, December 12–13, 1942, two paintings by Picasso reached the astronomical sums of 1,610,000 and 1,300,000 francs. See Bernard et al., 165.

26. See correspondence from Bucher to Picasso quoted in Bernard et al., 166.

27. Sebba, 82–85.

28. See Sinclair.

29. In a letter of July 29, 1940, banker Max Pellequer told Picasso, "Your friend Paul Rosen-berg who I saw in Bordeaux has left France with his family. There are no more [Jewish] dealers left in Paris." Archives Picasso.

30. Archives Picasso.

31. Assouline, 268.

32. Assouline, 273–75.

33. Assouline, 284.

34. Picasso, *Desire*, 44.

35. Picasso, *Desire*, 45–46.

36. Picasso, *Desire*, 46. On March 19, 1944, over one hundred people gathered in the Leirises' apartment for the first performance of the play, directed by Albert Camus, with music by Georges Hugnet. Dora was supposed to play the role of Tart but apparently demurred because it required her to appear nearly naked. The actress Zanie Campan took the role instead. See Nash, 223, and Combalía, 195.

37. Cabanne, *Pablo Picasso,* 332. Dora recalled having an argument with Gertrude Stein at the end of the war, when Gertrude discovered that Picasso had appropriated the electric radiators—appliances that were still very unfamiliar in France—from her empty apartment. He borrowed them, Dora said, because he suffered even more from cold than from hunger, and because Dora's studio, equipped for photography, had far more electric outlets than the typical Paris apartment. The author's unpublished interviews with Dora Maar, 1991–92, JR Archives.

38. Riding, 106.

39. Arnaud, 658.

40. Z.XI.319.

41. Z.XI.284a.

42. Goggin, 138.

43. Baldassari, *Picasso: Life with Dora Maar,* 243.

44. Z.XI.112.

45. Janis, 57.

46. Z.XI.160.

47. Brassaï, *Conversations*, 60.

48. Malo.

49. Quoted in Serena Bucalo-Mussely, "Souvenirs d'une amitié: Picasso vu par Giacometti," in Bucalo-Mussely and Perdrisot, 33 n. 41.

50. Brassaï, *Conversations*, 59.

51. September 18, 1940.

52. November 24, 1941.

CHAPTER 22
The Occupation

1. John Richardson, foreword to *Julio González: A Retrospective Exhibition* (Dickinson & Art Focus: New York and Zürich, 2002), 7. See also Richardson, *A Life: Triumphant Years*, 350–51.

2. In 1941, González asked Picasso for money to help his German son-in-law, the painter Hans Hartung, flee occupied France and join the Foreign Legion in North Africa. See Tomas Llorens, "The Collection of Julio González at the Fondation Hartung," in *Work by Julio González and Other Artists from the Fondation Hartung* (London: Christie's, June 30, 1999), 7.

3. Z.XII.35.

4. Brassaï, *Conversations*, 61.

5. Quoted in Guigon et al., 152–53.

6. In July 1943 Picasso would make a series of portrait drawings of Fabiani. See Fabiani, 127.

7. Fabiani, 128.

8. Karrels, 516–17.

9. Leiris, *Journal*, 363; quoted in Baldassari, *Picasso: Life with Dora Maar*, 234.

10. Dora took the apartment in March or April as her home and studio. She had previously lived at her mother's apartment and worked at her studio on rue d'Astorg. Mrs. Markovitch wrote to her husband on July 8, 1942: "[Dora] found something very nice and very much to her taste at 6 rue de Savoie—two steps from the Quai [des] Grands-Augustins . . . She wanted to live by herself. It's a *fait accompli* and I accept it." Quoted in Combalía, 199.

11. Cocteau, *Journal,* 108.

12. Arnaud, 619: "After having called for desertion and conscientious objection for so long, the Surrealists now elected to go into exile rather than resist. Paralyzed by the pact between Hitler and Stalin, most of the Communists waited for more than a year to throw themselves into the fight."

13. Drake, 148.

14. A. Barr, "Picasso 1940–1944," 3: "Picasso has stated that so far as he knew he had no Jewish blood, though he wished he had. Had he been even partly Jewish the Germans would scarcely have left him unmolested."

15. Gerhard Heller, *Un Allemand à Paris,* *1940–1944* (Paris: Éditions du Seuil, 1981), 118; quoted in Bertrand Dorléac, 215.

16. Quoted in Gold and Fizdale, 286–7.

17. Quoted in Gold and Fizdale, 289.

18. Richardson, *Sorcerer's Apprentice*, 118–19.

19. Vaughan, 130–31, 149–55.

20. Feliciano, 121; 264 n. 9.

21. Fabiani, 141, claimed to have helped the clandestine literary journal *Les Lettres Françaises* and to have sheltered one of its editors from the Vichy police.

22. Hugo, 484–85.

23. Arnaud, 660. Picasso completed his commission on June 13, 1946, but never delivered it to the Anchorenas. See Klein, 112–13.

24. Matisse added that those who believed Picasso was in an asylum "may have confused him with his son, who is not very bright, but there is no question of the boy being put away—not yet, at any rate." Quoted in Russell, 231.

25. Richardson, *A Life: Triumphant Years*, 433.

26. Vlaminck's *Comoedia* article "Opinion libre . . . sur la peinture" (June 6, 1942) was presented as an analysis of cubism. *Comoedia* published a reply by André Lhote on June 13, and on June 20 a letter supporting Picasso written by Gaston Diehl and signed by forty-one artists.

27. Cocteau, *Journal*, 151. See Bernard et al., 166–67, for letters of support to Picasso in response to Vlaminck's article.

28. See Bertrand Dorléac, 83–91; also Cone, 154–58.

29. Dubois, 132.

30. Dubois, 145–46.

31. Gilot and Lake, 36.

32. Quoted in Guégan, 163.

33. Sebba, 120.

34. See Dubois, 145.

35. Arnaud, 663.

36. Cone, 162.

37. Arnaud, 662.

38. Quoted in Arnaud, 663.

39. Nazi censors forbade criticism of the exhibition and decreed that "no value judgment is ever adequate for looking at Breker's work." See Cone, 162.

40. For more on Breker's exhibition and its reception, see Bertrand Dorléac, 91–105.

41. Cone, 163–64.

42. Z.XII.69.

43. Z.IIa.235.

44. Cocteau saw *L'Aubade* in Picasso's studio on June 3, 1942. For him, the painting evoked Manet's *Olympia*. See *Journal*, 143.

45. Seckler, 5–6. Reprinted in McCully, 228.

46. Picasso stated, "I have not painted the war, because I am not the kind of a painter who goes out like a photographer for something to depict. But I have no doubt that the war is in these paintings I have done. Later on perhaps the historians will find them and show that my style has changed under the war's influence. Myself, I don't know." Peter D. Whitney, "Picasso Is Safe: The Artist Was Neither a Traitor to His Paintings nor His Country," *San Francisco Chronicle*, September 3, 1944.

47. Z.XII.156.

48. Z.IIa.233.

49. The affinity between Picasso's 1942 *Reclining Nude* and his earlier cubist nudes was noted in *The Collection of Victor and Sally Ganz* (New York: Christie's, 1997), 182–87.

CHAPTER 23
Epilogue

1. Cocteau, *Journal*, 27.

2. O. Widmaier Picasso, 135: "He paid Olga's maintenance like clockwork—and many other occasional expenses besides. Olga had the use of the Château de Boisgeloup. But did not move into it, moving at whim from hotel to hotel and always at Pablo's expense."

3. Bernard Ruiz-Picasso relayed this anecdote in conversation with the author.

4. O. Widmaier Picasso, 201.

5. Letter of June 6, 1942, quoted in John Russell, 231.

6. Combalía, 200.

7. Combalía, 205.

8. J. Lord, *Picasso and Dora*, 151.

9. Z.XII.154.

10. The canvas began with a portrait drawing of Dora by Cocteau done on March 26, 1942, which Picasso overpainted. See Cocteau, *Journal*, 58.

11. Brassaï, *Conversations,* 308–9. See also J. Lord, *Picasso and Dora,* 153.

12. Brassaï, *Conversations*, 150.

13. Brassaï, *Conversations,* 220–21.

14. P. Laporte, 144–46.

15. Brassaï, *Conversations*, 134.

16. Early in 1943 Rozsda, who was Jewish, decided he would be safer in his native Budapest than in occupied Paris. Fearing for his safety, Françoise became very upset. Rozsda would survive, and the two would remain very close friends.

17. Gilot and Lake, 14–15.

18. Z.XII.259.

19. Z.XIII.23.

BIBLIOGRAPHY

Adès, Dawn, Simon Baker, et al. *Undercover Surrealism: Georges Bataille and "Documents."* London: Hayward Gallery, 2006.

Agar, Eileen. *A Look at My Life.* London: Methuen, 1988.

Alix, Josefina. *Picasso: "Guernica."* Madrid: Ministerio de Cultura, 1993.

Andral, Jean-Louis, et al. *M. Pablo's Holidays: Picasso in Antibes, Juan-les-Pins, 1920–1946.* Antibes: Musée National Picasso, 2018.

Aristophanes. *Lysistrata.* Translated by Gilbert Seldes; illustrated by Picasso. New York: Limited Editions Club, 1934.

Arnaud, Claude. *Jean Cocteau.* Translated by Lauren Elkin and Charlotte Mandell. New Haven and London: Yale University Press, 2016.

Ashton, Dore. *Picasso on Art.* New York: Da Capo, 1972.

Assouline, Pierre. *An Artful Life: A Biography of D. H. Kahnweiler, 1884–1979.* New York: G. Weidenfeld, 1990.

Baldassari, Anne. *Picasso: Life with Dora Maar, Love and War, 1935–1945.* Flammarion: Paris, 2006.

———. *The Surrealist Picasso.* Riehen/Basel: Fondation Beyeler; Paris: Flammarion, 2005.

Baring, Louise. *Dora Maar: Paris in the Time of Man Ray, Jean Cocteau, and Picasso.* New York: Rizzoli, 2017.

Barr, Alfred. *Picasso: Forty Years of His Art.* New York: Museum of Modern Art, 1939.

———. *Picasso: Fifty Years of His Art.* New York: Museum of Modern Art, 1946.

———. "Picasso 1940–1944: A Digest with Notes." *The Bulletin of the Museum of Modern Art* 12, no. 3 (January 1945): 2–9.

Barr, Margaret Scolari. "Our Campaigns." *The New Criterion,* Special Issue, Summer 1987: 23–74.

Barrault, Jean-Louis. *Memories for Tomorrow: The Memoirs of Jean-Louis Barrault.* Translated by Jonathan Griffin. London: Thames and Hudson, 1974.

Basilio, Miriam. *Visual Propaganda, Exhibitions, and the Spanish Civil War.* Farnham, Surrey, England; Burlington, VT: Ashgate, 2013.

Beechey, James, Chris Stephens, et al. *Picasso and Modern British Art.* London: Tate, 2012.

Benkemoun, Brigitte. *Finding Dora Maar: An Artist, an Address Book, a Life.* Translated by Jody Gladding. Los Angeles: Getty Publications, 2020.

Bernadac, Marie-Laure. "Picasso, Leiris: *Guernica* et *Miroir de la tauromachie.*" In *Guernica.* Paris: Musée Picasso, 2017.

Bernadac, Marie-Laure, and Androula Michaël. *Picasso: Propos sur l'art.* Paris: Gallimard, 1998.

Bernadac, Marie-Laure, and Christine Piot, eds. *Picasso: Collected Writings.* Translated by Carol Volk and Albert Bensoussan. London: Aurum Press, 1989.

Bernard, Sophie, et al. *Picasso, 1939–1945: Au Coeur des ténèbres.* Paris: In Fine Éditions and Musée de Grenoble, 2019.

Bertrand Dorléac, Laurence. *Art of the Defeat: France, 1940–1944.* Translated by Jane Marie Todd. Los Angeles: Getty Research Institute, 2008.

Borchardt-Hume, Achim, and Nancy Ireson, eds. *Picasso 1932: Love, Fame, Tragedy.* London: Tate, 2018.

Bottois, Ozvan. "Corrida: La mort du torero." In *Guernica.* Paris: Musée Picasso, 2018.

Bouvard, Émilie, and Géraldine Mercier, eds. *Guernica.* Paris: Musée Picasso, 2018.

Brassaï. *The Artists of My Life.* New York: Viking Press, 1982.

———. *Conversations with Picasso*. Chicago: University of Chicago Press, 1999.

———. *Letters to My Parents*. Translated by Peter Laki and Barna Kantor. Chicago: University of Chicago Press, 1997.

———. *Picasso and Company*. Translated by Francis Price. New York: Doubleday, 1966.

Brenan, Gerald. *The Spanish Labyrinth: The Social and Political Background of the Spanish Civil War*. Cambridge (UK) and New York: Cambridge University Press, 1950.

Breton, André. *Le Surréalisme et la peinture*. Paris: Gallimard, 1928.

———. *Mad Love*. Translated by Mary Ann Caws. Lincoln, NE, and London: University of Nebraska Press, 1998.

Breton, André, et al. *Violette Nozières*. Brussels: Éditions Nicolas Flamel, [1933].

Brunner, Kathleen. *Picasso Rewriting Picasso*. London: Black Dog, 2004.

Bucalo-Mussely, Serena, and Virginie Perdrisot. *Picasso–Giacometti*. Paris: Musée National Picasso, 2016.

Buñuel, Luis. *My Last Sigh*. Translated by Abigail Israel. New York: Alfred A. Knopf, 1983.

Burgard, Timothy Anglin. "Picasso's *Night Fishing at Antibes*: Autobiography, Apocalypse, and the Spanish Civil War." *The Art Bulletin* 68, no. 4 (December 1986): 657–72.

Cabañas Bravo, Miguel. "Picasso y su ayuda a los artistas españoles de los campos de concentración franceses." In *Actas del Congreso Internacional: La Guerra Civil Española,1936–1939*. Madrid: Sociedad Estatal de Commemoraciones Culturales, 2008.

———. *Josep Renau: Arte y propaganda en guerra*. Madrid: Ministerio de Cultura, 2007.

———. "Renau i el pavelló espanyol de 1937 a Paris, amb Picasso i sense Dalí." In *Josep Renau, 1907–1982: Compromís i cultura*. Valencia: Universitat de Valencia, 2007.

Cabanne, Pierre. *Pablo Picasso: His Life and Times*. New York: Morrow, 1977.

———. "Picasso et les joies de la paternité." *L'Oeil* 226 (May 1974): 1–11.

———. *Le Siècle de Picasso 3: "Guernica" et la guerre (1937–1955)*. Paris: Gallimard, 1975.

Cary, Michael. "Balzac/Picasso." *Gagosian Quarterly* (Spring 2018): 149–52.

Caws, Mary Ann, ed. *The Milk Bowl of Feathers: Essential Surrealist Writings*. New York: New Directions, 2018.

Chipp, Herschel B. *Picasso's "Guernica": History, Transformations, Meanings*. Berkeley: University of California Press, 1988.

Clark, T. J. "Picasso and Tragedy." In *Pity and Terror: Picasso's Path to "Guernica."* Madrid: Museo Nacional Centro de Arte Reina Sofía, 2017.

Cocteau, Jean. *Journal: 1942–1945*. Paris: Gallimard, 1989.

———. *Le Passé défini* II. Paris: Gallimard, 1953.

Colorado Castellary, Arturo. *Éxodo y exilio del arte: La Odisea del Museo del Prado durante la Guerra Civil*. Madrid: Cátedra, 2008.

Colvile, Georgiana. "Through an Hourglass Lightly: Valentine Penrose & Alice Rahon-Paalen." In *Reconceptions: Reading Modern French Poetry*. R. King and B. McGuirk, eds. Nottingham: University of Nottingham Monographs in the Humanities 11, 1996.

Combalía, Victoria. *Dora Maar: La Femme invisible*. Lille: Éditions Invenit, 2019.

Cone, Michèle C. *Artists Under Vichy: A Case of Prejudice and Persecution*. Princeton: Princeton University Press, 1992.

Cooper, Douglas. *Picasso Theatre*. New York: Harry N. Abrams, 1968.

Cowling, Elizabeth. "The Image of Picasso-Sculptor in the 1930s." In *Pablo Picasso and Marie-Thérèse: L'Amour Fou*. New York: Gagosian Gallery/Rizzoli, 2011.

———. *Picasso Portraits*. London: National Portrait Gallery, 2016.

———. *Picasso: Style and Meaning*. London: Phaidon, 2002.

———. *Visiting Picasso: The Notebooks and Letters of Roland Penrose*. New York: Thames & Hudson, 2006.

Cowling, Elizabeth, and Anne Baldassari. *Matisse Picasso*. London: Tate, 2002.

Daix, Pierre. *Picasso: Life and Art*. New York: Icon Editions, 1993.

Daix, Pierre, and Armand Israël. *Pablo Picasso: Dossiers de la Préfecture de Police, 1901–*

1940. Paris: Éditions des Catalogues raisonnés, 2003.

Derouet, Christian. *Zervos et Cahiers d'Art*. Paris: Centre Pompidou, 2011.

Domènech, Silvia, et al. *Picasso 1936: Huellas de una exposición*. Barcelona: Museu Picasso, 2011.

Drake, David. *French Intellectuals and Politics from the Dreyfus Affair to the Occupation*. New York: Palgrave Macmillan, 2005.

Dubois, André-Louis. *À travers trois Républiques: Sous le signe de l'amitié*. Paris: Plon, 1972.

Dudley, Andrew, and Stephen Ungar. *Popular Front Paris and the Poetics of Culture*. Cambridge, MA: Harvard University Press, 2005.

Dufaud, Gérard. *Picasso: Un Réfugié à Royan, 1939–1940*. [Vaux-sur-Mer]: ComédiaArt, 2012.

Dupuis-Labbé, Dominique. "Picasso's Horse." In *Picasso: Horses*. Malaga: Museo Picasso, 2010.

Éluard, Paul. "Je parle de ce qui est bien," *Cahiers d'Art* 10, nos. 7–10 (dated 1935 but published in 1936): 165–68.

———. *Letters to Gala*. Translated by Jesse Browner. New York: Paragon House, 1989.

Etherington-Smith, Meredith. *The Persistence of Memory: A Biography of Dalí*. New York: Random House, 1992.

Fabiani, Martin. *Quand j'étais marchand de tableaux*. Paris: Julliard, c. 1976.

Farnoux, Alexandre. "Zervos and Ancient Greek Art." In *Christian Zervos and Cahiers d'Art: The Archaic Turn*. Athens: Benaki Museum, 2019.

Feliciano, Hector. *The Lost Museum: The Nazi Conspiracy to Steal the World's Greatest Works of Art*. New York: Basic Books, 1997.

Fisher, David James. *Romain Rolland and the Politics of Intellectual Engagement*. Berkeley: University of California Press, 1998.

FitzGerald, Michael. *Making Modernism: Picasso and the Creation of the Market for Twentieth-Century Art*. New York: Farrar, Straus and Giroux, 1996.

———. "Reports from the Home Fronts: Some Skirmishes over Picasso's Reputation." In *Picasso and the War Years: 1937–1945*. San Francisco: Fine Arts Museums of San Francisco, 1998.

Flam, Jack. *Matisse and Picasso: The Story of Their Rivalry and Friendship*. Cambridge, MA: Icon Editions, 2003.

Fondation Vincent van Gogh. *Pablo Picasso: Portraits d'Arlésiennes, 1912–1958*. Arles: Actes sud; Fondation Vincent van Gogh, 2005.

Freedberg, Catherine Blanton. *The Spanish Pavilion at the Paris World's Fair*, vol. 2. New York: Garland, 1986.

Freeman, Judi. *Picasso and the Weeping Women: The Years of Marie-Thérèse Walter and Dora Maar*. Los Angeles: Los Angeles County Museum of Art and New York: Rizzoli, 1994.

Garelick, Rhonda K. *Mademoiselle: Coco Chanel and the Pulse of History*. New York: Random House, 2015.

Gascoyne, David. *Collected Journals, 1936–42*. London: Skoob Books, 1991.

Gasman, Lydia. *Mystery, Magic and Love in Picasso, 1925–1938: Picasso and the Surrealist Poets*. PhD dissertation, Columbia University, 1981.

———. "Death Falling from the Sky: Picasso's Wartime Texts." In *Picasso and the War Years: 1937–1945*. San Francisco: Fine Arts Museums of San Francisco, 1998.

Gateau, Jean-Charles. *Éluard, Picasso et la peinture: 1936–1952*. Geneva: Droz, 1983.

Gibson, Ian. *Federico García Lorca: A Life*. London: Faber and Faber, 1989.

Gilot, Françoise, and Carlton Lake. *Life with Picasso*. New York: New York Review of Books, 2019.

Giménez Caballero, Ernesto. *Memorias de un dictador*. Madrid: Planeta, 1979.

Godefroy, Cécile. "*Femmes à leur toilette (Women at Their Toilet)*: From Collage to Wool." *Cahiers d'Art* 39 (Special Issue 2015: *Picasso in the Studio*): 166–75.

Goeppert, Sebastian. *Pablo Picasso, The Illustrated Books: Catalogue Raisonné*. Geneva: Patrick Cramer, 1983.

Goggin, Mary-Margaret. *Picasso and His Art During the Occupation, 1940–1944*. PhD dissertation, Stanford University, 1985.

Gold, Arthur, and Robert Fizdale. *Misia: The Life of Misia Sert*. New York: Morrow Quill Paperbacks, 1981.

Greeley, Robin Adèle. *Surrealism and the Spanish*

Civil War. New Haven: Yale University Press, 2006.

Grimberg, Salomon. "Jacqueline Lamba: From Darkness, with Light." *Woman's Art Journal* 22, no. 1 (Fall 2000–Winter 2001): 5–13.

Grossman, Wendy A. "Unmasking Adrienne Fidelin: Picasso, Man Ray, and the (In)Visibility of Racial Difference." https://modernism modernity.org/articles vol. 5, cycle 1 (April 24, 2020).

Guégan, Stéphane. *Les Arts sous l'occupation: Chronique des années noires.* Paris: Beaux Arts Éditions, 2012.

Guigon, Emmanuel, et al. *Pablo Picasso, Paul Éluard: Une Amitié sublime.* Barcelona: Museu Picasso and Paris: Musée National Picasso, 2020.

Hugo, Jean. *Le Regard de la mémoire.* Arles: Actes Sud, 1983.

Irujo, Xabier. *Gernika, 1937: The Market Day Massacre.* Reno: University of Nevada Press, 2015.

Janis, Harriet Grossman and Sidney. *Picasso, the Recent Years, 1939–1946.* Garden City, NY: Doubleday & Company, 1946.

Kahnweiler, Daniel-Henry. *Huit Entretiens avec Picasso.* Paris: L'Echoppe, 1988.

Kamenish, Paula K. "Naming the Crime: Responses to the Papin Murders from Lacan, Beauvoir, and Flanner." *The Comparatist* 20 (May 1996): 93–110.

Karrels, Nancy Caron. "Reconstructing a Wartime Journey: The Vollard-Fabiani Collection, 1940–1949." *Journal of Cultural Property* 22 (2015): 505–26.

Klein, John. *Matisse and Decoration.* New Haven: Yale University Press, 2018.

Kosmadaki, Polina, ed. *Christian Zervos and Cahiers d'Art: The Archaic Turn.* Athens: Benaki Museum, 2019.

Lacan, Jacques. "Motifs du crime paranoïaque: Le Crime des soeurs Papin." *Minotaure* 3/4 (December 1933): 25–28.

Laporte, Geneviève. *Sunshine at Midnight: Memories of Picasso and Cocteau.* Translated with annotations by Douglas Cooper. London: Weidenfeld and Nicolson, 1973.

Laporte, Paul M. "The Man with the Lamb." *Art Journal* 21, no. 3 (Spring 1962): 144–50.

Leiris, Michel. *Journal, 1922–1989.* Paris: Gallimard, 1992.

———. *Manhood: A Journey from Childhood into the Fierce Order of Virility.* Chicago: University of Chicago Press, 1992.

———. "Toiles récentes de Picasso." *Documents* 2 (1930): 57–70.

———. "Picasso the Writer, or Poetry Unhinged." In Marie-Laure Bernadac, ed. *Picasso: Collected Writings.* New York: Abbeville Press, 1989.

Lord, Carmen Belen. "Picasso's *Dream and Lie of Franco.*" In *Barcelona and Modernity: Picasso, Gaudí, Miró, Dalí.* Cleveland: Cleveland Museum of Art, 2007.

Lord, James. *Picasso and Dora: A Personal Memoir.* New York: Fromm International, 1994.

Madeline, Laurence. *Picasso 1932.* Paris: Musée National Picasso, 2017.

Mallen, Enrique, ed. *Online Picasso Project.* Huntsville, TX: Sam Houston State University, 1997–2020.

Malo, Pierre. "Picasseries et Picasso." *Comoedia,* August 30, 1940.

Marín, Juan. "Conversando con Dora Maar." *Goya* 311 (March–April 2006): 113–23.

Martin, Russell. *Picasso's War.* New York: Pocket Books, 2004.

McCully, Marilyn. *A Picasso Anthology: Documents, Criticism, Reminiscences.* London: Arts Council of Great Britain, 1981.

Medrano, Jérôme. *Une Vie de cirque.* Paris: Arthaud, 1983.

Meyer-Plantureux, Chantal. *Théâtre populaire, enjeux politiques de Jaurès à Malraux.* Paris: Éditions Complexe, 2006.

Minchom, Martin. *Spain's Martyred Cities: From the Battle of Madrid to Picasso's "Guernica."* Brighton: Sussex Academic Press, 2015.

Musée National Picasso, Paris. *Les Archives de Picasso: "On est ce que l'on garde!"* Paris: Réunion des Musées Nationaux, 2003.

Museo de Arte Moderno. *Alice Rahon: Una surrealista en México.* Mexico City: Museo de Arte Moderno, 2009.

Nash, Steven A., ed. *Picasso and the War Years, 1937–1945.* San Francisco: Fine Arts Museums of San Francisco, 1998.

Neufert, Andreas. *Auf Liebe und Tod: Das Leben des Surrealisten Wolfgang Paalen*. Berlin: Parthas Verlag, 2015.

O'Brian, Patrick. *Pablo Ruiz Picasso: A Biography*. Putnam & Sons: New York, 1976.

Olivier, Fernande. *Picasso et ses amis*. Paris: Stock, 1933.

Orban, Séverine Aline. *Avis de recherche: Valentine Penrose, œuvre et vie d'une artiste surréaliste*. PhD dissertation, Louisiana State University, 2014.

Otero, Roberto. *Forever Picasso: An Intimate Look at His Last Years*. Translated by Elaine Kerrigan. New York: Harry N. Abrams, 1974.

Palau i Fabre, Josep. *Picasso, 1927–1939: From the Minotaur to "Guernica."* Translated by Graham Thomson and Sue Brownbridge. Barcelona: Ediciones Polígrafa, 2011.

Parinaud, André. *The Unspeakable Confessions of Salvador Dalí*. Translated by Harold J. Salemson. London: Quartet Books, 1977.

Patané, Vincenzo. *The Sour Fruit: Lord Byron, Love and Sex*. Rome: John Cabot University, 2019.

Penrose, Roland. *Picasso: His Life and Work*. London: Victor Gollancz, 1958.

———. *Scrap Book, 1900–1981*. London: Thames and Hudson, 1981.

Perl, Jed. *Calder: The Conquest of Time: The Early Years, 1898–1940*. New York: Alfred A. Knopf, 2017.

Philippot, Émilia, Joachim Pissarro, and Bernard Ruiz-Picasso. *Olga Picasso*. Paris: Musée National Picasso, 2019.

Picasso, Pablo. *The Burial of the Count of Orgaz and Other Poems*. Edited and translated by Jerome Rothenberg and Pierre Joris. Cambridge: Exact Change, 2004.

———. *Desire*. Translated by Bernard Frechtman. New York: Philosophical Library, 1948.

Pierce, Samuel. "The Political Mobilization of Catholic Women in Spain's Second Republic: The CEDA, 1931–36." *Journal of Contemporary History* 45, no. 1 (January 2010): 74–94.

Pierre, José, ed. *Investigating Sex: Surrealist Discussions, 1928–1932*. London: Verso, 2011.

Preston, Paul. *The Spanish Civil War*. New York: W. W. Norton, 2007.

Ray, Man. *Self Portrait*. Boston: Little, Brown, 1963.

Read, Herbert. "*L'Art en Grèce* by Christian Zervos." *The Burlington Magazine for Connoisseurs* 64, no. 373 (April 1934): 190–91.

Rhodes, Richard. *Hell and Good Company: The Spanish Civil War and the World It Made*. New York: Simon & Schuster, 2016.

Richardson, John. *A Life of Picasso: The Prodigy, 1881–1906*. New York: Alfred A. Knopf, 2007.

———. *A Life of Picasso: The Cubist Rebel, 1907–1916*. New York: Alfred A. Knopf, 2007.

———. *A Life of Picasso: The Triumphant Years, 1917–1932*. New York: Alfred A. Knopf, 2007.

———. "Epilogue." In Fernande Olivier, *Loving Picasso: The Private Journal of Fernande Olivier*. Foreword and notes by Marilyn McCully. New York: Harry N. Abrams, 2001.

———. "How Political Was Picasso?" *The New York Review of Books*, November 25, 2010.

———. "Picasso and L'Amour Fou." *The New York Review of Books*, December 19, 1985.

———. "Picasso and Marie-Thérèse Walter." In *Picasso and Marie-Thérèse: L'Amour fou*. New York: Gagosian Gallery, 2011.

———. "Picasso's Broken Vow." *The New York Review of Books*. June 25, 2015.

———. *The Sorcerer's Apprentice: Picasso, Provence, and Douglas Cooper*. New York: Alfred A. Knopf, 2019.

Richardson, John, et al. *Picasso and the Camera*. New York: Gagosian Gallery, 2014.

Riding, Alan. *And the Show Went On: Cultural Life in Nazi-Occupied Paris*. New York: Vintage Books, 2010.

Rolland, Andrée. *Picasso et Royan aux jours de la guerre et de l'occupation*. Royan: Impr. Nouvelle, 1967.

Rosenblum, Robert. "Picasso's Blond Muse: The Reign of Marie-Thérèse Walter." In *Picasso and Portraiture: Representation and Transformation*. New York: Museum of Modern Art, 1996.

Ruiz-Picasso, Bernard. "Olga's Trunk." In *Olga Picasso*. Paris: Musée Picasso, 2019.

Russell, John. *Matisse: Father and Son*. New York: Harry N. Abrams: 1999.

Sabartés, Jaime. *Picasso: An Intimate Portrait*. New York: Prentice-Hall, 1948.

Sadoul, Georges. "Une Demi-heure dans l'atelier de Picasso." *Regards*, July 31, 1937.

Sebba, Anne. *Les Parisiennes: How the Women of Paris Lived, Loved, and Died Under Nazi Occupation.* New York: St. Martin's Press, 2016.

Seckel, Hélène, ed. *Max Jacob et Picasso.* Paris: Musée National Picasso, 1994.

Seckler, Jerome. "Picasso Explains." *New Masses* 54, no. 11 (March 13, 1945).

Sert, Josep Lluís. "La Victoria del *Guernica.*" In *"Guernica": Legado Picasso.* Madrid: Ministerio de Cultura, 1981.

Sinclair, Anne. *My Grandfather's Gallery: A Family Memoir of Art and War.* New York: Farrar, Straus and Giroux, 2014.

Southworth, Herbert Rutledge. *Guernica! Guernica! A Study of Journalism, Diplomacy, Propaganda and History.* Berkeley: University of California Press, 1977.

Spurling, Hilary. *Matisse the Master: A Life of Henri Matisse—The Conquest of Colour, 1909–1954.* New York: Alfred A. Knopf, 2005.

Stein, Gertrude. *The Autobiography of Alice B. Toklas.* Illustrated by Maira Kalman. New York: Penguin, 2020.

———. *Everybody's Autobiography.* Cambridge, MA: Exact Change, 1993.

Stein, Gertrude. *Picasso.* New York: Dover, 1984.

Stein, Gertrude, and Thornton Wilder. *The Letters of Gertrude Stein and Thornton Wilder.* Edited by Edward M. Burns and Ulla E. Dydo, with contributions by William Rice. New Haven and London: Yale University Press, 1996.

Stein, Louis. *Beyond Death and Exile: The Spanish Republicans in France, 1939–1955.* Cambridge, MA: Harvard University Press, 2013.

Stuckey, Charles. "Olga in the 1930s: 'The worst time of my life.'" In *Olga Picasso.* Paris: Musée Picasso, 2019.

Suleiman, Susan. "Between the Street and the Salon: The Dilemma of Surrealist Politics in the 1930's." *Visual Anthropology Review* 7, no. 1 (Spring 1991): 39–50.

Surya, Michel. *Georges Bataille: An Intellectual Biography.* Translated by Krzysztof Fijalkowski and Michael Richardson. London and New York: Verso, 2002.

Temkin, Ann, and Anne Umland, eds. *Picasso Sculpture.* New York: Museum of Modern Art, 2015.

Utley, Gertje. *Picasso: The Communist Years.* New Haven: Yale University Press, 2000.

van Hensbergen, Gijs. *"Guernica": The Biography of a Twentieth-Century Icon.* London: Bloomsbury, 2004.

Vaughan, Hal. *Sleeping with the Enemy: Coco Chanel's Secret War.* New York: Knopf, 2011.

Vlaminck, Maurice de. "Opinion libre . . . sur la peinture." *Comoedia,* June 6, 1942.

Warnod, André. "'En peinture tout n'est que signe,' nous dit Picasso." *Arts* (Paris), June 29, 1945.

Warnod, Jeanine. "An Interview with André Masson, October 27, 1983, in his apartment, 26 rue Sévigné, Paris." In *Focus on Minotaure: The Animal-Headed Review.* Geneva: Musée d'Art et d'Histoire, 1987.

———. "Visit to Tériade, Winter 1982." In *Focus on Minotaure: The Animal-Headed Review.* Geneva: Musée d'Art et d'Histoire, 1987.

Widmaier Picasso, Diana. "The Marie-Thérèse Years: A Frenzied Dialogue for the Sleeping Muse, or the Rebirth of Picasso's Plastic Laboratory." In *Picasso and Marie-Thérèse: L'Amour Fou.* New York: Gagosian Gallery, 2011.

———. "Rescue: The End of the Year." In *Picasso 1932: Love, Fame, Tragedy.* London: Tate, 2018.

Widmaier Picasso, Olivier. *Picasso: The Real Family Story.* Munich, London, New York: Prestel, 2004.

Wilson, Sarah. *Picasso/Marx and Socialist Realism in France.* Liverpool: Liverpool University Press, 2013.

Zervos, Christian. *Catalan Art from the Ninth to the Fifteenth Centuries.* London: W. Heinemann, 1937.

———. "Conversation avec Picasso." *Cahiers d'Art* 10, no. 10 (1935): 173–78.

———. *L'Art en Grèce, des temps préhistoriques au début du XVIIIe siècle.* Paris: Cahiers d'Art, 1934.

INDEX

Page numbers in *italics* refer to illustrations.

ILLUSTRATION CREDITS

162 Dora Maar © 2021 Artists Rights Society (ARS), New York/ADAGP, Paris. Photograph © CNAC/MNAM/Dist. RMN-Grand Palais/Art Resource, NY.

165 Antonia Reeve, National Galleries of Scotland, Edinburgh.

165 Christie's, NY.

166 Photograph © Maurice Aeschimann.

168 bpk Bildagentur/Staatsgalerie, Stuttgart/Art Resource, NY.

168 Digital Image © The Museum of Modern Art/Licensed by SCALA/Art Resource, NY.

169 Photograph © RMN-Grand Palais/Mathieu Rabeau/Art Resource, NY.

171 Photograph © RMN-Grand Palais/René-Gabriel Ojéda/Art Resource, NY.

172 Digital Image © The Museum of Modern Art/Licensed by SCALA/Art Resource, NY.

174 Image © The Metropolitan Museum of Art. Image source: Malcolm Varon/Art Resource, NY.

176 Robert Bayer, Münchenstein.

177 Photograph © RMN-Grand Palais/Adrien Didierjean/Art Resource, NY.

177 Paul Hester. The Menil Collection, Houston.

179 Photograph © FABA. Photo: Éric Baudouin.

181 Museu Picasso, Barcelona. Photo: Gasull Fotografia. MPB70231. Digital File.

182 Photograph © RMN-Grand Palais/Art Resource, NY.

184 Art Gallery of New South Wales, Jenni Carter, L2014.6.

185 Photograph © RMN-Grand Palais/Adrien Didierjean/Art Resource, NY.

187 Photograph © George Hoyningen-Huene Estate Archives, Stockholm.

188 Ron Meisel, NY.

190 Dora Maar © 2021 Artists Rights Society (ARS), New York/ADAGP, Paris. Photograph © RMN- Grand Palais/Art Resource, NY.

191 Archives Succession Picasso.

194 © Estate Brassaï—RMN-Grand Palais. Photograph © RMN-Grand Palais (Musée National Picasso, Paris)—© Repro photo: Franck Raux/Art Resource, NY.

196 Combier Macon, All rights reserved.

197 Rheinisches Bildarchiv Cologne, rba_ c013641. Image Inv.-Nr. ML/Z 1994/036.

198 © Estate Brassaï—RMN-Grand Palais. Photograph © RMN-Grand Palais (Musée National Picasso, Paris)—© Franck Raux/ Art Resource, NY.

198 © Estate Brassaï—RMN-Grand Palais. Photograph © RMN-Grand Palais (Musée National Picasso, Paris)—© Repro photo: Mathieu Rabeau/Art Resource, NY.

199 Photograph © RMN-Grand Palais/Mathieu Rabeau/Art Resource, NY.

199 Photograph © RMN-Grand Palais/ Madeleine Coursaget/Art Resource, NY.

199 Photographer unknown, All rights reserved.

200 Photograph © Béatrice Hatala.

200 Dora Maar © 2021 Artists Rights Society (ARS), New York/ADAGP, Paris. Photograph © CNAC/MNAM/Dist. RMN-Grand Palais/Art Resource, NY.

201 © Dora Maar © 2021 Artists Rights Society (ARS), New York/ADAGP, Paris. Photograph © RMN-Grand Palais/Repro photo: Franck Raux/Art Resource, NY.

202 Rafael Lobato. Photograph © Museo Picasso Málaga.

203 Photograph © CNAC/MNAM/Dist. RMN-Grand Palais/Thierry Le Mage/Art Resource, NY.

204 Dora Maar © 2021 Artists Rights Society (ARS), New York/ADAGP, Paris. Photograph © CNAC/MNAM/Dist. RMN-Grand Palais/Repro photo: Georges Meguerditchian/Art Resource, NY.

206 Photograph © RMN-Grand Palais/Art Resource, NY.

207 Dora Maar © 2021 Artists Rights Society (ARS), New York/ADAGP, Paris. Photograph © RMN- Grand Palais/Art Resource, NY. FPPH176.

207 Dora Maar © 2021 Artists Rights Society (ARS), New York/ADAGP, Paris. Photograph © CNAC/MNAM/Dist. RMN-Grand Palais/Art Resource, NY.

208 Photograph © CNAC/MNAM/Dist. RMN-Grand Palais/Bertrand Prévost/Art Resource, NY.

209 Digital Image © The Museum of Modern Art/Licensed by SCALA/Art Resource, NY.

210 Sotheby's, NY.

211 Photograph © RMN-Grand Palais/Mathieu Rabeau/ Art Resource, NY.

211 Photograph © RMN-Grand Palais/Adrien Didierjean/Art Resource, NY.

212 Dora Maar © 2021 Artists Rights Society (ARS), New York/ADAGP, Paris. Photograph © CNAC/MNAM/Dist. RMN-Grand Palais/Art Resource, NY.

214 Photograph © RMN-Grand Palais/Adrien Didierjean/Art Resource, NY.

215 Photographer unknown, All rights reserved.

216 Archives Succession Picasso.

216 Photograph © RMN-Grand Palais/Mathieu Rabeau/Art Resource, NY.

217 Photograph © RMN-Grand Palais/Art Resource, NY. Photographer unknown, All rights reserved.

218 © Estate Brassaï—RMN-Grand Palais. Photograph © RMN-Grand Palais (Musée National Picasso, Paris)—© image RMN-GP/Art Resource, NY.

225 Dora Maar © 2021 Artists Rights Society (ARS), New York/ADAGP, Paris. Photograph © CNAC/MNAM/Dist. RMN-Grand Palais/Repro photo: Philippe Migeat/Art Resource, NY.

226 Photograph © RMN-Grand Palais/Adrien Didierjean/Art Resource, NY.

226 Photograph © RMN-Grand Palais/Adrien Didierjean/Art Resource, NY.

228 Henie Onstad Collection /Photo: Øystein Thorvaldsen.

229 Kunstmuseum Basel, Martin P. Bühler.

230 Photograph © Ed Glendinning.

230 Nagasaki Prefectural Art Museum.

231 Dora Maar © 2021 Artists Rights Society (ARS), New York/ADAGP, Paris. Photograph © CNAC/MNAM, Dist. RMN-Grand Palais/Philippe Migeat/Art Resource, NY.

231 Dora Maar © 2021 Artists Rights Society (ARS), New York/ADAGP, Paris. Photograph © CNAC/MNAM/Dist. RMN-Grand Palais/Art Resource, NY.

232 Photograph © RMN-Grand Palais/Mathieu Rabeau/Art Resource, NY.

232 Photograph © RMN-Grand Palais/Mathieu Rabeau/Art Resource, NY.

235 Ohara Museum of Art, Kurashiki.

235 Photograph © RMN-Grand Palais/Mathieu Rabeau/Art Resource, NY.

235 The Albertina Museum, Vienna. The Batliner Collection.

236 Digital Image © The Museum of Modern Art/Licensed by SCALA/Art Resource, NY.

237 bpk Bildagentur/Museum Berggruen, Nationalgalerie, Staatliche Museen, Berlin/ Jens Ziehe/Art Resource, NY.

238 Jean Cocteau © ADAGP/Comité Cocteau, Paris, Artists Rights Society (ARS), New York/ ADAGP, Paris 2021.

240 © Raymond Voinquel—RMN. Photograph © Ministère de la Culture/Médiathèque du Patrimoine, Dist. RMN-Grand Palais/Art Resource, NY.

243 PVDE/Bridgeman Images.

245 Charlotte Rohrbach. ullstein bild/ GRANGER.

247 bpk Bildagentur/Museum Berggruen, Nationalgalerie, Staatliche Museen, Berlin/ Jens Ziehe/Art Resource, NY.

248 Endre Rozsda. Photograph © J.M. Atelier Rozsda, Paris, 2021.

250 © Succession Picasso 2021.

250 © Succession Picasso 2021.

250 © Succession Picasso 2021.

252 Photograph © RMN-Grand Palais/Thierry Le Mage/Art Resource, NY.

252 Photograph © RMN-Grand Palais/Thierry Le Mage/Art Resource, NY.

252 Photograph © Ed Glendinning.

253 Photographic Archives Museo Nacional Centro de Arte Reina Sofia, Madrid.

254 Archives Succession Picasso.

COLOR INSERTS

Le Sauvetage (The Rescue). Fondation Beyeler, Riehen/Basel, Robert Bayer, Basel.

Le Sauvetage (The Rescue). Photograph Luc Chessex. © Fondation Jean et Suzanne Planque.

Head of a Warrior. Photograph © FABA. Photo: Éric Baudouin.

Silenus Dancing. bpk Bildagentur/ Nationalgalerie, Museum Berggruen, Staatliche Museen, Berlin/Jens Ziehe/Art Resource, NY.

The Sculptor and His Statue. bpk Bildagentur/ Nationalgalerie, Museum Berggruen, Staatliche Museen/Jens Ziehe/Art Resource, NY.

Nude in a Landscape. Rheinisches Bildarchiv Cologne, rba_c014312. Museum Ludwig, Inv.-Nr. ML/Z 2001/051.

Bullfight: Death of the Toreador. Photograph © RMN-Grand Palais/Mathieu Rabeau/Art Resource, NY.

Two Figures (Marie-Thérèse and Her Sister Reading). Koons Collection.

Nude with Bouquet of Irises and Mirror. Photograph © RMN-Grand Palais/Mathieu Rabeau/Art Resource, NY.

Reclining Nude Before a Window. Museum Collection Rosengart, Lucerne.

Nude in a Garden. Photograph © RMN-Grand Palais/Mathieu Rabeau/Art Resource, NY.

Bull's Head. Archives Succession Picasso.

Minotaur and Wounded Horse. The Art Institute of Chicago/Art Resource, NY. Anonymous gift. 1991.673.

La Minotauromachie, state VII. Photograph © RMN-Grand Palais/Mathieu Rabeau/Art Resource, NY.

Woman with Hat. Photograph © CNAC/ MNAM/Dist. RMN-Grand Palais/Georges Meguerditchian/Art Resource, NY.

Dora Maar with Green Fingernails. bpk Bildagentur/Nationalgalerie, Museum Berggruen, Staatliche Museen, Berlin/Jens Ziehe/Art Resource, NY.

The Pencil That Speaks. Photograph © 2020 Christie's.

Portrait of a Young Girl. Photograph © RMN-Grand Palais/Adrien Didierjean/Art Resource, NY.

Minotaur with a Wheelbarrow. Photograph © Archives Succession Picasso.

Women in an Interior. Photograph © RMN-Grand Palais/Jean-Gilles Berizzi/Art Resource, NY.

The Remains of the Minotaur in a Harlequin Costume. Jean-Luc Auriol and Alain Gineste. Deposit at the Abattoirs, Musée— Frac Occitanie Toulouse © Archives Succession Picasso.

Dora and the Minotaur. Photograph © RMN-Grand Palais/Thierry Le Mage/Art Resource, NY.

Portrait of Marie-Thérèse. Photograph © RMN-Grand Palais/Adrien Didierjean/Art Resource, NY.

On the Beach. Peggy Guggenheim Collection, Venice (The Solomon R. Guggenheim Foundation, New York, 76.2553 PG 5).

Large Bather with a Book. Photograph © RMN-Grand Palais/Mathieu Rabeau/Art Resource, NY.

Guernica. Photographic Archives Museo Nacional Centro de Arte Reina Sofía, Madrid.

Horse Head. Photographic Archives Museo Nacional Centro de Arte Reina Sofía, Madrid.

Mother with Dead Child (IV). Photographic Archives Museo Nacional Centro de Arte Reina Sofía, Madrid.

The Weeping Woman. Accepted by HM Government in lieu of tax with additional payment (Grant-in-Aid) made with assistance from the National Heritage Memorial Fund, the Art Fund and the Friends of the Tate Gallery 1987. Photograph © Tate, London/Art Resource, NY.

Lee Miller. Antonia Reeve, National Galleries of Scotland, Edinburgh.

The Supplicant. Photograph © RMN-Grand Palais/Mathieu Rabeau/Art Resource, NY.

Women at Their Toilette. Photograph © RMN-Grand Palais/Adrien Didierjean/Art Resource, NY.

Maya with a Doll. Photograph © RMN-Grand Palais/Adrien Didierjean/Art Resource, NY.

Head of a Bearded Man. Photograph © RMN-Grand Palais/Adrien Didierjean/Art Resource, NY.

The Sailor. bpk Bildagentur/ Nationalgalerie Museum Berggruen, Staatliche Museen, Berlin/Jens Ziehe/Art Resource, NY.

Seated Woman (Dora Maar). Private Collection, courtesy of The Heller Group.

Still Life: Palette, Candlestick and Head of Minotaur. The National Museum of Modern Art, Kyoto.

Marie-Thérèse Leaning on One Elbow. Photograph © Robert McKeever.

Bull Skull, Fruit, Pitcher. The Cleveland Museum of Art, Leonard C. Hanna, Jr. Fund, 1985.57. Photograph courtesy of The Cleveland Museum of Art.

Cat Devouring a Bird. Acquavella Galleries.

Woman with a Bird (Dora Maar). All rights reserved.

Night Fishing at Antibes. Digital Image © The Museum of Modern Art/Licensed by SCALA/Art Resource, NY.

Portrait of Jaime Sabartés. Album/Art Resource, NY.

Three Lamb's Heads. Photographic Archives Museo Nacional Centro de Arte Reina Sofía, Madrid.

Woman with a Green Hat. The Phillips Collection, Gift of the Carey Walker Foundation, 1994. Photograph: The Phillips Collection, Washington, DC. Any reproduction of this digitized image shall not be made without the written consent of The Phillips Collection, Washington, DC.

Head of a Woman. Photograph © RMN-Grand Palais/Mathieu Rabeau/Art Resource, NY.

The Soles. Antonia Reeve, National Galleries of Scotland, Edinburgh. Purchased 1967.

Woman Dressing Her Hair. Digital Image © The Museum of Modern Art/Licensed by SCALA/Art Resource, NY.

Café des Bains. Photograph © RMN-Grand Palais/Mathieu Rabeau/Art Resource, NY.

Flowers and Lemons. SIK-ISEA, Zurich (J.-P. Kuhn).

Woman with an Artichoke. Rheinisches Bildarchiv Cologne, rba_c004725. Museum Ludwig, Inv.-Nr. ML 01291.

Seated Woman with Hat (Dora Maar). Kunstmuseum Basel—Martin P. Bühler.

Seated Woman with Fish-Hat. Album / Art Resource, NY.

Head of a Bull. Milano, Laboratorio Fotografico della Pinacoteca di Brera.

The Aubade. Photograph © CNAC/MNAM/ Dist. RMN-Grand Palais/Georges Meguerditchian/Art Resource, NY.

Still Life. Photograph © Archive Museum Würth. Würth Collection Inv. 9222.

Woman in Satin Bodice (Portrait of Dora Maar). All rights reserved.

A NOTE ABOUT THE AUTHOR

John Richardson is the author of the memoir *The Sorcerer's Apprentice*; an essay collection, *Sacred Monsters, Sacred Masters*; and books on Manet and Braque. The first volume of his *Life of Picasso* won England's prestigious Whitbread Award. He wrote for *The New York Review of Books, The New Yorker,* and *Vanity Fair.* He was instrumental in setting up Christie's in the United States; was made a corresponding fellow of the British Academy in 1993; and served as the Slade Professor of Fine Art at Oxford University in 1995–96. In 2019, Rizzoli Books published *John Richardson: At Home*, featuring Richardson's art collection and interior design. He died in 2019.